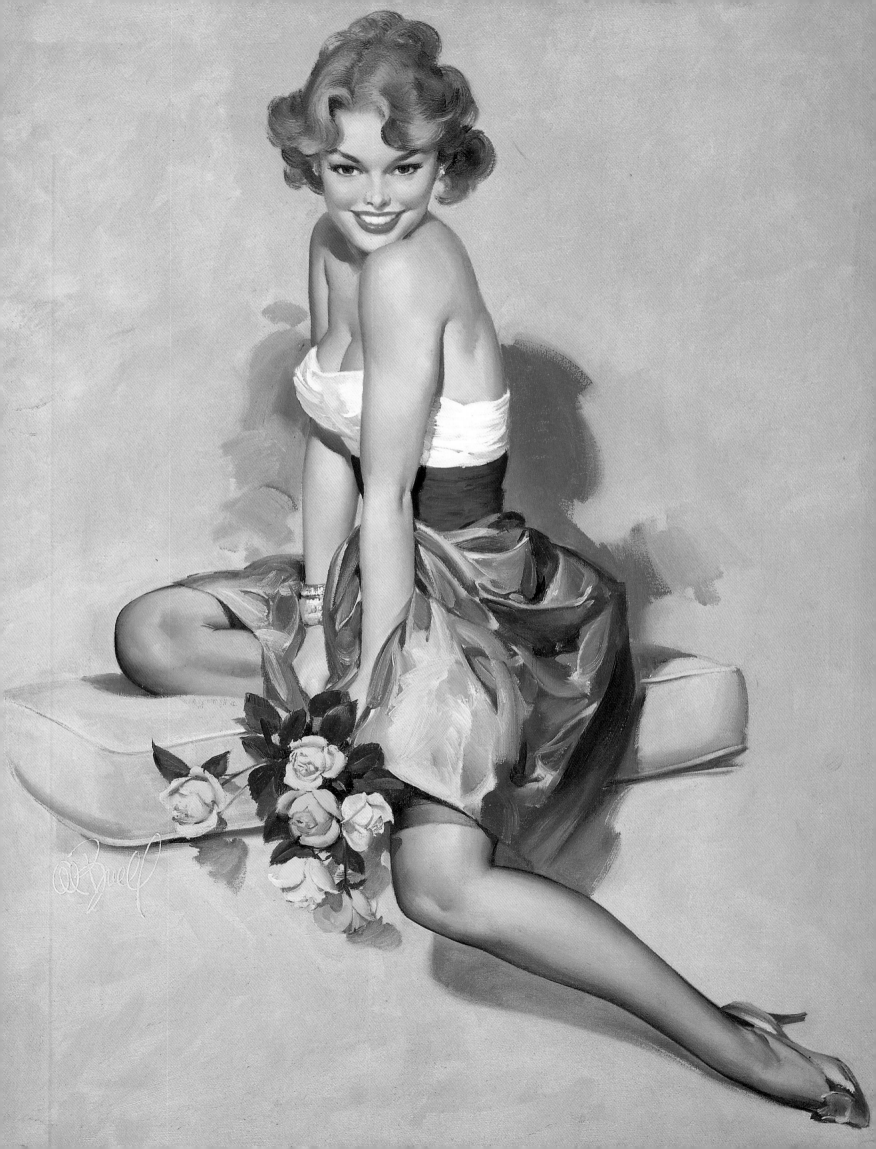

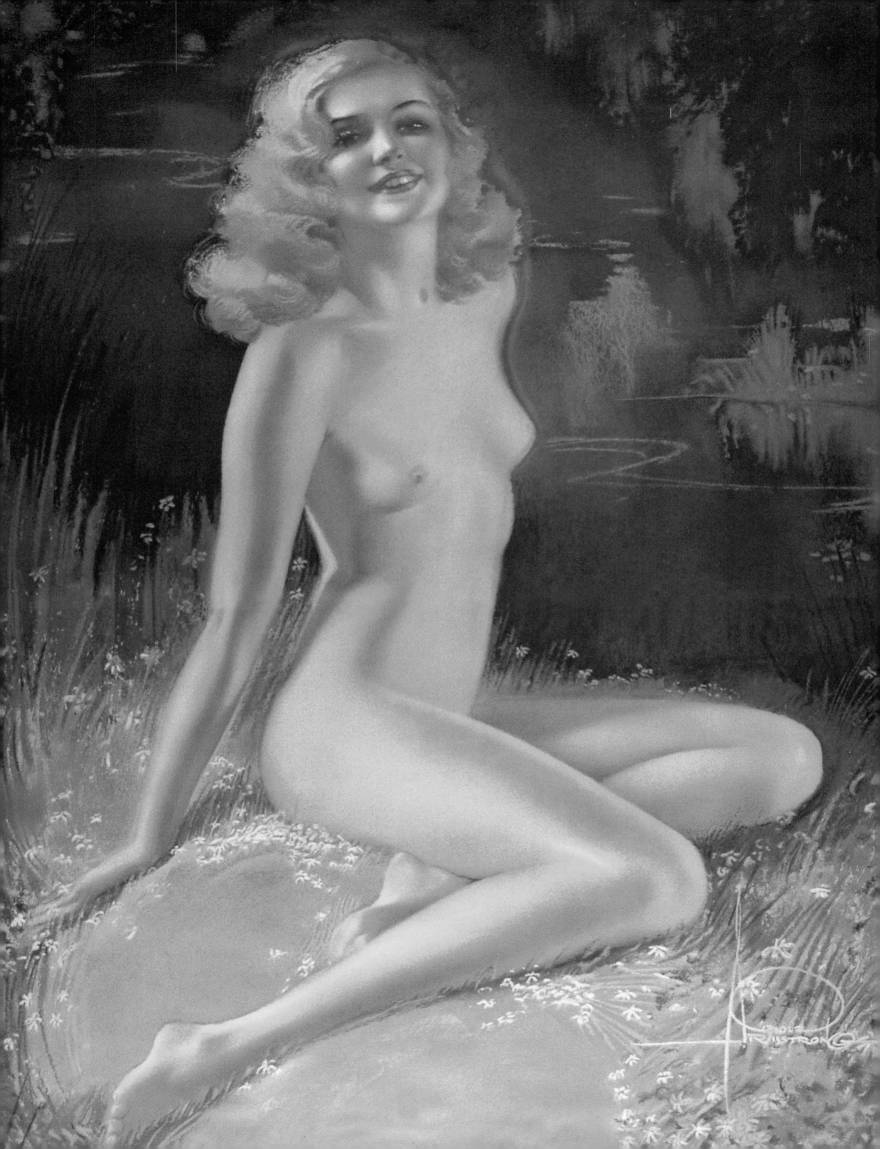

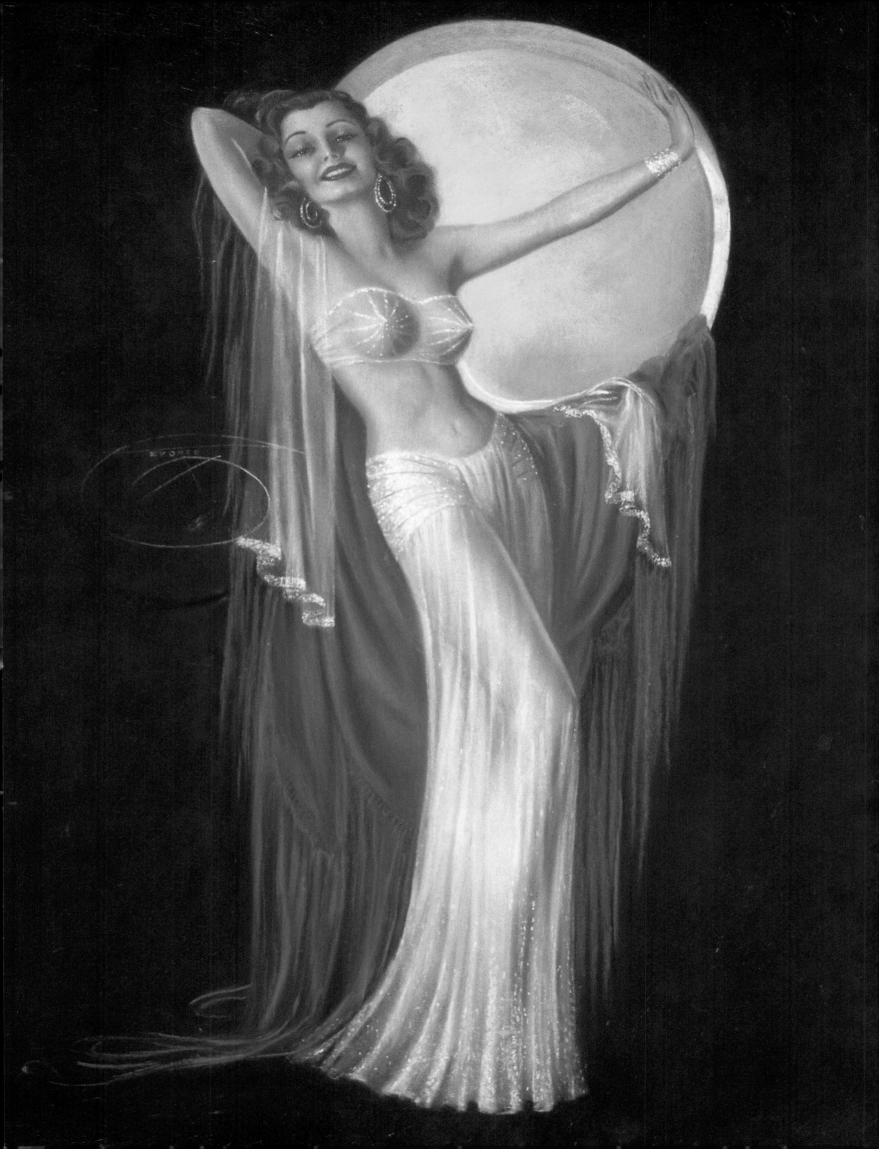

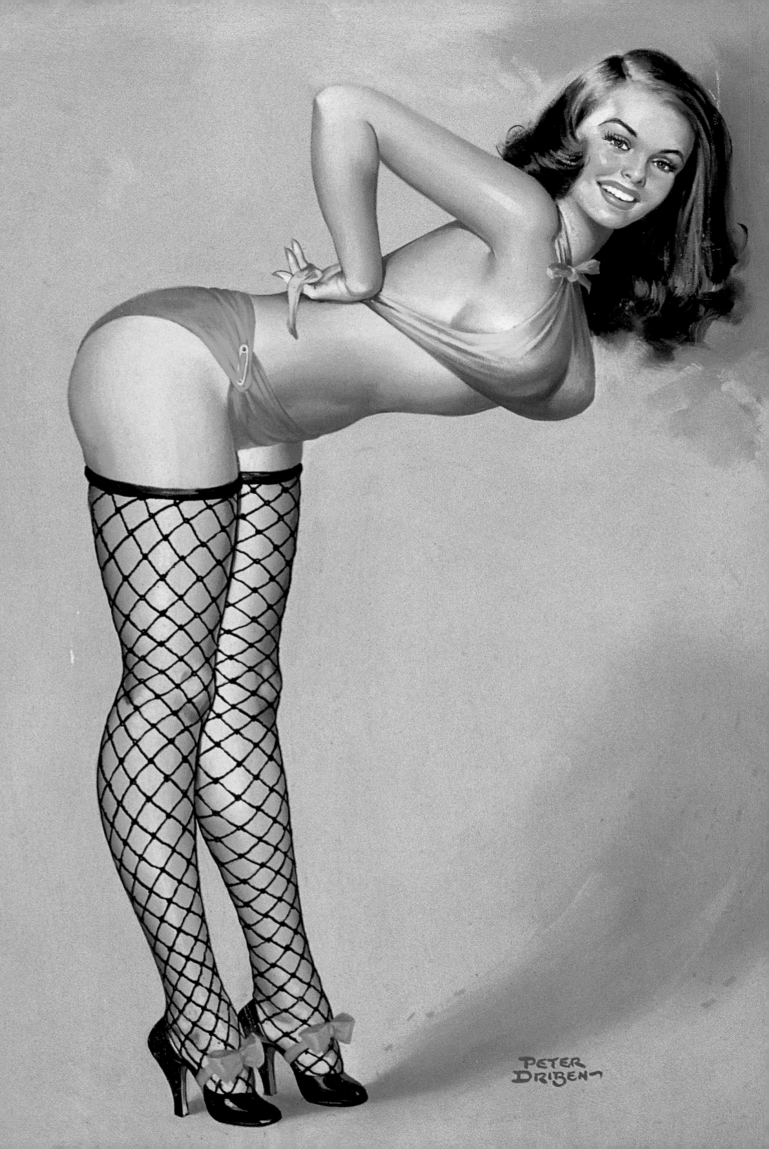

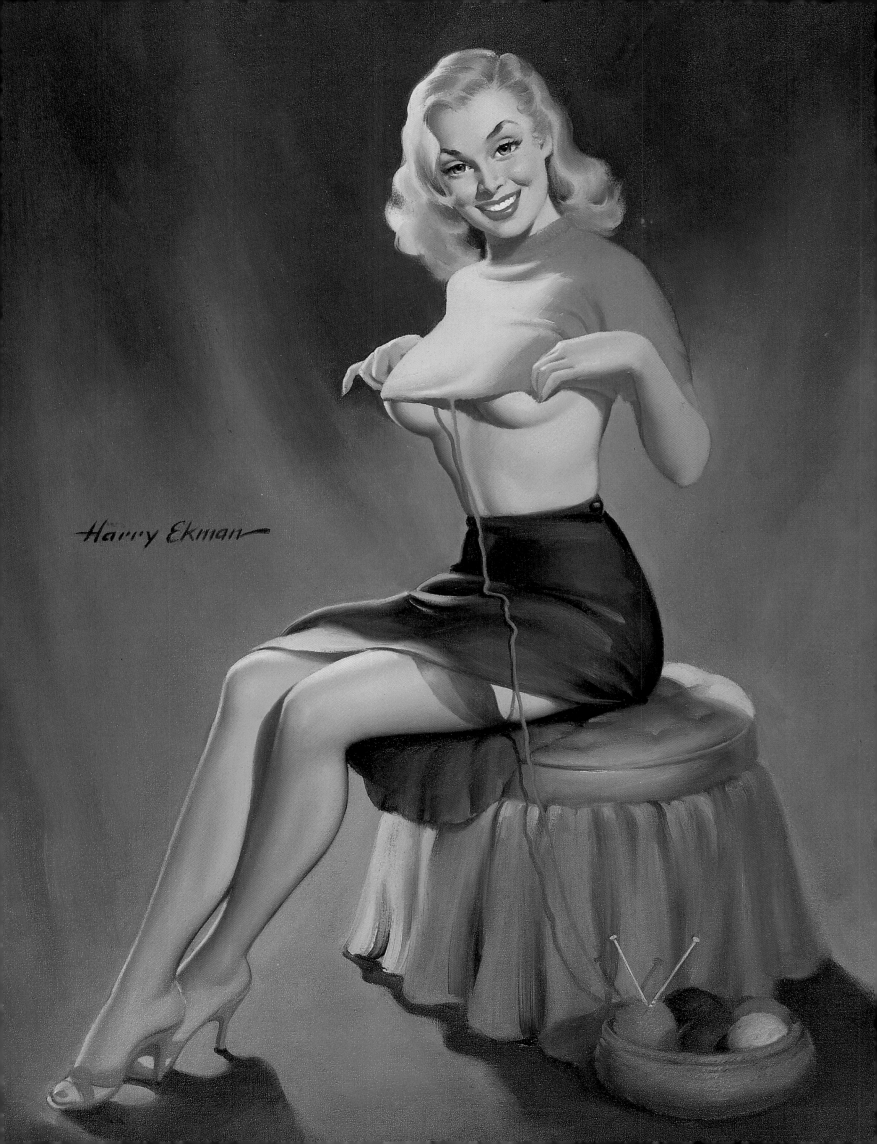

Harry Ekman

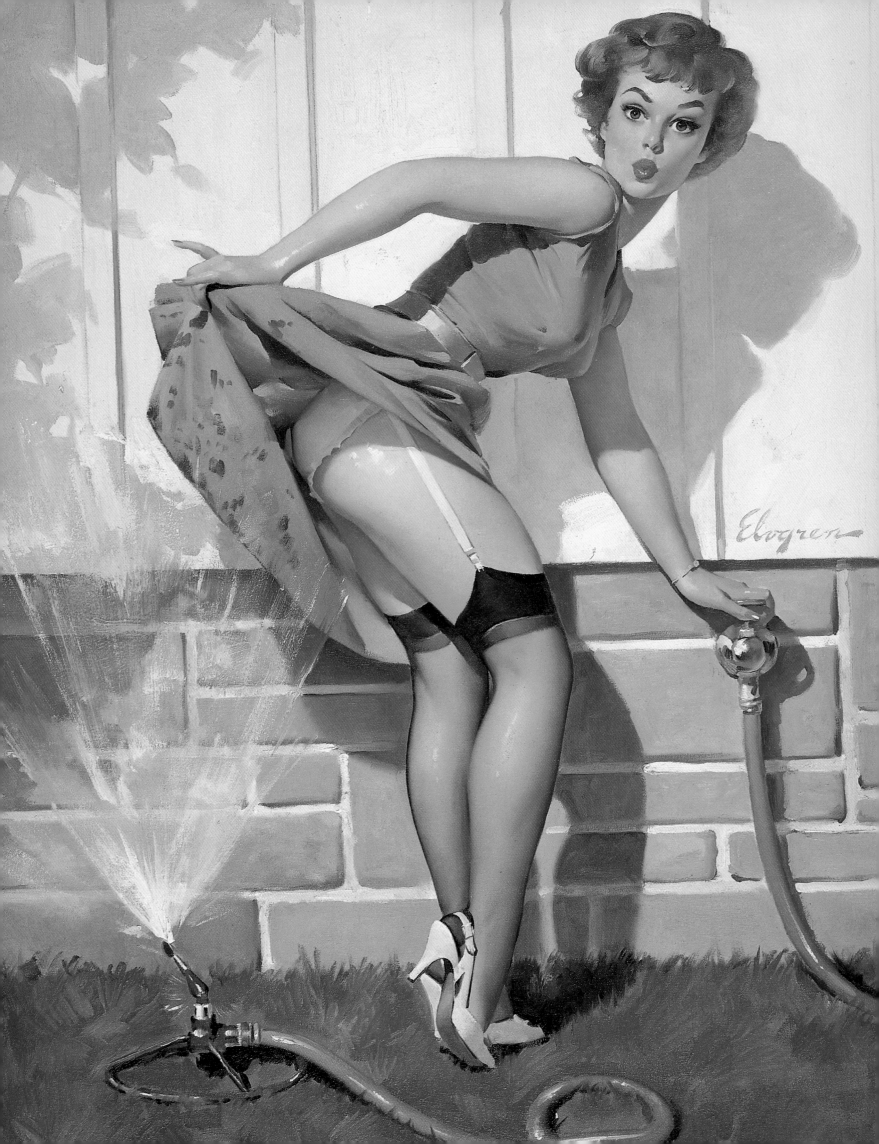

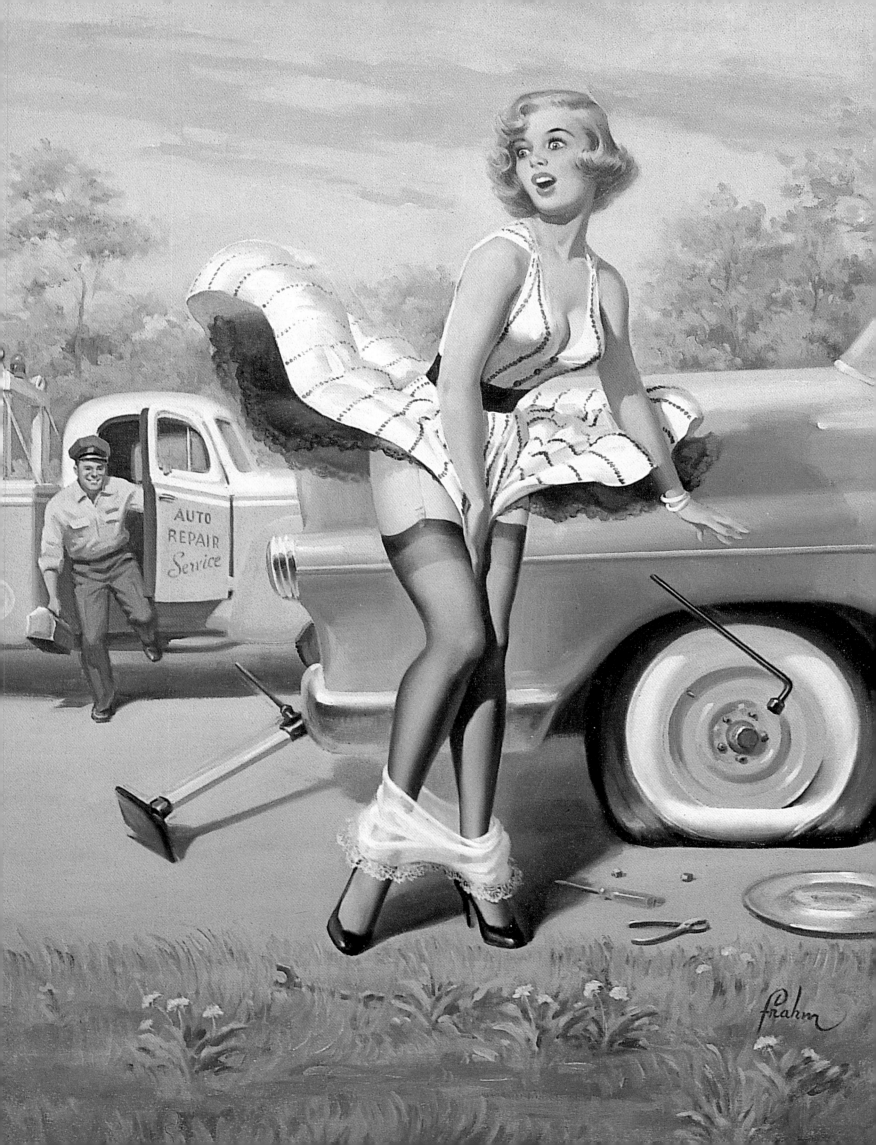

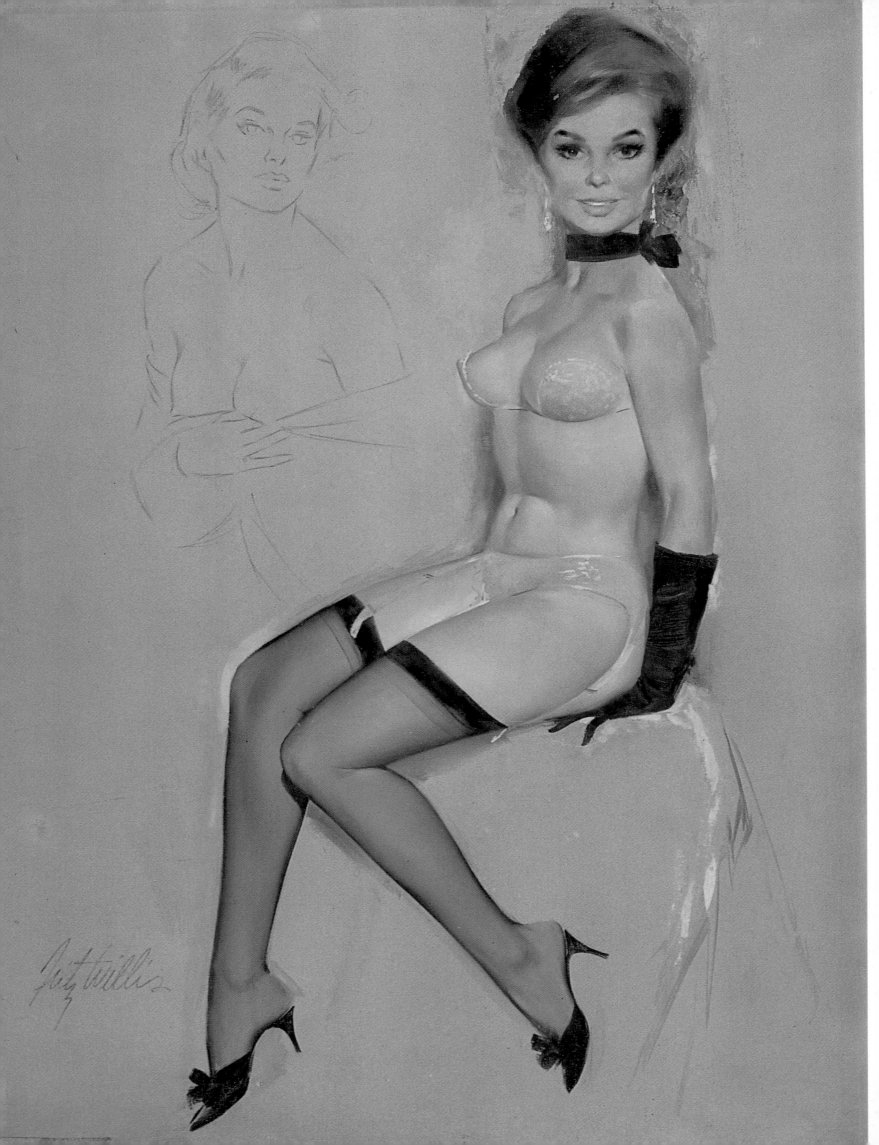

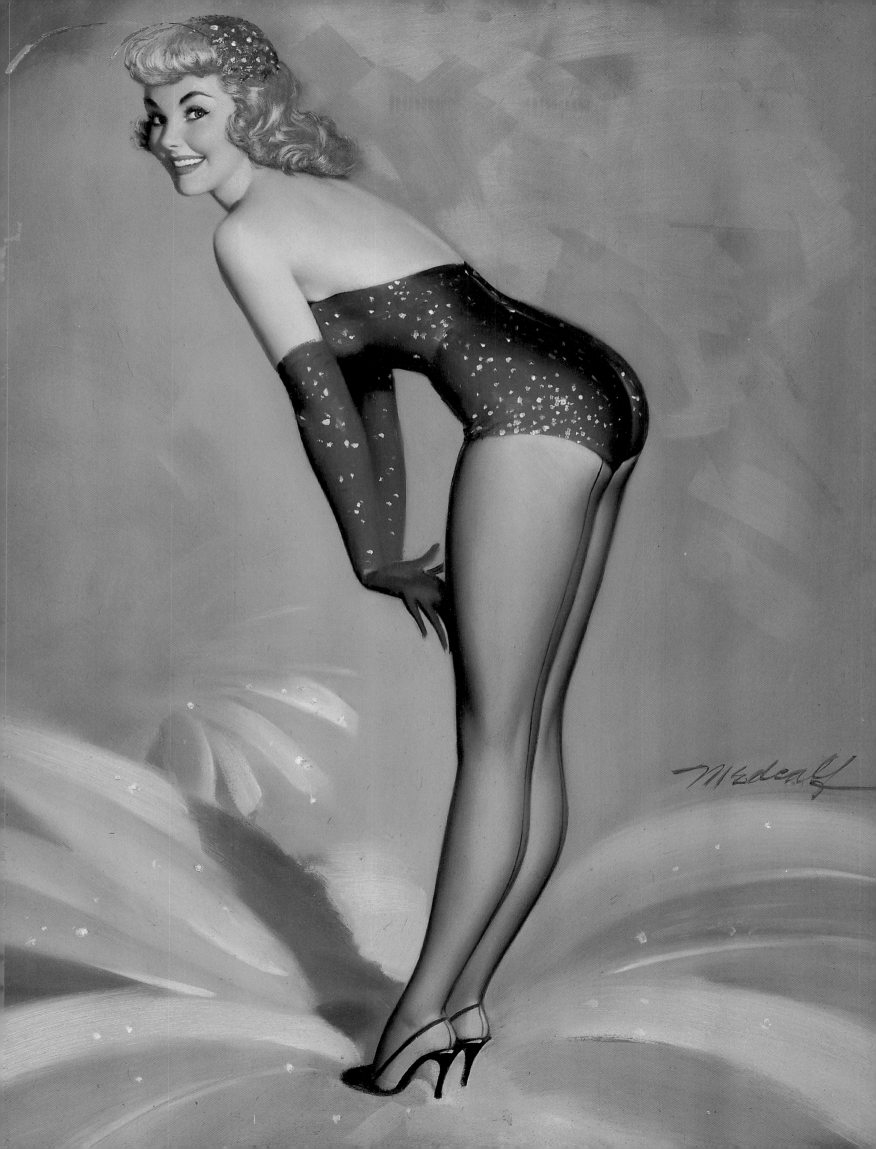

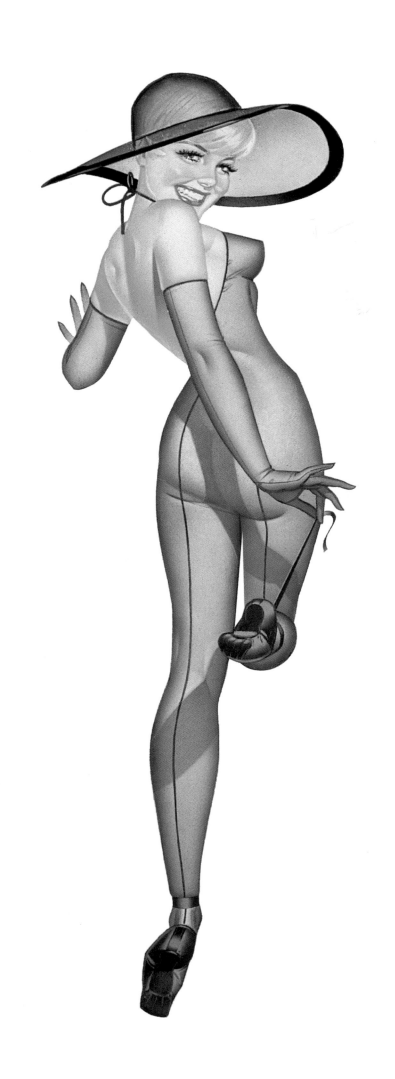

The Great American
Pin-Up

Charles G. Martignette
Louis K. Meisel

TASCHEN

KÖLN LISBOA LONDON NEW YORK PARIS TOKYO

To the eternal memory of my mother, Marie Della Femina, and to my father, Charles G. Martignette, Sr., who, as the best of Catholic parents, unselfishly supported all of my ideas, interests, and dreams from the day I was born. Without their love and encouragement, there would be no glamour in my life.
Charles G. Martignette

My part of this book is dedicated to the memory of Grace Elizabeth Moak, my mother, who at twenty-one in 1941 was, and continued to be, the all-American girl this book is about. It is also in celebration of Susan Pear, whom I immediately recognized in 1964 as my Femlin, my Pin-Up, my Wife.
Louis K. Meisel

This book was printed on 100% chlorine-free bleached paper in accordance with the TCF standard.

© 1996 Charles G. Martignette and Louis K. Meisel
Quotation from Hilton Kramer reprinted by permission of *The New York Observer*.
All illustrations of work by Alberto Vargas: © 1940, 1941, 1942, 1943, 1944, 1945, 1946, and 1947. The Hearst Corporation, All Rights Reserved.
By permission of *Esquire* Magazine/The Hearst Corporation. All Rights Reserved: images by Ben-Hur Baz, Al Buell, Eddie Chan, Ernest Chiriaka, Joe De Mers, Mike Ludlow, Al Moore, George Petty, Scali, J. Frederick Smith, and Fritz Willis.
Art from the Archives of Brown and Bigelow: works illustrated herein by Rolf Armstrong, Joyce Ballantyne, Roy Best, Al Buell, Edward Eggleston, Gil Elvgren, Jules Erbit, Bill Medcalf, Earl Moran, Zoë Mozert, K. O. Munson, Mayo Olmstead, Gene Pressler, Louis Shabner, and Fritz Willis.
Illustrations and information on Earl Mac Pherson are courtesy Mark Gamill, Estate of Earl Mac Pherson.
Illustrations and information on Peter Driben are courtesy of Leo, Adrienne, Aaron, and the Driben family.
Reproduction of art by George Petty: © the George Petty Estate, has been approved and permitted by the Estate, with the assistance of Ronald Feldman.

We have made our best efforts to contact the owners of copyrights for all the other art reproduced in this book. Most of the publishers of calendar art no longer exist, and in most cases, the art has now fallen into public domain. We acknowledge all the unidentified families and estates of these artists and thank them in absentia for their contributions.
We would like to encourage anyone with additional material on any of the artists herein to submit such information, or photographs of any original artwork, to the Archives of Pin-Up and Glamour Art. Such material will be used for historical documentation and may be included in monographs on the individual artists. Material should be submitted to either Charles G. Martignette, P.O. Box 293, Hallandale, Florida 33008, or Louis K. Meisel, Meisel Gallery, 141 Prince Street, New York, New York 10012.

Printed in Spain
ISBN 3-8228-8497-9
GB

Illustrations page 1, Al Buell (figure 1); page 2, Rolf Armstrong (figure 2); page 3, Billy De Vorss (figure 3); page 4, Peter Driben (figure 4); page 5, Harry Ekman (figure 5); page 6, Gil Elvgren (figure 6); page 7, Art Frahm (figure 7); page 8, Fritz Willis (figure 8); page 9, Bill Medcalf (figure 9); page 10, George Petty (figure 10); page 13, Earl Moran (figure 11)

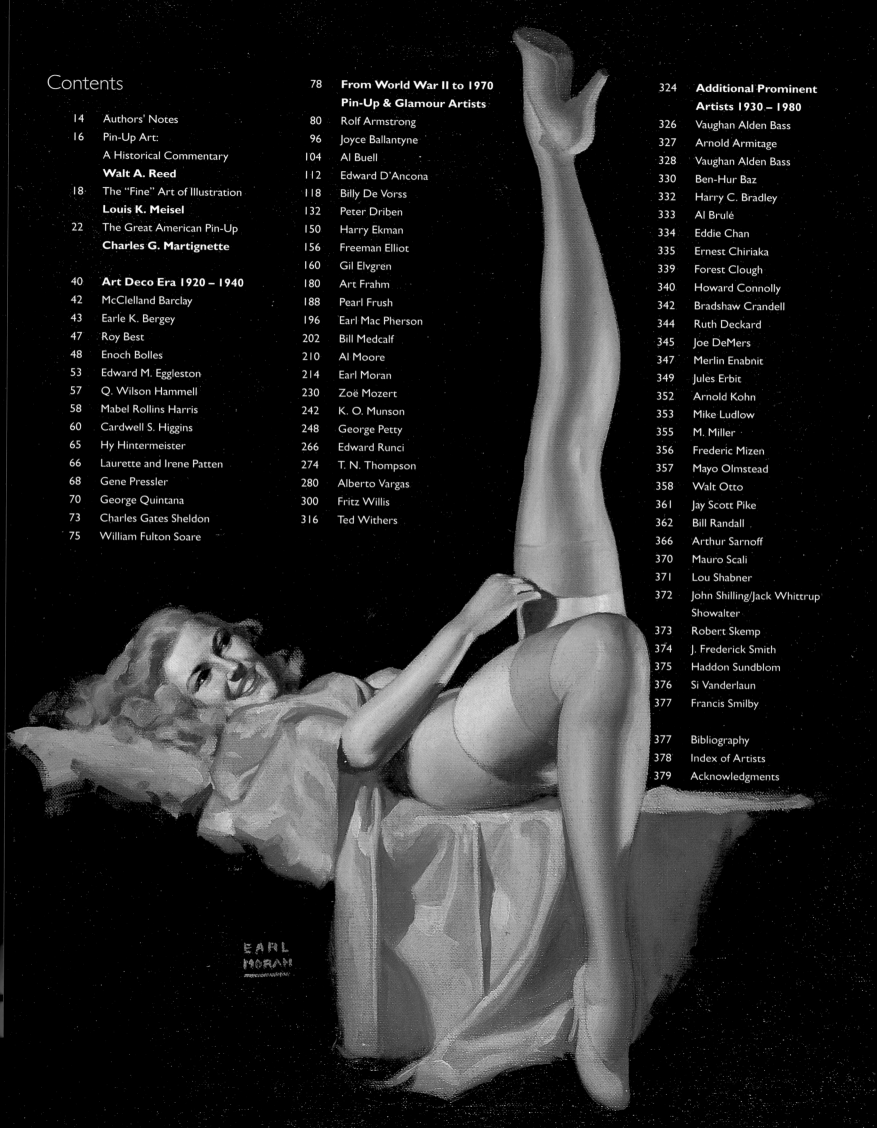

Contents

Authors' Notes

Charles G. Martignette with "A Real Swinging Sweetie", an original oil painting by Gil Elvgren, circa 1965

It was about 1955 when I saw my first pin-up. My Aunt Anna would sometimes baby-sit with me, and one of our regular activities during those special nights was to read the day's newspaper together. Being five year old, I obviously couldn't understand the words, but I would cry out with delight every time I saw a pretty girl in an ad for ladies' shoes. At the end of the evening, we would both count together how many shoe ads we had seen.

When I was eight, my Uncle Mike began taking me for my haircuts. There, on the wall of the barbershop in Somerville, Massachusetts, I saw my first pin-up calendar. I began looking for pictures of pin-up girls everywhere I went. In 1960, at the grand old age of ten, I started to accompany Uncle Mike on Saturday mornings when he went to a local doughnut shop for coffee and doughnuts. There I discovered an entire wall decorated with pin-up and glamour art calendars, many of which, according to the owner of the shop, Mr. Rose, dated back almost to World War I.

It wasn't until December 1978 that I saw my first original pin-up painting – *A Refreshing Lift* by Gil Elvgren. I bought the work, which became my new prized possession: an oil on canvas, measuring 30 x 24 inches (76.2 x 61 cm), that had been reproduced by Brown and Bigelow in 1969. I was in love. I was in heaven. And I was smitten with the idea of collecting more originals.

During the last fifteen years, I have been fortunate to have found and bought most of the original pin-up art in existence. I have shared that material with fellow collectors, both in the United States and abroad. This book presents the best of my pin-up and glamour art paintings, by both major and lesser-known artists in the field.

I feel strongly that the time has come for American pin-up and glamour art to be recognized worldwide for its special place in the history of American art. I have joined forces with Louis Meisel to produce numerous exhibitions of this art as well as a series of informative and, we hope, entertaining books, of which this is the first.

While I searched for artwork and for information on pin-ups, I also discovered other illustrators who worked in a broad range of subjects for magazines and advertisers in the "mainstream" sector. I found myself loving the work of these contemporaries of Norman Rockwell as much as I loved my glamorous pin-ups, for they were all the *real* art of America.

I firmly believe that time and history will recognize the hundreds of American illustrators as truly significant artists of the twentieth century. It was their art that recorded for all of us the social and cultural development of our country. And pin-ups and glamour art played a key role in that process.

Charles G. Martignette

When the Fabulous Fifties arrived, I was eight years old. For the first three years of the decade, I was entirely absorbed in airplanes, specifically the Sabre jet. I wrote to all the airplane manufacturers for promotional pictures and built a terrific collection to adorn my room. I always preferred the pictures that showed paintings of airplanes to those that were merely photographs.

I was a teenager by the middle of the decade, and my interest turned to girls. Again, I was more drawn to paintings of girls than to photographs of them. My favorites were the kinds that showed girls who looked like the prettiest of my high school classmates in Tenafly, New Jersey. Whenever I got a copy of *Wink*, *Whisper*, or *Beauty Parade*, I was happy with the Peter Driben pin-up on the cover, while my friends were more turned on by the photographs inside, showing girls in their underwear who were to me tacky, unattractive, and sloppy. Nothing illustrated the ideal American girl better than the Brown and Bigelow calendars of that period painted by Gil Elvgren, Earl Moran, Rolf Armstrong, and Zoë Mozert.

At the end of the decade, I began to meet the artists of the New York School, or the Abstract Expressionists, as they were called. My attention was diverted to the field of fine art. Then, in 1963 or 1964, I discovered the Pop artist Mel Ramos. The sole link between the so-called fine-art world and that of pin-up illustration, Ramos acknowledged Elvgren as an inspiration and was himself a collector of pin-up art.

In 1972, I began to represent Mel and to seriously collect his art. At the same time, I began a search, which proved largely unsuccessful, for original pin-up art. In 1982, my wife, Susan, and I presented an exhibition of works by Elvgren, Mozert, and Armstrong at Susan P. Meisel Decorative Arts. The paintings we showed were primarily from the collection of our friend Marvin Oshansky. For the rest of the 1980s, we always had a pin-up or two on exhibition.

By the 1990s, I had acquired a good deal of pin-up art and had rekindled my relationship with Charles Martignette. I felt ready to act on an idea I had thought about for a long time. Charles and I joined together to present these artists and their work in a serious way, to proclaim and promote them as the fine artists they are.

Louis K. Meisel

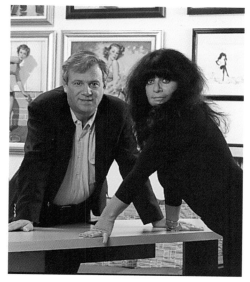

Louis K. Meisel and Susan P. Meisel with a "Femlin"-painting by LeRoy Neiman and two paintings by Gil Elvgren
Photo: Steven Lopez

Frank Hoffman, Earl Moran, Zoë Mozert, Norman Rockwell

Pin-Up Art:
A Historical Commentary

Walt A. Reed

At the turn of the century, "family values" ran rampant. Still subject to repressive and cloistered mores of the Victorian era, women were corseted, petticoated, and so covered from head to toe that the glimpse of an ankle was a racy titillation. The unmentionable word was spelled "s_x" and any books relating to that subject in the public library were kept under lock and key behind glass cases. It's a wonder that the population rate didn't fall precipitously.

Somehow Mother Nature persevered, and if the printed word was being policed by the Boston-based Anthony B. Comstock Society, magazine publishers were risking censure or confiscation by printing pictures of scantily clad maidens under the more-difficult-to-censor guise of art. Or, as in the case of *The Police Gazette*, should the peccadilloes of vaudevillians involve murder or mayhem, it was perfectly legitimate to illustrate the story by showing the leading lady in her tights, in the interests of news.

Nor did art museum attendance languish. Academic painters found great public favor by depicting Grecian maidens in diaphanous robes or innocently emerging from ornate pools covered only by a strategic lily pad. If the figures were of Greek or Roman mythology, the public was historically and safely removed from contemporary temptation.

A few more subversive influences were looming. D. H. Lawrence railed against sexual repression in his infamous novel *Lady Chatterley's Lover*. Certainly any library with a copy kept it locked up! The aftermath of World War I brought back a generation of lusty young soldiers from Europe, where the population was much less inhibited and French postcards were the ultimate in sensuality.

The 1920s became a revolt against everything the older generation stood for, and young women as well as men sought emancipation. The illustrator John Held, Jr., portrayed the leggy, short-skirted "flappers" who were accompanied by the bell-bottomed, saxophone-playing "sheiks" with pomaded hair à la Rudolph Valentino whose manners were as sullen as their fathers' had been gallant.

The magazines *Judge*, *Life*, and *College Humor* enthusiastically published the flappers of Held and Russell Patterson and the bathing beauties of Coles Phillips and Rolf Armstrong.

Publishers of "pulp" magazines like *Spicy Detective*, *Weird Tales*, and *The Mysterious Wu Fang* saw no reason to withhold from an eager public lurid paintings, showing heroines in bondage or mortal danger from the "yellow peril". Renegade illustrators, including Jerome and George Rozen, John Newton Howitt, and H. J. Ward, lent their considerable talents to this risqué genre and were later joined by the daring Margaret Brundage. Even as far back as "Little Egypt" at the 1898 World's Fair, pin-ups have had an exotic ancestry. A "nice girl" wouldn't display her figure, but it was all right for sloe-eyed Eurasians or Belly Dancers to cavort about and inspire naughty pictures.

Some publishers developed a specialized niche in the nudist magazines reflecting that new fad. Others, like *Captain Billy's Whiz Bang*, *Snappy Stories*, and *Film Fun*, needed no excuse to combine sex with humor. As with the adventure pulps, the main expense was for cover art. Many of these early magazines operated with very slim budgets – some did not survive beyond the first printing. The artwork reflected this lack of funds, and their covers were necessarily done by second-rate performers. The social standing of such magazines was so low that few self-respecting illustrators would touch them. Even later, with improvement in magazine budgets and content, pin-up art was considered a lowbrow specialty. There was little crossover between mainstream magazine illustrators and those in the pin-up field. Unabashed, pin-up artists such as Earle Bergey, Enoch Bolles, and George Quintana raised the artistic level of the art and came to dominate the covers of this budding branch of pathfinding publications.

Brown and Bigelow, the earliest and biggest of the calendar publishers, began using bathing beauties as an important part of their line early in the century. After the 1920s, nearly every garage in the country had a sultry beauty by Rolf Armstrong, Earl Moran, Earl Mac Pherson, or Billy De Vorss on display over the workbench.

Esquire magazine in the 1930s Depression brought a monthly relief from the bad economic outlook with morale-boosting centerfolds, featuring first the George Petty Girl and then

Antonio Vargas's airbrushed beauties. As a lavish slick-paper magazine, *Esquire* could attract more established artists, and later *Esquire* artists included Gilbert Bundy, Mike Ludlow, Fritz Willis, Joe De Mers, Al Moore, Ben-Hur Baz, and many other talents.

World War II turned the pin-up into a major industry. It was to become the golden age of the art, with room for any artist who could paint an enticing figure. Girls by artists such as Gil Elvgren, Zoë Mozert, Joyce Ballantyne, and Earl Moran vied for space in the GIs' lockers along with photographic images of movie actresses, such as Betty Grable, Rita Hayworth, and Veronica Lake, and a host of starlets.

The returning veterans of World War II wanted only to settle down, to build houses and raise families. A few efforts to push the sexual frontiers, such as the lavish *Eros* magazine, were quickly quashed by the postal authorities. While the garage calendar was still the thriving mainstay format, a group of younger artists led by Gil Elvgren and his protégés Art Frahm, Ed Runci, Al Buell, and Harry Ekman were taking over the pin-up genre. And, not to be taken too seriously, subgroups of "plump" pin-ups, "dropped-panty" pin-ups, male pin-ups, and other fragmented specializations found their enthusiastic partisans.

During this time, the newest showcase for pin-up art was on the covers of the paperbacks. Born of a need for cheap, pocket-sized reading matter for GIs and restricted by paper shortages, the pent-up postwar public response was seemingly without limit. Every kind of subject was published in a ten-cent format with an illustrated cover. Even titles by such classic authors as William Faulkner, Emily Brontë, and John Steinbeck could be illustrated with a lot of leg. Hundreds of artists were involved in painting the covers; among the best were James Avati, Rudy Belarski, Baryé Phillips, and Bob McGinnis. Some had been recruited from the pulps, others from the ranks of the dwindling major "slicks", which were falling right and left. Among these were such publications as *American*, *Collier's*, *Liberty*, and *Woman's Home Companion*; later on even the mighty *Saturday Evening Post* folded in competition with T.V. and the paperback.

With the availability of the Pill, it was the baby boomers of the 1960s who brought down the sexual barriers. Hugh Hefner became the new guru through *Playboy*, which directly confronted censorship rules for use of the mails. Under legal challenges, the Supreme Court waffled about how to rule on obscenity within the vague definition of "prurient and with no redeeming social value". Consequently, the gates came down and many other magazines rushed into competition. The "skin" magazines became an international phenomenon.

By the 1970s, photography had taken over the pin-up genre, with graphics that tended to take the fun out of the subject and to put the emphasis on literal examination of sexual parts more appropriate to the medical profession.

The subject having been pursued about as far as it can go, an inevitable reaction may be in the offing. Excesses of freedom without taste or responsibility, AIDS, and increasing public concern about lost standards of behavior are certainly adding to the clamor for a return to "family values". Will the pendulum swing back to its original extreme in the next century? Will we return to that errant ankle?

The "Fine" Art of Illustration

Louis K. Meisel

Where is the line between illustration and fine art, between illustrator and artist? More to the point, why in the 1990s is there still such a line?

Until the camera was invented in the middle of the nineteenth century, all artists essentially illustrated – for their contemporaries and for posterity – the faces (portraits), places (landscapes), and objects (still lifes) of their time. Artists were commissioned to paint portraits of pharaohs, emperors, kings, nobles, and wealthy patrons and their families; later, commercial enterprises gave them similar "assignments". They traveled the world, for a myriad of reasons, recording places and historical events, and they created still lifes as decorative ornament since the earliest eras of human life. (And speaking of subject matter, I would venture to suggest that, in the thirty thousand years or so since the "Venus" of Willendorf, the female form has been more popular than any other theme as a subject for artists.)

In theory, the introduction of the camera and the photograph was to take over the artists' responsibility for recording and illustrating, thus freeing them to pursue more "intellectual" concerns and challenges. In reality, however, a long chain of events – beginning with the Impressionists' questioning of the conventions by which earlier artists had been bound – has led to the utter rejection of the "illustrative" function of art and the disparagement of those who make realism the core of their art.

Sometime during the 1980s, I realized that there was in fact a vast universe of artists out there who, by the very nature of their careers, have always addressed the general public, not the infinitesimally small "art world", and who have consistently been required to be disciplined craftsmen with an ability to communicate effectively through their art. In fact, these artists' works have always been so clear and communicative that no critic has ever needed to interpret and evaluate them for the public. The level of quality, craftsmanship, and discipline in their work has been monitored by editors and other professionals, not by critics. Perhaps because they perform in such a "real" world rather than in the confines of the art community, it has been thought necessary to label these artists "illustrators".

The word *illustrator* has been used to describe many kinds of artists, but it has usually carried a derogatory connotation. There are, to be sure, several different ways in which illustrators have approached their work. Some, who may be called the technicians, obviously accept assignments with nothing more in mind than taking a series of dictated ideas and realizing them on paper. For example, Pan Am wants a picture of an airline pilot in the cockpit; he's in the left seat, with his jacket off, is graying at the temples, shows three small children the gauges and controls of the 747, and so on. Then there are those illustrators who, given a story, book, or film to contemplate, can distill its essence into a single picture for a book cover, magazine page, or poster. Still others can create appealing images (pretty girls being classic examples) which, because they catch and retain the attention of a great number of people, can be used to mass-market and advertise products. And, to go even further, there are those whose work, created independently, can be used to transform concepts and words into stunning visual communications.

Somewhere along this continuum, we probably cross the line between the job of illustrating and the creation of fine art, but the question is whether it is really worth trying to pinpoint that place exactly. I have found that practically every artist who created what we now call pin-ups in the vintage years from 1920 to 1970 was closer to the creative side of the spectrum – a fine artist whose work happened to be employed by others in various commercial enterprises.

Of course, some artists in the genre were better than others, but all loved doing their work. All shared the same inspiration and communicated the same truths about their time and place, as artists have always done. The girls and women they all portrayed were free from the influence of a warped fashion world or a distorted feminism. They looked the way most women of the time wanted to look and certainly the way men (particularly those returning from World War II) wanted them to look: sexy but chaste and all-American.

It is interesting to note that virtually none of the artists documented here ever had an exhibition of his or her work in a gallery or museum. Almost none sold paintings as collectible works

of art, and all but two or three are no longer here to keep their names and reputations alive. Yet over the decades, a handful of serious art collectors (including the authors of this book) have collected and preserved between one and two thousand originals of their works.

Let's look at some of the factors that have led to the wholesale rejection of such artists as "illustrators". For one thing, illustrators belong to the category of commercial artists, who as the name suggests conduct their activities for financial gain in the world of business. To argue that commerce should have no place in the sphere of art is to engage, I think, in a basically hypocritical discourse. In thirty years of art dealing, I have rarely, if ever, come upon an artist who was not hoping for a monetary reward for his or her efforts. (It is true, of course, that Earthwork and Conceptual artists had no product to sell, but they certainly did capitalize on the documentation, photographs, and artifacts spun off from their main work.)

The same "holier-than-thou" attitude is adopted by the artists who speak exaltedly of their noncommercial, intellectual, dedicated work. Usually fueled by some sort of political agenda, the work of such artists is generally inept, poorly executed, undisciplined, and lacking in aesthetic qualities. Yet, despite their protestations of the sacredness of their mission and their creations, these artists have all placed price tags on their works. Their sanctimonious attitudes are gladly reinforced by critics, museum curators, and art school administrators who glorify ineptitude and mediocrity in their search for the novel, the trendy, and the lucrative.

Another factor diminishing the status of the illustrator has been the antirealist trend in modernist art. For almost half a century now, we have been led to believe that Abstract Expressionism is the true American modernist movement – the movement that wrested artistic pre-eminence from Europe and firmly planted it in New York City. But one could argue just as strongly that the true American art form has always been, and still is, entrenched in realism and that this strain has affected European art forcefully for more than two hundred and fifty years. Early American, Primitive, Hudson River School, Ashcan, The Eight, WPA art, Magic Realism, to list only a few, all had clear counterparts on the other side of the Atlantic.

In this great American realist tradition, Hopper followed Eakins and Homer, and was in turn followed by Andrew Wyeth. As some of the finest realist painters of the twentieth century, these artists had colleagues – just over a very blurry line – in illustrators like N. C. Wyeth, J. C. Leyendecker, Rolf Armstrong, Howard Chandler Christy, and Norman Rockwell. They were all fine realists – period.

Furthermore, the American modernists' rejection of realism in favor of abstraction was responsible, in part, for a gradual but insidious deterioration of artistic standards. When Abstract Expressionism and its progeny threw out the rules and the discipline that had traditionally governed realist art, the flood-gates were opened for anyone who sought an easy path to being an artist. By the late 1980s, in fact, this trend had gone so far that some in the American art world began an attack on the word *quality*. They labeled the word, which represented a set of standards established over thousands of years, sexist, racist, and otherwise severely limiting to the masses of would-be artists who might ordinarily be thought unqualified and unworthy of the name. When they evaluate the work of contemporary artists, today's art schools, museums, critics, and magazines deem it necessary to give more weight to such matters as race, gender, and political content than to the appearance of the art itself. This tendency has gathered such strength in the past decade that nowadays the artist's ability to make art, and the viewer's to recognize it, has been severely compromised.

Of course, such license to be undisciplined does not hold for doctors, lawyers, engineers, scientists, or the many other professionals who, if they perform unsatisfactorily, are subject to swift identification and disqualification, regardless of the political consequences. Only in the area of the arts (and I mean all the arts) are clear-cut criteria for excellence lacking, and the possibility that the public may be deceived is therefore quite real. Multitudes of aspiring artists have entered the field in recent years and found some measure of success, if only for a while. Time will judge their true worth, although I am convinced that many of them will be forgotten before we proceed very far into the new century.

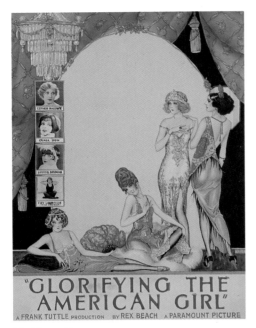

20. Alberto Vargas
Glorifying the American Girl
Watercolor, 1927

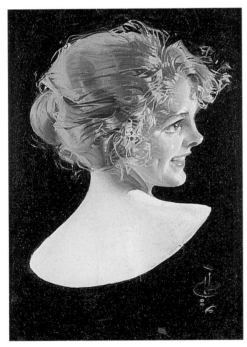

21. J. C. Leyendecker
"Leyendecker Girl,"
Chesterfield Cigarette advertisement
Oil on canvas, c. 1910

scapes. Occasionally, he would accept a special commission if the project was tempting or challenging. Such was the case when Christy agreed, in the early 1920s, to create a series of murals for the famous Café des Artistes in New York.

From 1915 to his death in 1952, Christy both lived and worked at the Hotel des Artistes, where the Café was located, just off the lobby; his studio in the hotel was one of the most elegant in the world. When the commissioned work was finished, all the walls of the Café were splendidly adorned with Christy's life-size nudes frolicking in a lush forested landscape.

Later, about 1925, the artist received another commission, from a private patron, for a work of almost mural size. The painting Christy created in response (figure 22) might be thought of as a sort of fifth wall for the Café. The work features three nudes in a dreamlike Garden of Eden, and to underscore the special nature of the scene, Christy chose twenty-four-carat gold paint for the sky and the setting sun.

Christy's murals may still be seen at the Café des Artistes. Like all his masterly images of feminine beauty, they remain as a permanent testimony to his art, to the brilliance of his brushstrokes, and to the sensuality and eroticism of his female nudes.

Harrison Fisher (1875–1934) was another Art Deco artist who, like Gibson and Christy, had such talent and attained such fame that his creations were known by his name. The son and grandson of painters, Fisher was a native of New York who later moved with his parents to San Francisco. He studied art in that city's Mark Hopkins Institute of Art. After further art education in England and France and jobs with the Hearst newspapers in San Francisco, Fisher returned to New York in 1897. He soon became known for his work as a staff artist at *Puck*, especially for his front-cover pen-and-ink drawings (to which color was later added).

Working primarily in gouache and pastel for most of his career, Fisher expressed his vision of the ideal American girl in an extraordinarily long-lasting series of images – the front covers that he created from 1912 to 1934 for *Cosmopolitan* magazine. That publication described the Fisher Girl in these words: "healthy, well poised, clear-eyed, . . . neither slob nor sloven, . . . who wins by the sheer charm of her personality, who is genuine, gracious, tender when need be, buoyant when occasion calls, and feminine always."

In addition to his special relationship with *Cosmopolitan*, Fisher provided work to other mainstream publications like *The Saturday Evening Post, McClure's, Ladies' Home Journal*, and *Scribner's*; a gouache entitled *Dear Sweetheart* that was published in 1914 as a front cover for *American Sunday Monthly Magazine* is typical of such work (figure 23). Fisher was also well known for his illustrations of popular romantic novels.

Like the other prominent illustrators of his day, Fisher became a wealthy man who was much sought after by models seeking to pose for him. He, too, had books published that featured his pictures of American beauties. And, in a final parallel to Gibson and Christy, Fisher turned to easel painting and portraiture toward the end of his life.

It is clear from the preceding examples that Art Deco artists quite often either incorporated pin-up and glamour images into their work or used them as starting points for many different kinds of illustrations. The examples we have seen come from the most famous of the mainstream illustrators working in the early decades of the twentieth century. Although one of the works was a "glamour art" image used in a national advertising campaign (see figure 21), it was not a true pin-up.

For a real pin-up image, we must turn to a superb watercolor by Coles Phillips that was first published in 1922 as a full-page advertisement for Holeproof Hosiery (figures 24 and 25). Virtually all the leading mainstream magazines, including *The Saturday Evening Post, Cosmopolitan*, and even *Good Housekeeping*, carried the advertisement, and many readers wrote to request prints of the image. Obviously, the tranquil pose of the model, coupled with Phillips' sophisticated composition and design, allowed the pin-up subject here to work with grace, elegance, and sensuality.

Coles Phillips had a short-lived but successful career that spanned just under twenty years (1908–1927). Like Christy and Gibson before him, he received his first assignments from *Life*.

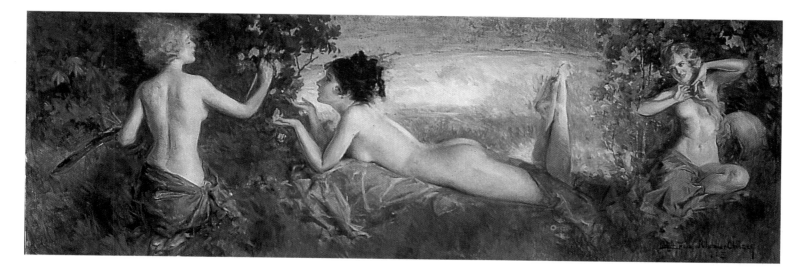

Unlike his two peers, however, Phillips graduated to front-cover assignments a few months afterwards and continued to produce them until his death. His designs also graced the front covers of most of the major magazines – *Ladies' Home Journal*, *Collier's*, *McCall's*, *Liberty*, and *Woman's Home Companion*, in addition to the ones already mentioned – and the great majority of such images were designed and painted with a pin-up or glamour theme. His art was eventually featured in a popular book entitled *A Gallery of Girls*.

Phillips was particularly concerned with the design element of his work, seeing it as his first and primary tool in creating an image. In fact, he became famous for his inventive use of the "fade-away" method of design, in which one element of the picture, a man's overcoat, for instance, is blended into the background while his figure and face are defined by the skillful use of highlights.

Coles Phillips accomplished much during his brief life, and both the art world and the general public were saddened by his untimely death in 1927. At his funeral, his friend J. C. Leyendecker eulogized Phillips as "an artist unique in his field, one with a highly developed sense of decoration and color . . . he was ahead of his time [in] depicting the American type of womanhood".

Of all the successful mainstream artists of "pretty girl" subjects, James Montgomery Flagg (1877–1960) was the most flamboyant. A natural "rebel", Flagg was one of those rare individuals who achieved both public acclaim and the respect of his peers in the art world. His life-style was often compared to that of Howard Chandler Christy: both men loved traveling around the world with the "jet set" of their day. Flagg spent a great deal of time in Hollywood, where he socialized with a colorful assortment of writers, actors, and bohemian characters, among them his longtime friend John Barrymore.

Flagg grew up, worked, and died in New York City. Again, like many other great illustrators of the time, he got his start working for *Life* and continued to do so for many years. As his career flourished, his paintings and drawings appeared as illustrations for magazine covers, calendars, advertisements, and stories. Almost every magazine of consequence during the first half of the century published Flagg's work. In a glamour painting reproduced about 1930 as a magazine cover, probably for *Life* or *Judge*, the artist captures an Art Deco beauty in a sensual, sophisticated pose as she applies her lipstick (figure 26).

As an artist, Flagg was supremely versatile and skillful. Often working with incredible speed, he was at home in many mediums, including oils, pen and ink, opaque and transparent watercolor, charcoal, and graphite; he was also a fine sculptor. In addition, his numerous recruitment posters during World War II – especially the depiction of Uncle Sam entitled *I Want You* – brought him much fame.

Flagg most particularly loved painting beautiful women, who played a large part in his personal as well as his social life. Like other famous illustrators of the 1920s and 1930s, he was a connoisseur of the female form. He and his artist friends partied quite often at the private clubs

22. Howard Chandler Christy
Garden of Eden
Oil on canvas, c. 1925
25" x 72"

23. Harrison Fisher
Dear Sweetheart
Gouache, published as front cover of American Sunday Monthly Magazine, *May 3, 1914*

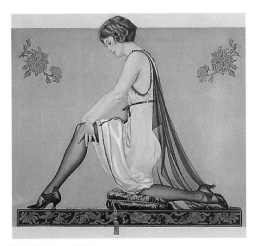

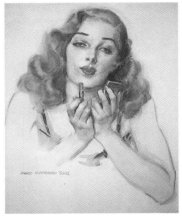

24–25. Coles Phillips
Original (watercolor) and reproduction (right) as an advertisement for Holeproof Hosiery, 1922

25

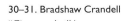

26. James Montgomery Flagg
Glamour Girl with Lipstick
Reproduced as cover for Life or Judge, c. 1930

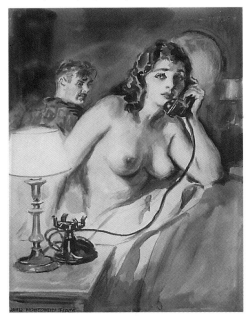

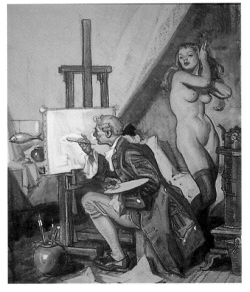

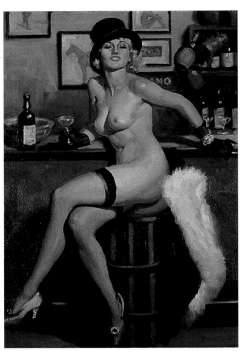

27. James Montgomery Flagg
Illustration for the Dutch Treat Club
Wash drawing, c. 1930

28. Dean Cornwell
Illustration for the Dutch Treat Club
Charcoal drawing, c. 1935

29. William Reusswig
Nude Model
Illustration for the Dutch Treat Club
Oil on canvas, c. 1930

30–31. Bradshaw Crandell
"Glamour Art" Image
Original (pastel, left) and reproduction (below)
as cover of Cosmopolitan, August 1940

32. Bradshaw Crandell
Illustration for the Dutch Treat Club Yearbook
Oil on board, 1952

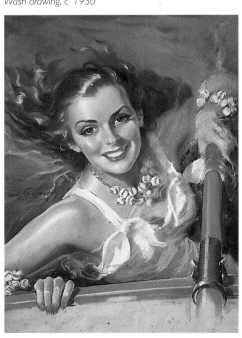

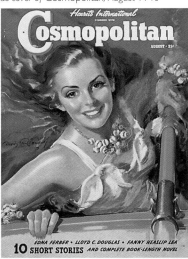

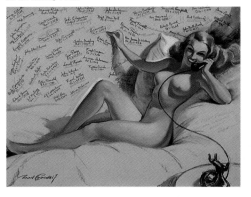

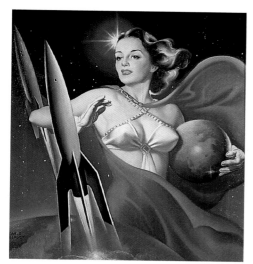

33. Earle K. Bergey
Rocket Girl
Oil on canvas, cover for Thrilling Wonder Stories,
June 1950

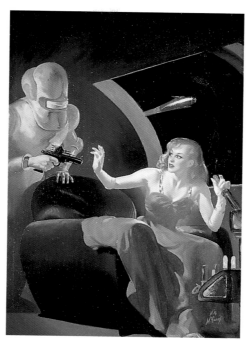

34. Howard McCauley
Alien and Glamour Girl
Oil on canvas, 1940

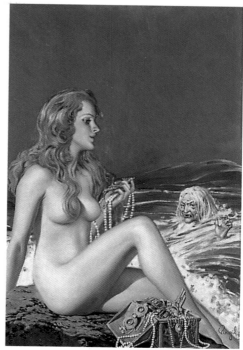

35

they had formed and at various gathering places for the Dutch Treat Club's annual soirées.
A wash drawing done about 1930 for the club's yearbook (figure 27) shows a bare-breasted
model in bed answering the phone and saying, "No, madam — you have the wrong number —
this is the Museum of Natural History!" The man in the background is the artist's friend the
illustrator John LaGatta, whom Flagg liked to tease as often as possible.

Another important mainstream illustrator who employed pin-up and glamour themes was
Dean Cornwell (1892–1960). In an original charcoal drawing done about 1935 for the Dutch
Treat Club, Cornwell illustrates the extremely popular subject of an artist and his model (figure
28). This theme was one that artists certainly were familiar with and that the public appreciated
for its hints of glamour and naughtiness. In recognition of Cornwell's artistic skill, his fellow
artists called him the "Dean of Illustrators".

William Reusswig (1902–1978) was an illustrator who regularly employed pin-up themes in
his work for major magazines as well as in his advertising assignments for prominent clients.
Like his friends Flagg and Cornwell, Reusswig contributed regularly to the yearbooks of the
Dutch Treat Club. One of his illustrations shows a nude model seated at a bar that could be in
a corner of the 21 Club, the Lotos Club, or any of the other nightspots in New York where
artists regularly gathered (figure 29). Both the sauciness of her pose and her unashamed nudity
convey something of the playfulness of the artist-model relationship at that time.

Bradshaw Crandell (1896–1966) was the last of the "pretty girl" artists of the 1920s and
1930s to become so popular with the American public that his name was regularly linked to his
creations. Crandell did some work for the calendar pin-up market, but was best known for the
pastel front-cover images he delivered every month to *Cosmopolitan* for more than twelve
years starting in the mid-1930s (he took over this assignment from Harrison Fisher). One of
these works is the typical "glamour art" pastel that was reproduced as a front cover for
Cosmopolitan in August 1940 (figures 30 and 31).

Crandell devoted most of his artistic career to painting pictures of attractive women — an
activity that was greatly aided by his membership in the Dutch Treat Club and other artists'
groups in Manhattan. In 1952, a clever Crandell painting was used as the endsheets for the

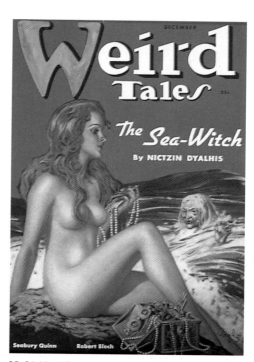

35–36. Virgil Finlay
Original (oil on canvas) and reproduction as front cover of
Weird Tales, *December 1937*

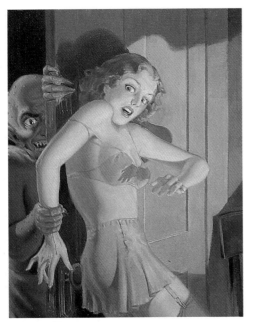

37

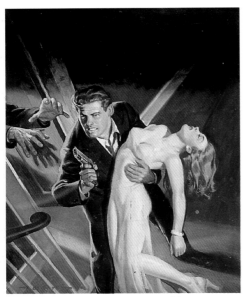

38

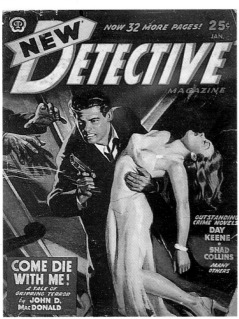

39

Dutch Treat Club's Yearbook (figure 32). The names and phone numbers on the wall behind the model are those of club members, and each name bears a humorous notation supposedly made by the model. If ever there was a "mainstream" pin-up, this Crandell work is it!

One kind of pin-up art that spanned both the Art Deco period and the years after World War II was the pulp-magazine illustration, which had its own "golden age" from the 1920s through the 1940s. Focusing on subjects like crime, science fiction, horror, and adventure, the provocative pulps featured sexy pin-up girls depicted in perilous — and usually highly erotic — situations.

The pulps relied on their own stable of artists who basically specialized in either color front covers or black-and-white illustrations of stories. Many pin-up and glamour artists in the 1920s and 1930s had their early work published on the covers of pulp magazines, including Earle K. Bergey, Enoch Bolles, Peter Driben, George Quintana, Arthur Sarnoff, and William Fulton Soare. A classic science-fiction glamour subject by Bergey, for example, was published as a front cover for *Thrilling Wonder Stories* (figure 33).

Similarly, many artists who restricted their careers to pulps incorporated pin-up and glamour themes into their subjects, as in Howard McCauley's vintage pulp from 1940 (figure 34). Even *Weird Tales* published pin-up themes, like the spectacular nude by Virgil Finlay, the "grand-daddy" of pulp art (figures 35 and 36). A few artists enjoyed moving regularly between the two genres as well as branching out to other areas of illustration art; among these were the versatile Bergey; George Rozen, the creator of the famous *Shadow* magazine covers; Jerome Rozen, George's brother; John Newton Howitt; and Harry T. Fisk.

Devoting their time and talent primarily to pulp-magazine pin-up covers were Margaret Brundage, who provided pastel pin-ups for the covers of *Weird Tales*, and Hugh J. Ward and Harry Parkhurst, both of whom worked on covers for *Spicy* magazine (although Ward sometimes illustrated such mainstream magazines as *Liberty* and *Collier's*). How much the front covers of the spicy pulps were oriented toward pin-ups can be seen from the magnificent Ward cover that so effectively combines pin-up and horror themes (figure 37). In addition, illustrations for detective pulps, like the ones by Raphael DeSoto and George Gross (figures 38 through 41), regularly placed their heroes and villains in the company of pin-up girls.

As we have seen, both the publishing and the calendar business burgeoned during the period from after the end of World War I to 1940. In both of these fields, pin-up and glamour themes were among the biggest sellers — so much so that many mainstream illustrators, from Gibson to Flagg, incorporated them into their art. There was a group of artists, however, who focused their attention on such themes as the very basis for their work, finding calendars and men's magazines among their most lucrative markets.

The most prolific and visible of the Art Deco pin-up artists who specialized in magazine covers was Enoch Bolles. Bolles's campy, playful, and seductive pin-ups appeared on the covers of such men's magazines as *Film Fun* and *Gay Book*, while his more provocative designs were seen on spicy pulp magazines like *Bedtime Stories*, *Tattle Tales*, and *Pep Stories*. Equaling Bolles, in both talent and success, were two other important pin-up artists whose magazine covers were seen on news-stands from coast to coast, Earle K. Bergey and George Quintana. Both worked primarily for the spicy pulp magazines but also for other men's magazines like *Real Screen Fun*, *Movie Humor*, and *Reel Humor*.

Of those artists who provided pin-up and glamour-art images to calendars, Edward M. Eggleston, Henry Clive, and Gene Pressler were clearly the most talented working during the 1920s and 1930s. All three were proficient in many mediums, although Eggleston and Clive favored oil on canvas and Pressler pastels on canvas. Each of these artists was an academic painter who could easily have been influenced by John Singer Sargent.

Peter Driben, who would become one of the giants of pin-up cover art in the 1940s and 1950s, began his career during the Deco years: while in Paris during the 1920s, he started providing risqué drawings and paintings to the American pin-up pulp-magazine market. (Interestingly, Driben was not the only major pin-up artist whose career spanned the decades both

before and after World War II. Those whose works were equally important in both periods include Rolf Armstrong, Bradshaw Crandell, Billy De Vorss, Gil Elvgren, Jules Erbit, Earl Moran, Zoë Mozert, George Petty, and Alberto Vargas.)

Three other pin-up artists who began their careers during the Deco period are Charles Sheldon, Billy De Vorss, and Jules Erbit. During the 1920s and 1930s, Sheldon's fashion drawings inspired a series of famous ads for women's shoes, stockings, and lingerie which appeared in *Ladies' Home Journal* and *Woman's Home Companion*. In 1937, he created the first of his legendary Breck Girl Shampoo ads, a campaign that was to be one of the most successful in the history of American advertising. Sheldon's images of the Breck Girl are considered by many to be the ultimate examples of the "glamour art" type of pin-up.

Mainly pastel artists, De Vorss and Erbit were both extremely prolific, working in large formats that averaged 40 × 30 inches (101.6 × 76.2 cm). De Vorss's glamorous women often looked as if they had just walked off the set of a swank 1930s Hollywood movie. Erbit's, on the other hand, were a bit less sophisticated and, more often than not, portrayed the sort of girl that every young man of the 1930s wanted to bring home to mom and dad.

There were four women artists in the Art Deco era whose pin-ups and glamour girls were part of the American scene for more than two decades: Mabel Rollins Harris, Laurette Patten, Irene Patten, and Pearl Frush. Harris had an exceptional command of and flair for the medium of pastels, which she used to conjure up an extraordinary range of images and moods. Also accomplished in pastels, the Pattens were sisters whose styles were so similar that their works at times seemed interchangeable. Frush is truly an undiscovered artistic treasure. Her original works, painted in gouache on illustration board, often have the look of tightly executed oils. In fact, Frush's technical brilliance was such that, upon close examination, her works even begin to take on a photographic clarity. Those knowledgeable collectors who have studied her paintings have often judged her the equal of Alberto Vargas in artistic excellence.

In the late 1930s and early 1940s, as America worked its way out of the Depression, a new concern developed about the perilous situation in Europe. With the thought that their country could become involved in war at any moment, American men and women experienced a sense of anxiety that touched every person's life in one way or another. As people always have, many sought escape from their worries in entertainment – listening to the radio, going to the movies, and reading magazines, books, and novels. Spurred by this increased interest, the taste for pin-ups, and for the magazines and calendars that featured them, only grew.

By the fall of 1940, *Esquire* had become one of the most important literary publications in America. Drawing upon the nation's leading writers, artists, and photographers, the magazine also employed a top-notch staff, which was under the vigorous direction of publisher David Smart. In the environment of excellence fostered by *Esquire*, the American pin-up was to experience an elevation in status. Taking the pin-up out of locker rooms, garages, dormitories, barracks and clubhouses, where it had been surreptitiously enjoyed by generations of American men, the magazine had begun to give it a new stature as early as 1933, when its first issue appeared.

Rather than sales at newsstands, however, it was *Esquire*'s massive subscription list that was responsible for the pin-up's new status. Every month, American families welcomed the magazine into their living rooms, where everyone enjoyed its brilliant articles and fiction as well as its dazzling display of humor, photography, and art. Without *Esquire*'s determination to deliver to its readers the best talent that money could buy, the American public might never have accepted quality pin-ups as readily as they did just prior to the war.

The October 1940 issue of *Esquire* featured centerfold pin-ups by two artists who were significant both to the magazine itself and to the place of the pin-up in American society. One was George Petty, who had attained fame as the creator of the Petty Girl, the first modern pin-up image to emerge from the lean years of the Depression. *Esquire* had done much to foster Petty's career, making a major commitment to the artist by publishing at least one of his images every month throughout the 1930s. The other was Alberto Vargas, who had specialized in the

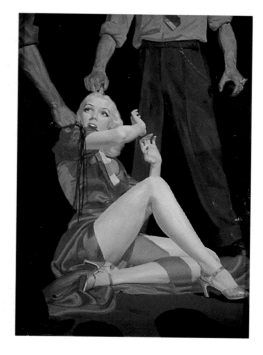

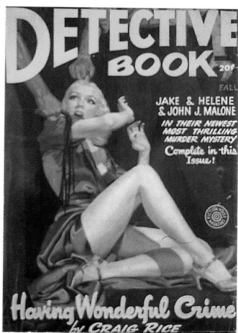

40–41. George Gross
Original (oil on canvas) and reproduction as front cover of Detective Book, Fall 1944

Opposite page:
37. Hugh J. Ward
Bug-eyed Monster
Oil on canvas, c. 1930

38–39. Raphael DeSoto
Original (oil on board) and reproduction as front cover of New Detective Magazine, January 1948

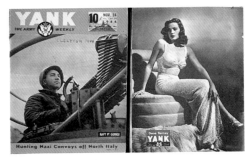

42. *Yank magazine*
Front and back covers (with photograph of Gene Tierney),
November 24, 1944

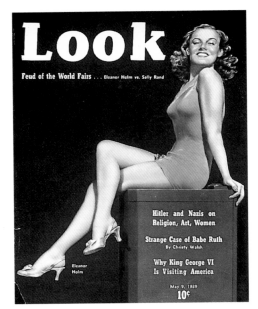

43. *Look magazine*
Front cover, May 9, 1939

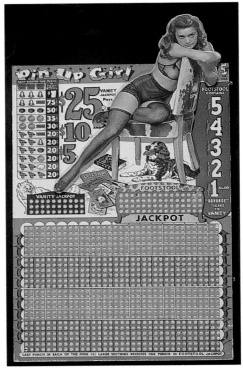

44. *Punch-board game, c. 1945*

1920s in portraits and promotional artwork for the Ziegfeld Follies and in the 1930s in works portraying and publicizing the Hollywood motion picture industry.

The appearance of Vargas's first pin-up in *Esquire* marked the beginning of worldwide fame for the artist. His dreamlike Varga Girls (the magazine had taken the liberty of dropping the "s" from his name) were promoted by *Esquire* again, just two months later, when it published its first calendar by the artist. The 1941 calendar was followed by seven more, and each of them made publishing history as the best-selling calendar of any kind worldwide; the Varga Girl became part of American society. Within a year of the Varga Girl's introduction, the country was preparing to go off to war. When American soldiers boarded the transport ships for their destinations overseas, they carried not only their guns, their gear, and pictures of their loved ones but also their favorite pin-ups.

Besides photographic prints themselves, the soldiers might have playing cards, calendars, and notepads decorated with pin-up and glamour themes. Such images boosted morale by giving many a soldier something to dream about during the hours, days, and weeks of wartime. Both General Eisenhower and General MacArthur commented publicly on this phenomenon, citing the help that such images afforded to their men.

Although Vargas is perhaps the most well known of the World War II pin-up artists, there were many others who specialized in the field during this era, which constituted the second major boom in the pin-up and glamour art industry. The most important of these artists was undoubtedly Gil Elvgren. Since the late 1930s, Elvgren's work had been published by the Louis F. Dow Calendar Company in St. Paul. As demand for his images increased during the war years, Dow produced Elvgren's pin-ups in booklets measuring 8 × 10 inches (20.3 × 25.4 cm) – a format that was suitable for mailing overseas and for "pinning up" on all kinds of surfaces. After the war, Elvgren's popularity increased even more; his work for Brown and Bigelow from the late 1940s through the early 1970s was reproduced so extensively that it is estimated that there were more than a billion images of Elvgren Girls in circulation throughout the world.

Elvgren's pin-ups had that extraordinary, undefinable "something extra" that made him not only enormously popular with the public but the envy of his artistic contemporaries as well. One part of his unique talent was his skillful employment of the "situation" picture, and Elvgren seemed capable of inventing an endless variety of clever scenarios to delight his audience. Whether victims of an unexpected wind or ambushed by a pesky tree branch, his girls were invariably involved in interestingly revealing escapades. Another important element of Elvgren's pin-up mastery was his rich painterly technique. His style, with its creamy brushstrokes and deep colors comparable to John Singer Sargent's, was imitated by many fellow artists – not only because they admired it for itself but also because art directors in search of a best-selling image often ordered them to paint like him.

Another major pin-up and glamour-art artist of this period was Earl Moran. Beginning in the mid-1930s, Moran established a name equal to Elvgren's, although their styles were basically different. Often more moody than Elvgren's images, Moran's pastel pin-ups became enormously popular during the war. So much so that an article on popular calendar art in the 1940 New Year's issue of *Life* magazine was illustrated mostly with his work, as well as with a photograph of him working in the studio with his daughter, who often posed for him.

Rolf Armstrong was already a major pin-up artist by the time the war started. During the 1920s and 1930s, his glamorous beauties, drawn in pastels, had appeared on magazines and sheet music, in advertising displays, and of course on calendars. However, most of his earlier images had been glamour art depictions, showing only the head of his model; now, in the wartime world of the 1940s, Armstrong turned to the more traditional full-length pin-up. Armstrong's pin-ups of the 1940s and 1950s, like those of Elvgren and Moran, were published by Brown and Bigelow. During World War II, this firm continued to be the single most significant calendar-publishing company in America, as it is today.

Two women pin-up artists became superstars in the 1940s and 1950s: Zoë Mozert and Pearl Frush. Mozert often used herself as the model for her pastel pin-ups, posing in front of a mirror

Most Americans who lived during the last quarter of the nineteenth century and the first half of the twentieth were not able to visit museums or purchase art books. The only art they saw on a regular basis was illustration art. In all their varied forms, illustrations infiltrated every aspect of American existence and wove their images into the very fabric of everyday life. In this sense, illustration art may be said to be the real art of the American public.

The history of American illustration closely parallels the growth and development of the nation. As the population began to expand rapidly about 1875, so too did the need for addtional means of communication. Advances in existing printing techniques also contributed to an increase in the number of local and regional newspapers. National magazines and periodicals like *Scribner's*, *The Century*, *Puck*, *Harper's Weekly*, and *The Saturday Evening Post* primarily served their new audiences by acting as vehicles for the transfer of news, information, ideas, and services. In addition, their fiction articles (featuring tales of romance, adventure, crime, and the like) and their reports on social happenings, politics, and sports were tremendously entertaining.

The magazine publishers soon learned that if an article or story was accompanied by a picture, people were more likely to read it. They also realized that the artwork reproduced on their front covers was an important point-of-sale factor at newspaper stands which directly affected their subscription rates. By 1920, the competition for readers had become an all-out battle among the publishers of magazines and other periodicals. And it was this ferment that ushered in the Golden Age of American Illustration, which was to last until 1970. In reviewing the history of the American pin-up, it is necessary to understand that such images were by no means limited to a specialized audience. Almost all the leading "mainstream" magazines commissioned scores of artists to paint pictures of attractive men, women, and children, singly or in groups, to decorate their weekly or monthly covers. The publishers knew only too well that, in the highly competitive market place, one sure way to secure new readers was to have either captivating people or highly dramatic narratives adorn their covers. And among the most captivating people to portray were attractive women, who were presented in three general categories of illustrations: the "pin-up", the "glamour art" image, and the "pretty girl" subject.

A definition of terms would be helpful here. A "pin-up" image is one that shows a full-length view of its subject and characteristically has an element of a theme or some kind of story. The woman in a pin-up is usually dressed in a form-revealing outfit, either one that may be worn in public, such as a bathing suit, sunsuit, or skimpy dress, or one that is more provocative and intimate, such as lingerie. Sometimes, a pin-up may be shown as a nude, but this is more the exception than the rule.

A "glamour art" image may be either a full-length view or a presentation of only the head and shoulders of the subject. The "glamour" woman is generally attired in an evening gown, fancy dress, or some other attire that is less revealing than that in a pin-up. "Pretty girl" art is a term used to refer to painting of a glamour art nature that was done by mainstream illustrators. It found its audience among popular magazines like *The Saturday Evening Post* and *Cosmopolitan* and in the world of advertising. Thus, the terms "pin-up art" and "glamour art" generally refer directly to works by artists concentrating in these genres, while "pretty girl art" almost always means the "glamour" work of the mainstream illustration community. Most of the important mainstream illustrators chose to paint "pretty girl" subjects at one time or another, since these images seemed to have widespread public appeal. Some of these illustrators' pictures had the qualities of pin-ups, but most focused on the "glamour" aspects of feminine beauty.

Among the major magazines that heartily supported pin-up and glamour themes when artists submitted them for front-cover publication were *The Saturday Evening Post*, *Collier's*, *Liberty*, *Ladies' Home Journal*, *Cosmopolitan*, *Woman's Home Companion*, *Life*, *Judge*, *McCall's*, *Redbook*, *American Weekly*, *Vogue*, *Esquire*, and *True*. Even *Time*, which billed itself as "America's Weekly Newsmagazine", published original pin-up art paintings on its front cover: its November 10, 1941, issue reproduced a pin-up of Rita Hayworth painted by George Petty, the father of twentieth-century American pin-up and glamour art.

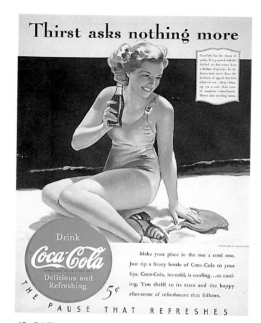

45. Gil Elvgren
Advertisement for Coca-Cola, 1950

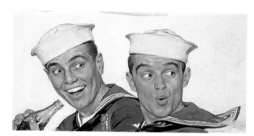

46. William Dolwick
Advertisement for Coca-Cola, c. 1950

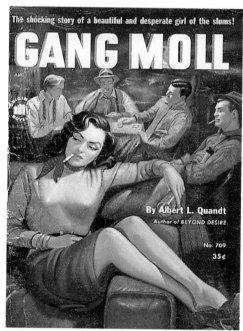

47. Rudy Nappi
Front cover for Gang Moll, *1953*

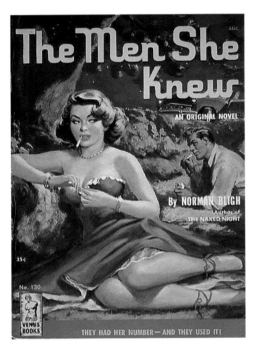

48. Anonymous
Front cover for The Men She Knew, *1953*

boards had become a billion dollar a year business, with pin-up and glamour images constituting most of their illustrations.

Pin-up and glamour images appeared in the advertisements of many American companies during and after the war; the firms saw them as a way to promote their products while also raising the spirits of the public. Coca-Cola was the largest of such companies to feature pin-ups prominently; the firm was actually responsible for an informal stable of pin-up illustrators that grew up around the artist Haddon Sundblom. Sundblom, who had established his own studio in Chicago in the 1920s, went on to become the mentor of many important pin-up and glamour illustrators. He himself created the tremendously popular, classic image of Santa Claus that was the center of many Coca-Cola advertisements throughout the years.

The Sundblom Circle, as the group around the artist was called, included many of the leading lights of the contemporary American pin-up – artists like Joyce Ballantyne, Al Buell, Bill Medcalf, Robert Skemp, Al Moore, Thornton Utz, Jack Whittrup, Al Kortner, Euclid Shook, Harry Ekman, Walt Otto, Vaughn Bass, and, most prominently, Gil Elvgren. The works of the Sundblom Circle artists were, by and large, marked by a painterly technique. In fact, their brushstrokes were so rich, thick, and creamy that eventually their painting style came to be informally termed "the mayonnaise school".

Their styles were actually so alike that telling one from the other was hard even for the artists themselves. Yet the artistry of the Sundblom Circle was so great that Norman Rockwell often spoke of his desire to know Sundblom's secret – how, in Rockwell's words, his paintings achieved their characteristic "sunlight glow". This group was also noted for its truly generous spirit, for the artists inspired each other naturally, without conscious effort, as a response to the good will that Sundblom engendered.

The Sundblom style of advertising art is clearly evident in Gil Elvgren's 1950 advertisement for Coca-Cola (figure 45). William Dolwick, another member of the Sundblom Circle, painted an imaginative Coke ad in which two sailors drinking sodas flirt with a pin-up girl just outside the picture (figure 46). Like all the works inspired by Sundblom, this picture is brilliantly composed – only the end of the mysterious pin-up girl's pink scarf, seen in the lower right-hand corner, teasingly suggests her presence.

Ed Runci, Joyce Ballantyne, and Al Buell were three important pin-up illustrators who had both a format and an artistic influence in common. All worked in oil, on canvases measuring 30 x 24 inches (76.2 x 61 cm), and all were products of the Sundblom Circle early in their careers. Like Elvgren, Runci often set his pin-ups in narrative situations, but his thin application of paint set him apart from other members of the group. Ballantyne is most often compared with Elvgren in style, color, and the use of situation poses, and the two did in fact work quite closely together in Chicago. Adding to Art Frahm's preliminary sketch ideas, she created the well known Coppertone billboard ad showing a little girl whose dog is pulling at her bathing suit. Buell's style of painting was tighter than that of the other two, although his work resembled theirs in many respects.

Two other Sundblom students, Harry Ekman and Vaughn Bass, were greatly influenced by working with Elvgren and went on to have successful careers of their own. Bass began his working life with a commission to redo some of Elvgren's paintings. In the late 1930s, the Louis F. Dow Company hired him to rework many of the pin-ups that Elvgren had done for the firm in order that the works could be used again. Employing the same creamy painting technique as Elvgren, Bass tried to work mainly on the backgrounds and clothing of the figures, leaving their faces and bodies as Elvgren had originally painted them. (Fortunately, a few of the Elvgren originals that were not overpainted survive intact.)

Shortly after the war ended, so too did the reign of Vargas at *Esquire*; the magazine's 1947 calendar did contain twelve of the artist's creations, but neither his name nor his signature appeared on it. *Esquire* soon found a replacement for Vargas in Al Moore, one of Sundblom's talented group. For almost the next ten years, Moore's collegiate pin-up girls – a far cry from Vargas' – appeared as the central two-page gatefold of the magazine. Moore's pin-ups were

also seen on *Esquire*'s calendars, which continued to sell every year (although not as well as Vargas') until 1958, when photographs replaced paintings as the artwork.

During the 1950s, *Esquire* continued to be the biggest promoter of pin-ups and glamour art on a worldwide scale. Supplementing Moore's work for the magazine was a group of talented artists that included Fritz Willis, Joe De Mers, Ernest Chiriaka, Thornton Utz, Frederick Varady, Eddie Chan, Euclid Shook, and Ben-Hur Baz. Interestingly enough, every one of these illustrators also enjoyed a highly successful career painting front covers and illustrating stories for the national mainstream magazines, the most prominent among those using such work being *The Saturday Evening Post*. Yet, these *Esquire* artists were the only pin-up and glamour art illustrators who managed to have two lucrative full-time careers; most of the others, like Elvgren, Moran, and Mozert, limited themselves to working in one genre only.

During the postwar years, *True* magazine sought to follow in the footsteps of *Esquire*. Originally carrying features on adventure, sports, travel, fashion, and the outdoors for a mostly male audience, the magazine began to publish Petty Girl centerfolds every month. It soon added works by Vargas, which were often accompanied by photographs of the artist painting or photographing a model in his studio. In 1947 and 1948, Fawcett, the parent company of *True*, issued two special Petty Girl calendars that duplicated exactly the size and format of Esquire's Vargas calendars.

As it had in every decade of the century, Brown and Bigelow in the 1950s commissioned, produced, sold, and distributed more pin-up art than any other company. Impressed, like many others in the illustration world, by the talent of the Sundblom Circle, the firm made many of these artists — including Elvgren, Ballantyne, and Buell — into the stars of its roster.

At the same time, Brown and Bigelow introduced a best-selling series of calendars called the Artist's Sketch Pad, first developed by Earl Mac Pherson in 1942. Although several different artists were later responsible for this series — K. O. Munson, Ted Withers, Joyce Ballantyne, Freeman Elliot, and Fritz Willis — the fact that it had the same basic format gave a unified look to the results. There was always a main subject, primarily a pin-up, at the center of the calendar image, surrounded by two or three separate sketches that were preliminary to the larger picture. Mac Pherson later devised a highly successful version of the format for the Shaw-Barton company which was eventually taken over by his assistant, T. N. Thompson.

There is no question that the pin-up world of the 1950s was dominated, as it had been in the 1940s, by the work of Gil Elvgren. Elvgren remained preeminent in the calendar and advertising fields for those two decades, and his "girls" continued to be the most popular pin-ups even throughout the 1960s. Art Frahm was the artist who perhaps came closest, at this time, to Elgren's popularity. Although Frahm had been active as an artist for more than a decade before, he had his heyday in the 1950s, when he came up with an idea for a series of pin-ups with a common theme: a girl caught in some ordinarily innocent everyday situation that causes her panties to somehow fall down around her ankles. Frahm's girls with errant underwear — variations on Elvgren's adroit use of situations — sold millions of calendars and advertising-specialty products. His publisher, the Joseph C. Hoover and Sons calendar company, kept Frahm's images in their line for many years, and they proved to be the most durable and successful theme-oriented pin-up series of the century.

Billy De Vorss, who had been prominent since the late 1930s, produced many wonderful pin-up and glamour images in the 1950s. He worked mostly in pastels, sometimes in oil, and his calendar girls were reproduced and published so widely that one estimate put their number at more than fifty million worldwide. The pin-up artist Edward D'Ancona was known primarily for his calendar subjects, which were also reproduced on products like paperweights, key chains, and men's wallets.

Bill Medcalf was another accomplished pin-up artist who reached his peak in the 1960s. His work for Brown and Bigelow displayed a beautiful creaminess reminiscent of the work of the Sundblom Circle "mayo boys", but the texture of his painting surface was uniquely smooth. Since Medcalf received many special assignments through Brown and Bigelow from companies

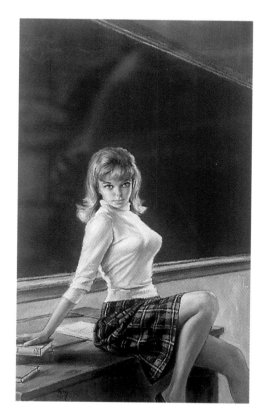

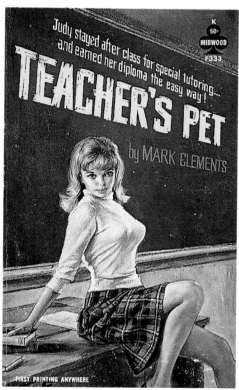

49–50. Paul Radar
Original and reproduction as front cover of Teacher's Pet, *1958*

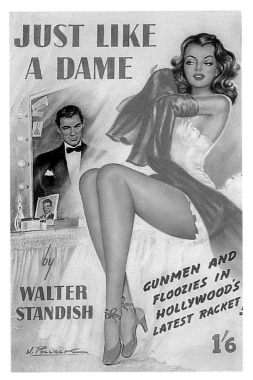

51. N. Pollack
Front cover for Just Like a Dame
Gouache on board, 1948

52. Edward D'Ancona
Miss Me
Oil on canvas, reproduced in a calendar on safety, 1960

in the automobile industry, his pin-ups often contain cars and automotive accessories. Another master of the "slick" style of the Sundblom Circle, Walt Otto, built a successful career in advertising with a subject that became his specialty – the wholesome farm girl. Whether fishing by a stream or stacking hay, the Otto girl reveled in the country. She was usually smiling and wearing shorts and a straw hat, and her trusty dog was beside her, as best friend and protector.

Arthur Sarnoff was probably the most versatile of the pin-up artists working during these years. He was primarily a mainstream illustrator, and his work was regularly published from 1935 to 1975 in the major American magazines, particularly *The Saturday Evening Post*. Yet Sarnoff also produced so much significant pin-up and glamour art, working within the field itself, that he was alone among the artists of the era in being a major name both in the pin-up field and in the world of advertising and magazines. He was so much in demand that many of the calendar companies for which he worked would book his time years in advance.

One business that had particularly grown and flourished during the war was the paperback novel industry. The armed forces had supplied soldiers with these small-format books, and when the troops came home, they – and many other Americans – had learned to appreciate paperbacks. Publishers knew that the quality of cover art often determined how well a title would sell. They therefore recruited the top illustrators of the day, hoping that these artists' pictures would boost sales of paperbacks at news-stands, drugstores, and bookstores. In the early days of the paperback, "digest" books – which were a little bit bigger than the traditional paperback, closer to the size of today's *TV Guide* – were extremely popular (figures 47 and 48). An illustration by pin-up artist Paul Radar appeared on the cover of a novel entitled *Teacher's Pet* in 1958 (figures 49 and 50). Sometimes the pin-up painting would actually include the text for the front cover of the book, as in *Just Like a Dame* (figure 51), which is a classic example of how pin-ups were used on the covers of paperback novels.

At the height of their postwar popularity, pin-ups could even be seen on the covers of such venerable mainstream magazines as *The Saturday Evening Post*. Artists like Norman Rockwell and his contemporaries often acknowledged the power of such images by incorporating pin-up themes into works that were basically of a very different nature. In the 1950s and 1960s, even the most sentimental and traditional calendars might flirt with the idea of the pin-up. A calendar on safety by Edward D'Ancona, for instance, draws on many aspects of the idealized, Rockwellian vision of American life. Yet D'Ancona can't resist including one little *Miss Me* pin-up among all the homespun imagery (figure 52).

It was not until the mid-1960s that production of the artist-rendered pin-up calendar began to be phased out. Although most of the leading American calendar companies had introduced photography for other kinds of subjects starting in the late 1940s, they continued to illustrate pin-up themes with artwork. A significant step in the final switch to photography occurred in England in January 1964, when the tire manufacturer Pirelli published the firm's first photographic pin-up calendar. Robert Freeman (who had worked as a photographer with the Beatles) joined art director Derek Forsyth and designer Derek Birdsall in creating a calendar that was to be instrumental in shifting the balance over to photographed pin-ups.

One pin-up and glamour-art artist did, however, remain popular well into the 1970s. Fritz Willis had first come to the public's notice in the 1940s, with his work for *Esquire*. When the magazine lost Vargas' services after the war, Willis was one of the artists it drew on most heavily to fill the void; the magazine also selected him in 1946 as the first artist to contribute to the prestigious *Esquire* Gallery Series. Willis continued his brilliant work for *Esquire* during the 1950s and began to emerge as a superstar in 1962, with his first Artist's Sketch Book and Memo Calendar for Brown and Bigelow.

Willis' women both looked sexy and created a sexy atmosphere around themselves. They were extremely sophisticated and provocative, whether overtly or covertly. Willis often portrayed them wearing revealing lingerie or stockings and subtly touching their breasts. Many of his pin-ups included a lushly painted bowl of fruit, and he might playfully add a bottle of wine or a pack of cigarettes as another suggestive touch. Willis's pin-up creations were special – classy,

elegant, and erotic women of the world – and they had a special way of interacting with the viewer. His fame will continue to grow as he is increasingly recognized as one of the giants in the field.

By the time of Willis' last Artist's Sketch Book and Memo Calendar, in 1975, there was only one other pin-up and glamour art illustrator who consistently delighted the American public – and satisfied Brown and Bigelow's art directors as well. Mayo Olmstead had worked for America's premier calendar company for more than twenty-five years. In the early and mid-1970s, Olmstead's female figures became more contemporary, responding to modern tastes and paving the way for Brown and Bigelow to enter the era of the photographic pin-up and glamour calendar.

By the mid-1970s, almost all of the American calendar publishers were using fashion and commercial photographers rather than painters to illustrate their calendars with pin-up or glamour motifs. Offering top fashion models and exotic locations, these calendars evolved into a popular art form that has continued up to the present. When artist-rendered pin-up and glamour girls disappeared from calendars, most of those who specialized in such themes either turned to portraiture or other kinds of fine-art easel painting, or retired altogether. The advent of photographic illustration also cut short the careers of many mainstream illustrators who worked in the fields of advertising and magazine publishing. Whatever their field of interest, many of these artist-illustrators are only now being recognized for their real contributions to the history of American art.

In the nearly one hundred years from the first Gibson Girl to the last Willis Girl, pin-up and glamour art served as a powerful testament to the beauty, vitality, and appeal of the American woman. Embraced by generations of Americans, of both sexes, pin-ups became a significant and rich part of the nation's art, society, and culture during the twentieth century.

Note: *The pages that follow are divided into three sections. The first contains artists whose work relates to the Art Deco style, prevalent during the early years of the twentieth century. The second, comprising the major body of pin-up and glamour art, contains artists whose careers were almost entirely devoted to this genre and who made important contributions to the field. In the third section, we include for historical purposes artists who did in fact create work in the genre but not in significant numbers.*

Until recently, originals of pin-up and glamour art had never been handled or distributed through the customary art-world channels. The art illustrated herein was therefore never accurately documented, measured, or described. Created for publication, pin-up and glamour art originals were turned over to publishers in exchange for fees. The artists rarely asked for, or got, the originals back, and the publishers disposed of them in various, undocumented ways.

The artists also did not title their works; instead, titles were assigned by copyrighters, advertising people, and even salesmen. The same image could appear in different formats, in different years, and with different titles (sometimes as many as three or four). The originals were never measured, and publishers did not record mediums. Artists did not usually date originals, which were sometimes published years after they were finished, and so dates of completion can be determined within a few years only.

In light of these circumstances, we have simply assigned a number to each work illustrated, in order to facilitate future reference. In the essays on the individual artists, we have endeavored, whenever possible, to indicate a range of dates and the typical medium and size for important series or types of images.

58

59

60

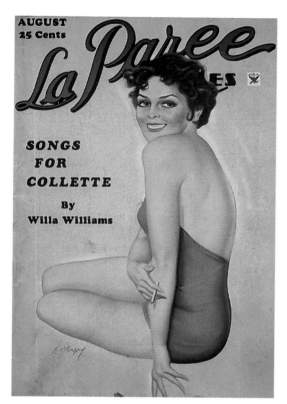

61

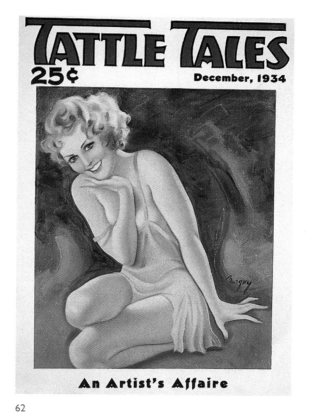

62

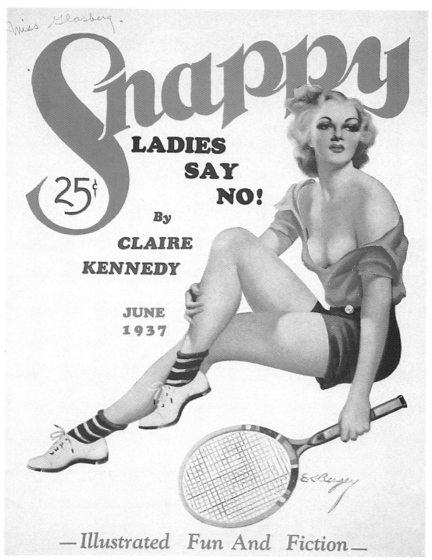

63

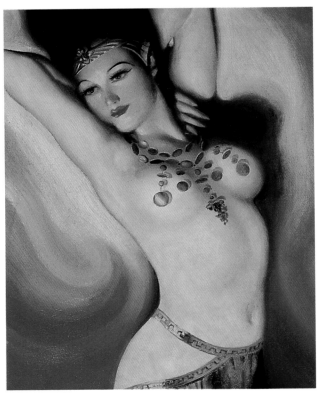

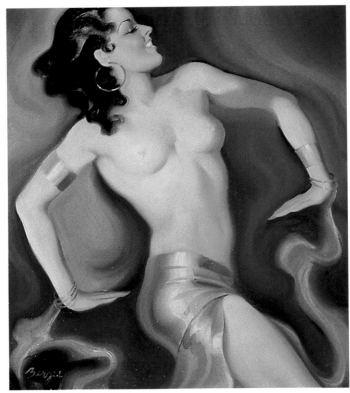

64

65

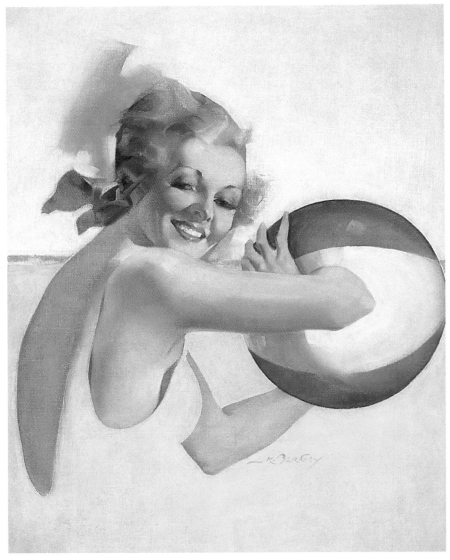

66

Roy Best

From the 1930s to the mid-1940s, Roy Best became known for creating strong, crisp pictures of all-American girls with pastels that reproduced beautifully when printed as calendars.

Best was born in Waverly, Ohio, and worked on railroad construction crews to support his studies at the Art Academy of Cincinnati. He subsequently moved to Chicago and enrolled in the Art Institute there. Later, in New York, he was represented by American Artists, Sidney and Celia Mendelsohn's well-known agency on West Forty-fourth Street which handled almost a hundred top-flight illustrators, including Norman Rockwell. In the 1930s, he painted several front covers for *The Saturday Evening Post*.

By 1931, Best was executing fabulous pastels of sensuous Art Deco pin-ups and nudes for the Joseph C. Hoover and Sons calendar company (figure 67). That year, he received a phone call from the Whitman Publishing Company in Racine, Wisconsin, asking him to consider an assignment for a series of twenty-one full-color, full-page illustrations for a children's book. Best accepted and went on to create a masterpiece – *The Peter Pan Picture Book*, based on the J. M. Barrie play.

In 1942, Best came to the attention of Brown and Bigelow, which offered him the opportunity to paint pin-ups and glamour art for the calendar market. Accepting the company's generous financial offer, Best went on to a highly successful calendar career.

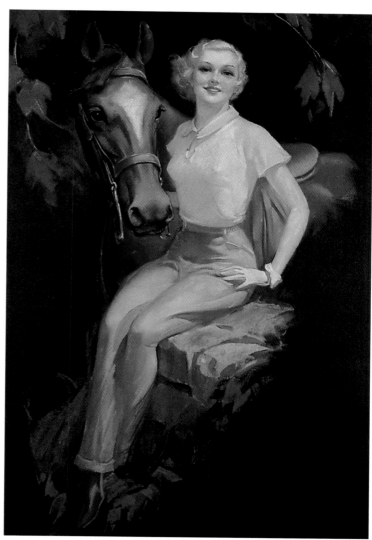

67

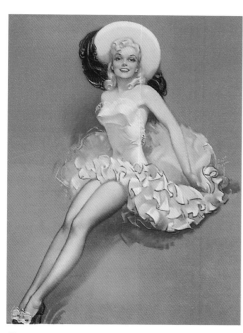

68

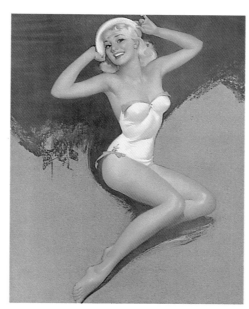

69

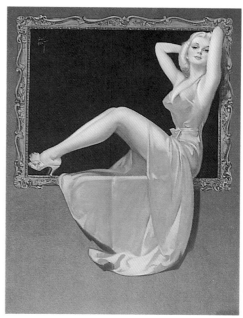

70

Enoch Bolles

After Alberto Vargas and George Petty, Enoch Bolles was the best known of the Deco-era pin-up artists, mostly because of the massive exposure his images received on newsstands from coast to coast. Bolles' art – both in terms of technique and subject matter, the playful, yet somewhat racy flapper girl – clearly exerted a strong influence on many artists of his time.

Bolles began his career in 1915, when he was hired by the Dell Publishing Company to paint front covers for its line of spicy pulp magazines (figures 71, 79, 80, and 82). He, like many other pin-up artists of the early Deco era, found a ready-made audience among the mostly male readership of the pulps. *Film Fun* was the pin-up magazine that immortalized the Bolles name. From 1921 to 1948, it carried his cover-art pin-ups (figures 72–77, 83, 84, and 87), which the American public came to recognize almost as much as the Petty Girl from *Esquire*. Bolles worked for many other pulps, including *Gay Book* and *Cupid's Capers*, which invited him to design their inaugural covers, and *Spicy Stories*, which had the biggest circulation among such magazines.

Bolles' pin-up girls were fun-loving and sexy, often provocative in their poses but occasionally caught in embarrassed or slightly self-conscious moods. Usually full of energy and brimming with health and a sense of adventure, they had almost childlike faces that contrasted with their sensual bodies. Bolles often incorporated Art Deco backgrounds, spotlights and other props, and clothing such as flimsy négligés and wet bathing suits into his work.

Bolles painted in oil on canvas in a variety of sizes ranging from 10 x 8 inches (25.4 x 20.3 cm) to 14 x 11 inches (35.6 x 27.9 cm) for his pulp magazine pin-ups all the way up to 30 x 24 inches (76.2 x 61 cm) for the *Film Fun* assignments. The wide variety of primary colors he employed was notable at a time when many of his contemporaries were using much more subdued tonal schemes. Although Bolles was a prolific artist, only a handful of his original paintings exist today.

Very little is known about Bolles' life. Probably born in the Chicago area, he worked in New York City, where he could be near the many publishing houses specializing in pulps and racy men's magazines in the 1920s and 1930s. It is rumored that Bolles had emotional problems near the end of his life that led him to overpaint some of his *Film Fun* covers, creating horrific expressions on his formerly fun-loving pin-up girls.

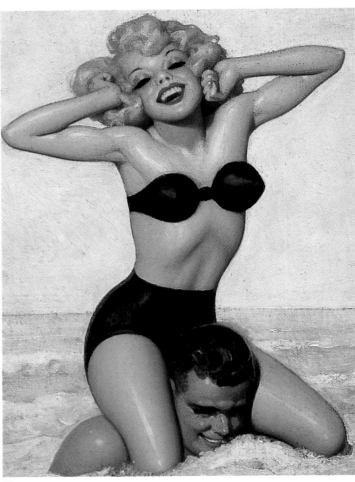

71

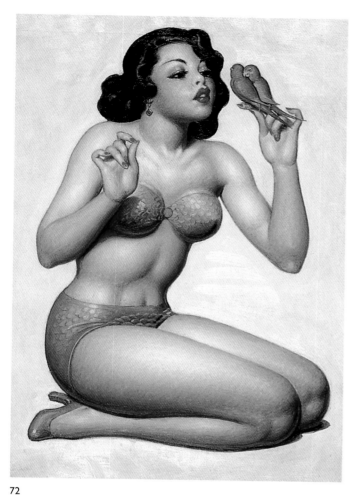

72

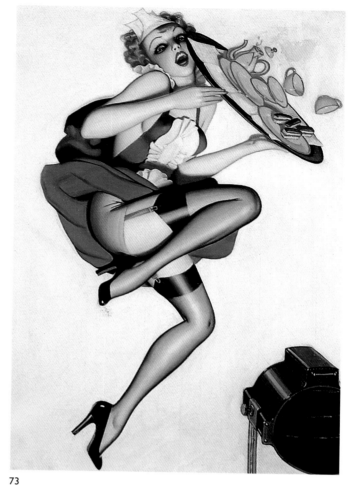

73

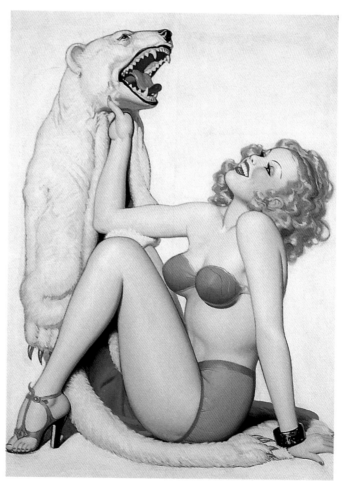

74

75

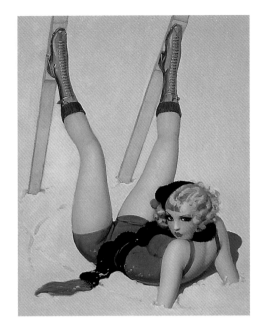

76

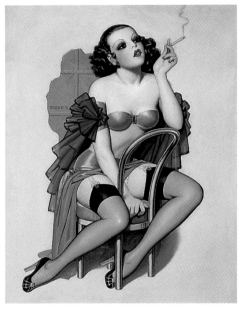

77

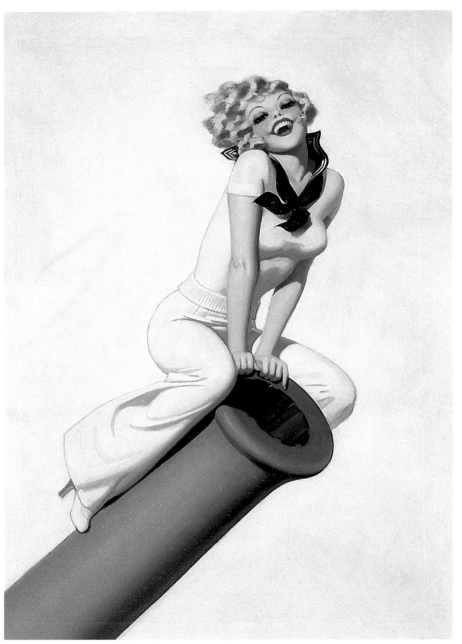

78

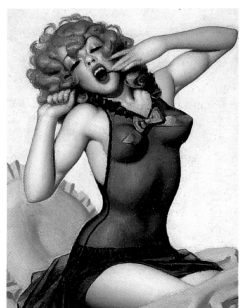

79

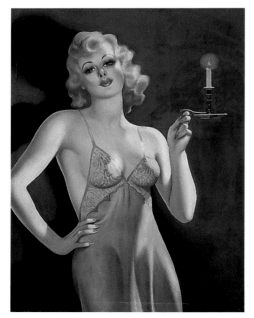

80

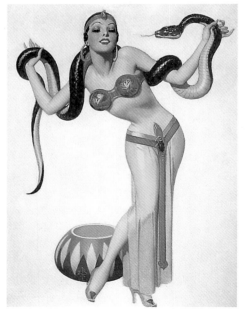

81

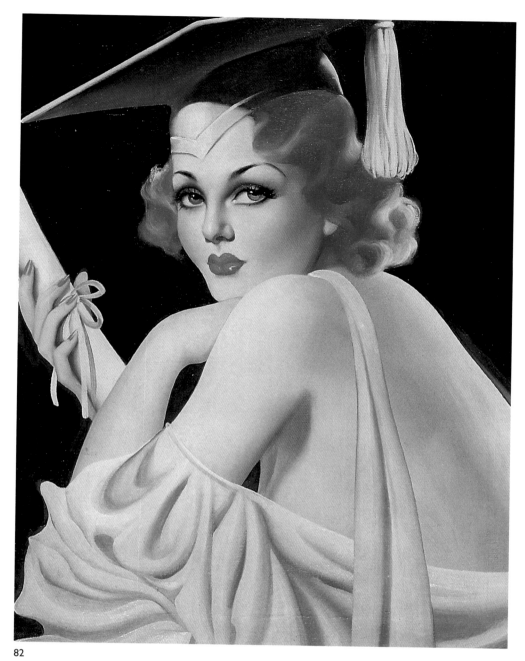

82

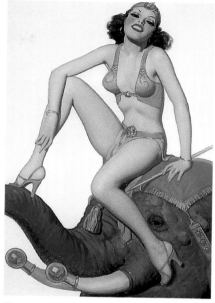

83

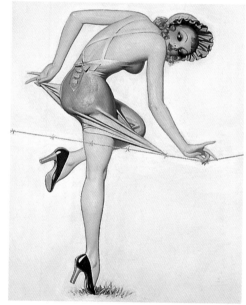

84

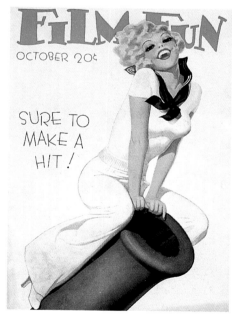

85

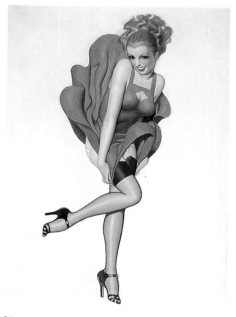

86

Henry Clive

Clive was born Henry O'Hara in 1882 and spent his childhood on a sheep ranch near Melbourne, Australia, before leaving home to become a magician. A strikingly handsome young man, he arrived in Hollywood in 1917 and soon found success in silent films. By 1920, he had transformed himself yet again, this time into an accomplished artist.

Clive's assignments in the early 1920s included paintings of the Ziegfeld Follies Girls (figure 88), a poster for Richard Barthelmess' film *Experience*, and portraits of Pola Negri and Gloria Swanson that were reproduced on lunch boxes distributed free to moviegoers. By 1925, after designing dozens of covers for *Theatre* magazine, he began to create pin-ups for a number of major publishing houses and calendar companies, most notably, Joseph C. Hoover and Sons in Philadelphia (figure 89).

Most of Clive's work was executed in oil on board in a fairly large format, generally about 30 x 24 inches (76.2 x 61 cm). His elaborately sensuous, painterly images showed a skillful use of color and almost always had beautifully painted backgrounds (figure 90).

Among the highlights of Clive's later career were his artwork for Billy Rose's extravaganza *Jumbo* and his weekly portraits of movie stars in exotic settings for the series entitled Enchantresses of the Ages, published in Hearst's *American Weekly Magazine*.

Embraced by both Hollywood and New York City, Clive lived a rich life. He maintained a studio in the renowned Beaux Arts Building in Manhattan until his death in 1960. As a tribute to his artistic brilliance, the hard-cover magazine *Audience* selected one of Clive's vintage pin-ups for its October 1971 front cover. Today, collectors value his calendar prints highly; no more than six of his original paintings are known to exist.

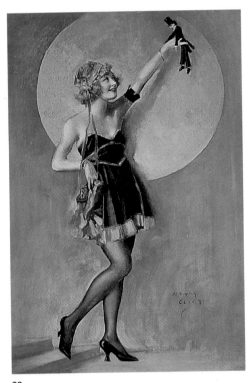

88

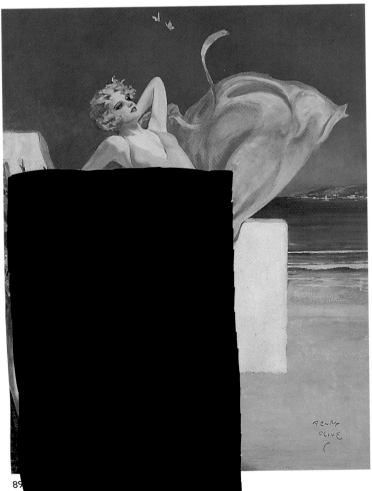

89

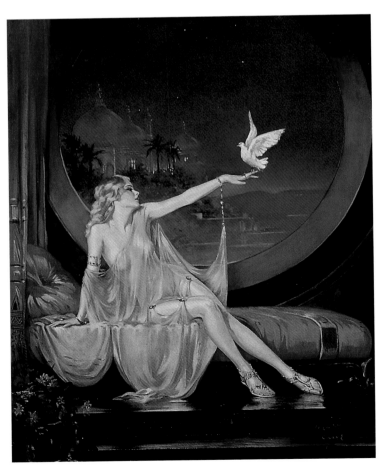

90

Edward M. Eggleston

Like his fellow illustrator Gene Pressler, Eggleston specialized in painting exotic, romantic subjects – Indian maidens, Hawaiian dancers, and "moonlight girls" with a fantastic Arabian Nights mood to them (figure 93).

In the early 1920s, Eggleston painted movie stars for the covers of film magazines; his 1922 portrait of Betty Compton for *Motion Picture Classic* was the talk of Hollywood when it hit the newsstands. He also did a series of hosiery ads during this time, as well as numerous magazine front covers, many of which were for mainstream publications.

In 1925, Eggleston opened a studio in New York and began painting pin-up and glamour images for the calendar market, most notably at first for the Thomas D. Murphy Company. His first assignment for Brown and Bigelow, *The Treasure Princess* (1928), was done to the company's exact specifications. After Eggleston insisted on being given free rein in choosing subjects, he began to design some of the most striking Art Deco pin-ups ever.

In 1932, Eggleston delivered to Brown and Bigelow the biggest-selling image of his career. According to the artist, he created *Let's Go America* (figure 95) in a time of economic depression "to symbolize renewed hope and confidence" in the nation's future. The work showed a beautiful lady riding a "magic carpet" through a midnight-blue Maxfield Parrish sky and surrounded by modern airplanes and a zeppelin.

In 1936, Eggleston began a productive relationship with the Joseph C. Hoover and Sons calendar company in Philadelphia; his first oil painting for Hoover, *Flaming Arrow* (1936; figure 91), was an extremely popular portrayal of an Indian girl. He followed this image up with *Cleopatra* (1938; figure 92), a classic Eggleston work and another smashing success.

Eggleston was still working out of his studio in Manhattan as late as 1940. His last recorded commercial work, from that year, was the front cover of the program guide for Billy Rose's Aquacade, which had been playing to record-breaking audiences at the New York World's Fair of 1939.

A distinguished, businesslike man, Eggleston created paintings that had a wealth of detail, careful drawing, superb composition, and a finished technique. He had a thorough knowledge of color values and was highly accomplished in oil, pastel, watercolor, and gouache. Most of his calendar assignments were executed in oil on canvas, in a large format averaging 30 x 24 inches (76.2 x 61 cm) to 40 x 30 inches (101.6 x 76.2 cm).

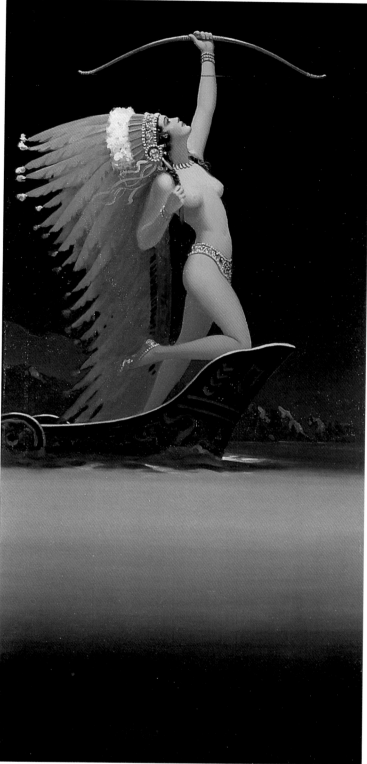

91

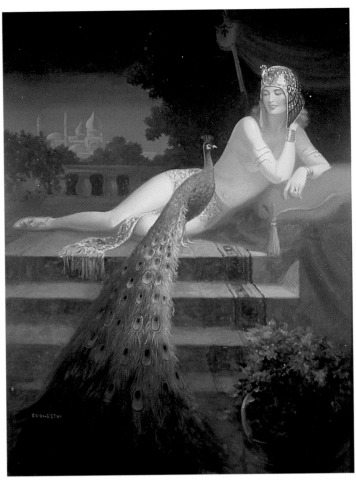

92

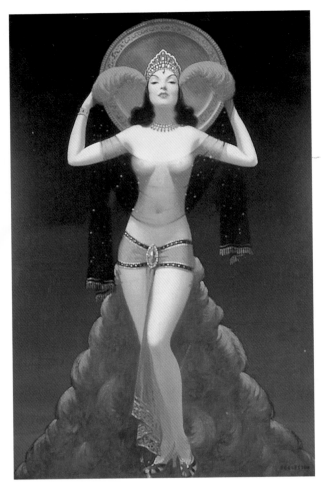

93

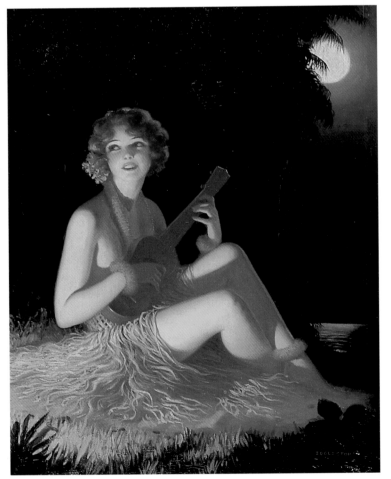

94

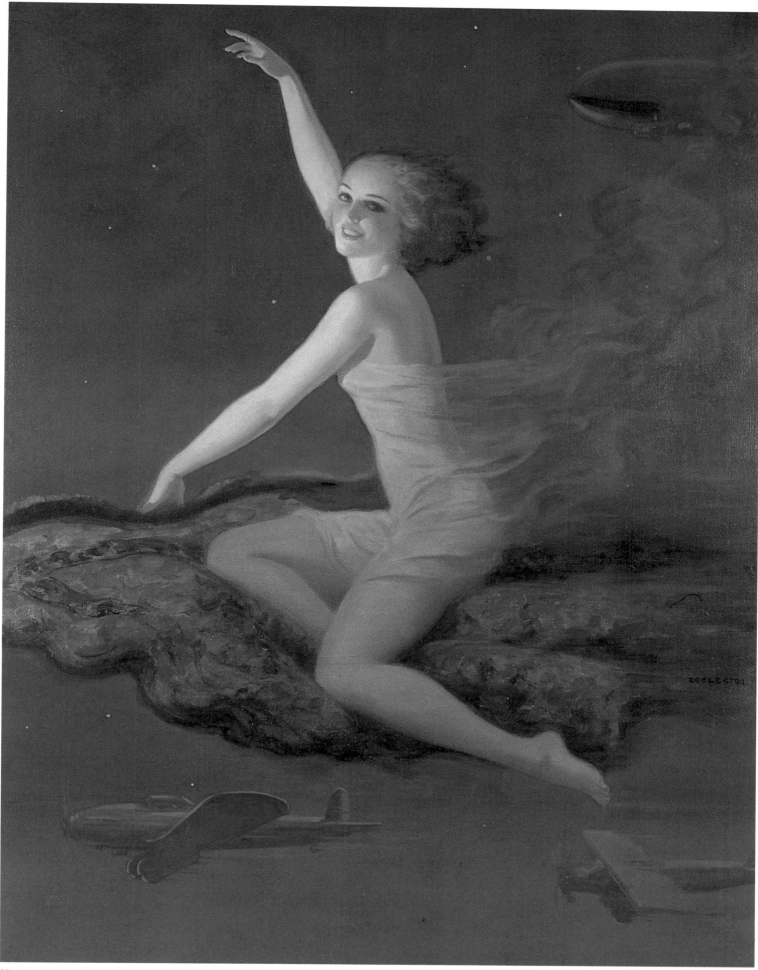

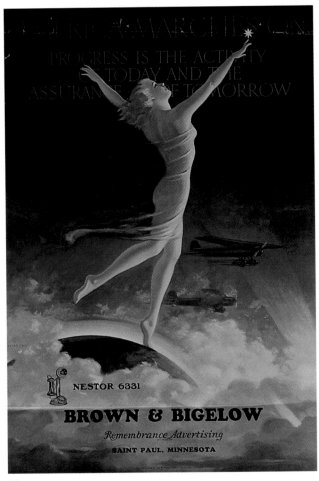

96

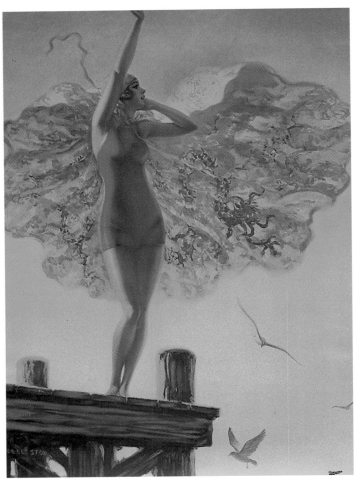

97

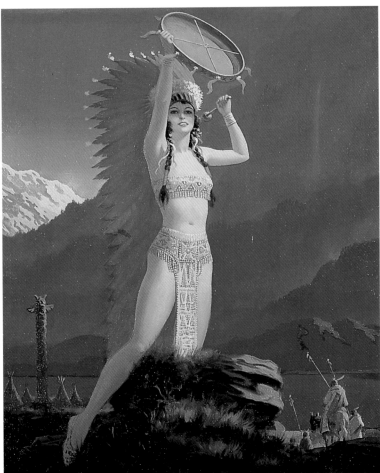

98

Q. Wilson Hammell

Hammell was one of the finest pastel pin-up and glamour artists working from the late 1920s through the 1930s. He has often been compared to Rolf Armstrong and Billy De Vorss, because the three utilized colors in the same way. Hammell worked in a large format and exclusively in pastels; his subjects ranged from full-length pin-ups to head-and-shoulder glamour subjects.

Hammell lived in Red Bank, New Jersey, but maintained a studio in New York City at Twenty-five West Forty-fifth Street. Known to his friends and fellow illustrators as Will, he was elected as an artist member to the Society of Illustrators on July 27, 1922. During the late-1920s, he painted a half dozen pin-up and glamour subjects for the prestigious Thomas D. Murphy Calendar Company.

During the 1930s, Hammell's name appeared on several million pin-up and glamour prints published by the Joseph C. Hoover and Sons calendar company in Philadelphia. Besides such sexy subjects, he also painted a series of sentimental themes for the calendar-art market; a number of these paintings were reproduced in the 1930s on picture puzzles for adults and children.

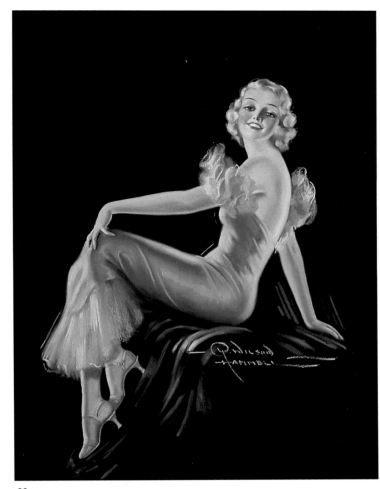

99

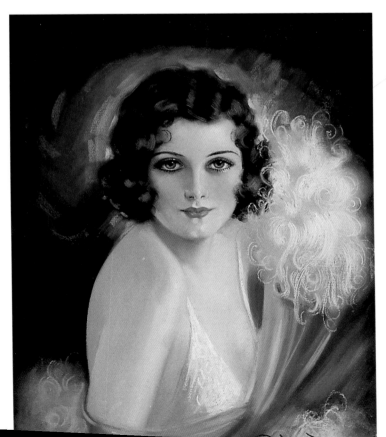

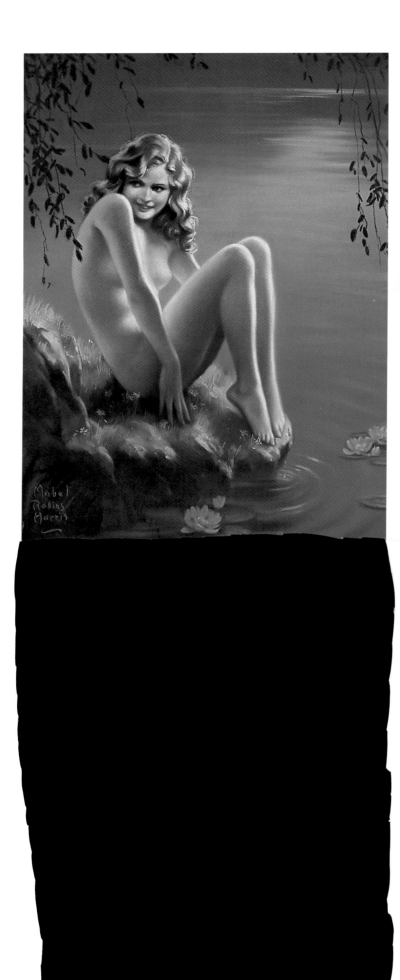

Mabel Rollins Harris

From the late 1920s until the end of the 1930s, Harris' exquisite pastels were among the most admired in the calendar-art business. Many of her great Art Deco pin-ups effectively expressed the magic and mystery inherent in the romantic themes that were so popular during the era. She was particularly known for spectacular nudes like *Golden Dawn* (1935; figure 103) and *Storm Queen* (1938; figure 104), which were kept in the catalogue of the Joseph C. Hoover and Sons calendar company for seven consecutive years.

Rollins' three pin-ups for the Thomas D. Murphy Company during the late 1920s aroused the admiration of Rolf Armstrong, who told the firm's art director that he envied the brilliant glow and softness of her finished pastels. Of her pin-ups during the 1930s for the Gerlach-Barklow Calendar Company, the most successful was another nude, seated in the moonlight on a rock surrounded by deep blue water (1930).

Harris also did calendar work for Brown and Bigelow, starting in 1933 with a commission for a sentimental subject entitled *Blue Heaven*. She continued to work on such non-pin-up themes, especially for Hoover, where her series depicting young girls in idyllic gardens was a great success. Her original paintings for such images were also executed in pastels, on stretched canvas; regardless of the subject matter, her paintings averaged 28 x 22 inches (71.1 x 55.9 cm).

Because of the special softness of Harris' pastels, her work was extremely popular in the mainstream illustration and publishing community. Major magazines like *The Saturday Evening Post* commissioned her to paint pastel images for their covers. For many years, she did freelance work for the Rustcraft and Norcross greeting card companies, specializing in religious and Christmas subjects.

Undoubtedly the finest female illustrator of the Art Deco era, Harris had her pin-up nudes and glamour art reproduced and published on millions of calendars. Her sentimental non-pin-up subjects enjoyed an equally long life span, being published in many forms, including puzzles, fans, and decorations on candy boxes.

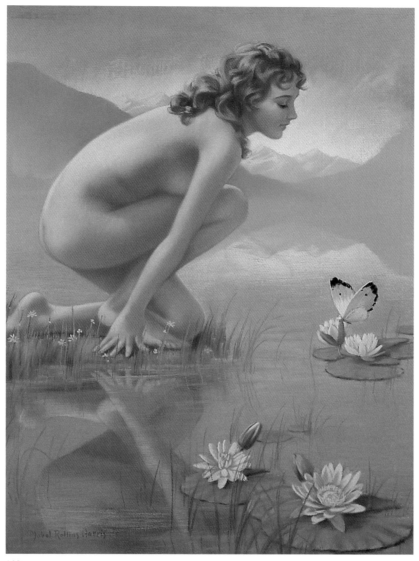

103

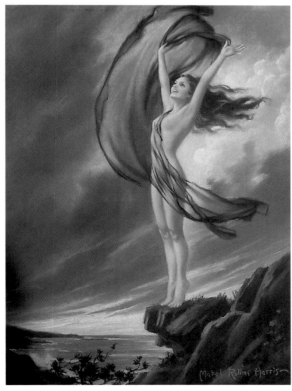

104

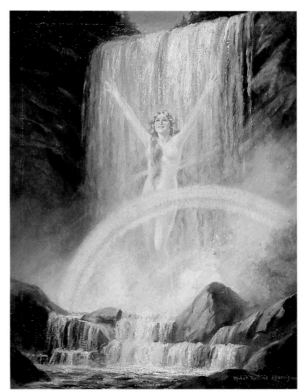

105

Cardwell S. Higgins

In 1927, two young artists joined the art department of Paramount Pictures in New York City: Alberto Vargas and Cardwell Higgins, who were to become good friends and artistic colleagues. Higgins had previously studied at the National Academy of Design, under George Bridgman and Ivan Olinsky, and at the Art Students League, under Harvey Dunn and Dean Cornwell. These four mentors greatly influenced the development of his career.

From 1932 to 1942, Higgins created highly stylized Art Deco pin-ups for the front covers of magazines like *Esquire*, *Film Fun*, *Screen Humor* (figure 112), *Silk Stocking Stories* (figures 110, 113, and 115), *Gayety* (figure 111), and *Sweetheart Stories*. A highlight of his advertising work came in 1937, when his painting for Palisades Park was made into a special billboard for Times Square (figures 106 and 107). This full-length portrayal of a long-legged pin-up girl in a bikini was such a success that the Park commissioned another Higgins work the following year (figures 108 and 109).

About the same time, Captain Eddie Rickenbacker hired Higgins to create a logo for Eastern Airlines that would "stand the test of time"; the artist responded with a design that would identify Eastern for the next forty years. In 1939, the New York World's Fair commissioned Higgins to design and paint the front cover for their *Railroads on Parade* brochure. Between 1937 and 1942, he also taught art at the Bloomfield Art League and the Fawcett School of Fine and Industrial Art in New Jersey. Besides all this work, he still found the time to create many illustrations with romantic themes for mainstream magazines.

The early years of World War II were the busiest of Higgins's career. He did a series of pin-up covers for leading detective magazines; he designed and painted two books of cutout dolls featuring Lana Turner and Carmen Miranda; and he painted his first front covers for Time-Life's *Omnibook* magazine, starting with a portrait of Winston Churchill and his cabinet. Higgins's single most famous work was his World War II poster for the USO depicting a WAC walking arm in arm with a soldier and a sailor, more than a million copies of which were distributed in the United States and overseas during the war.

Higgins was born in 1902, lived most of his life in West Nyack, New York, and died in 1983 in Hollywood, Florida. During World War II, he was an instructor in aviation camouflage in the Air Force's Corps of Engineers. He worked for ten years after the war as the art director of the Sears Roebuck catalogue and then retired.

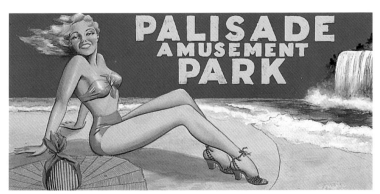

106

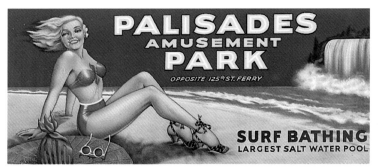

107

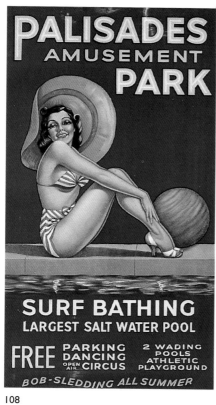

108

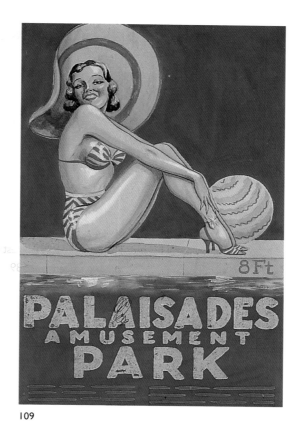

109

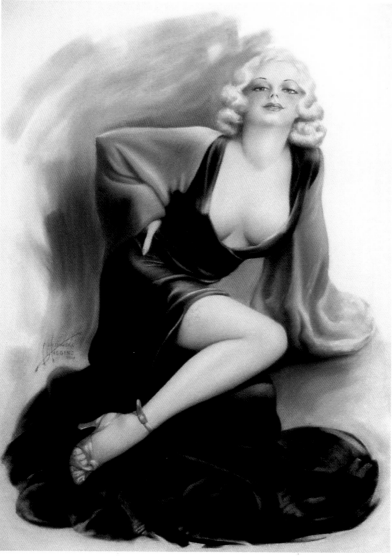

110

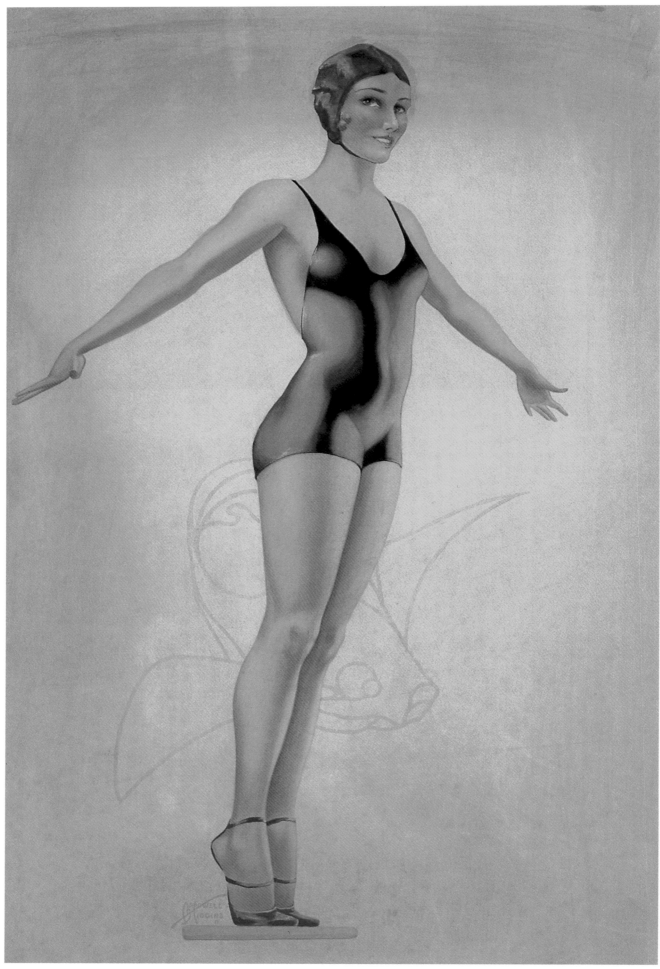

111

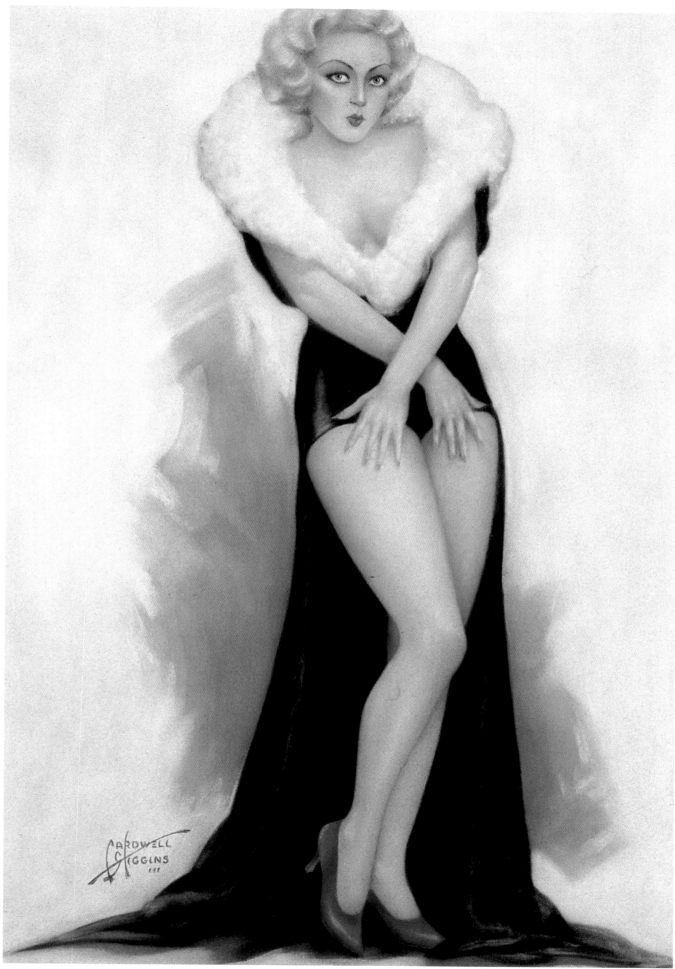

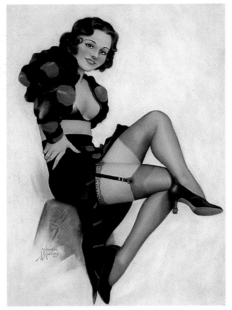

113

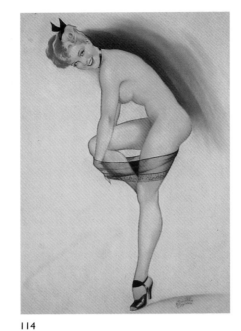

114

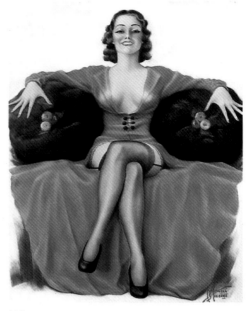

115

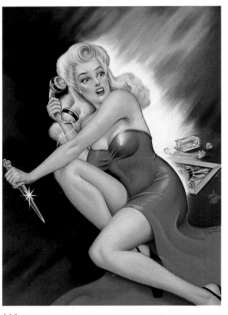

116

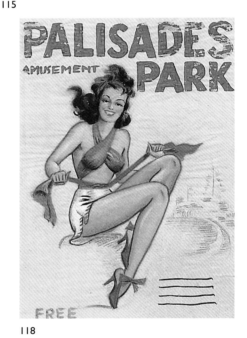

117

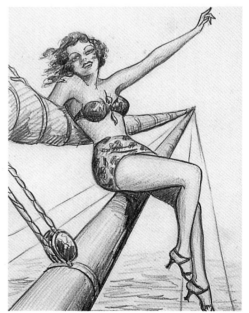

118

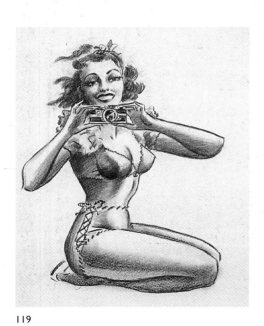

119

120

121

Hy Hintermeister

Henry (Hy) Hintermeister occupied a place in the calendar-art field comparable to Norman Rockwell's in American illustration as a whole. Like Rockwell, Hintermeister was a great painter. He was also a compulsive worker, more prolific than any other artist working on calendars; his clients included almost every major calendar company of the twentieth century.

Although Hintermeister's subject matter was generally sentimental and nostalgic, he painted practically every kind of picture, including a few true pin-up and glamour images (figure 122). Published by Brown and Bigelow in the 1930s as calendar prints and mutoscope cards, these images are distinctive both in color and mood.

Hintermeister, who was born in 1897, lived in Brooklyn while maintaining a studio in New York. His teachers included Weston Taylor, O. W. Beck, and Anton Otto Fisher. In the 1920s and 1930s, he painted hundreds of fabulous images for the Thomas D. Murphy, Shaw-Barton, and Brown and Bigelow calendar companies. His notable 1940s series of calendar paintings for Joseph C. Hoover and Sons featured an elderly grandmother playing with a group of youngsters while a priest watches from a distance. Hintermeister often portrayed the grandmother doing daring things like walking on a pogo stick, riding a merry-go-round, or speeding down a snow-covered mountain on a toboggan.

Hintermeister was recognized by his peers as not only a talented illustrator but also a highly accomplished fine-art painter. His son, who also became an artist, adopted his father's style and signature in a series of calendar-art paintings for Hoover in the early 1960s. However, these works could not compare to his father's — the elder Hintermeister's creations were the products of an exceptional talent and ability.

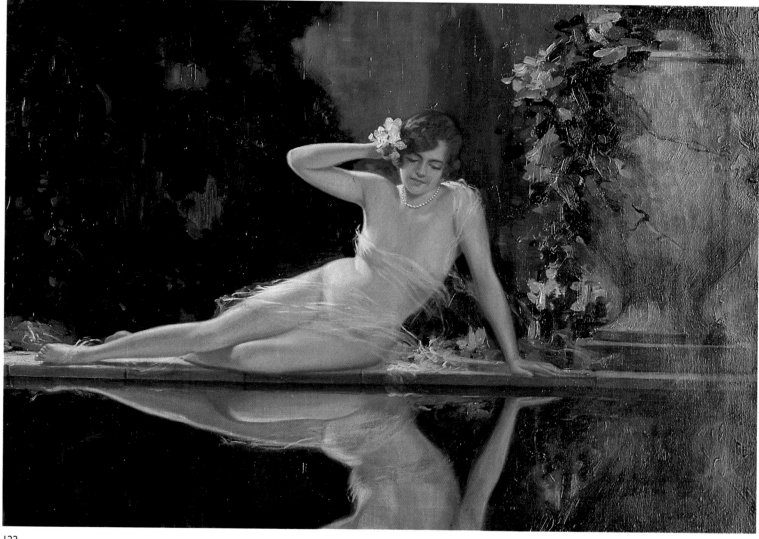

122

Laurette and Irene Patten

The Patten sisters worked together from 1920 to 1940, painting pastel pin-ups and glamour art subjects of high quality. Little is known about their backgrounds, except that they shared a studio at 7115 South May Street in Chicago. During their heyday, however, their names were well known among the country's leading publishers and throughout the calendar art industries.

Laurette and Irene Patten produced several hundred superb pin-up originals, which were published by many of the major American calendar companies, chief among them being Joseph C. Hoover and Sons in Philadelphia. Hoover published their work under the division name C. Moss, which included the firm's Superior Gift Line. The Pattens' illustrations were generally in the style of Rolf Armstrong, and their subjects ranged from the quite wholesome to images that were daring and provocative for the times.

The primary medium of the Pattens' originals was pastel on stretched canvas. They generally worked in a large format, with most pieces averaging between 30 x 24 inches (76.2 x 61 cm) to 40 x 30 inches (101.6 x 76.2 cm). Some originals were very large – 48 x 24 inches (121.9 x 61 cm) – and a few have surfaced that are quite small, 20 x 16 inches (50.8 x 40.6 cm). The Patten sisters usually shipped their original pastels to their publishers or printers in specially made wooden crates designed to protect the artwork.

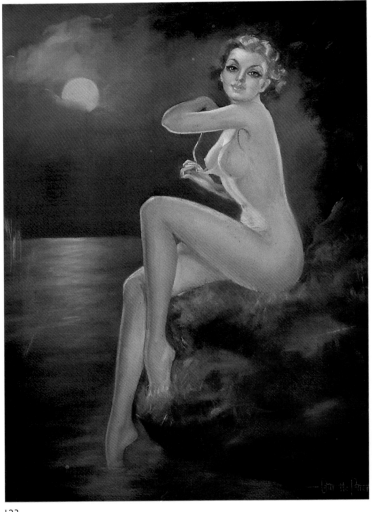

123

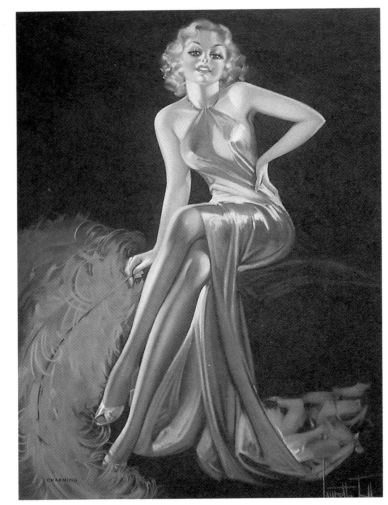

124

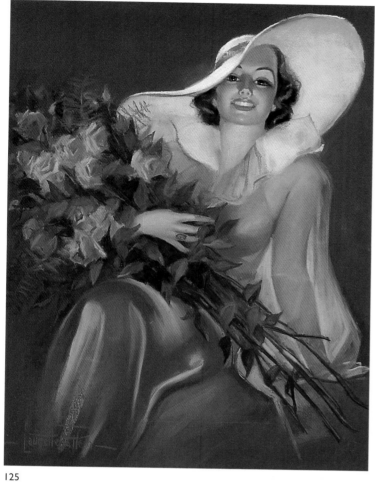

125

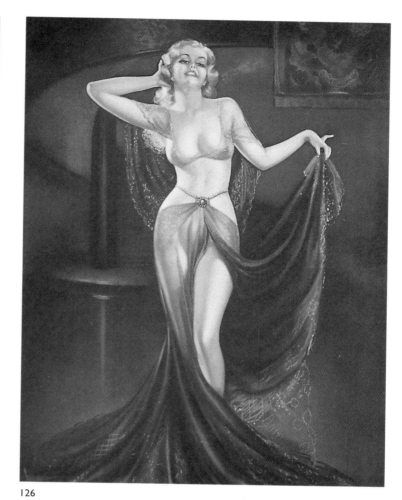

126

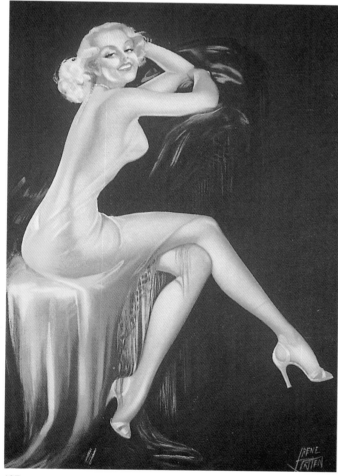

127

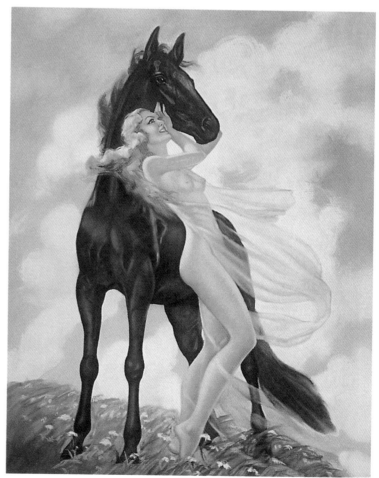

128

Gene Pressler

A prominent Art Deco artist, Pressler was born in 1893 in Jersey City, New Jersey. His teachers at the Art Students League included F. Louis Mora and Edward Dufner.

Pressler's most important work was published by the Joseph C. Hoover and Sons calendar company of Philadelphia from the 1920s to the mid-1930s. His images were mainly full-length pin-ups, but some — such as *Midnight and You* (figure 130) — were glamorous evening-gown scenes distinguished by Pressler's typically clever composition. By 1926, Pressler had joined Brown and Bigelow's staff and was contributing skillfully to their "girl subject" line. His highly successful Pompeian Cream panels (tall and narrow calendar images) were eventually known from coast to coast (figure 132).

Pressler also designed front covers for *The Saturday Evening Post* and other mainstream magazines. Working primarily in pastels on large-size canvas (40 x 30 inches; 101.6 x 72.2 cm), the artist insisted that his paintings be reproduced with the most up-to-date printing technology. His colors were generally rich and brilliant, like Armstrong's, but he was also adept at blending pastels in a blue-green color scale reminiscent of Maxfield Parrish's (figure 131).

Pressler retired about 1940, after a distinguished career. His original paintings are extremely rare.

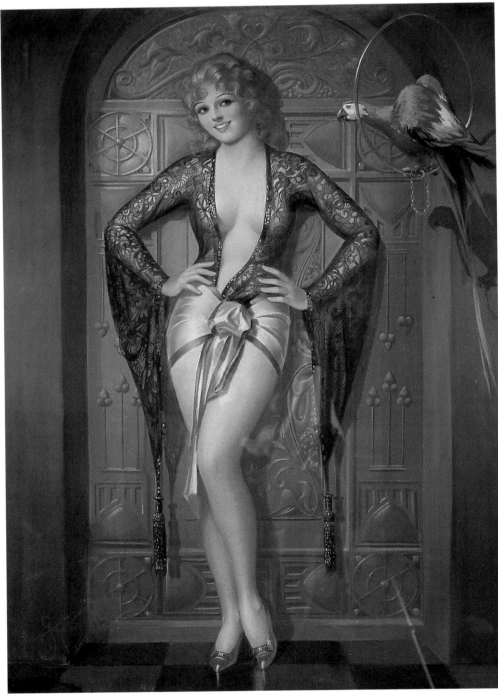

129

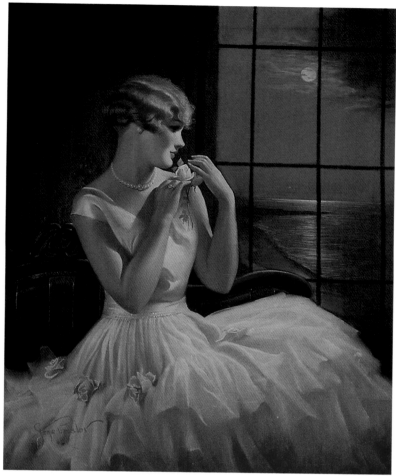

130

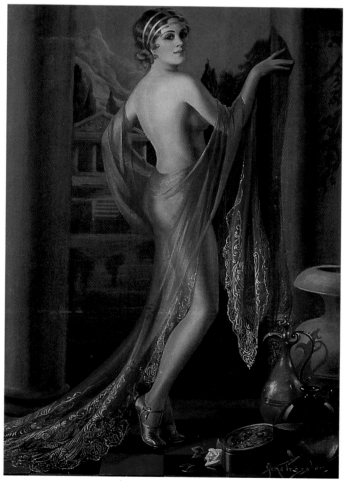

131

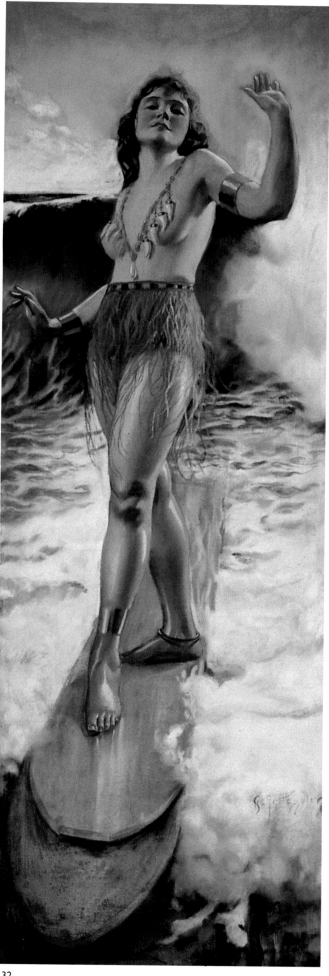

132

Rolf Armstrong

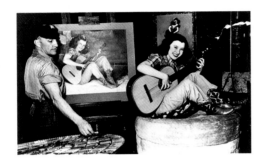

Born in Seattle in 1899, Armstrong grew up in the rugged environment of the Pacific Northwest. He moved to Chicago in 1908 and later enrolled at the Art Institute, where he studied for three years under the master draftsman John Vanderpoel. He then went on to New York, where he became a student of Robert Henri. Athletic as well as artistic, Armstrong both boxed and sketched at the New York Athletic Club; his early pictures regularly featured sailors, boxers, and cowboys.

After a trip in 1919 to study art at the Académie Julian in Paris, Armstrong established a studio in Greenwich Village and started to paint Ziegfeld Follies girls. In 1921, he went to Minneapolis-St. Paul to study calendar production at Brown and Bigelow. A perfectionist all his life, Armstrong mastered the technical aspects of modern publishing because he wanted his work to have the same "freshness and beaming color" on paper as on canvas. Not surprisingly, he refused to work from photographs, and his search for the perfect model was unending.

During the 1920s and 1930s, Armstrong's work appeared on numberless pieces of sheet music as well as on the front covers of many mainstream and theater and film magazines. All the great stars posed for his glamorous portraits – Mary Pickford, Greta Garbo, Marlene Dietrich, Katherine Hepburn; he even persuaded Boris Karloff to pose for him on the set of *Frankenstein*.

Armstrong's covers for *Pictorial Review* were largely responsible for the magazine's achieving, by 1926, a circulation of more than two million copies per issue. A year later, Armstrong emerged as the best-selling calendar artist at Brown and Bigelow. RCA hired Armstrong in 1930 to paint pin-ups to advertise their products, and by 1933 his popularity was so great that the Thomas D. Murphy Company signed him up to produce a series of ten paintings for their line – an honor shared only by Billy De Vorss.

Armstrong maintained a "fantasy mansion" on Little Neck Bay in Bayside, Long Island, complete with a lagoon and sailboats for his friends to enjoy. Because light was so crucial to his work, he often painted his models outdoors in the glow of the setting sun. Employing an extraordinary selection of pastel colors for most of his work, Armstrong also at times utilized charcoal, pencil, and oils. In the mid-1930s, the artist realized his quest for the "perfect, dream-come-true model" when he met Jewel Flowers, whom he later adopted. He lived in Hollywood, from 1935 to 1938, then returned to New York.

In 1943, Armstrong joined Earl Moran, Zoë Mozert, and Norman Rockwell as the guest artists at a War Advertising Conference in Minneapolis-St. Paul. With Jewel Flowers by his side, the articulate and elegant Armstrong generated a lot of press. When asked why he insisted on a live model, Armstrong said, "When I paint, I want the living person in front of me. As I look at her again and again and again while I work, I get a thousand fresh, vivid impressions . . . all the glow, exuberance, and spontaneous joy that leaps from a young and happy heart." (The last Armstrong model to have these qualities was Patty Jenkins.)

Armstrong was inspired by the glitter of society, and he appreciated beauty in people, cars, furniture, fabrics, and, of course, in art. A collector of swords and antique lances, he built one of the greatest private collections of ancient weapons in America. He died on February 22, 1960, on the island of Oahu in Hawaii, surrounded by his beloved blue ocean and tropical winds.

Armstrong's artistry was an amalgam of brilliant lighting techniques, magnificent vivid colors, superior craftsmanship, and beautiful subjects – his vivacious, spirited ideals of American femininity.

Opposite page:
148

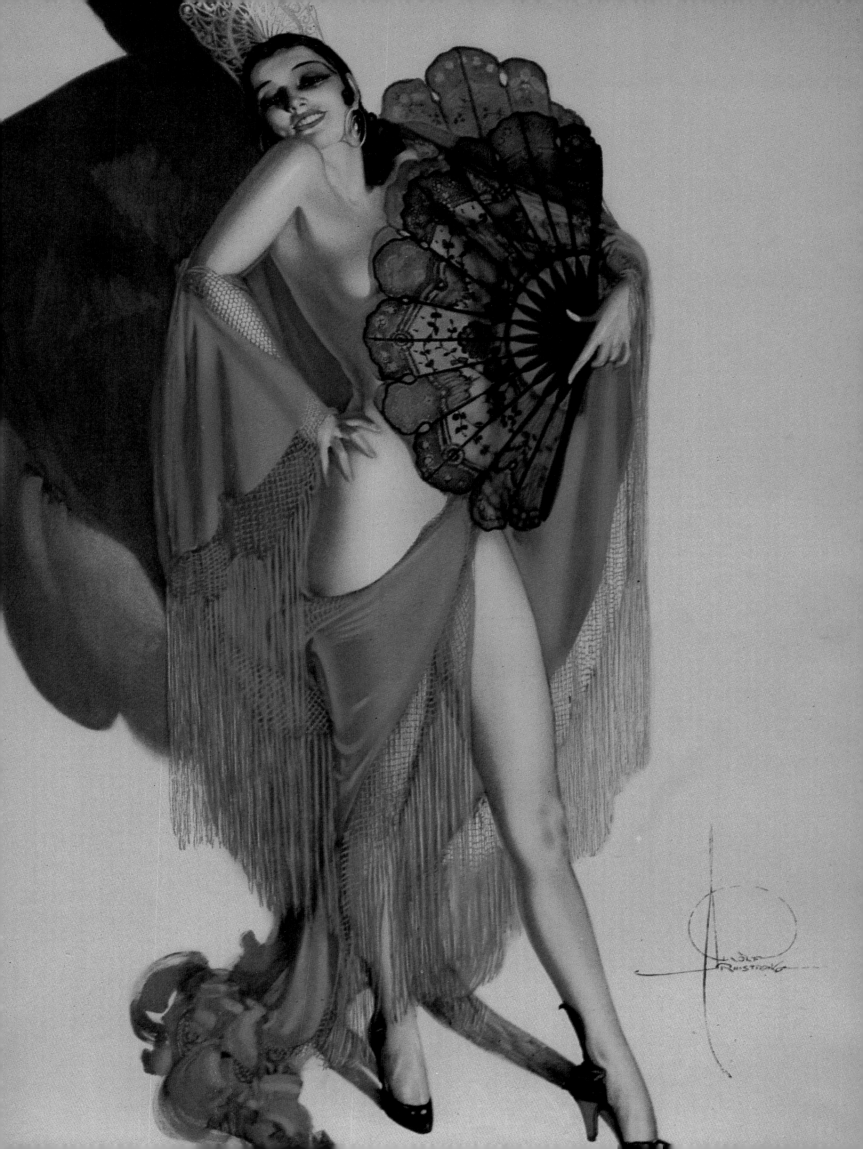

149

150

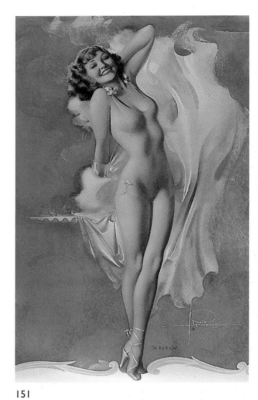

151

152

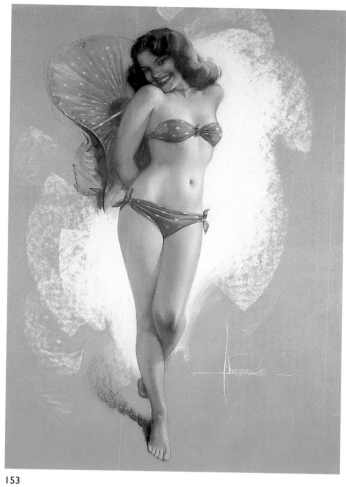

153

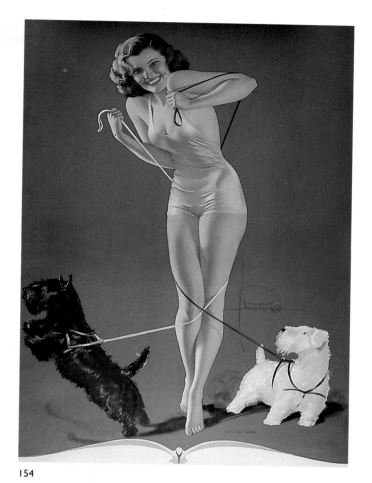

154

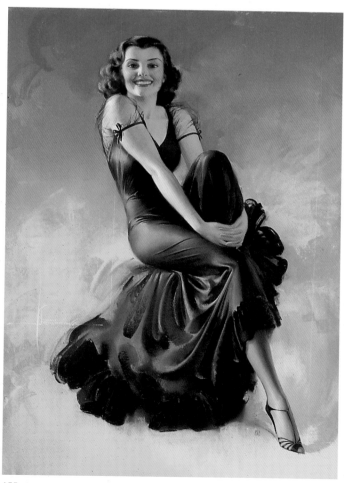

155

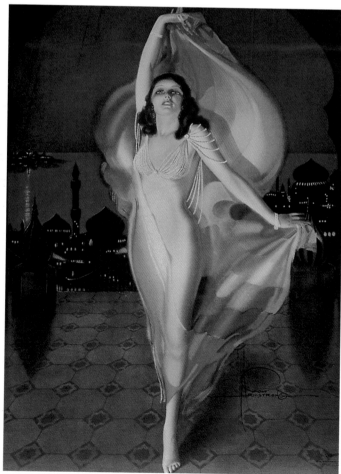

156

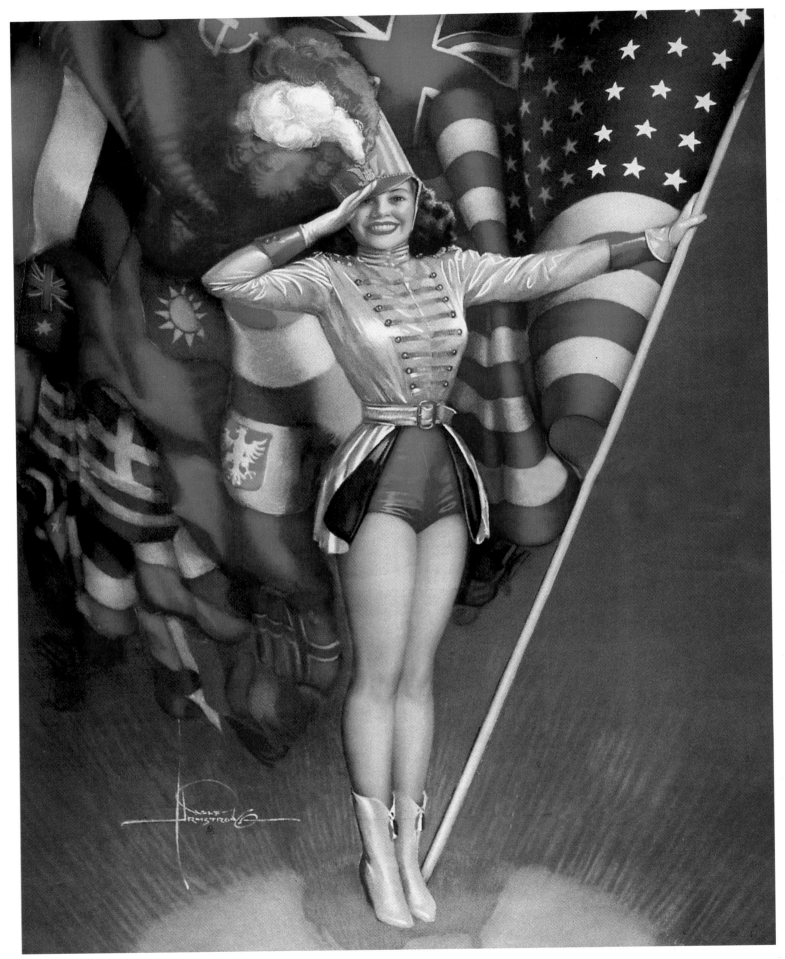

157

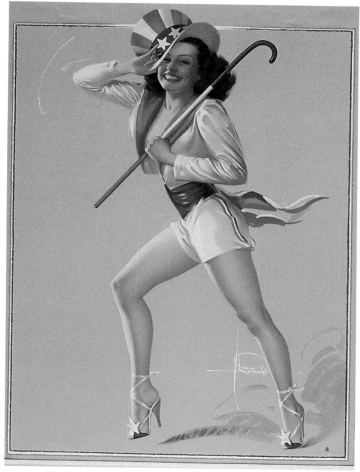

158

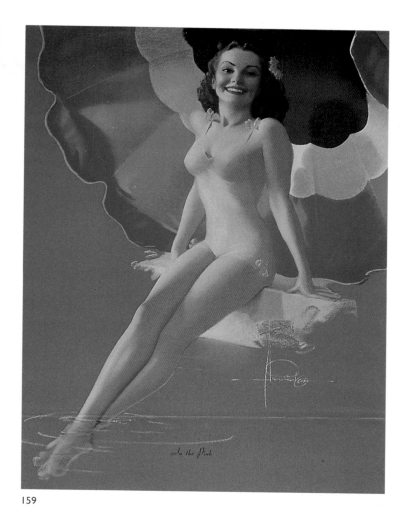

159

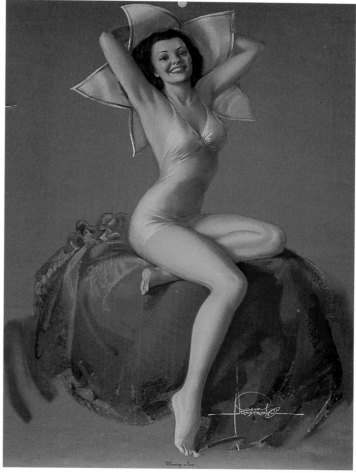

160

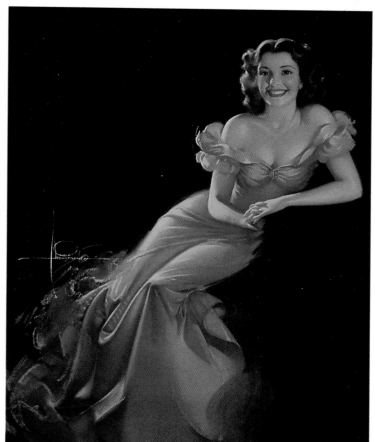

161

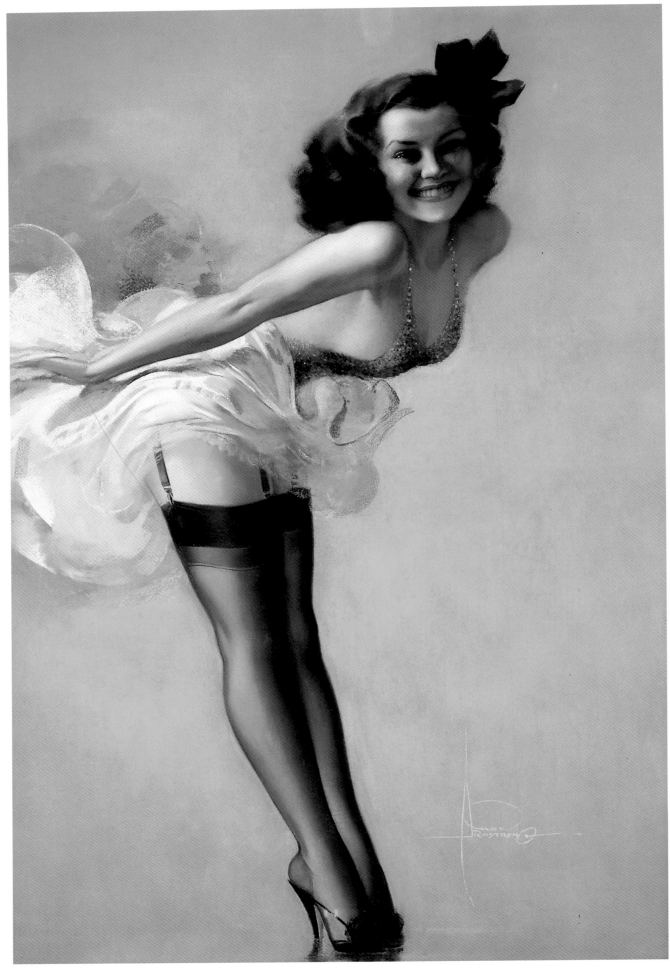

162

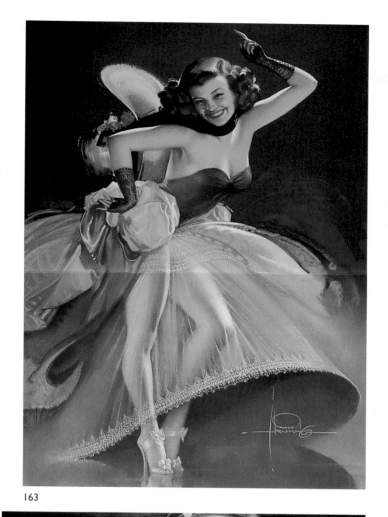

163

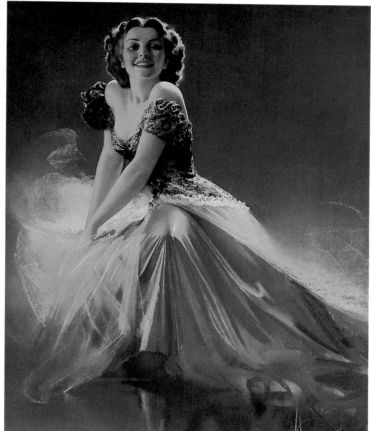

164

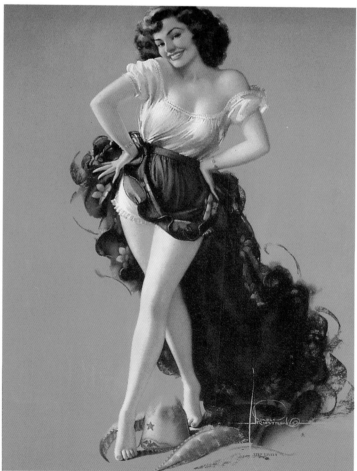

165

166

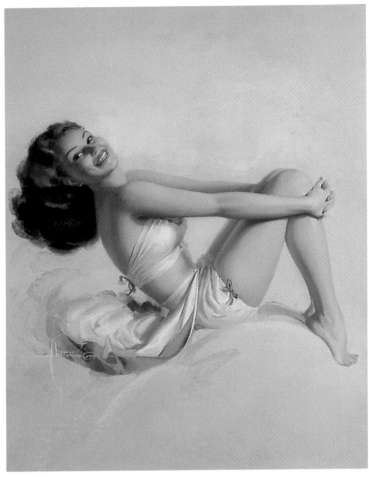

167

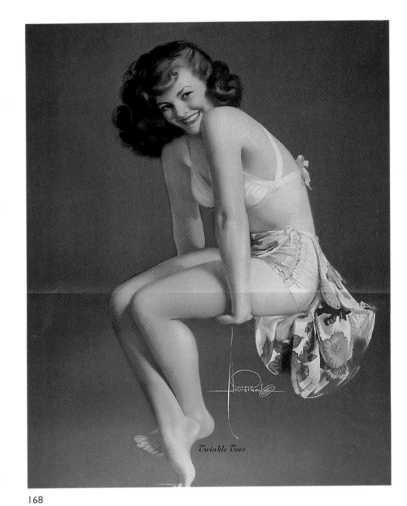

Twinkle Toes

168

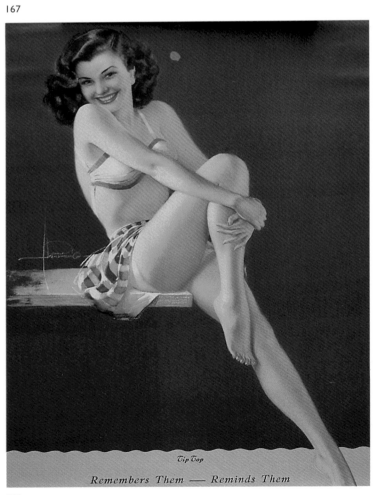

Tip Top

Remembers Them — Reminds Them

169

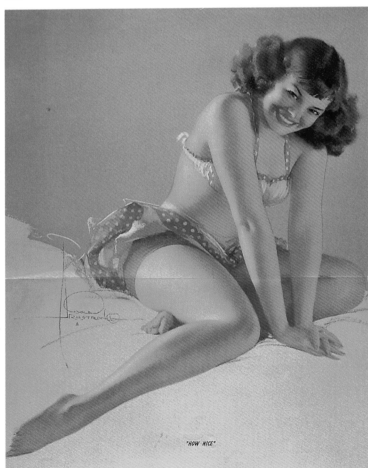

"HOW NICE"

170

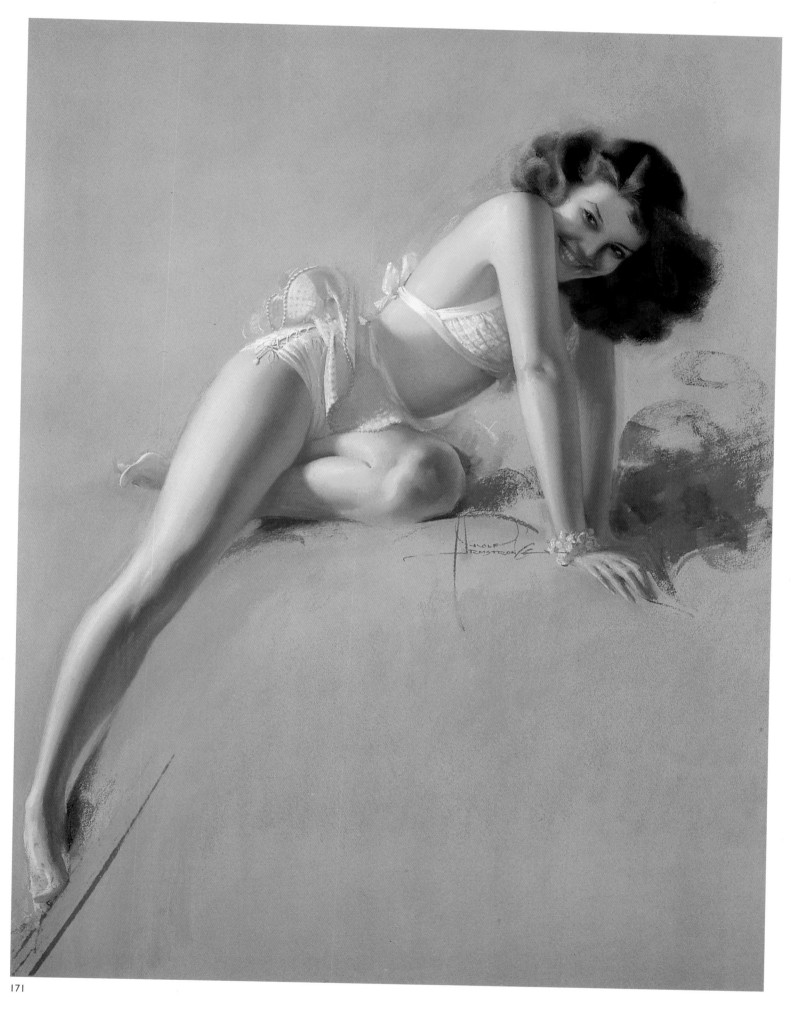

171

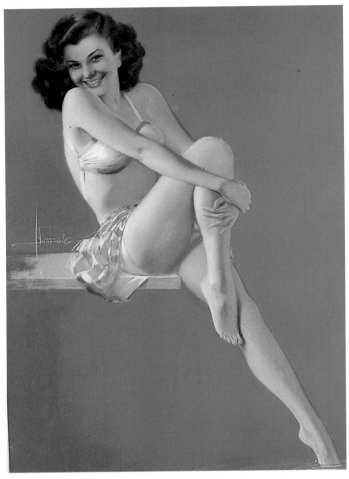

172

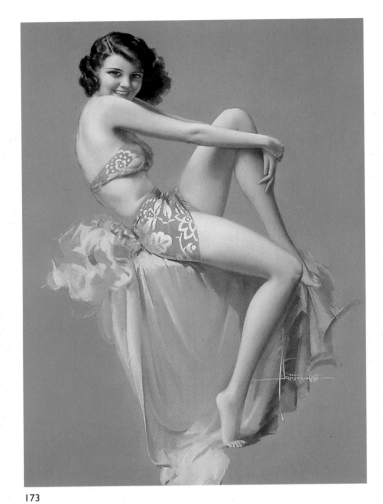

173

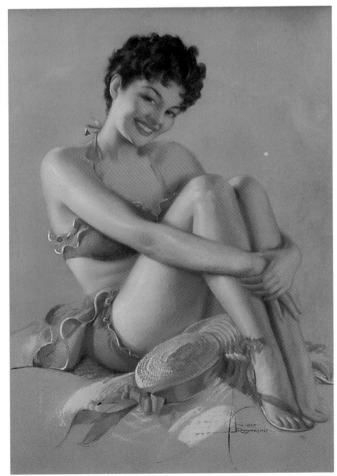

174

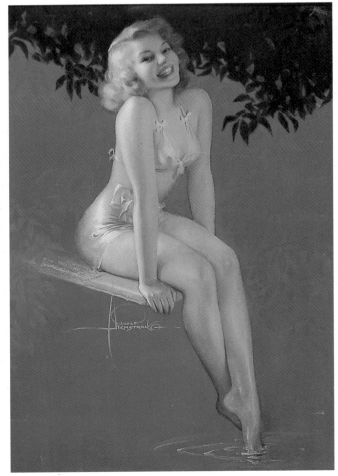

175

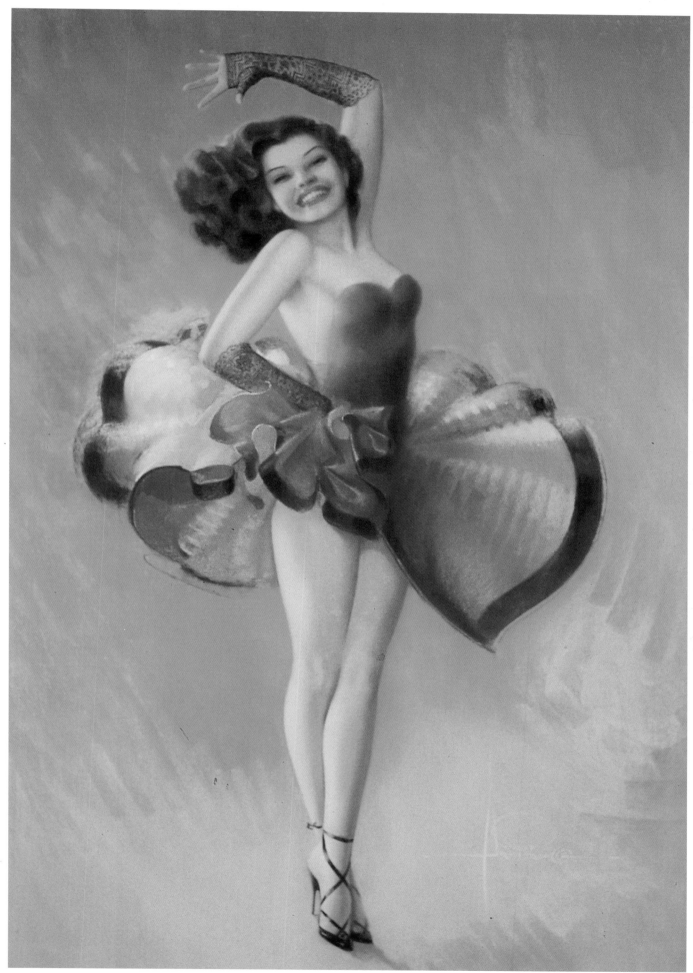

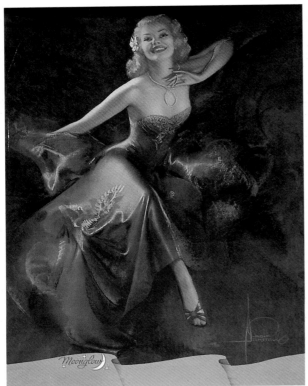

181

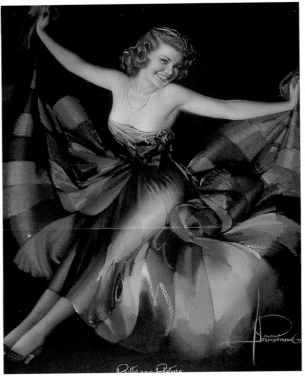

182

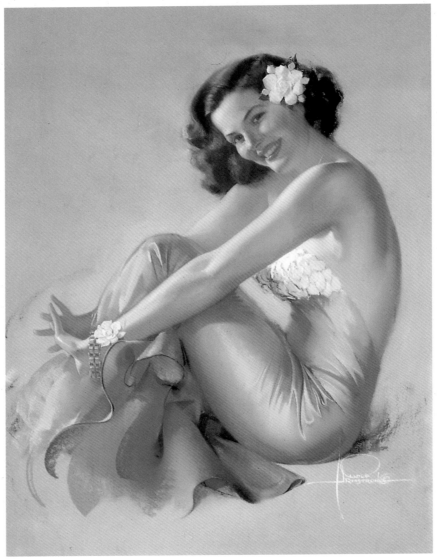

183

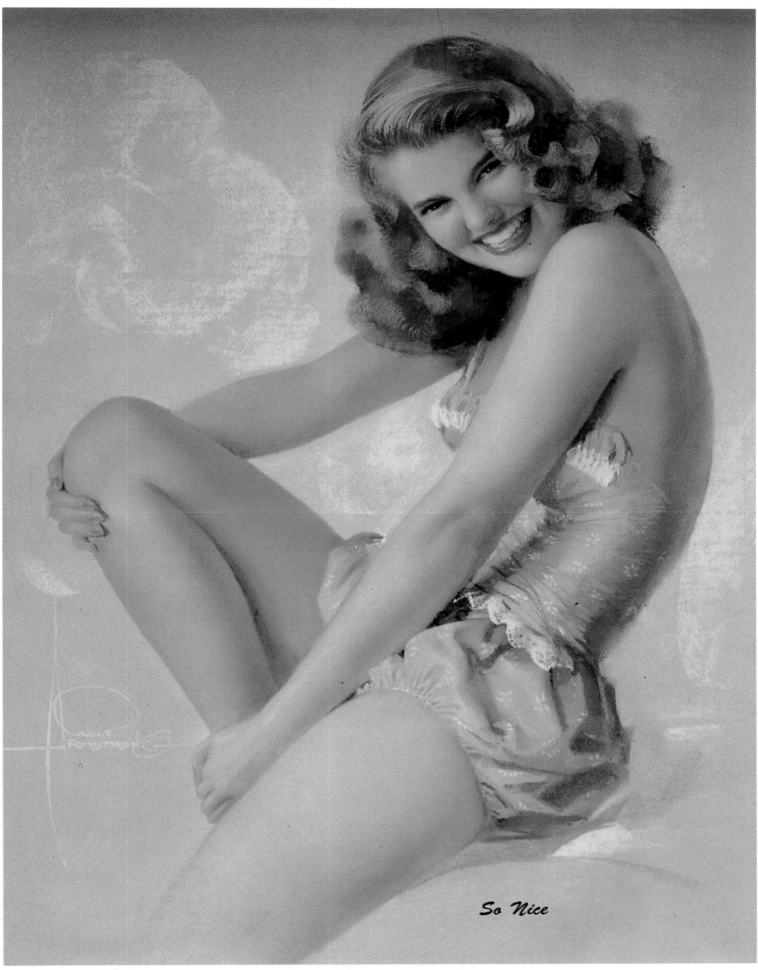

So Nice

Joyce Ballantyne

Ballantyne was born in Norfolk, Nebraska, just after World War I. She attended Nebraska University for two years, painting murals in her spare time for department stores and movie theaters before leaving to study commercial art. After studying at the Academy of Art in Chicago for two years, she joined Kling Studios, where she painted Rand McNally road maps and illustrated a dictionary for the Cameo Press.

Ballantyne then moved on to the Stevens/Gross studio, where she stayed for more than ten years. Influenced, as much of the studio was, by Haddon Sundblom, she became part of a group of artists who were extremely close, both professionally and personally, including Gil Elvgren, Earl Gross, Al Moore, Coby Whitmore, Thornton Utz, and Al Buell. She had first met Elvgren when he was teaching at the Academy of Art and she was a student. After years of working closely together, however, they often shared assignments if one of them became ill or if a schedule was tight.

In 1945, Ballantyne began painting pin-ups for Brown and Bigelow, having been recommended by Elvgren. The firm introduced her to their national sales and marketing staff as "the brightest young star on the horizon of illustrative art". Ballantyne designed a "novelty-fold" direct mail pin-up brochure for the company and eventually was given the honor of creating an Artist's Sketch Pad twelve-page calendar.

Ballantyne's most important pin-ups were the twelve she painted in 1954 for a calendar published by Shaw-Barton (figures 186–93, 197, 199, 200 and 202). When it was released nationally in 1955, the demand from new advertisers was so great that the company reprinted it many times. Ballantyne then went on to paint one of the most famous advertising images ever. Coppertone suntan lotion asked several illustrators to submit preliminary ideas for a special twenty-four-sheet billboard for their American and international markets. Ballantyne won the commission, and her final painting (based somewhat on an idea of Art Frahm's) became a national icon: its little pig-tailed girl whose playful dog pulls at her bathing suit charmed the entire nation.

Ballantyne also did much advertising work for other national clients, including Sylvania TV, Dow Chemical, Coca-Cola, and Schlitz Beer. She painted pin-ups for the calendar companies Louis P. Dow and Goes and illustrations for such magazines as *Esquire* and *Penthouse*.

The strikingly attractive Ballantyne often posed as her own model, as Zoë Mozert did. Like her friend Gil Elvgren, she preferred to work in oil on canvas that measured 30 x 24 inches (76.2 x 61 cm).

Ballantyne and her husband, Jack Brand, moved in 1974 to Florida, where she began painting fine-art portraits. She lives there today and still keeps in touch with her friends, and fellow Floridians, Al Buell and Thornton Utz.

Opposite page:
185

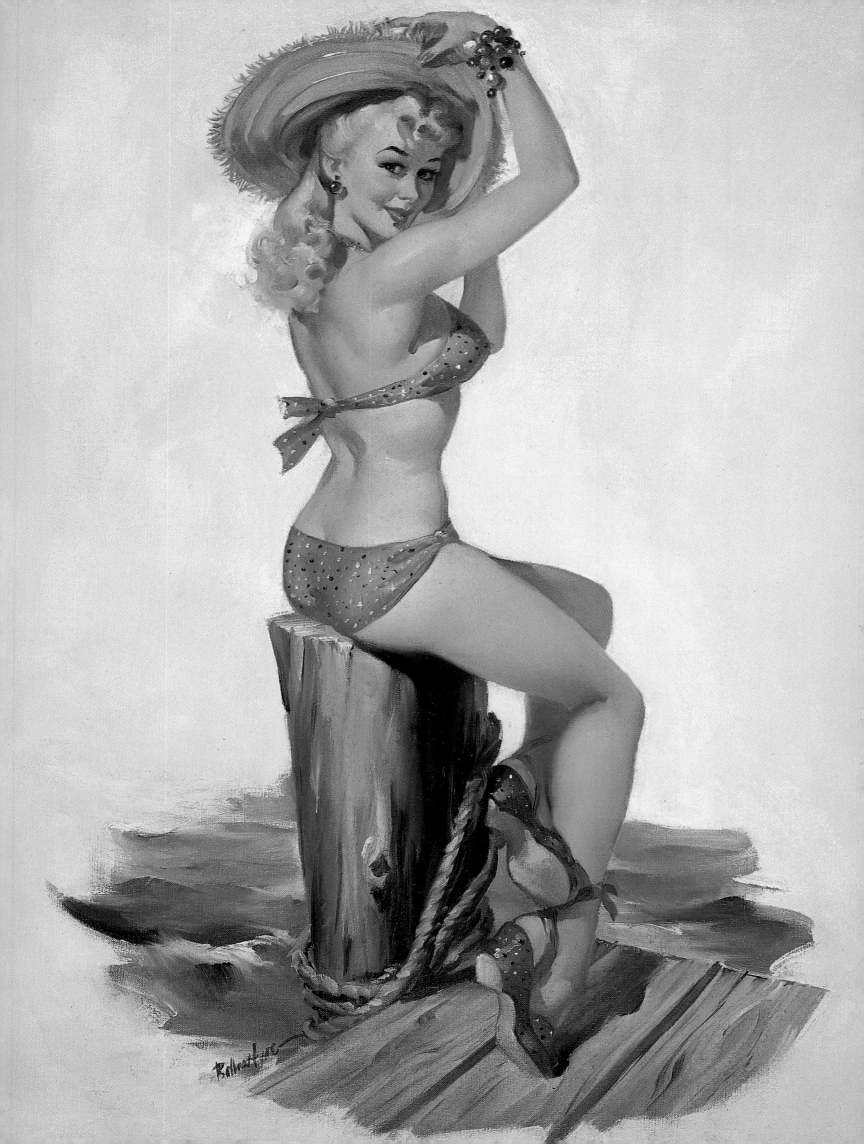

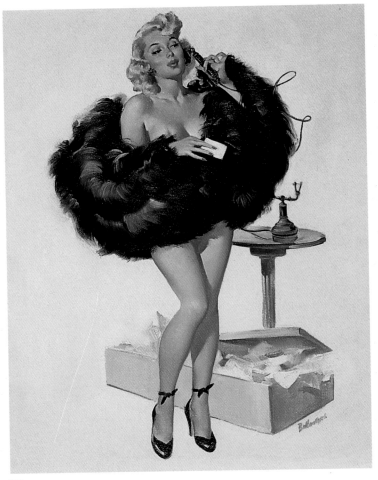

186

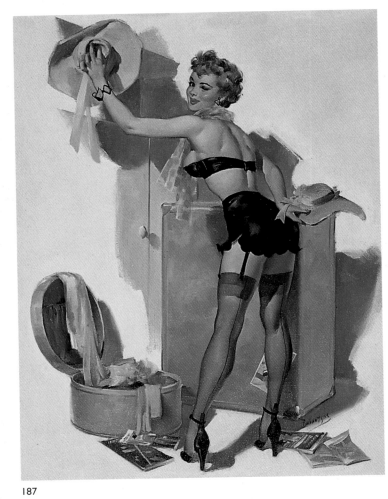

187

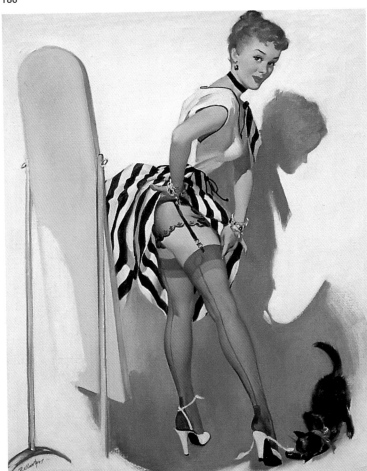

188

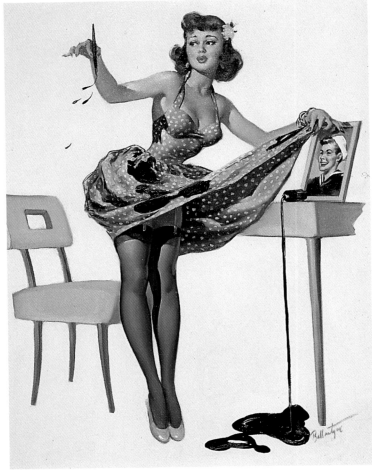

189

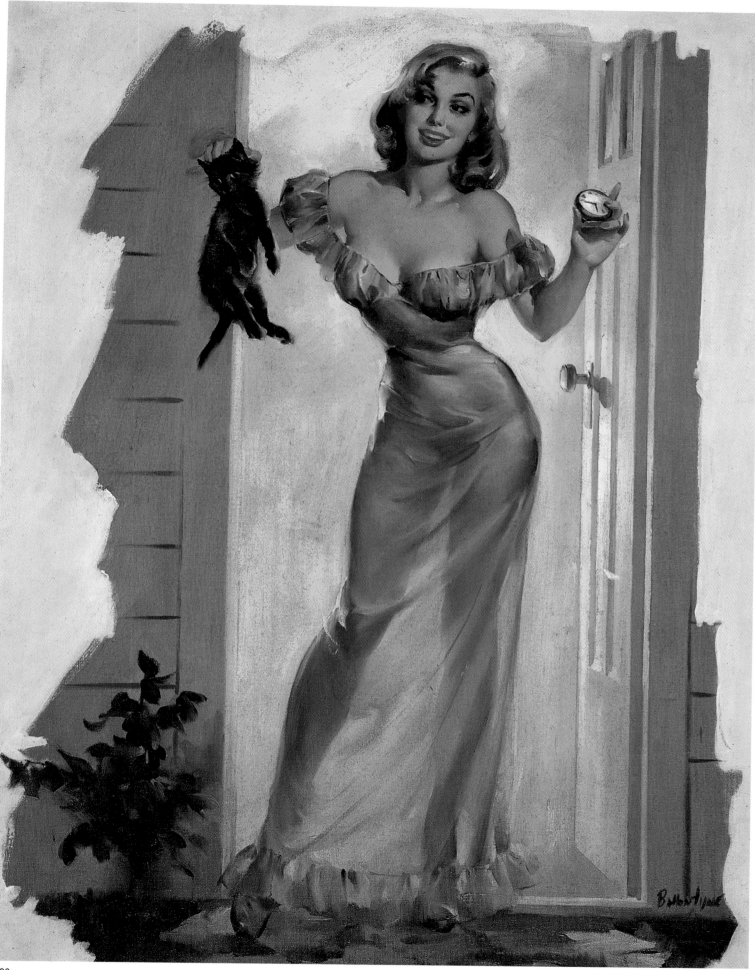

190

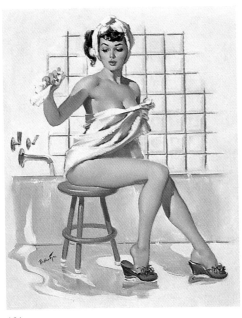

191

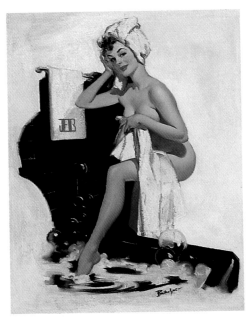

192

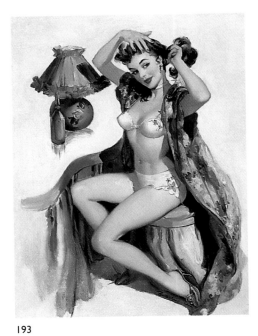

193

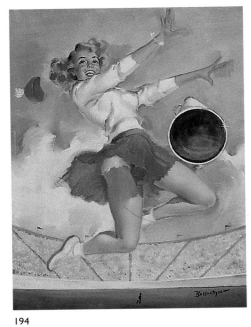

194

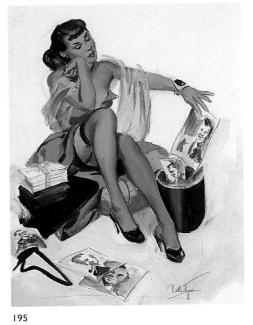

195

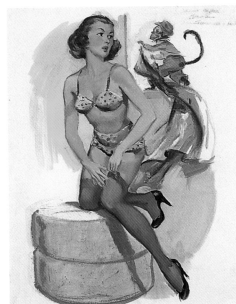

196

197

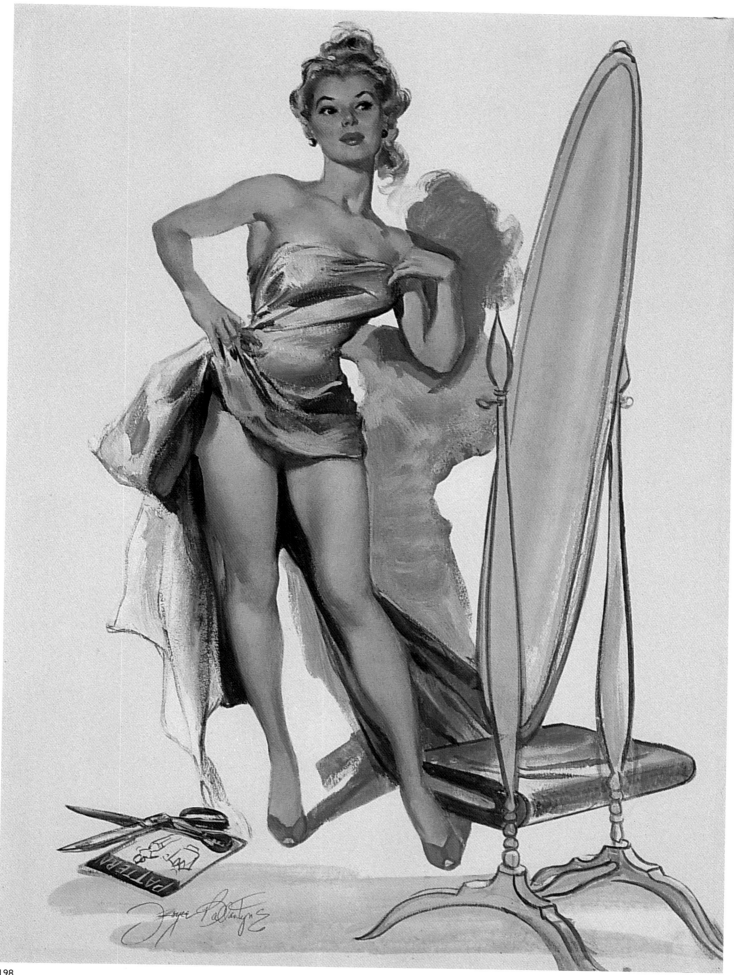

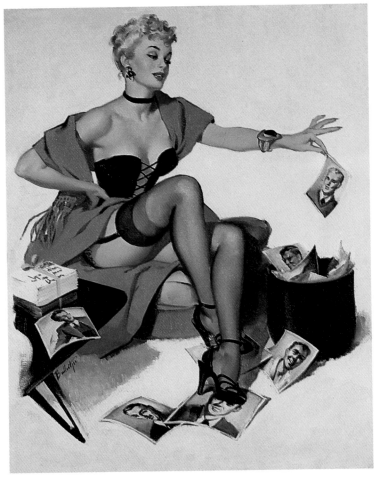

199

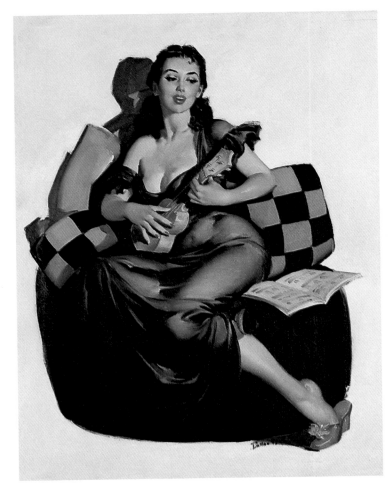

200

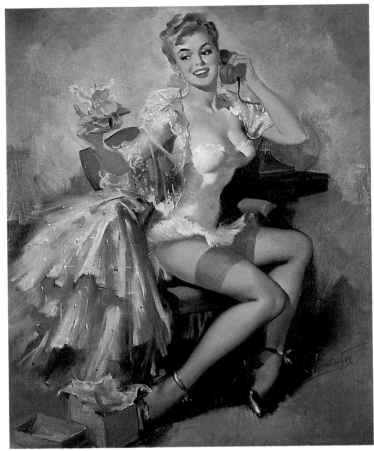

201

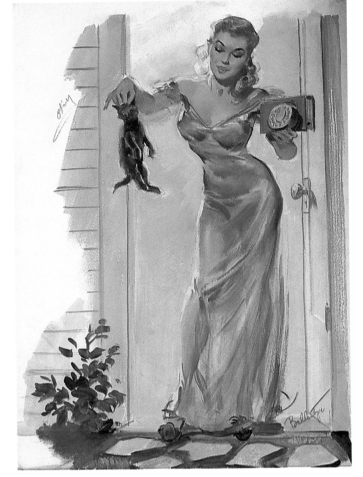

202

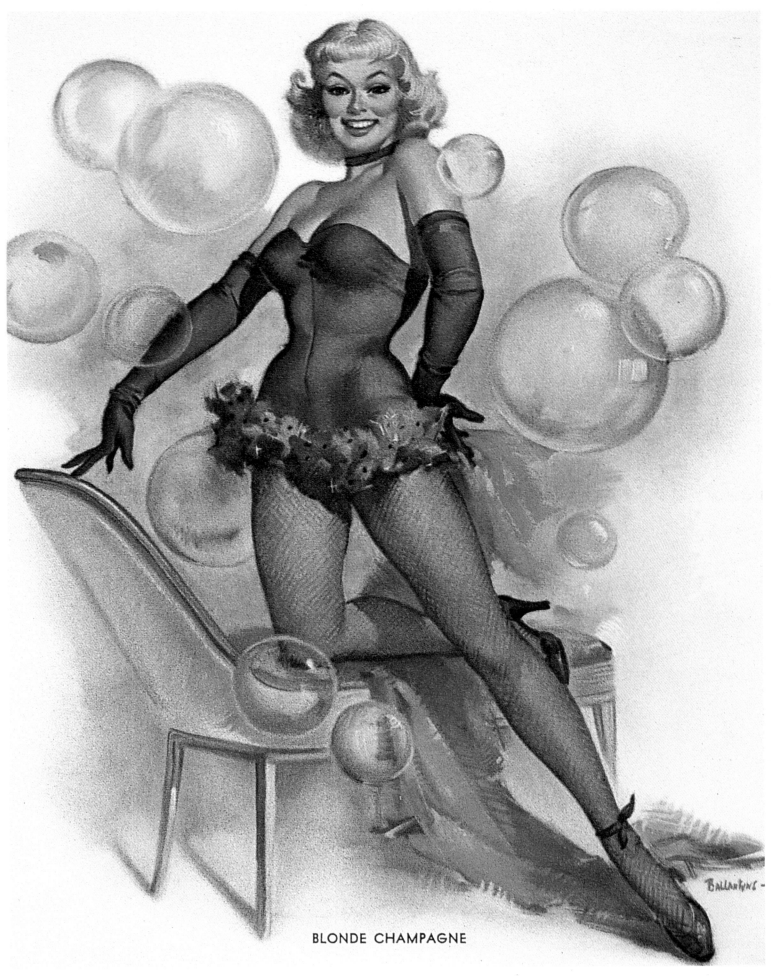

BLONDE CHAMPAGNE

Al Buell

Alfred Leslie Buell was born in 1910 in Hiawatha, Kansas, and grew up in Cushing, Oklahoma. He briefly considered an engineering career before classes at the Chicago Art Institute and a trip to New York City decided him on art. About 1930, he began to concentrate seriously on teaching himself to be an artist, and five years later, he and his new wife, Ruth, moved to Chicago where Alfred could better pursue his dream of being a commercial artist.

Buell joined the Stevens/Hall/Biondi art studio in Chicago in 1935, and his association there with Haddon Sundblom was to prove crucial to his artistic development. By 1940, Buell had opened his own studio, but he kept in touch with the Sundblom group for another five years, cherishing his friendships with artists like Gil Elvgren, Thornton Utz, and Joyce Ballantyne.

Buell painted pin-ups for the Gerlach-Barklow calendar company for five years starting about 1937 (figures 206, 208, 211, 213 and 214). His original paintings for the company were painted in oil on illustration board, averaged 20 × 16 inches (50.8 × 40.6 cm), and were signed with the block signature "Buell". Among the several other calendar companies he worked for in the early 1940s was Kemper-Thomas, for which he painted brightly colored canvases averaging 32 × 28 inches (81.3 × 71.1 cm), which he signed with his full name (figures 204 and 212).

Rejected by the draft in World War II, Buell spent the war years painting such popular pin-ups as *WAVE, WAC, Nurse* (1944) and *They're All Tops* (1945), which were terrific successes on Brown and Bigelow posters, calendars, and specialty products. About this time, the artist decided to adopt Al Buell as his official professional name.

Buell was among the important glamour artists who contributed to *Esquire*'s Gallery of Glamour, beginning in September 1946. He provided illustrations to many of America's mainstream magazines and was also active in the advertising field, most notably for Coca-Cola in the 1940s and 1950s. The only self-taught artist of the Sundblom Circle, Buell was featured in a June 1956 article on the group in *American Artist* magazine. After he and his family moved to Sarasota, Florida, in 1951, he began painting paperback-novel covers.

Buell returned to the Brown and Bigelow fold in the late 1950s, creating such fabulous images as *Summer Sweetheart* (1959; figure 207). In the early 1960s, he did his own twelve-page calendar for the firm, *Al Buell's DELECTaBELLES* (1960), followed by an Artist's Sketch Pad assignment (*Al Buell's Beauties*, 1961; figures 219–22) and the stunning glamour art image *Top Date* (1962; figure 1).

Buell ended his commercial career about 1965 and went on to paint fine-art subjects, including landscapes and portrait commissions. He remained active until 1993, when he was injured in an accident. He now resides in a nursing home.

Opposite page:
204

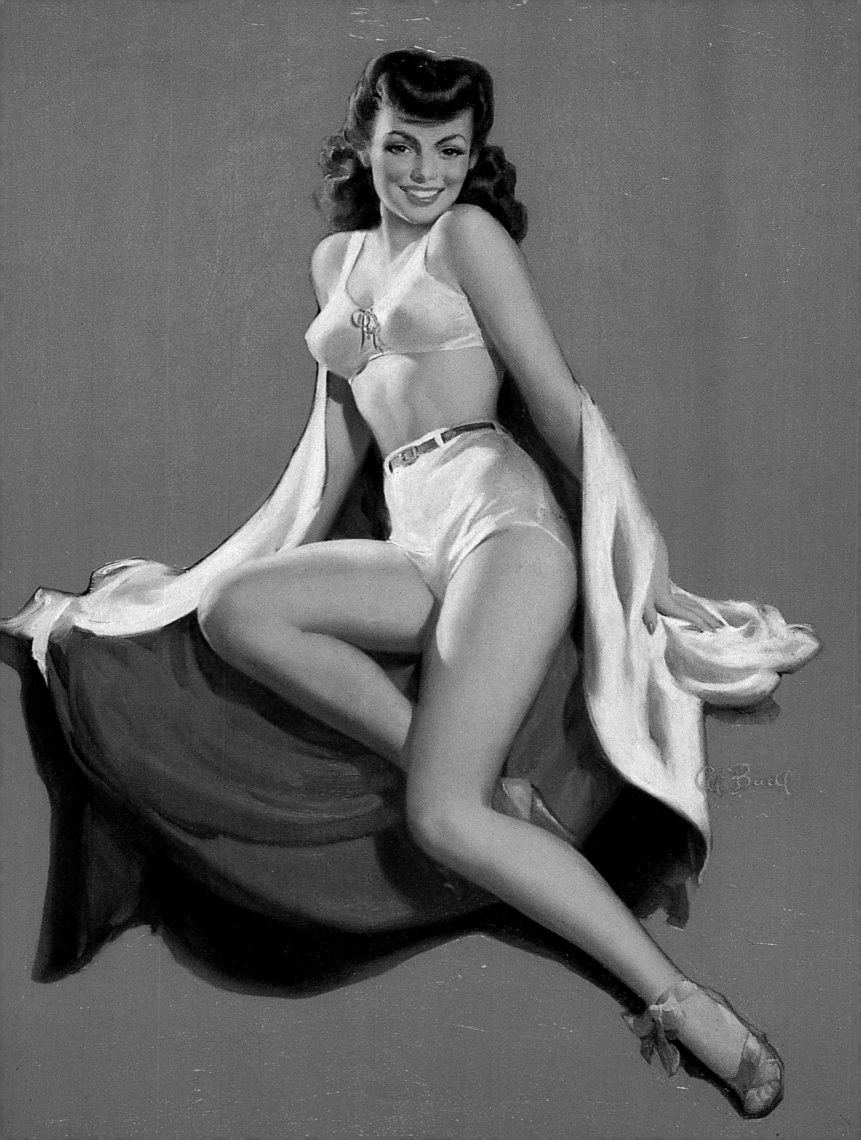

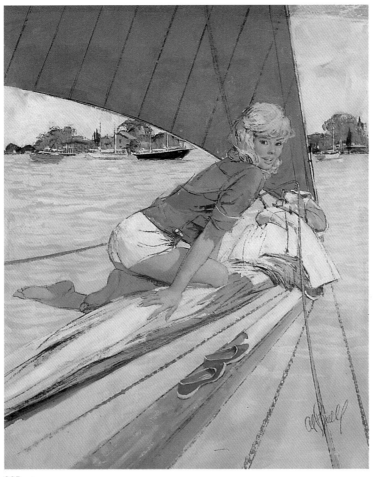

205

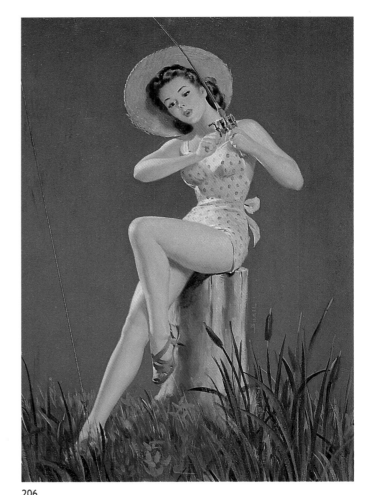

206

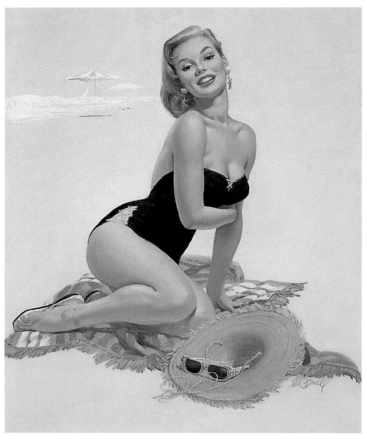

207

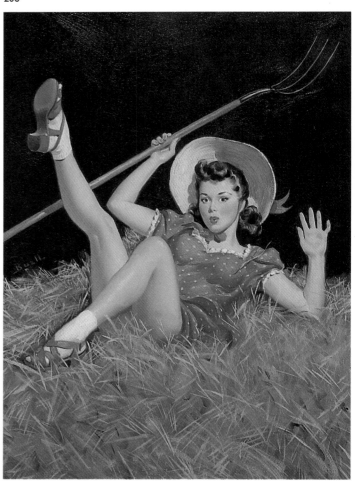

208

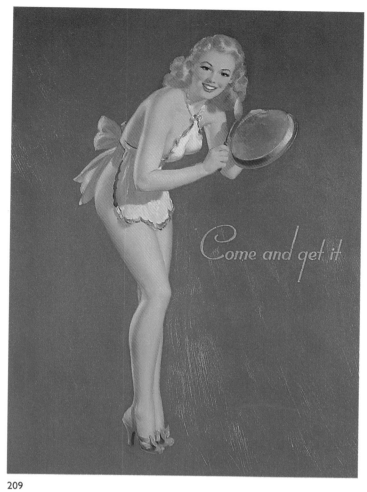

209

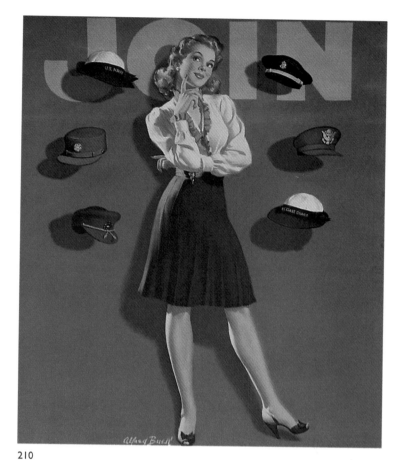

210

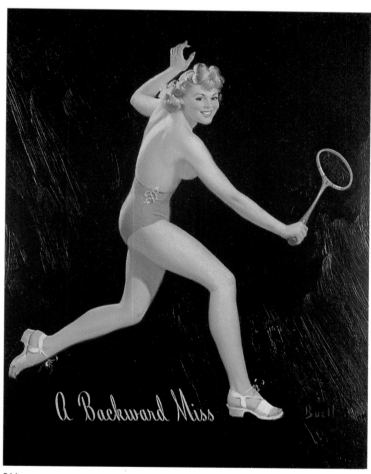

211

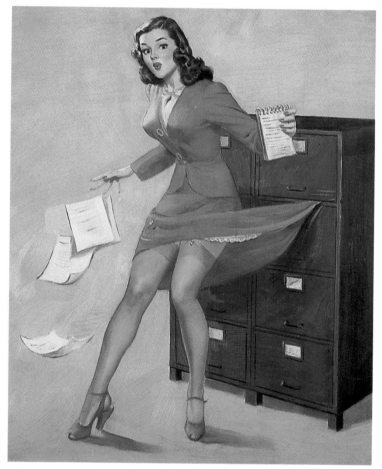

212

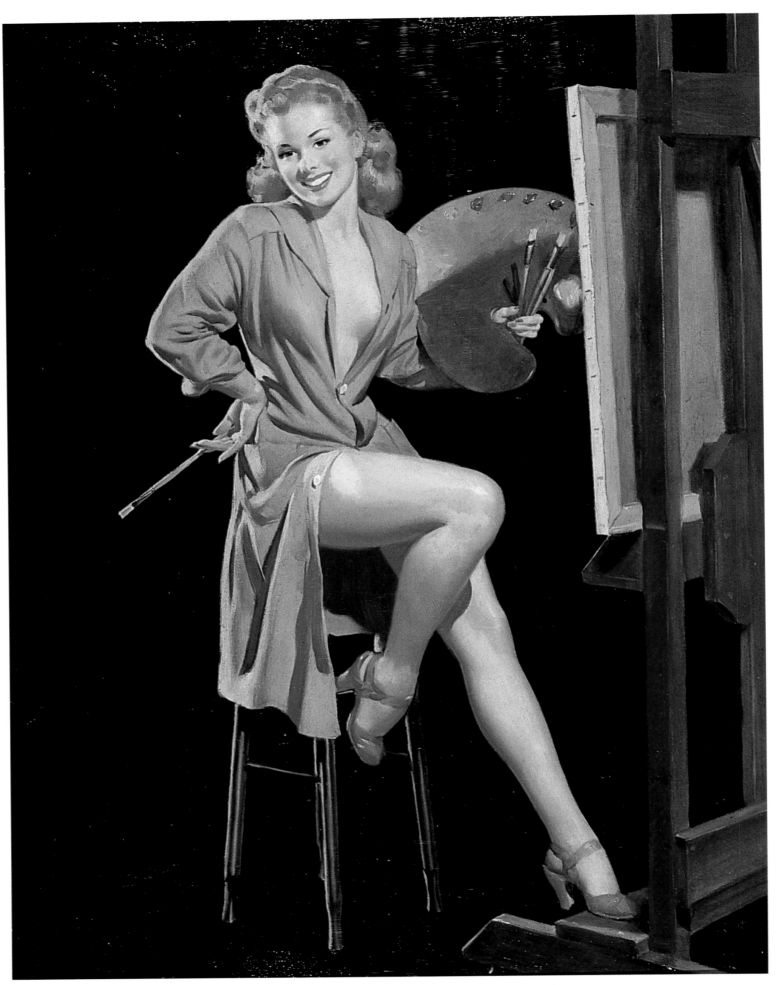

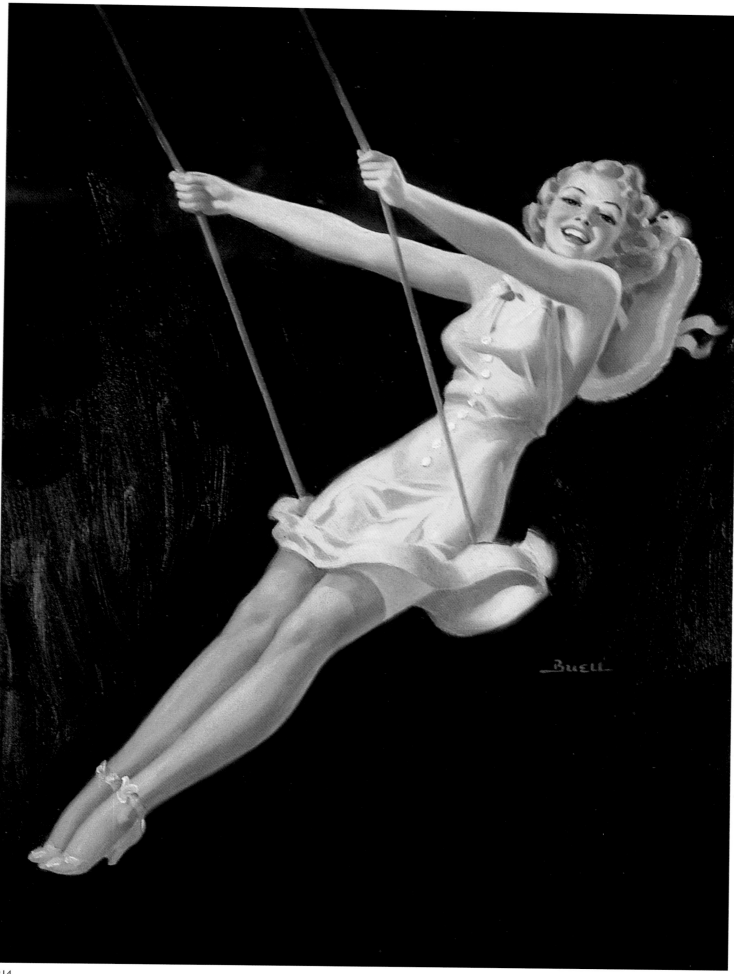

214

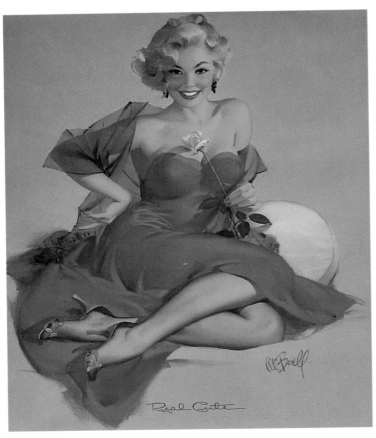

215

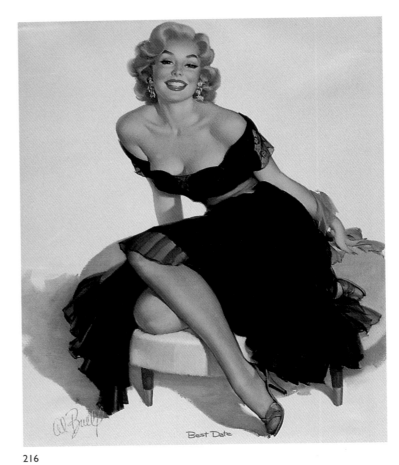

216

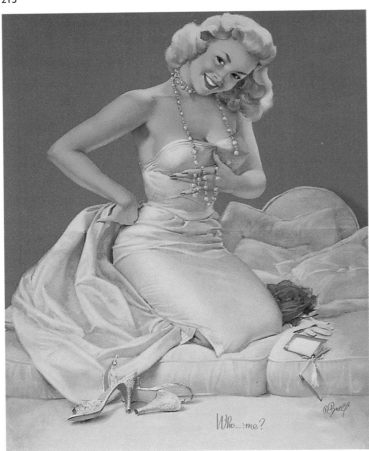

217

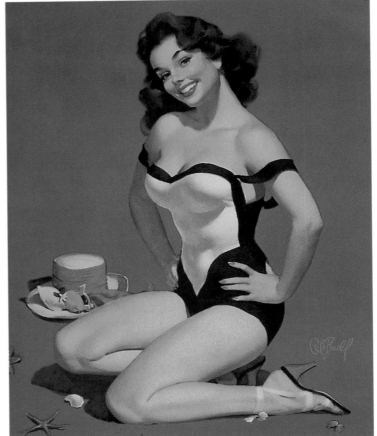

218

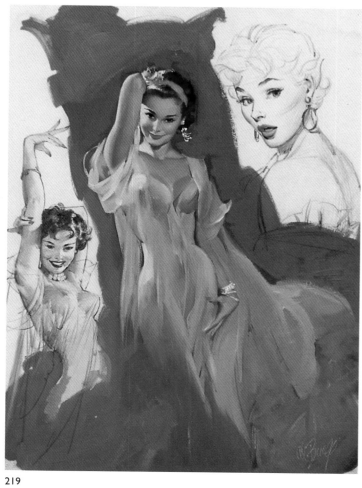

219

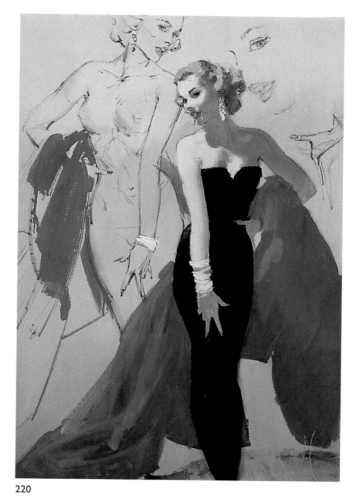

220

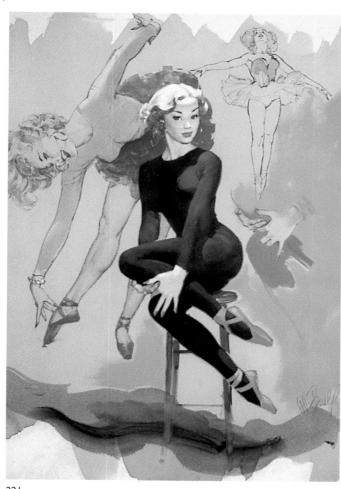

221

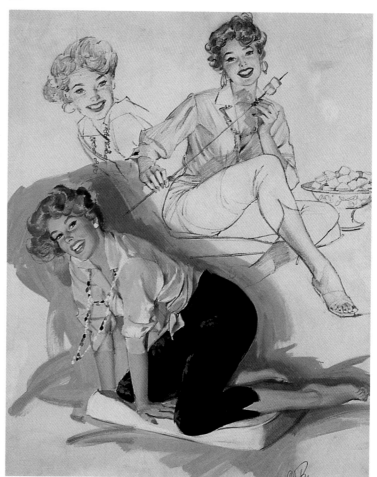

222

Edward D'Ancona

Although D'Ancona was a prolific pin-up artist who produced hundreds of enjoyable images, almost nothing is known about his background. He sometimes signed his paintings with the name "D'Amarie", but his real name appears on numerous calendar prints published from the mid-1930s through the mid-1950s, and perhaps as late as 1960.

The first company to publish D'Ancona pin-ups, about 1935 to 1937, was Louis F. Dow in St. Paul (figures 224, 225, 232, 236 and 238). D'Ancona worked in oil on canvas and his originals from that time usually measured about 30 x 22 inches (76.2 x 55.9 cm). His early work is comparable in quality to that of the young Gil Elvgren, who had begun to work for Dow in 1937. Because D'Ancona produced so much work for Dow, one might assume that he was born in Minnesota and lived and worked in the St. Paul-Minneapolis area. It is known that he supplied illustrations to the Goes Company in Cincinnati and to several soft-drink firms, which capitalized on his work's similarity to the Sundblom/Elvgren style, which was so identified with Coca-Cola.

During the 1940s and 1950s, D'Ancona's superb use of primary colors, masterful brushstrokes, and painterly style elevated him to the ranks of the very best artists in pin-up and glamour art. His subject matter at this time resembled Elvgren's: both enjoyed painting nudes and both employed situation poses a great deal. D'Ancona also painted a fair amount of evening-gown scenes, as did Elvgren, Frahm, and Erbit.

By 1960, D'Ancona had moved into the calendar art field. Instead of doing pin-ups and glamour images, however, he specialized in pictures on the theme of safety in which wholesome policemen helped children across the street in suburban settings that came straight out of Norman Rockwell.

Opposite page:
224

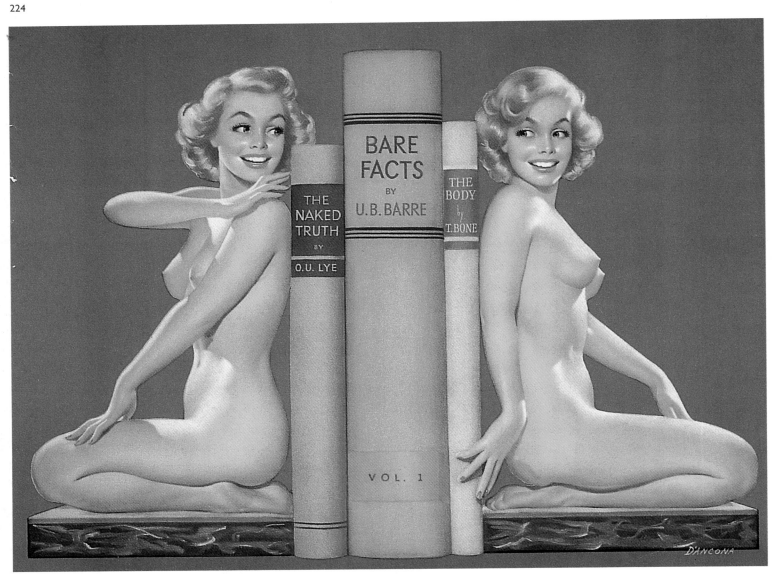

223

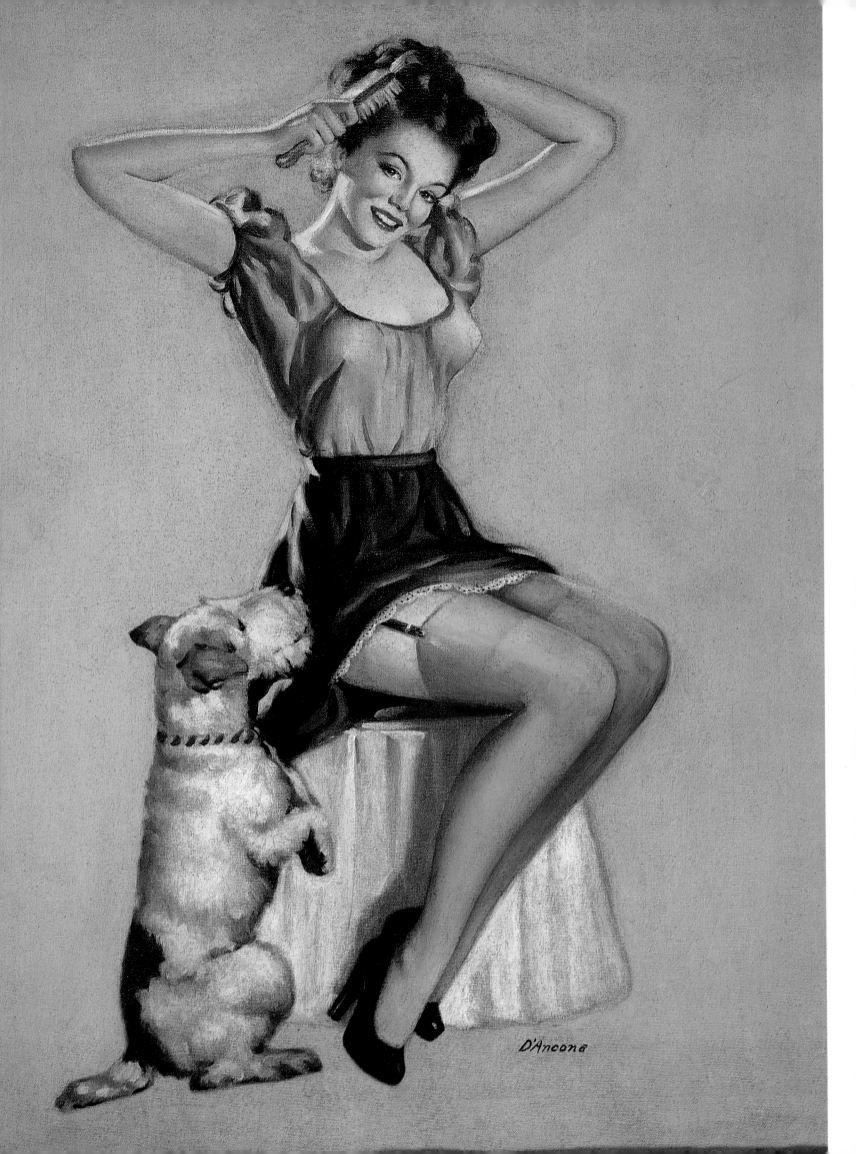

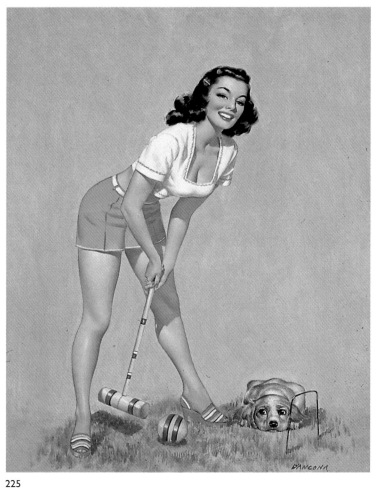

225

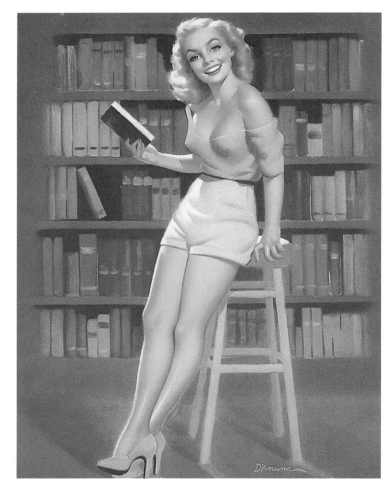

226

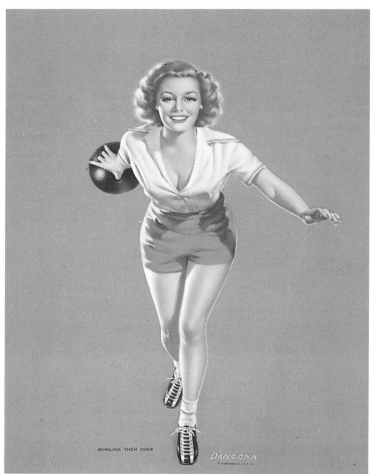

227

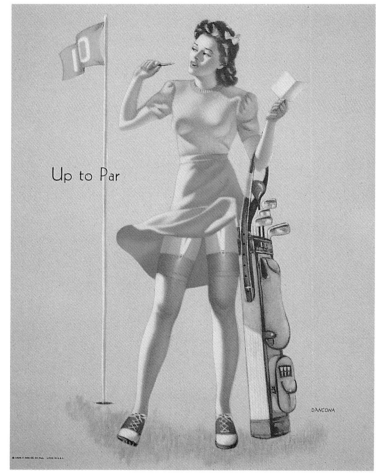

228

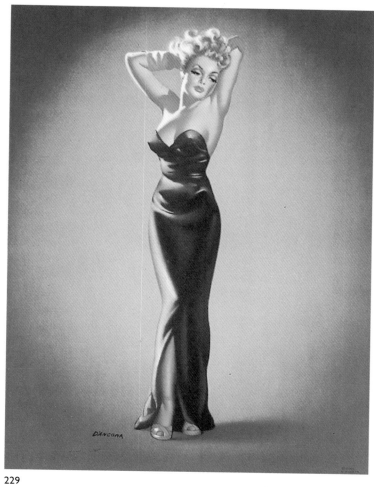

229

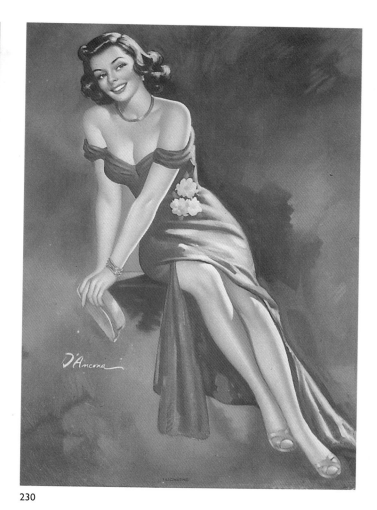

230

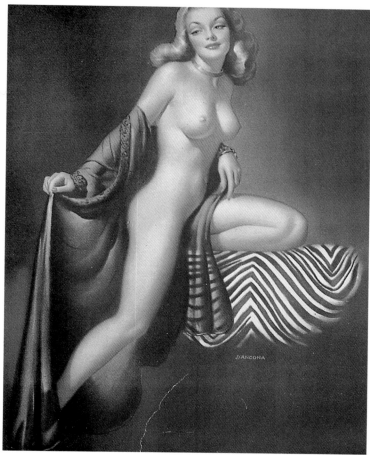

231

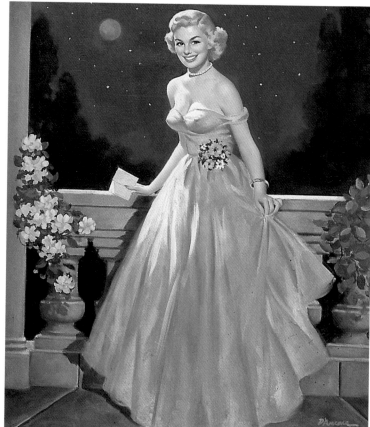

232

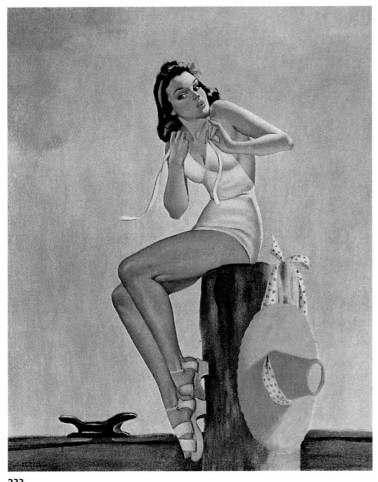

233

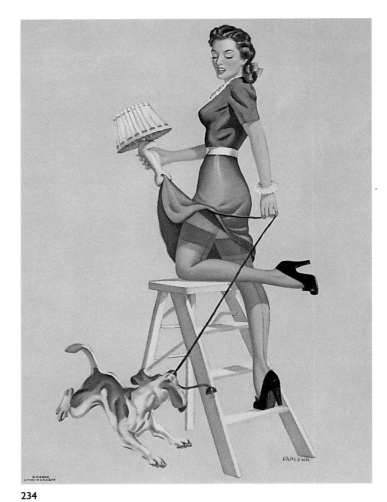

234

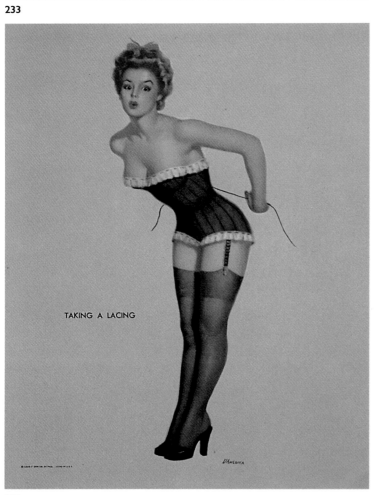

TAKING A LACING

235

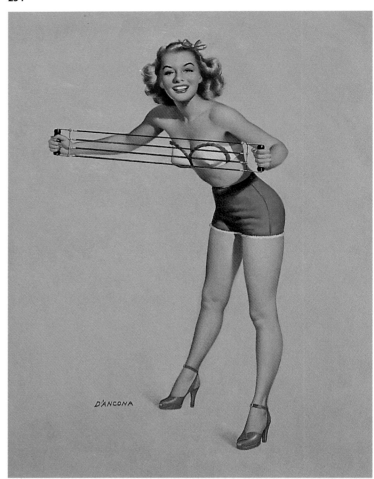

236

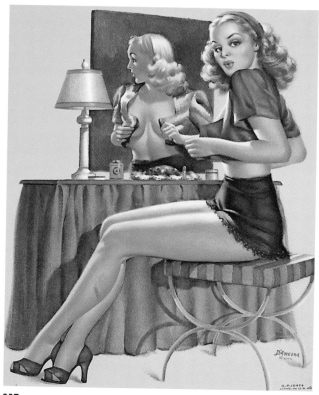

237

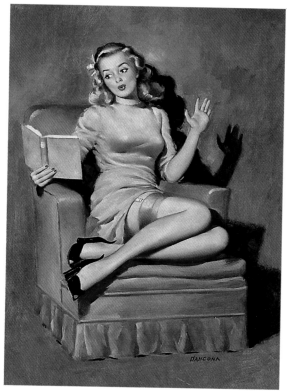

238

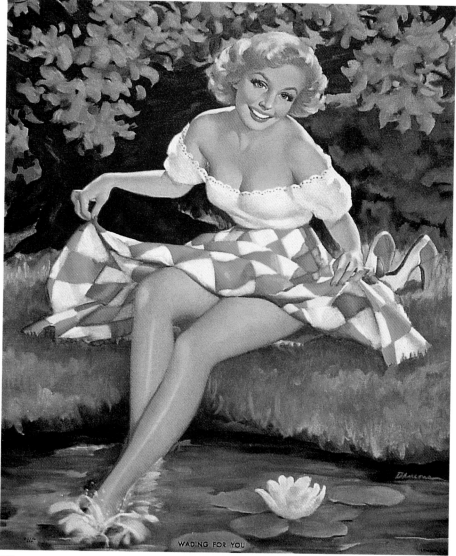

WADING FOR YOU

239

Billy De Vorss

Alone among the pin-up artists in being entirely self-taught, Billy De Vorss sold his first three published pin-ups to the Louis F. Dow Calendar Company in St. Paul about 1933. Until that time, he had been working as a teller in a bank in St. Joseph, Missouri; there he had met the stunning woman, Glenna, who became his wife and first official model. Encouraged to develop his talent by Gene Sayles, the manager of Brown and Bigelow's Kansas City branch office, De Vorss soon received his first commission from the company.

To celebrate, De Vorss and his wife moved to New York and set up a penthouse studio in the Beaux Arts Building, at Eighteen East Tenth Street. Signing up with the prestigious American Artists group, De Vorss spent the next several years working for calendar-publishing houses such as Brown and Bigelow, Joseph C. Hoover, and Louis F. Dow. Most of his pastel originals were large (40 x 30 inches; 101.6 x 76.2 cm) and bore his highly distinctive Art Deco–inspired signature.

Covers for *Beauty Parade* (figure 250) and the King Features Syndicate as well as calendar commissions from the Osborne and Goes companies followed in the early 1940s. *Help Wanted* (1944; figure 240), De Vorss' most famous pin-up image, was kept in the Shaw-Barton line for more than five years. In 1949, the artist illustrated a highly successful campaign for Botany Woolen's robes with depictions of handsome men lounging at home with their own De Vorss pin-up girls.

De Vorss used an incredible variety of pastel colors for his work, and he applied them directly onto the board, blending them dry with his fingers. His occasional oil paintings bear the rich, painterly brushstrokes of the Sundblom School. Like Rolf Armstrong, De Vorss always worked from live models for the final painting; he did, however, employ photographs for preliminary stages. His vibrant pin-ups, inspired by New York's theaters and nightclubs, display a fine sense of composition, a flowing, graceful line, and a daring blend of colors.

In 1951, Billy and Glenna De Vorss returned to St. Joseph, their first home. After some time there, they settled in Scottsdale, Arizona, where De Vorss died in 1985.

Opposite page:
240

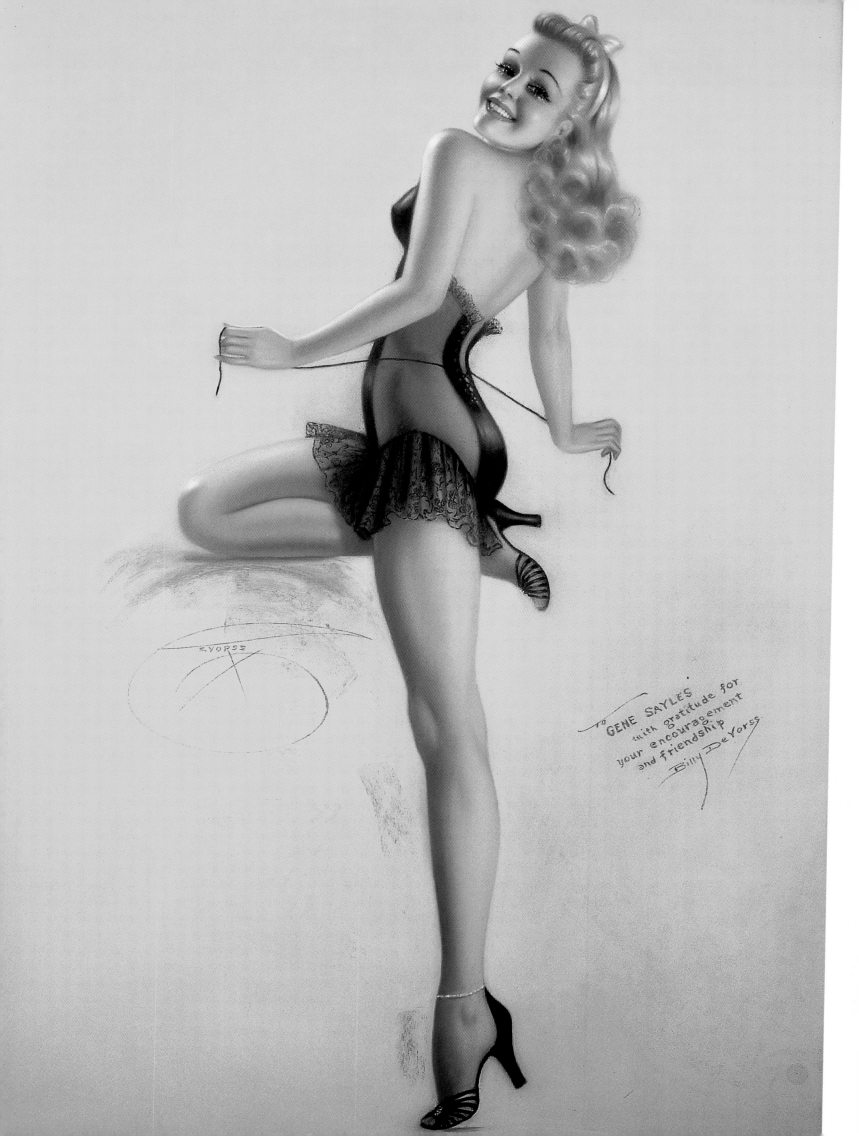

To GENE SAYLES with gratitude for your encouragement and friendship

Billy DeVorss

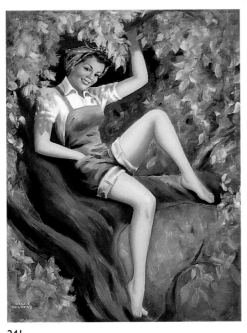

241

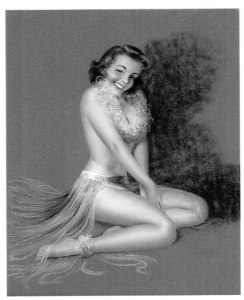

242

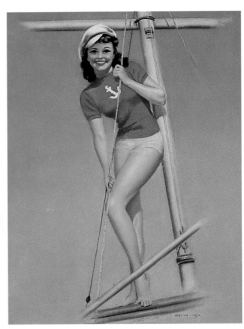

243

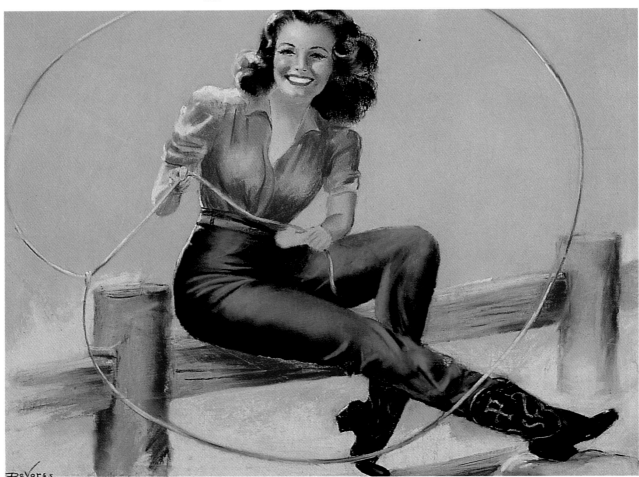

244

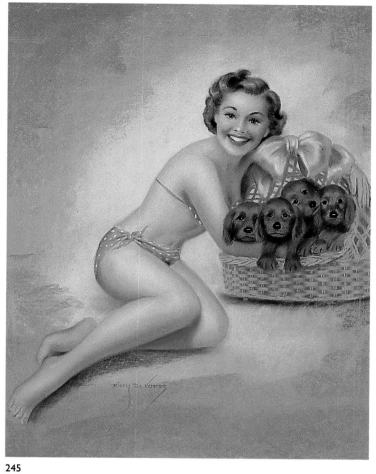

245

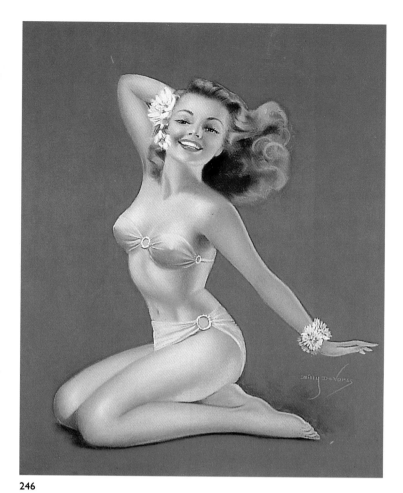

246

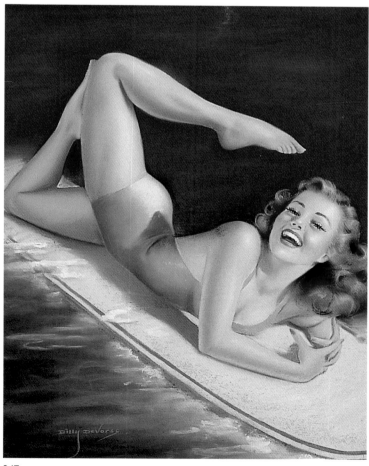

247

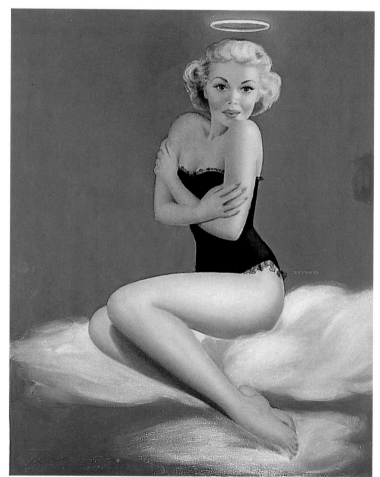

248

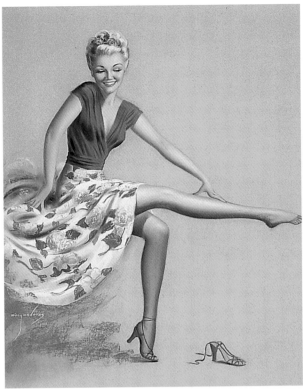

249

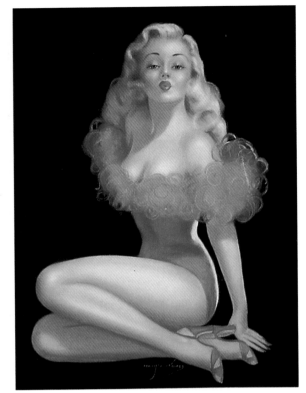

250

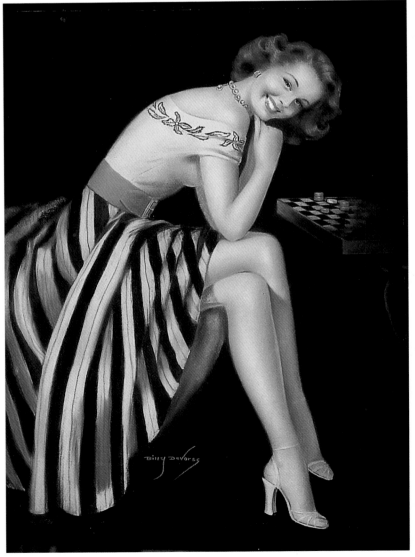

251

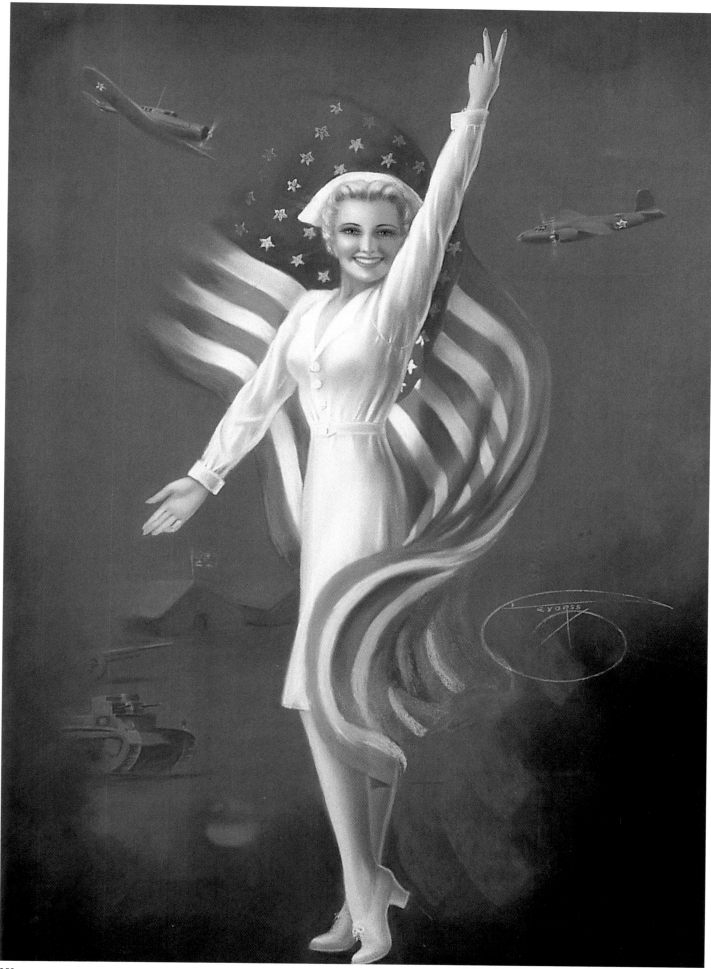

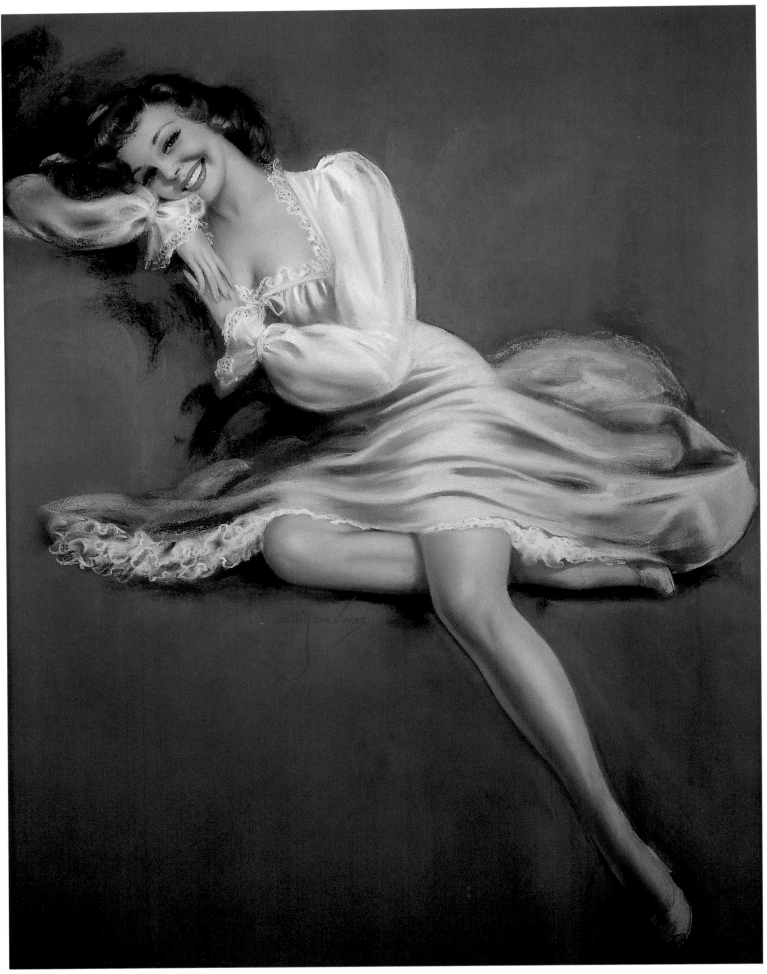

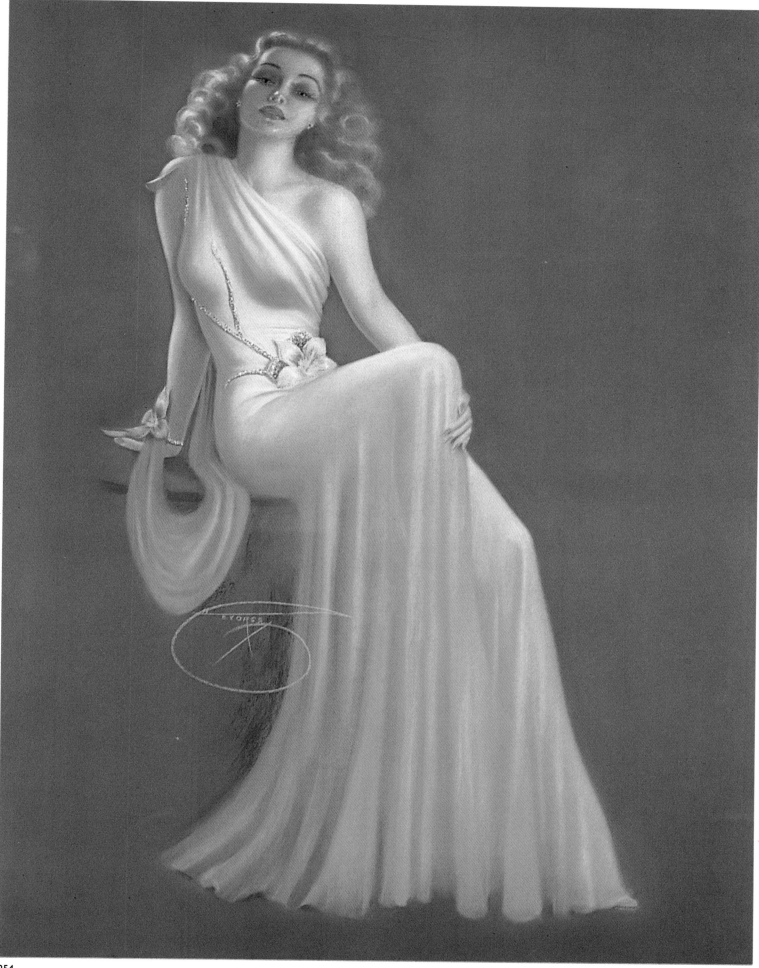

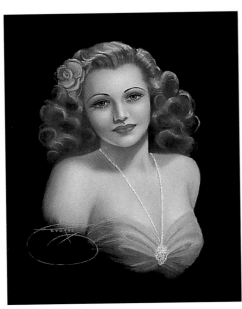

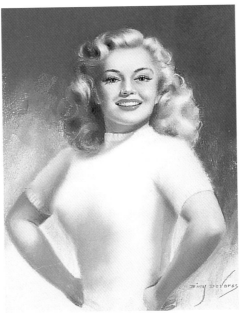

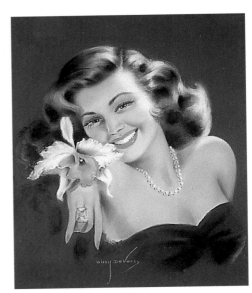

255

256

257

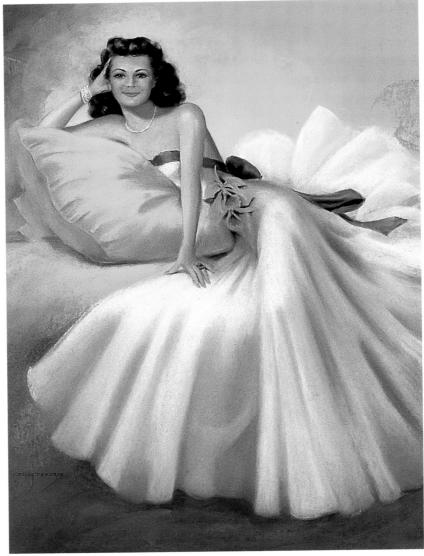

258

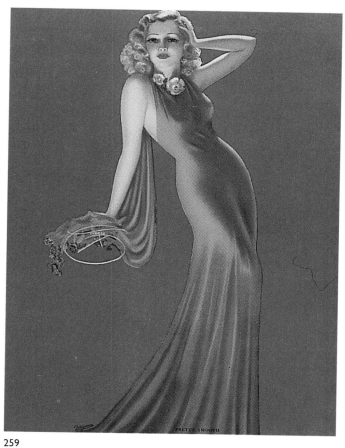

259

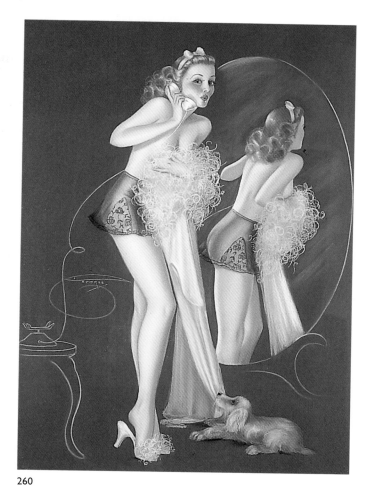

260

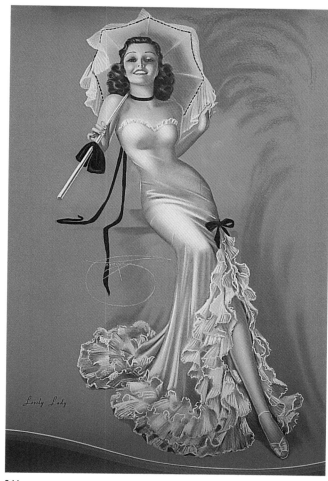

261

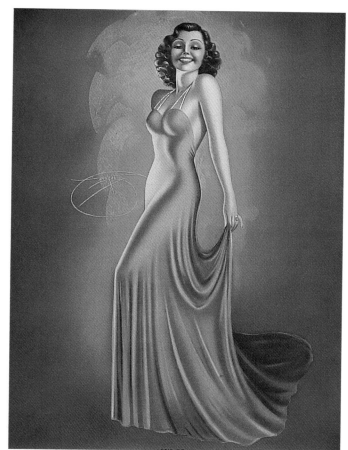

262

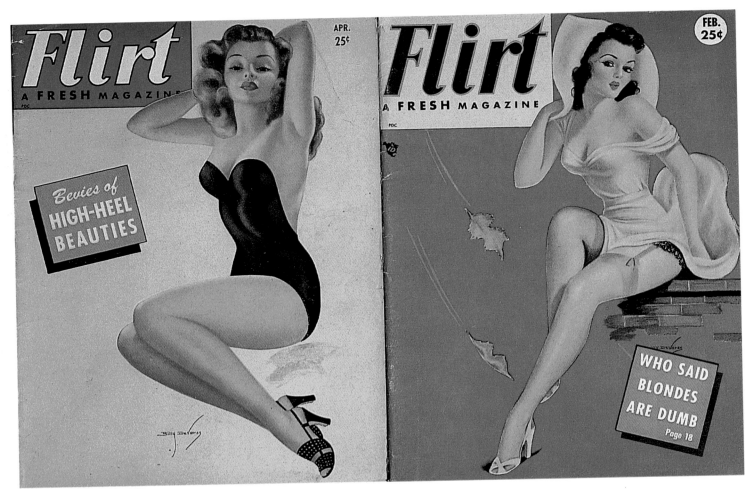

263

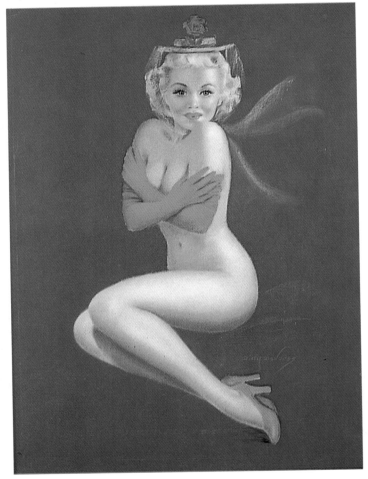

264

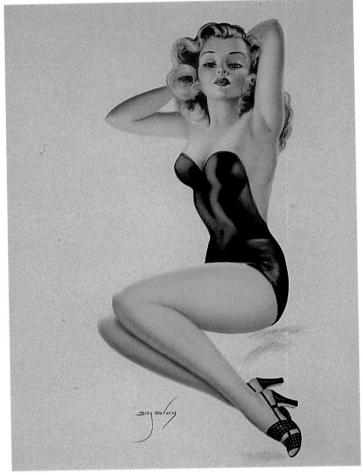

265

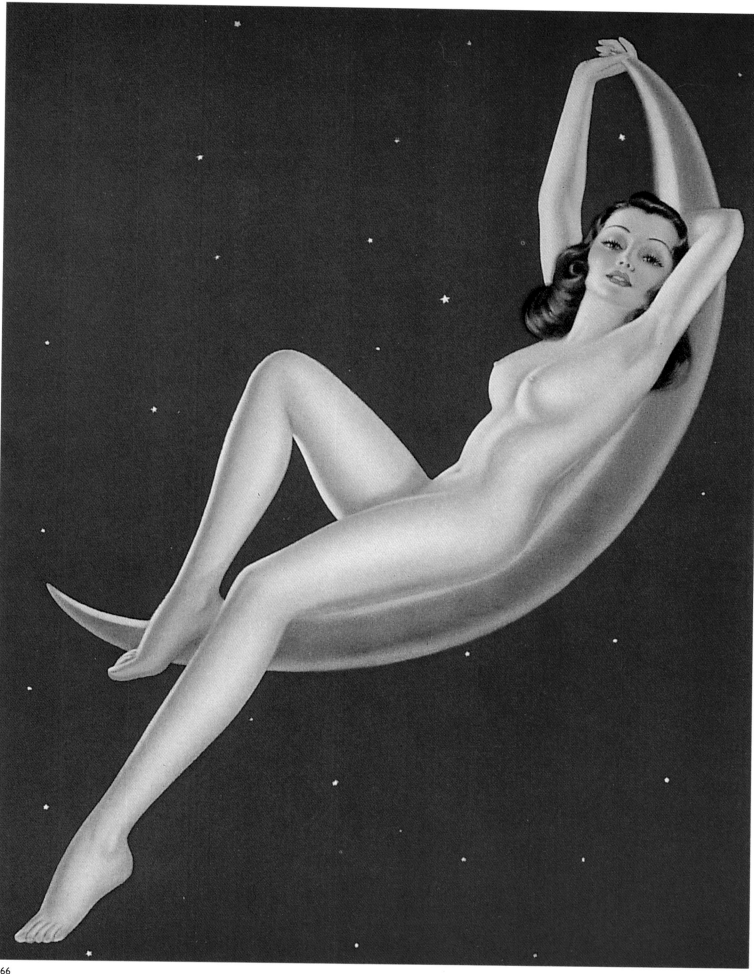

266

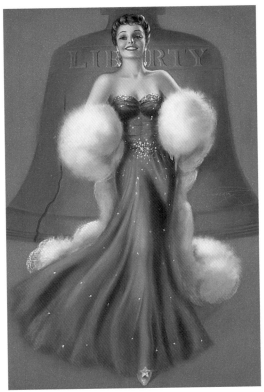

267

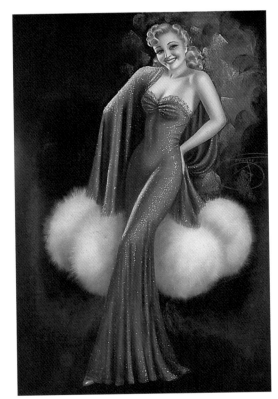

268

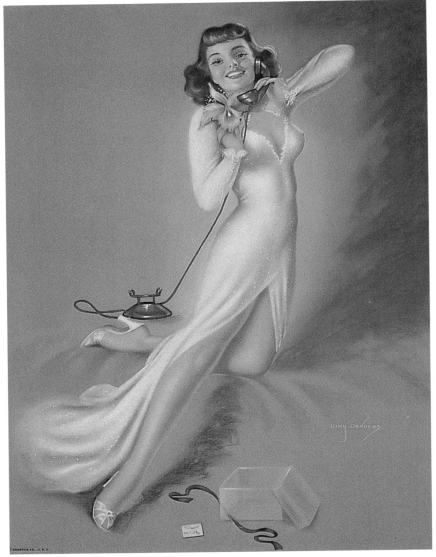

269

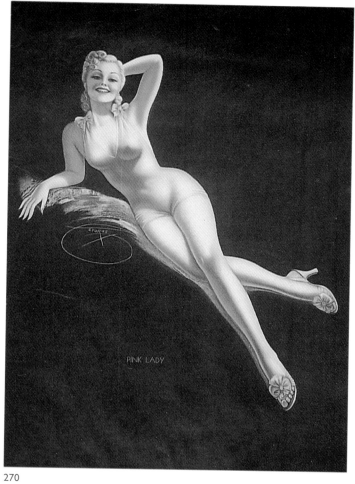

270

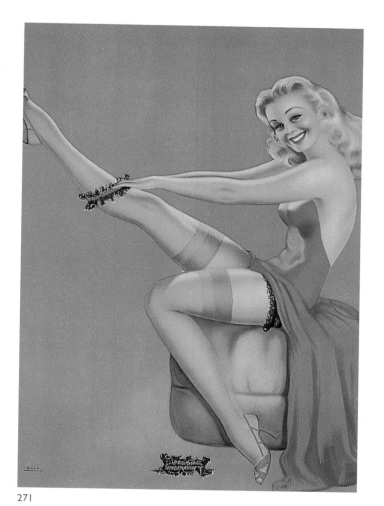

271

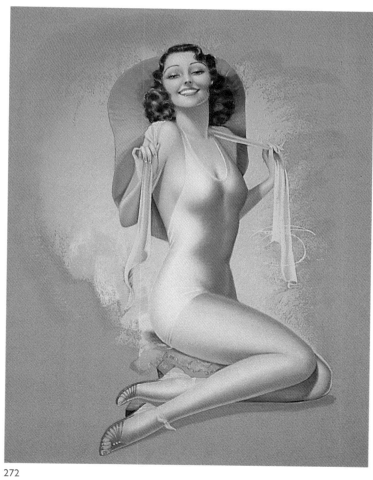

272

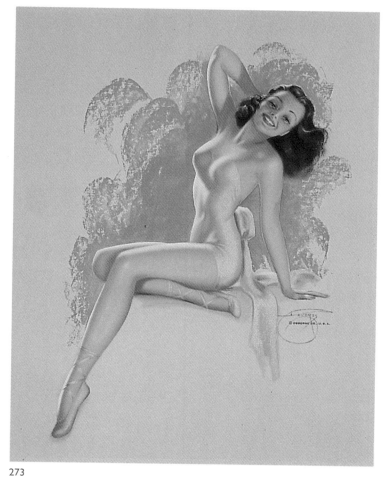

273

Peter Driben

Peter and Louise Driben

Driben's parade of sexy, fun-loving showgirls delighted the American public from the beginning of World War II until the great baby boom of the 1950s. Appearing on the front covers of five or six magazines a month, Driben's leggy dream girls were strikingly portrayed in as many bold colors as possible, especially red, yellow, blue, and green.

Born in Boston, Driben studied at Vaesper George Art School before moving to Paris about 1925. While taking classes at the Sorbonne, he began a series of highly popular pen-and-ink drawings of the city's showgirls. But American pulp magazines soon beckoned: the October 1934 *Tattle Tales* carried his first known pin-up front cover; in 1935, he contributed covers to *Snappy*, *Pep*, *New York Nights*, *French Night Life*, and *Caprice*, among others; and he later did pin-ups for *Bedtime Stories* and sixteen covers for *La Paree*. Driben also became known in the 1930s for his front covers for full-size pin-up magazines, including *Silk Stocking Stories*, *Gay Book*, *Movie Merry-Go-Round*, and his personal favorite, *Real Screen Fun*.

Driben's career expanded into advertising after he moved to New York late in 1936. He created original three-dimensional die-cut window displays for Philco Radios, Cannon Bath Towels, and the Weber Baking Company. Hollywood also came calling: he did the poster and publicity artwork for *The Maltese Falcon*, Warner Brothers hired him for *Bought*, and his work for *Big Business Girl* led to a close friendship with its star, Loretta Young. In the early 1940s, his beautiful, sexy – and generally terrified – glamour girls adorned covers of magazines like *Inside Detective* and *Exclusive Detective* (figures 314–17). Also adding to his full workload were several assignments for book jackets.

In 1941, his friend Bob Harrison asked him to contribute to a new men's magazine, *Beauty Parade*. After some negotiation, Driben signed on; he painted hundreds of spectacular pin-ups for that publication and for the other seven titles Harrison was to launch, *Flirt*, *Whisper*, *Titter*, *Wink*, *Eyeful*, *Giggles*, and *Joker*. Driben's work for Harrison established him as one of America's most recognized and successful pin-up and glamour artists.

Driben married the artist, actress, and poet Louise Kirby just before he began to work for Harrison. In 1944, he was offered the unusual opportunity, for a pin-up artist, of becoming the art director of the newspaper the *New York Sun*, a post he retained until 1946. During the war, his popular painting of American soldiers raising the flag at Iwo Jima sparked a considerable amount of media attention.

In 1956, Driben and Louise moved to Miami Beach. He spent his retirement years painting portraits (including one of Dwight Eisenhower) and other fine-art works, which were organized into successful exhibitions by his wife. Driben died in 1975, Louise in 1984.

Opposite page:
274

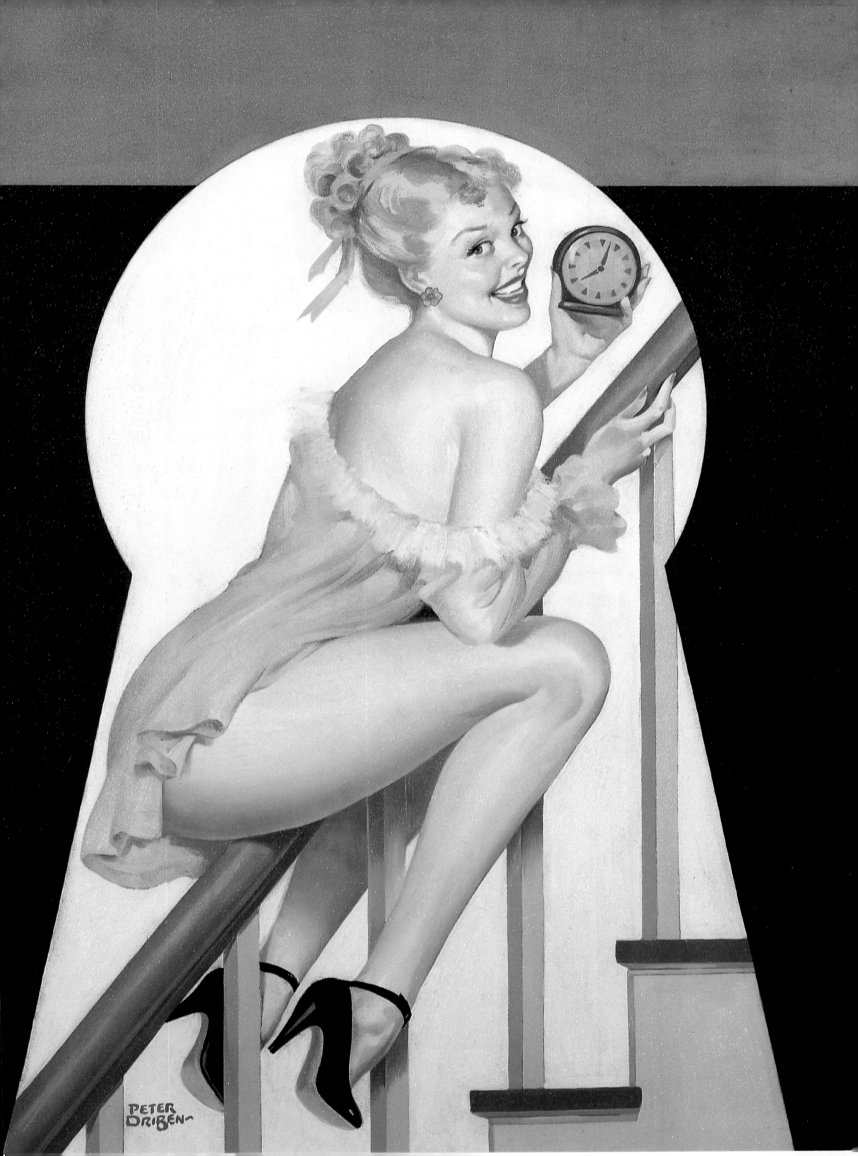

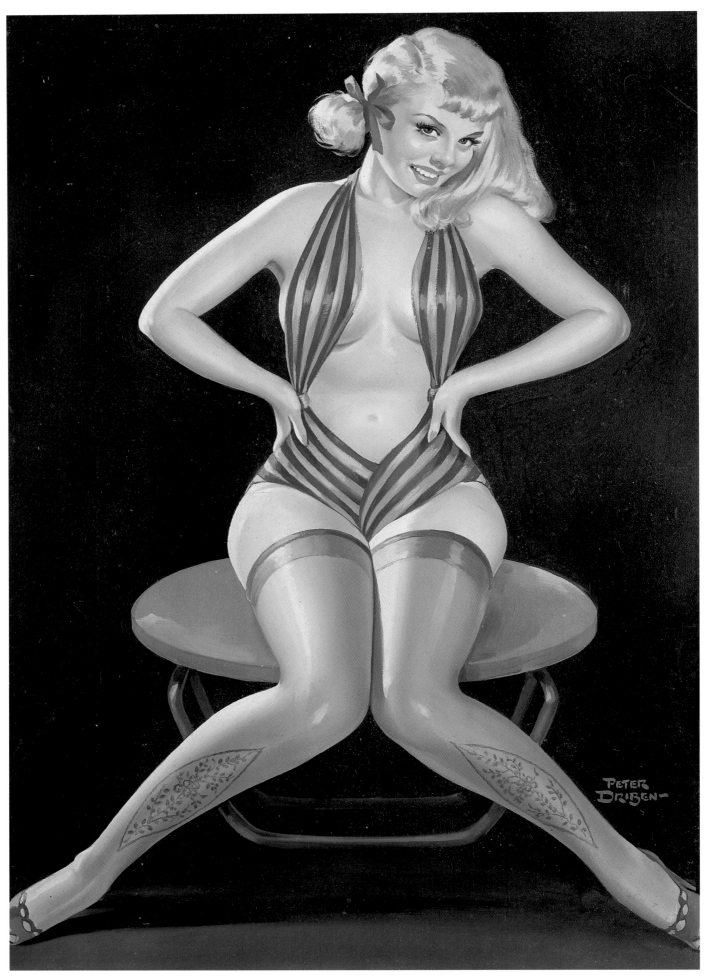

280

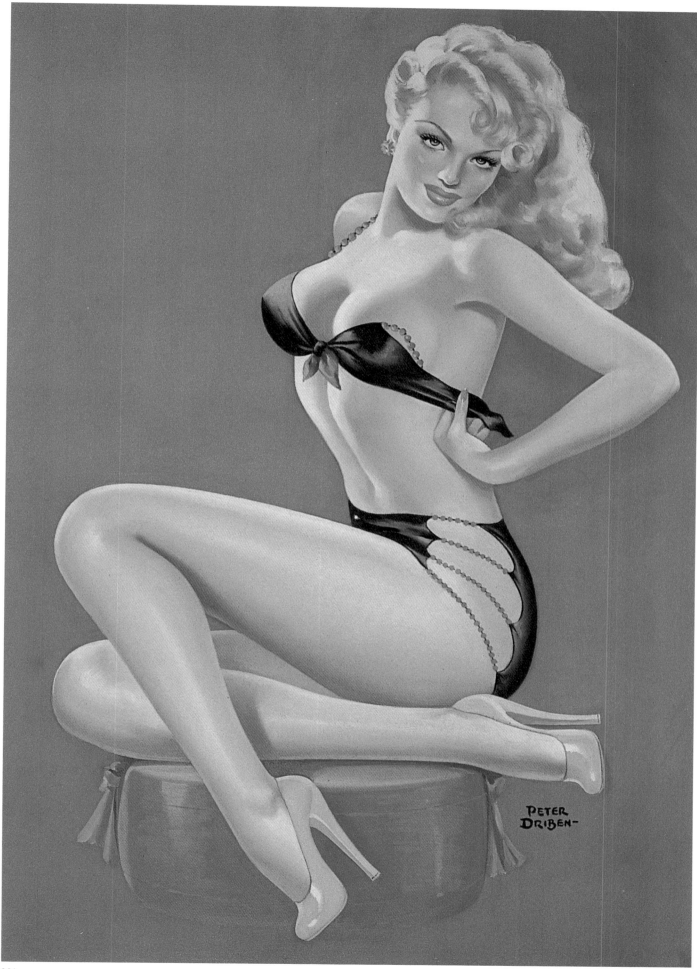

281

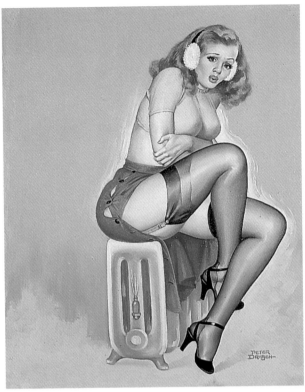

282

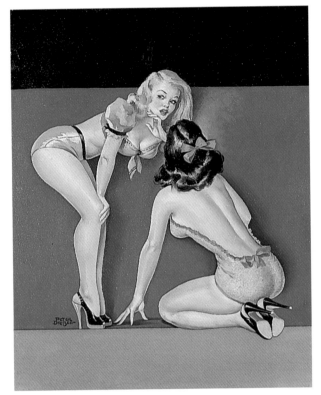

283

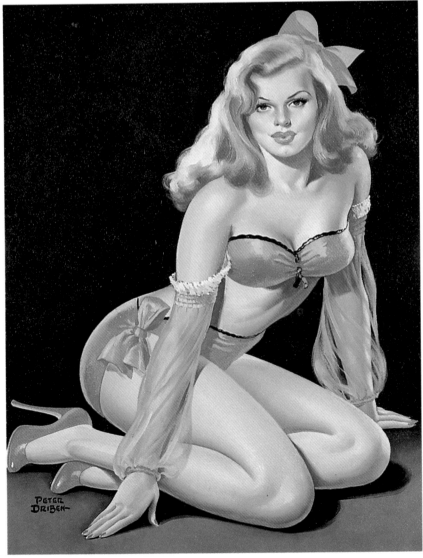

284

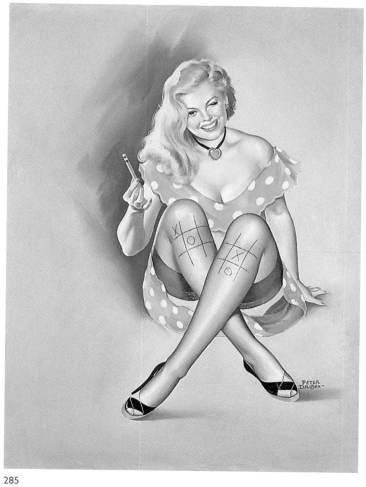

285

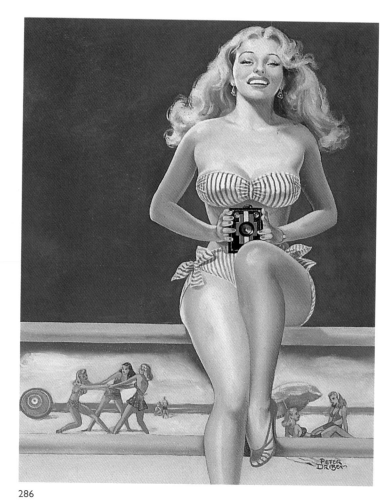

286

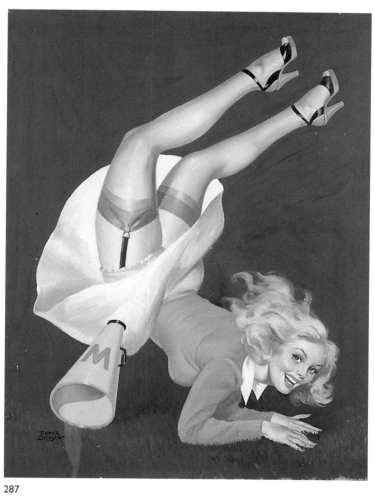

287

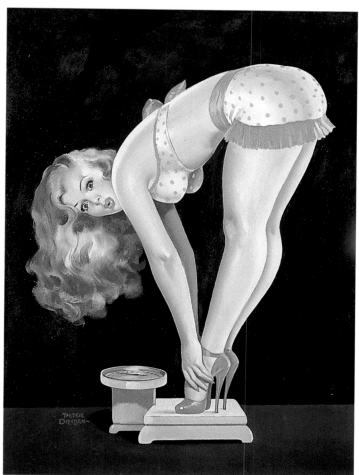

288

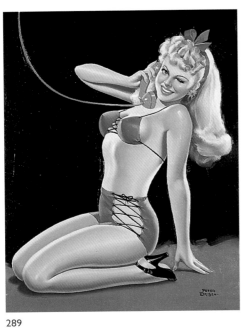

289

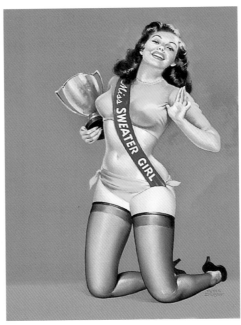

290

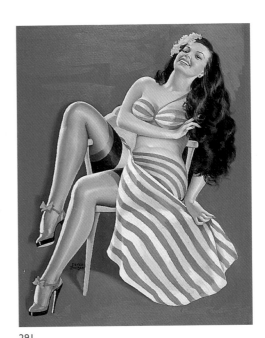

291

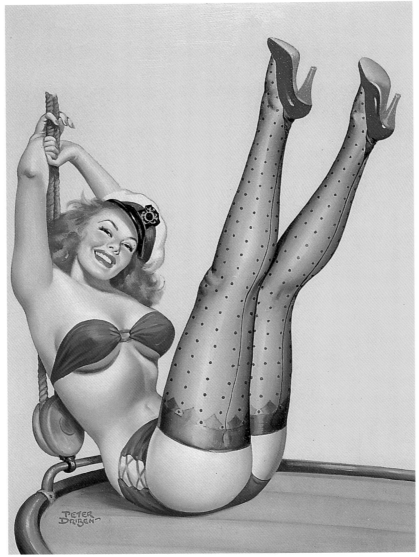

292

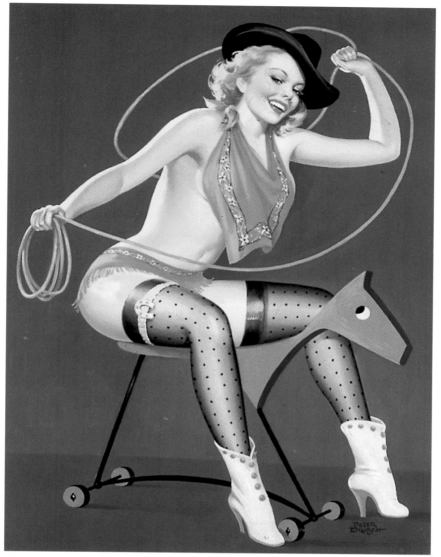

293

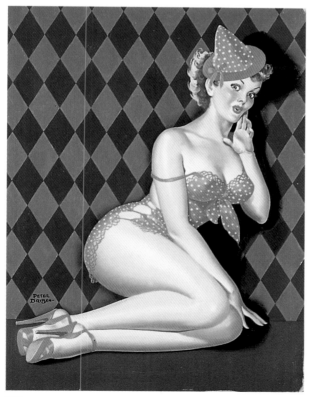

294

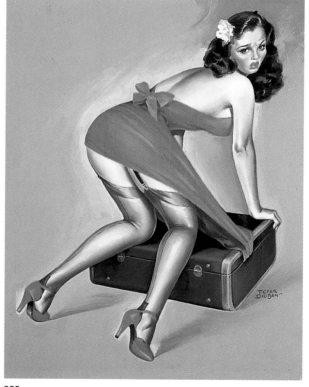

295

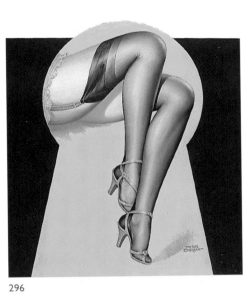

296

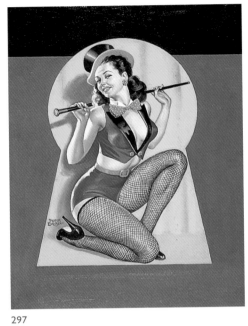

297

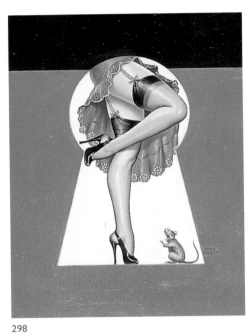

298

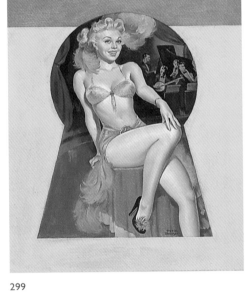

299

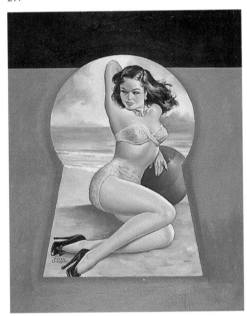

300

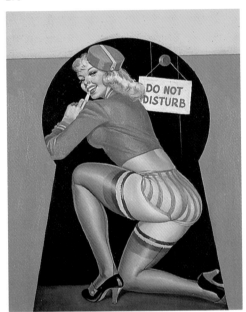

301

302

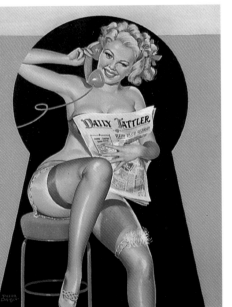

303

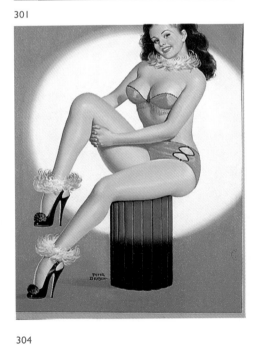

304

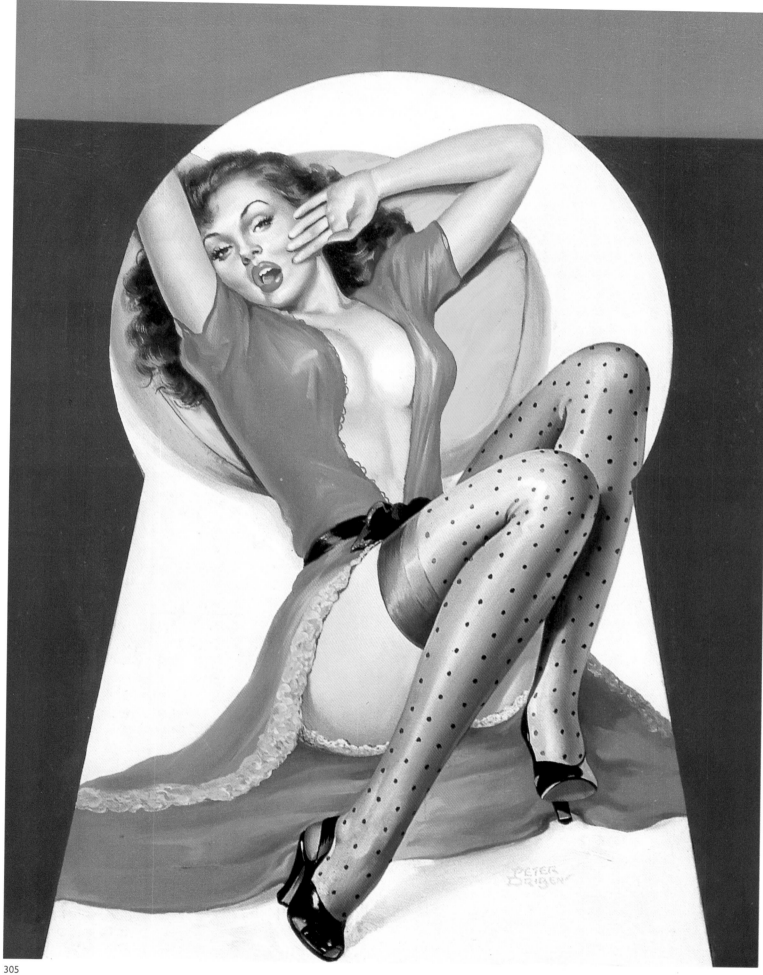

305

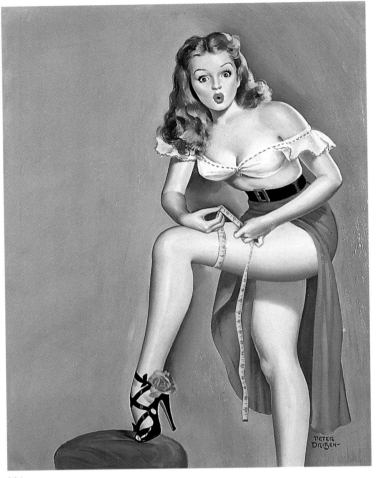

306

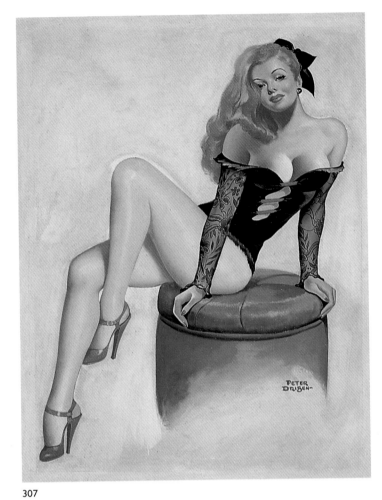

307

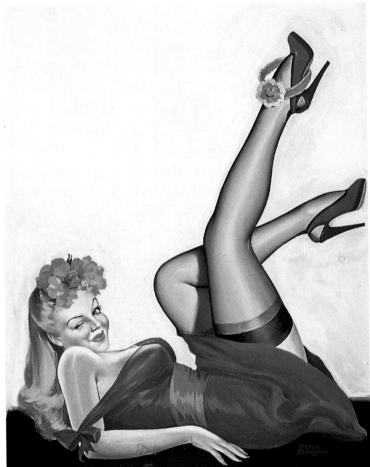

308

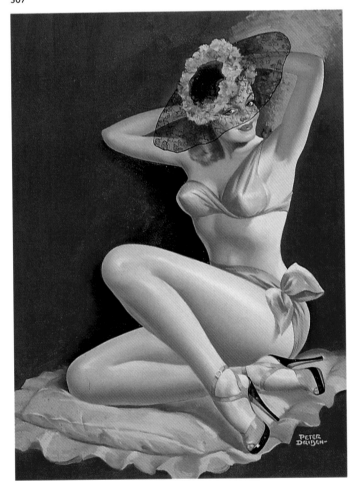

309

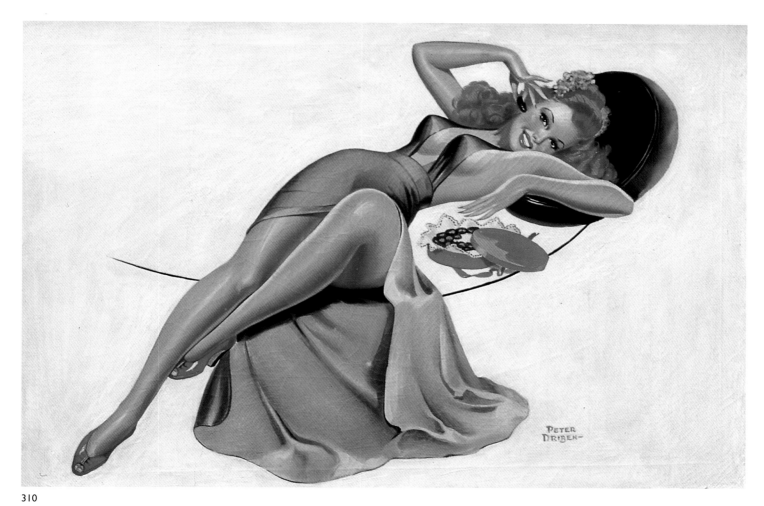

310

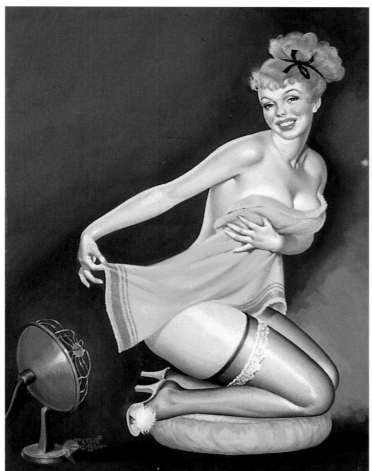

311

312

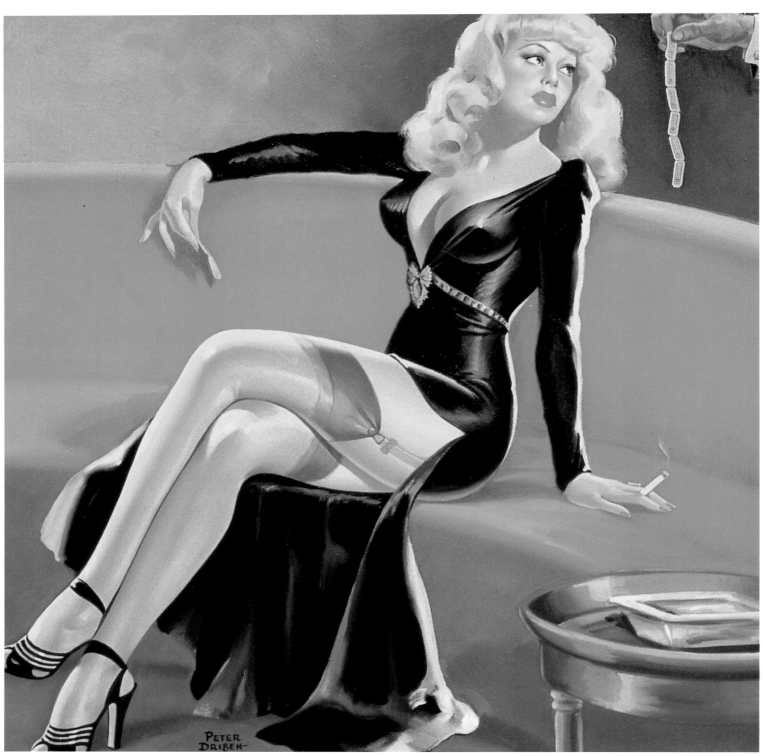

313

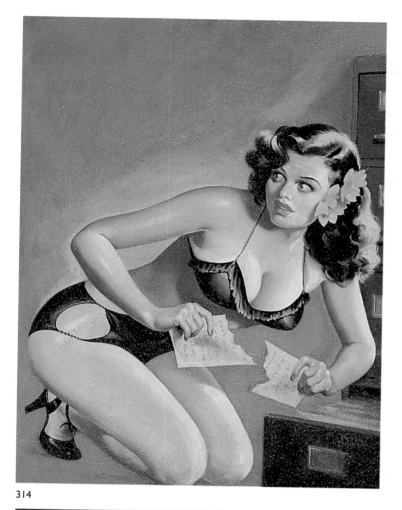

314

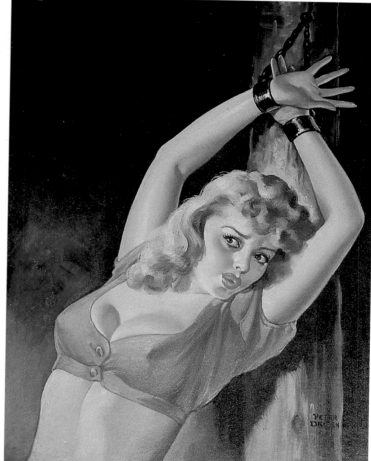

315

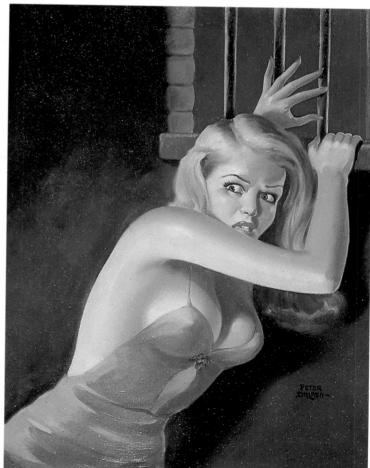

316

317

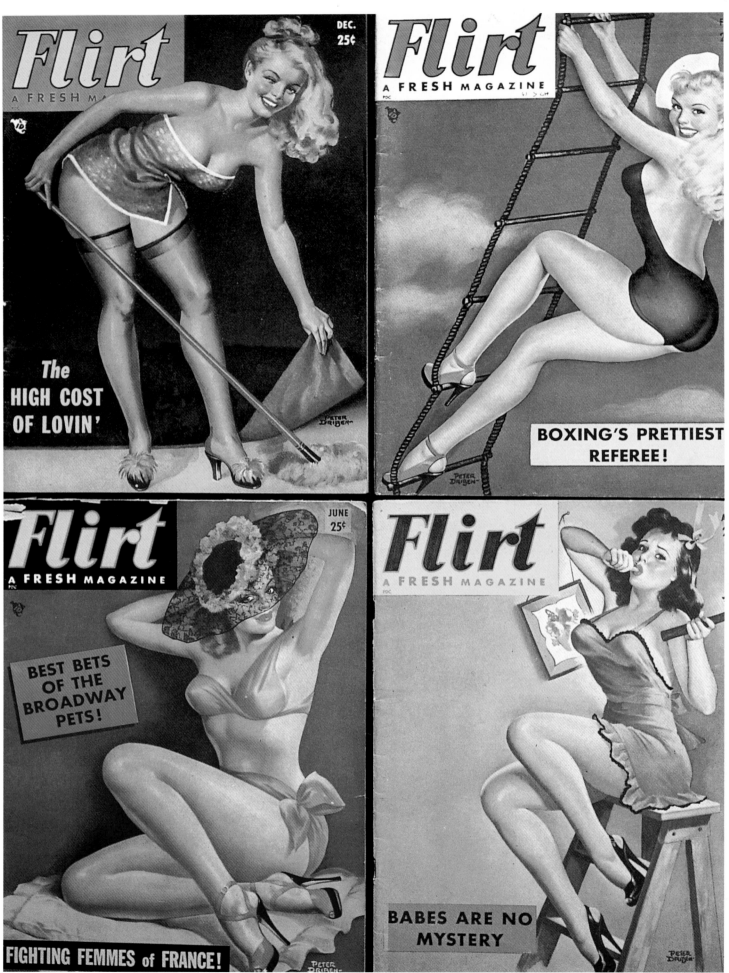

318

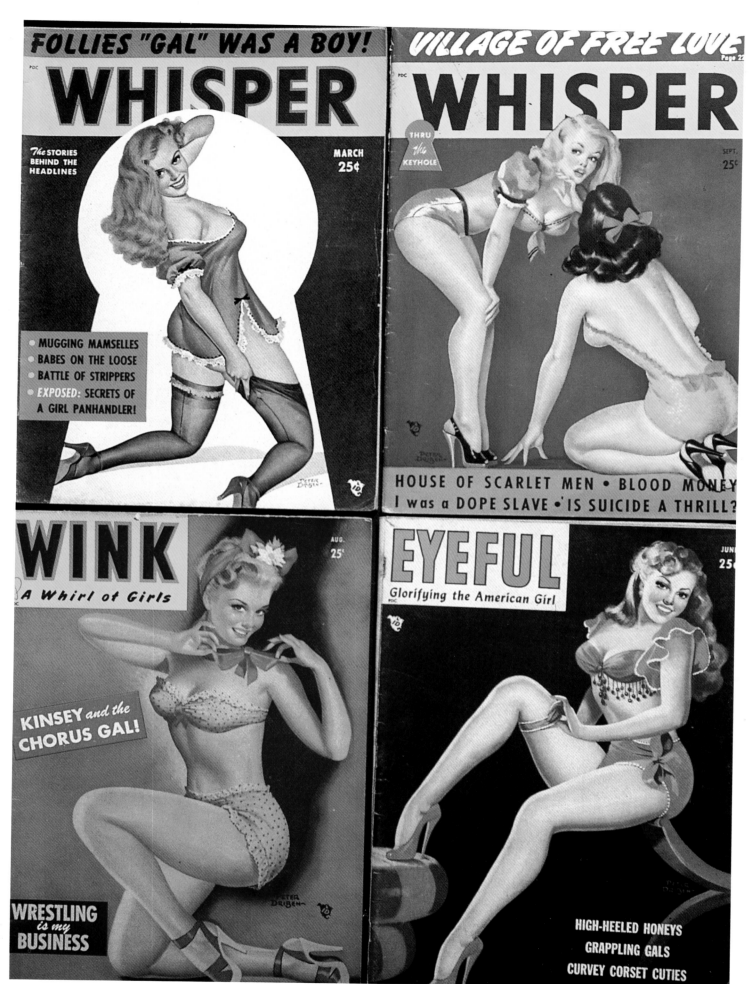

319

Harry Ekman

Harry Ekman's pin-ups are often compared in style and format to Gil Elvgren's (figures 320, 321, 323, 324 and 331). Born in Chicago, the home of the Sundblom "gang", Ekman actually worked as an apprentice to Elvgren. He not only absorbed as much as he could from his mentor but also helped Elvgren to develop ideas and themes.

Ekman's years with Elvgren paid off handsomely, for he immediately met with success when he went out on his own: he sold a number of his pin-up paintings to Shaw-Barton, the prestigious Ohio-based calendar-publishing house. Although Ekman mostly limited his calendar work to straightforward or situation pin-ups, he did create an exquisite glamour-oriented calendar showing girls with parrots for the Rustcraft Greeting Card Company's short-lived calendar division.

With their smiling faces, jaunty attitudes, and frequent canine companions, Ekman's pin-up girls always had a fresh, wholesome Sundblom-like glow. Like Elvgren, he always photographed his models before beginning to paint. By the winter of 1957, Ekman was the subject of an article published in *Art & Camera* magazine, testimony to how well established he had become as an artist and photographer in his own right.

Ekman worked almost identically to Elvgren in every way. His primary medium was oil on canvas, and his paintings were exactly the same size as Elvgren's, 30 x 24 inches (76.2 x 61 cm). Although Elvgren did not make many preliminary studies in pencil, Ekman rendered fully finished drawings of his images before beginning his canvases (figures 333, 334, and 337).

It is thought that Ekman moved from the Chicago area upon retirement and settled near Salt Lake City, Utah.

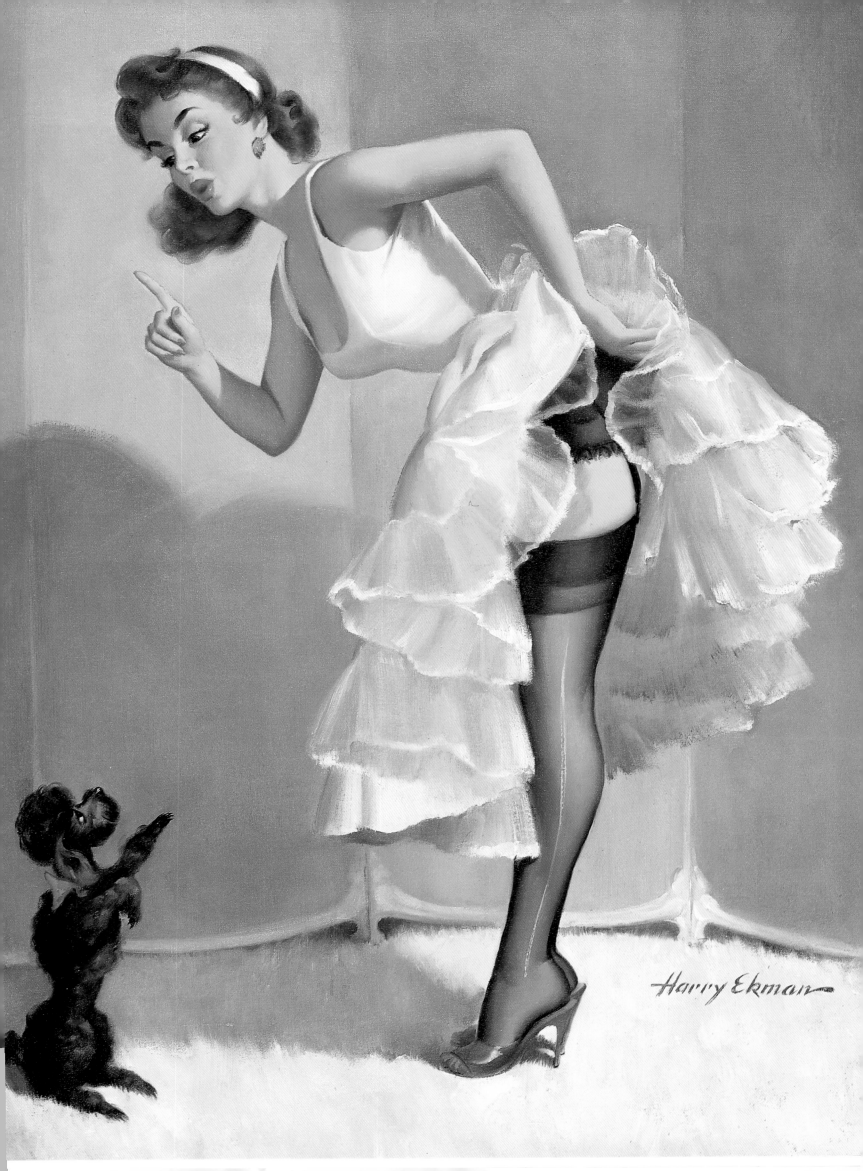

Gil Elvgren

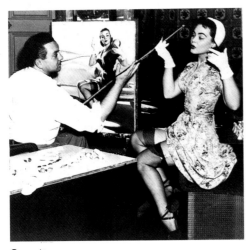

Opposite page:
352

Although George Petty and Alberto Vargas have achieved more fame and public recognition, Gil Elvgren has emerged in recent years as the artist most loved and respected by pin-up collectors and fans worldwide. A genius who set the standard for pin-up and glamour painting, Elvgren is in a class by himself because of his brilliant painting technique and his ability to make every pin-up entertaining and lifelike. Clearly influenced by John Singer Sargent and Haddon Sundblom, Elvgren combined creative compositional schemes and an exceptional use of color with magically rich, passionate brushstrokes. The Elvgren Girl had a fresh and wholesome personality, a slender, shapely form, and a sparkling quality that made her cuter, sexier, and more alive than any other pin-up in the world.

Elvgren was born March 15, 1914, in St. Paul, Minnesota. At nineteen years of age, he eloped with his high school sweetheart, Janet Cummins; the two would spend thirty-three happy years together. Elvgren enrolled at the University of Minnesota as an architecture major, but decided to become an artist after taking summer classes at the Minneapolis Art Institute.

In 1934, Elvgren moved with his wife to Chicago and immediately enrolled in both day and night courses at the American Academy of Art. There, he studied under Bill Mosby and met other students who would eventually become friends and artistic colleagues: Thornton Utz, Coby Whitmore, Andrew Loomis, Bob Skemp, Al Buell, Edwin Henry, and Harry Anderson. He graduated in 1936, moved back to St. Paul, and opened his first studio.

Elvgren was immediately hired to paint two pictures of the Dionne Quintuplets for Brown and Bigelow which, when published in 1937 and 1938, became smashing successes, generating hundreds of thousands of dollars in revenue. His second big break was a commission from the Louis F. Dow Company for a series of calendar and mutoscope pin-ups, an assignment that lasted until the beginning of World War II.

In 1938, as the Elvgrens became the proud parents of their first child, Karen, the artist agreed to paint a pin-up for Royal Crown Soda that would be reproduced on 6,500 life-size die-cut advertising displays. By 1940, the Elvgrens decided to return to Chicago, where Gil soon joined the Stevens/Gross studio. With Sundblom's guidance, he began a series of advertising paintings for Coca-Cola that were to become hugely significant, to the company, to the artist, and to the history of American advertising art. Appearing as full-page ads in mainstream magazines, twenty-four-sheet roadside billboards, posters, and special displays, these fresh, sentimental images captured the heart of the American public.

Just before the war started, Elvgren began to teach a few classes at the American Academy of Art. There he met a student, Joyce Ballantyne, who would become his protégé, friend, and new colleague at Stevens/Gross. When war broke out, the Dow company reissued many of his 1937–38 pin-up images as twelve-page 8 × 10 inch (20.3 × 25.4 cm) booklets to be mailed to soldiers stationed overseas. Elvgren and Janet had their second child, Gillette, Jr., in 1942.

Elvgren's own calendar continued to be booked solid. In 1944, his third child, Drake, was born, and Brown and Bigelow offered him $1,000 per painting if he would work exclusively for them. While considering this offer, he accepted a commission from Joseph C. Hoover and Sons calendar company for a glamour painting for their 1945 line, but insisted he would not sign the work since he did not want to jeopardize his negotiations with the other firm. His painting for Hoover, *Dream Girl*, was the finest full-length glamour subject he had ever executed and was so popular that *Hoover* kept it in their line for almost ten years.

Elvgren's decision to accept Brown and Bigelow's invitation marked the beginning of an almost thirty-year relationship that made calendar-art history. Launched with a major publicity campaign, Elvgren produced his first pin-up for the firm in 1945. One year later, his first nude image, *Sea Nymph*, became the best-selling nude in the company's history. More record-breaking images were to follow: *Aiming to Please* (1947), a cowgirl subject; *Too Good to be True*, published as a hanger calendar in 1948 and in 1952 as a page in the Ballyhoo Calendar; and *Vision of Beauty* (1948), another nude subject.

The March 1948 issue of *See* magazine ran a five-page article about Elvgren and his Brown and Bigelow pin-up girls, the first of dozens of such articles. In 1950, the Schmidt Lithography Company of Chicago and San Francisco asked Elvgren to paint a series of glamour heads for their "universal" billboards. In addition to regularly delivering pin-ups to Brown and Bigelow (about twenty-four a year for an average fee of $2,500 each), he accepted a great many advertising assignments during the 1950s for such clients as Schlitz Beer, Ovaltine, General Tire, General Electric, Serta Perfect Sleep, and Red Top Beer.

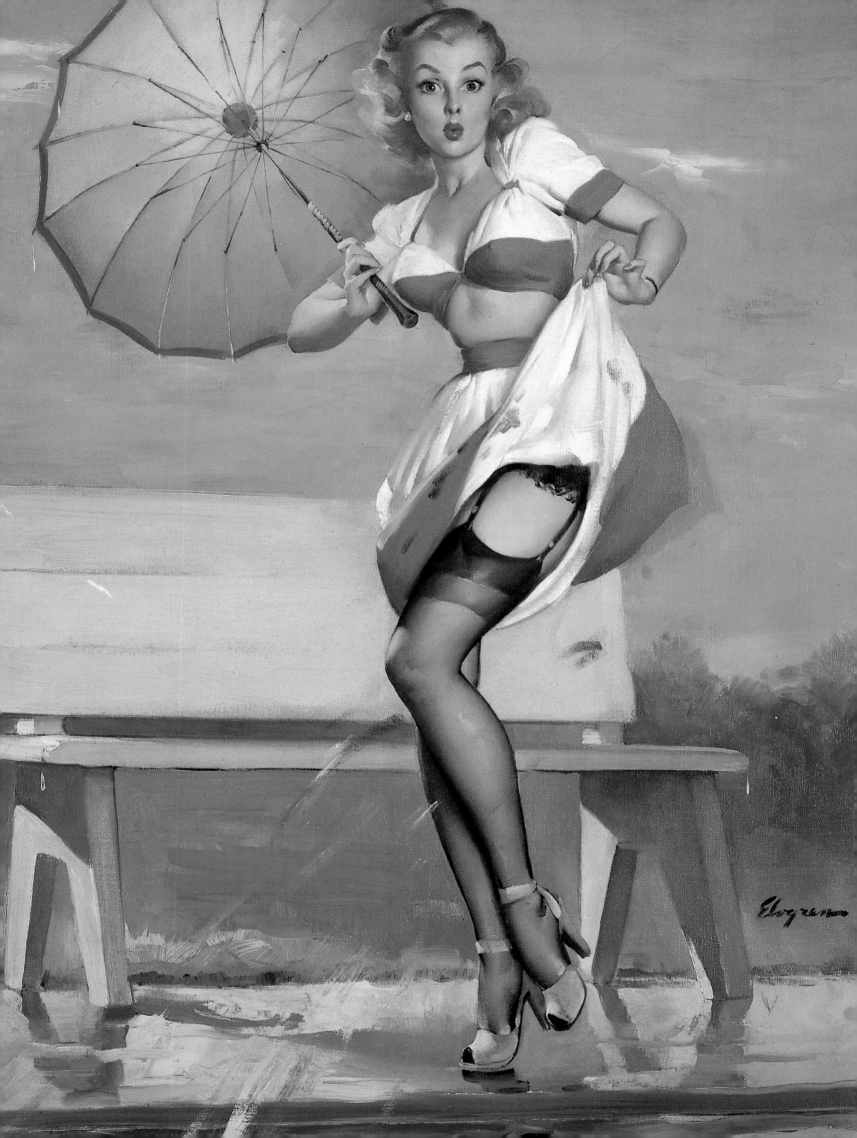

Elvgren and his family moved in 1956 to Siesta Key in Sarasota, Florida. As the decade came to a close, he had become the most important artist at Brown and Bigelow, which reproduced his pin-ups in every feasible form. Clair Fry, art director at the firm, said this about Elvgren: "Gil's work is sincere and very honest. The reaction to Gil's paintings is that here is a real girl. The carefully thought out gesture and expression are done with such mastery that they convey the exact meaning Gil intended without the phony quality that exists in such a vast percentage of commercial pin-ups".

The prolific Elvgren also spent hundreds of hours executing magazine-story illustrations, usually of boy/girl "love and romance" subjects, for such mainstream magazines as *Cosmopolitan*, *Redbook*, *McCall's*, *Woman's Home Companion*, and *The Saturday Evening Post*. The 1960s were the time of Elvgren's greatest success, for a number of reasons: the artist himself reached the peak of his skill, Brown and Bigelow marketed his images superbly, and the American public responded to them enthusiastically.

Elvgren once described his ideal model as having a fifteen-year-old face on a twenty-year-old body. He also cited the following features: high forehead, long neck, eyes that were set wide apart, small ears, pert nose, great hair, full but not overblown breasts, nice legs and hands, a pinched-in waist, and natural grace and poise. He explained that he made subtle alterations in the model's physique, accentuating areas like the legs, nose, and lips, and added that he tried to create the feeling that, underneath all the surface beauty, behind the model's eyes, there was a delicious, mischievous warmth. For him, the model "with highly mobile facial features capable of a wide range of expression is the real jewel. The face is the personality". Many of Elvgren's models, including Myrna Loy, Donna Reed, Arlene Dahl, Barbara Hale, and Kim Novak, went on to successful careers of their own.

Elvgren's pin-up paintings were always studiously planned out. Beginning with careful selection of the model, he would next choose the wardrobe, hair-style, background, props, and lighting. He then photographed the scene himself, shooting with a 2 1/4-inch (5.7-cm) format Rollei camera. With thirty-two colors on his palette, Elvgren set his canvas on a large wooden easel. He usually sat in a chair with wheels, thus allowing him to view the subject from different angles. For an overall view, he would look behind him at a mirror on the wall.

Almost all of Elvgren's Brown and Bigelow pin-up subjects were executed in oil on canvas measuring 30 × 24 inches (76.2 × 61 cm). Occasionally, while working for the firm in the late 1940s and the 1950s, Elvgren would do a pencil study of a pin-up subject, but few of these works survive. The only large preliminary studies of his career are the oil-on-board renderings that were part of a Brown and Bigelow project for the NAPA Corporation. These full-color works of the 1960s are almost as beautiful as finished paintings.

Elvgren's Dow pin-ups, which dated from 1937 to about 1942, were always painted in oil on canvas (28 × 22 inches; 71.1 × 55.9 cm) and were never signed. Many of these works were overpainted by Vaughn Bass at Dow's request; by thus changing the image, the company hoped to get a second use out of the paintings. A few of Elvgren's Dow originals have survived as they were painted, and a few of Bass' overpainted works are only minimally altered. When the Dow Elvgrens were published – both originally and after the overpainting – they bore a mechanical "slug" signature that depicted the artist's name in block, printed lettering.

Elvgren's wife passed away in 1966 after a bout with cancer, and he later remarried one of his former models, Marjorie Shuttleworth. He died of cancer in 1980.

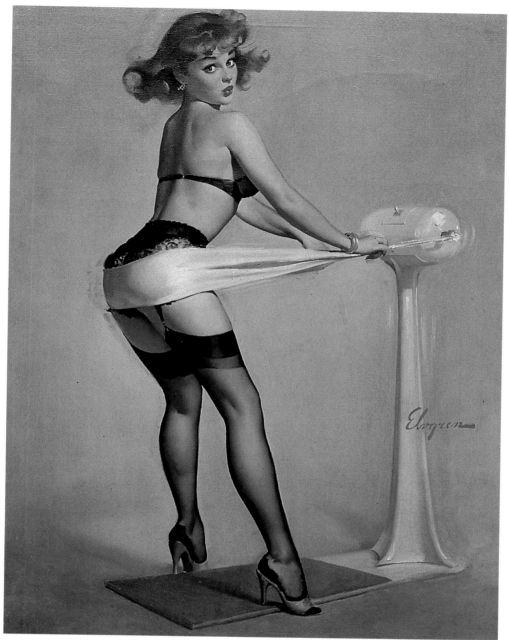

353

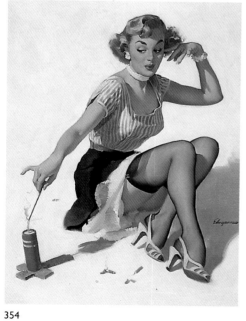

354

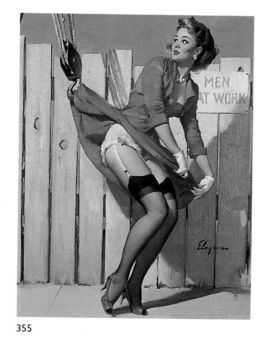

355

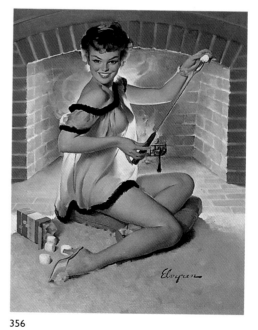

356

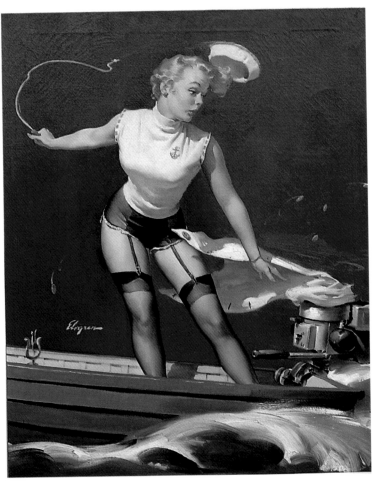

357

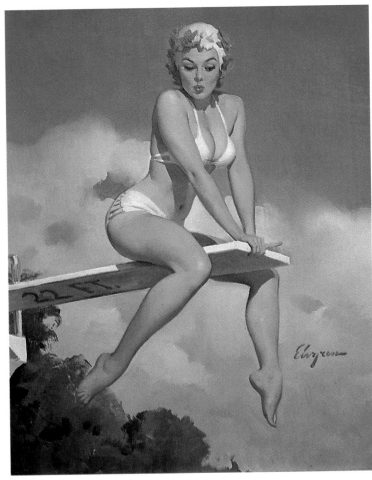

358

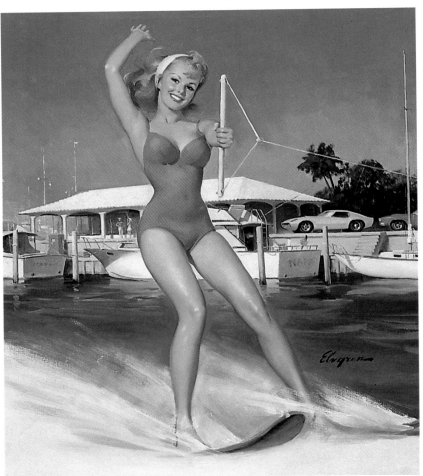

359

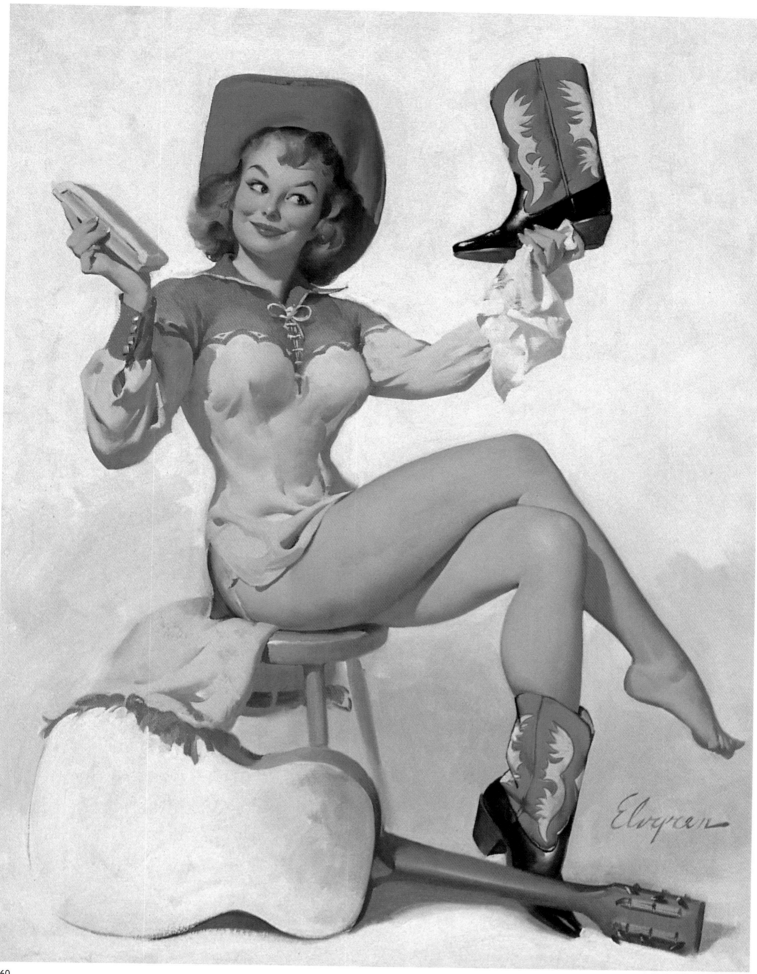

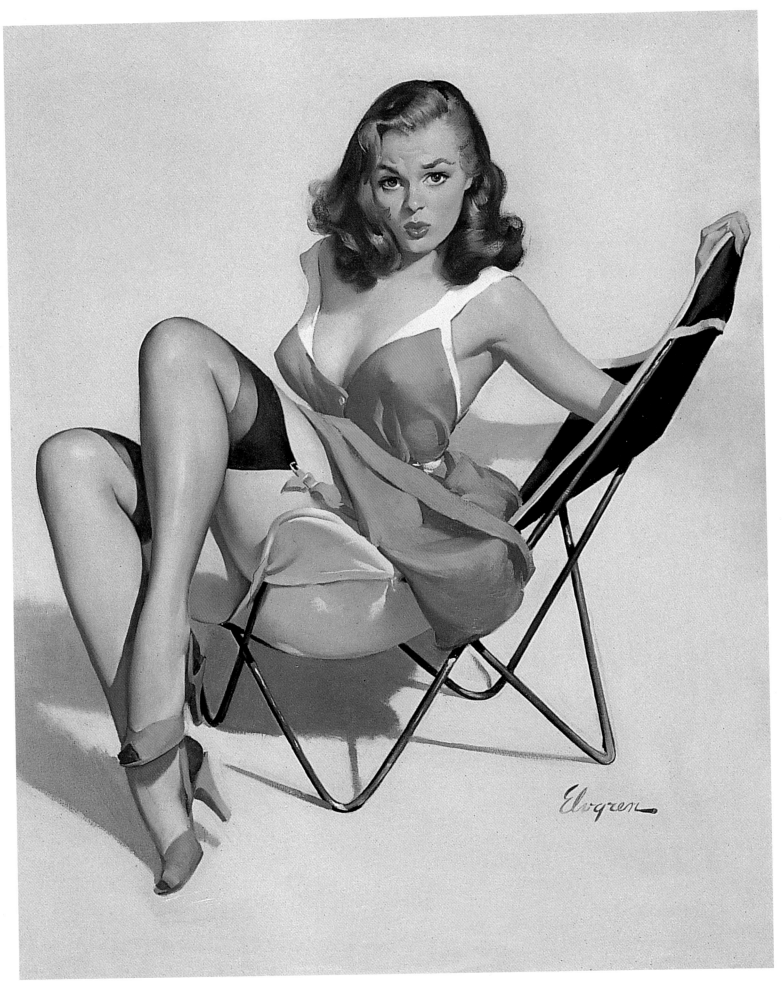

361

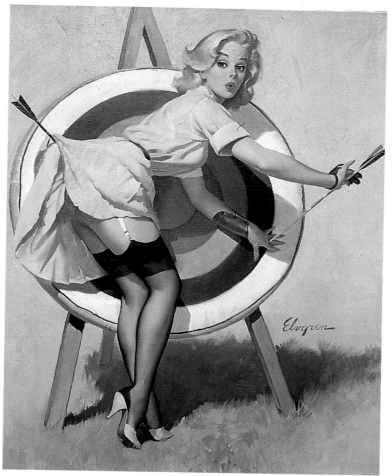

362

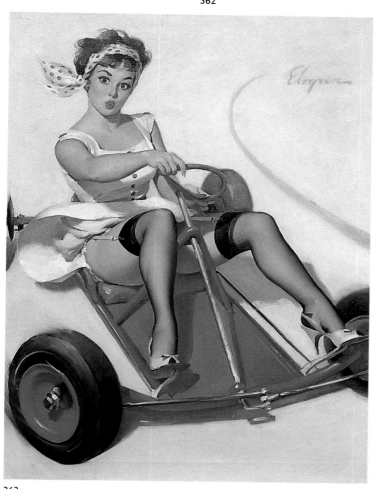

363

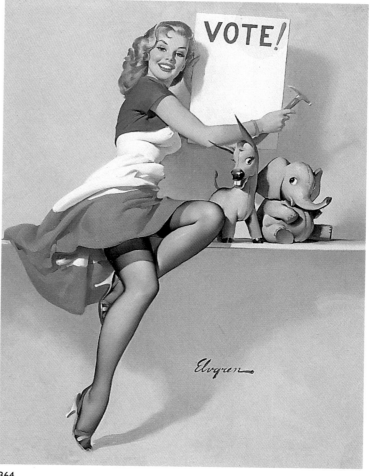

364

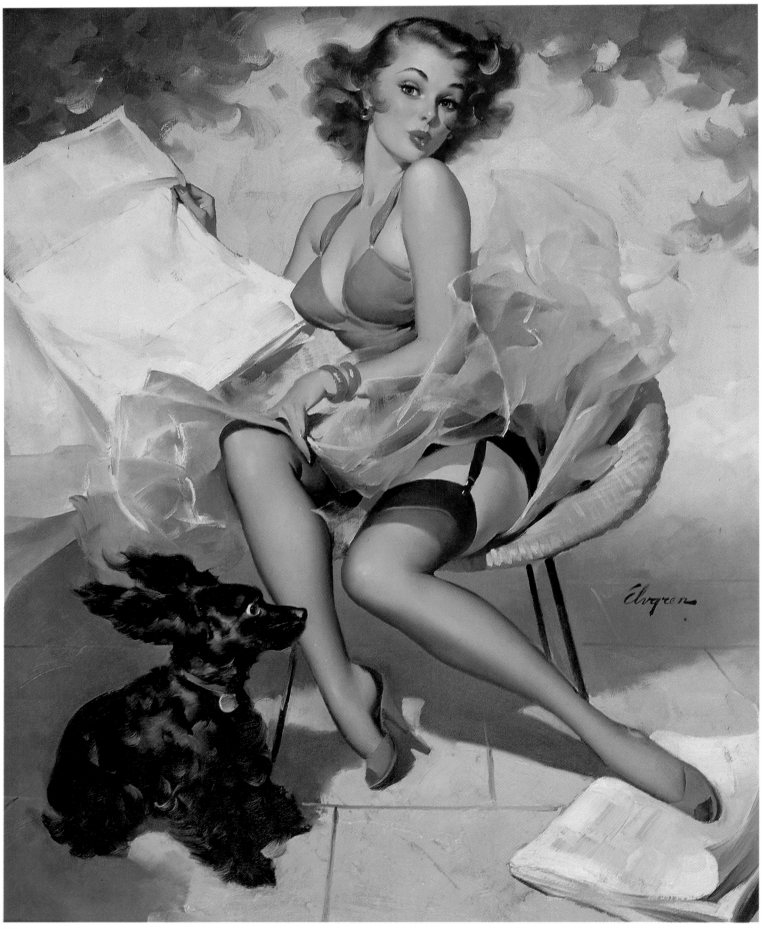

365

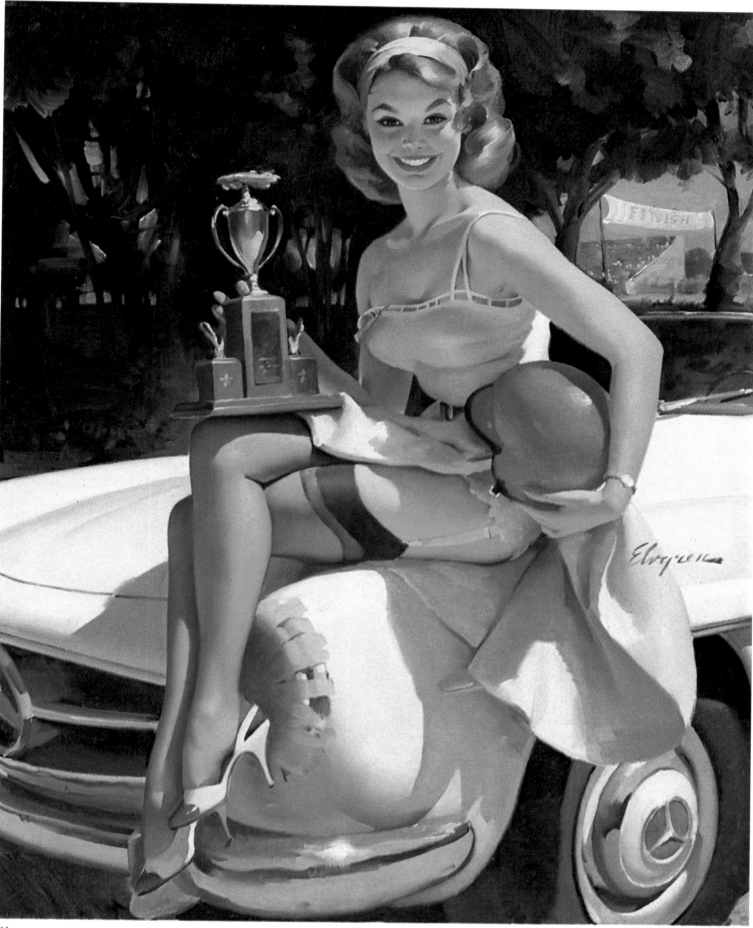

366

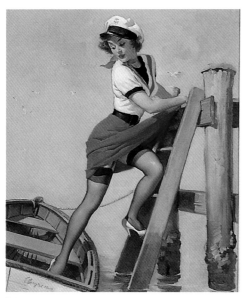

367

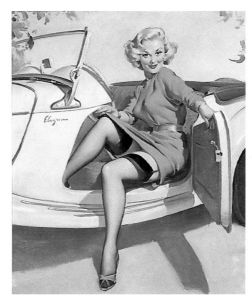

368

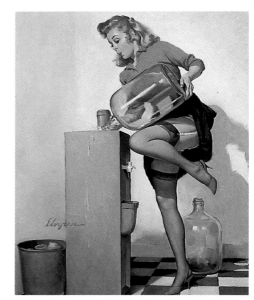

369

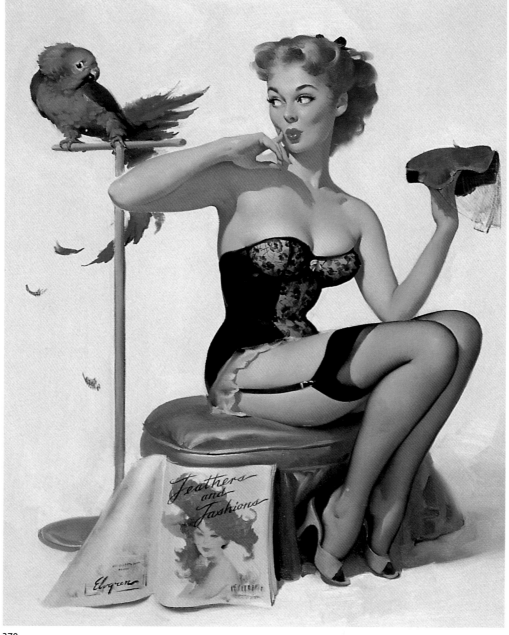

370

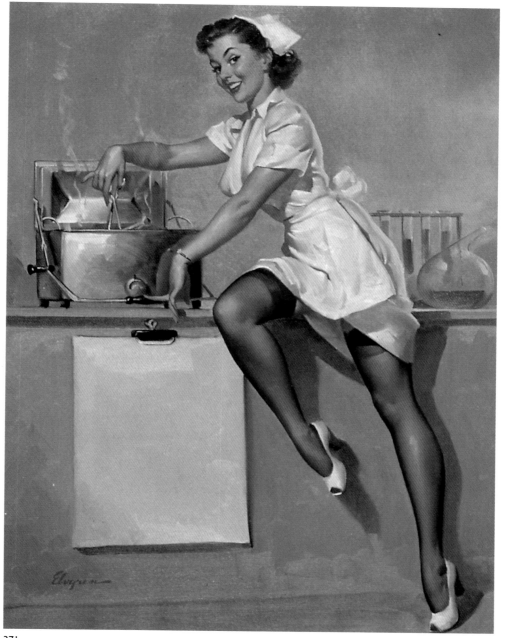

371

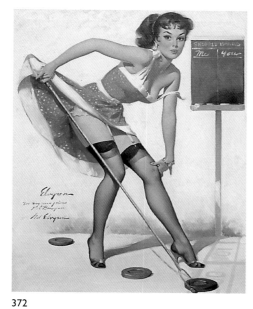

372

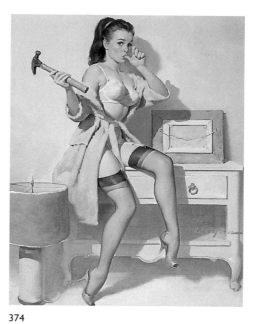

373

374

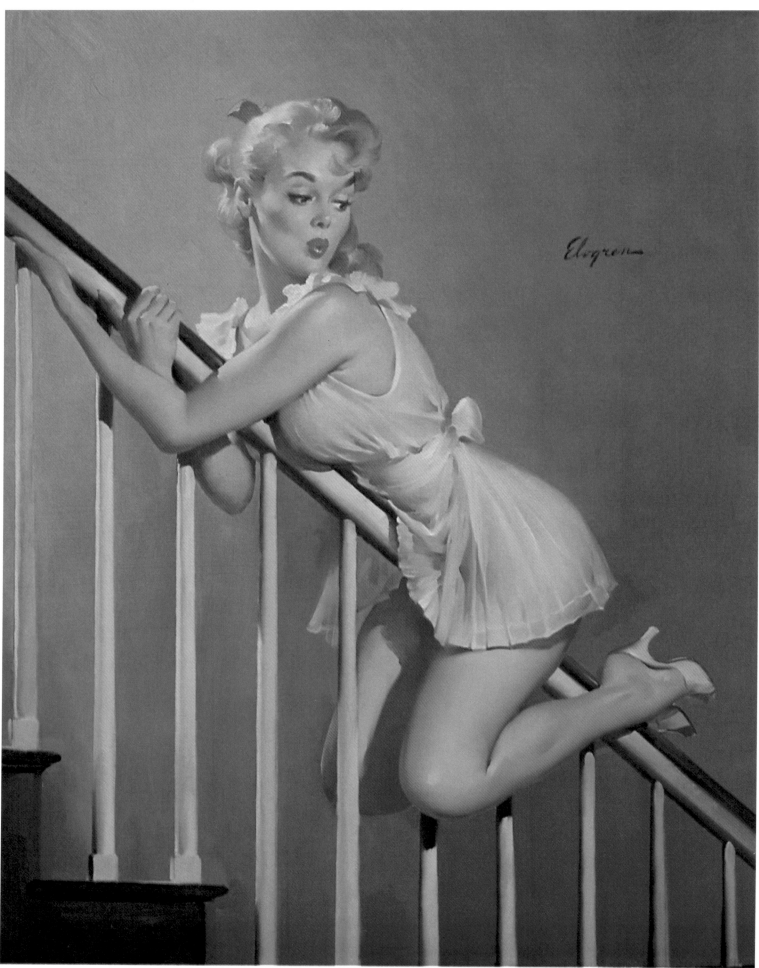

375

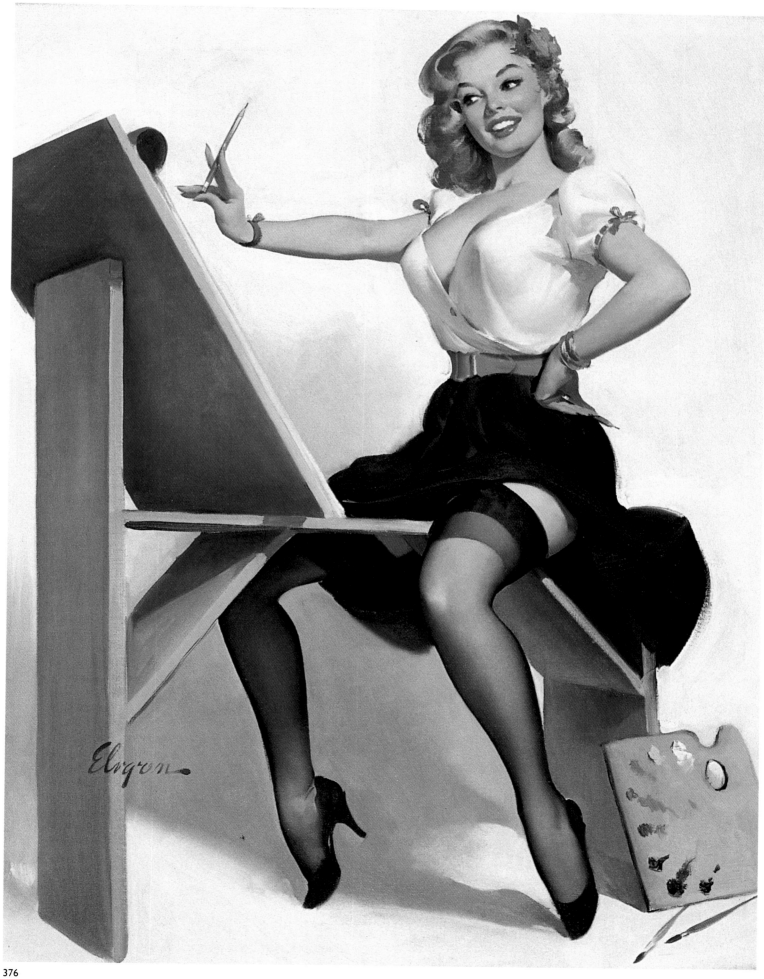

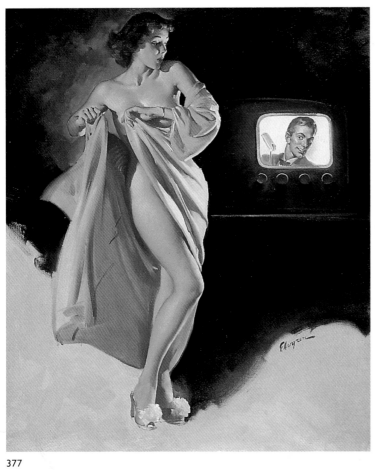

377

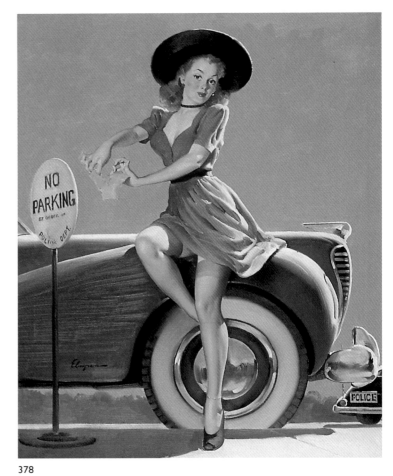

378

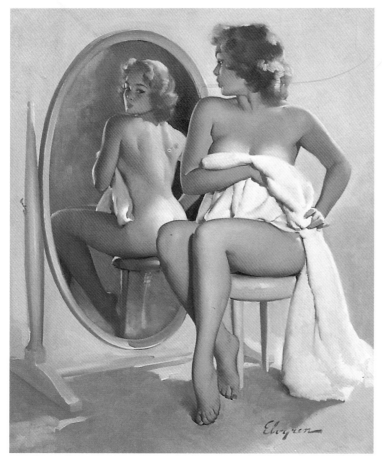

379

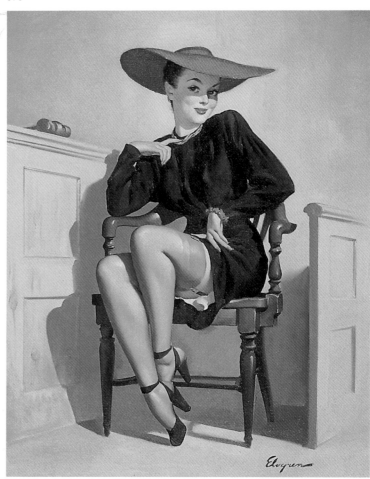

380

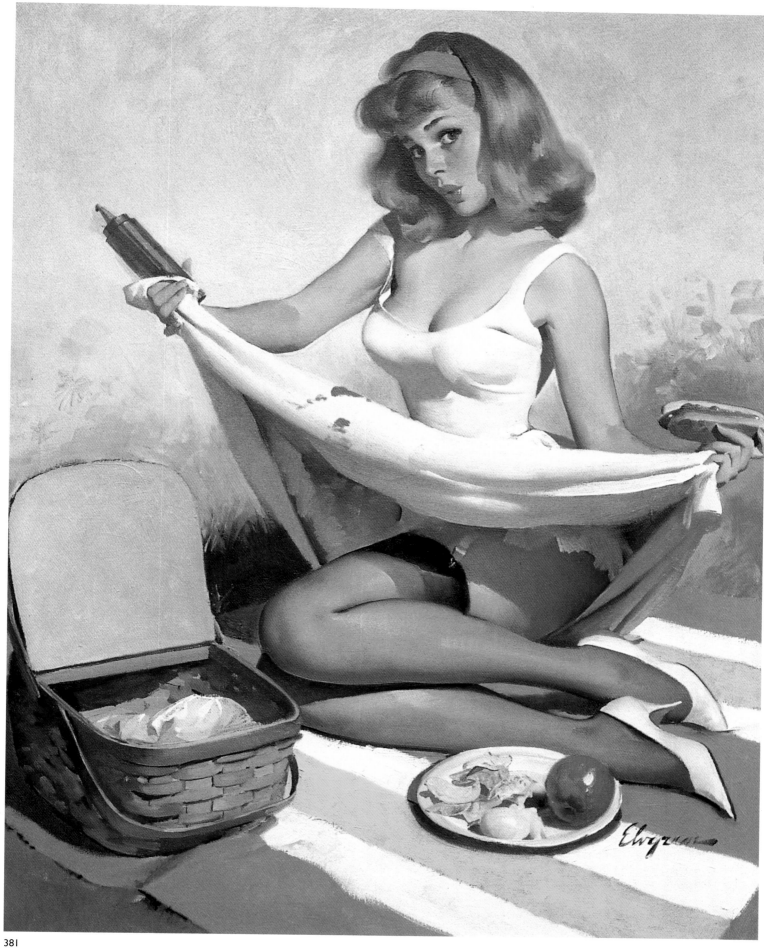

381

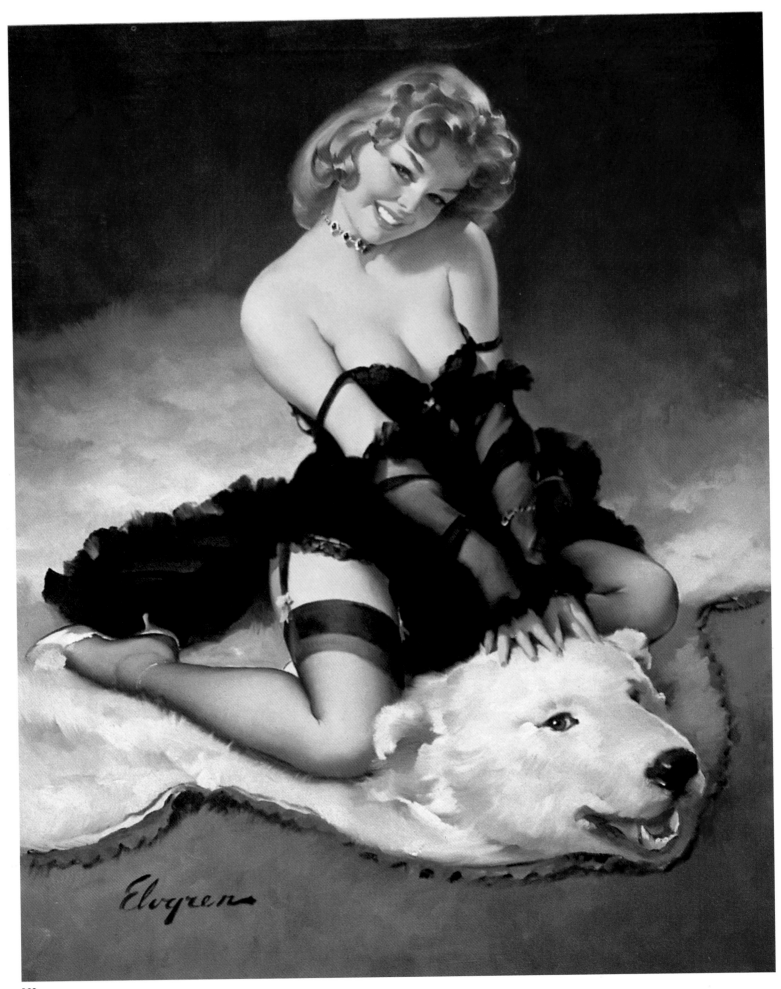

Elvgren

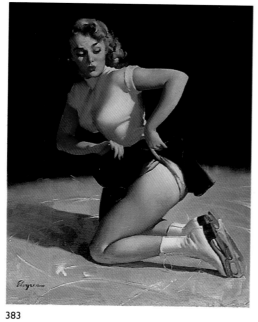

383

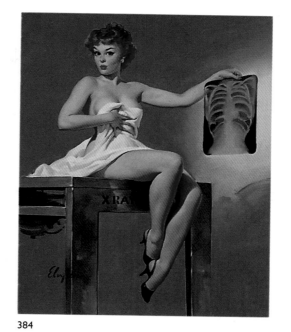

384

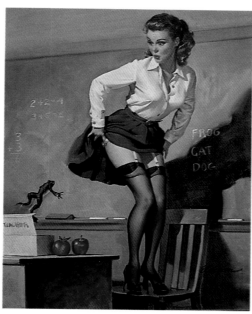

385

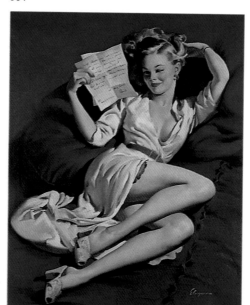

386

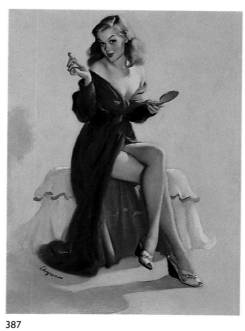

387

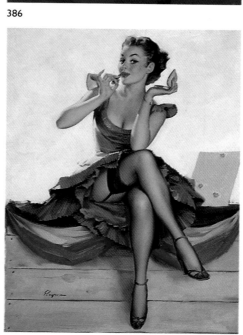

388

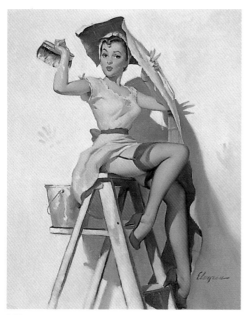

389

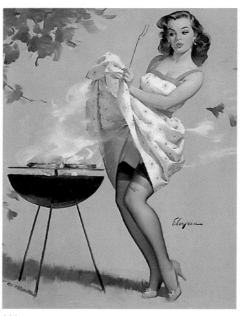

390

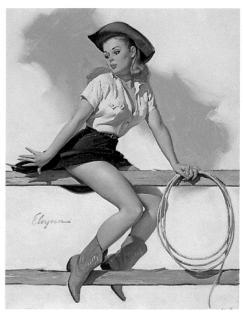

391

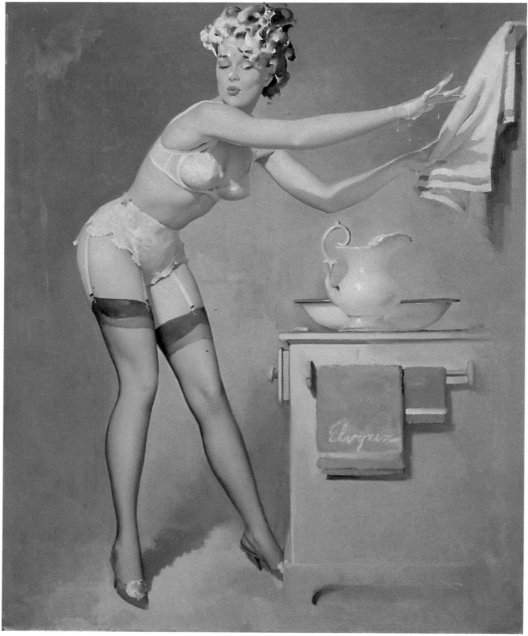

392

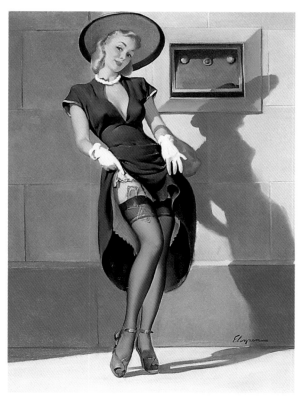

393

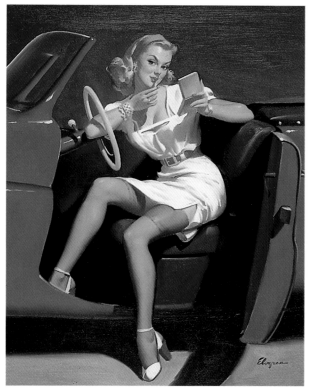

394

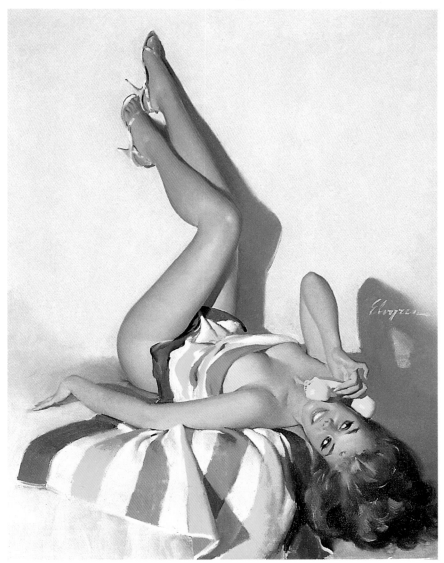

395

Art Frahm

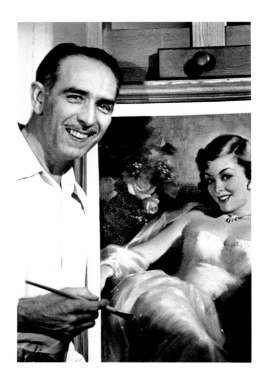

Frahm devised this century's most famous series of pin-up images in his ten "panties falling down" works, created for the Joseph C. Hoover and Sons calendar company from 1950 to 1960 (figures 7, 407–15).

Born in 1907 in Chicago, Frahm studied with three great American illustrators, Andrew Loomis, Frederic Mitzen, and Ben Stahl, at the Art Institute there. His first jobs after art school were at a printing and engraving company, where he learned much about graphic art and printing techniques, and at Zipprodt, Inc., where he soon became the firm's number one "idea" man in the billboard advertising division. In 1935, Frahm opened his own studio in Chicago and went on to sell pin-ups to several prominent calendar companies. Four years later, he and his wife, Ruth, had a daughter, Diana, who subsequently became the model for his classic Coppertone billboards.

Frahm also provided pin-ups to the Kemper-Thomas Calendar Company (1939) and Hoover's Superior line (1941). After spending the war years stationed in Italy with the army, he and his family moved in 1954 to Asheville, North Carolina, where he painted many of his finest pin-ups. About 1955, he began a series of full-length glamour paintings of evening-gowned women posed in the moonlight next to elaborate fountains or wrought-iron gates.

Frahm contributed a number of fabulous Sundblom-like paintings to Coca-Cola's national advertising campaign under the slogan "Work Refreshed". Especially notable was his blacksmith being handed a bottle of Coke, which was made in 1950 into a life-size display for grocery stores throughout the United States. Frahm also created the classic smiling Quaker on the Quaker Oats package, along with other memorable images for Crane Plumbing, Schlitz Beer, and Libby Foods. Two of his calendar series from the early 1960s were extremely successful: one depicting the adventures of a group of fun-loving hoboes traveling across America; the other, showing policemen instructing children on various aspects of safety.

Frahm generally worked in oil on canvas sized from approximately 30 x 24 inches (76.2 x 61 cm) to 36 x 24 inches (91.4 x 61 cm). He occasionally used heavy illustration board instead of canvas, and he varied his full-length pin-ups with head-and-shoulder glamour art. He died at Fountain Inn, North Carolina, in 1981.

Opposite page:
396

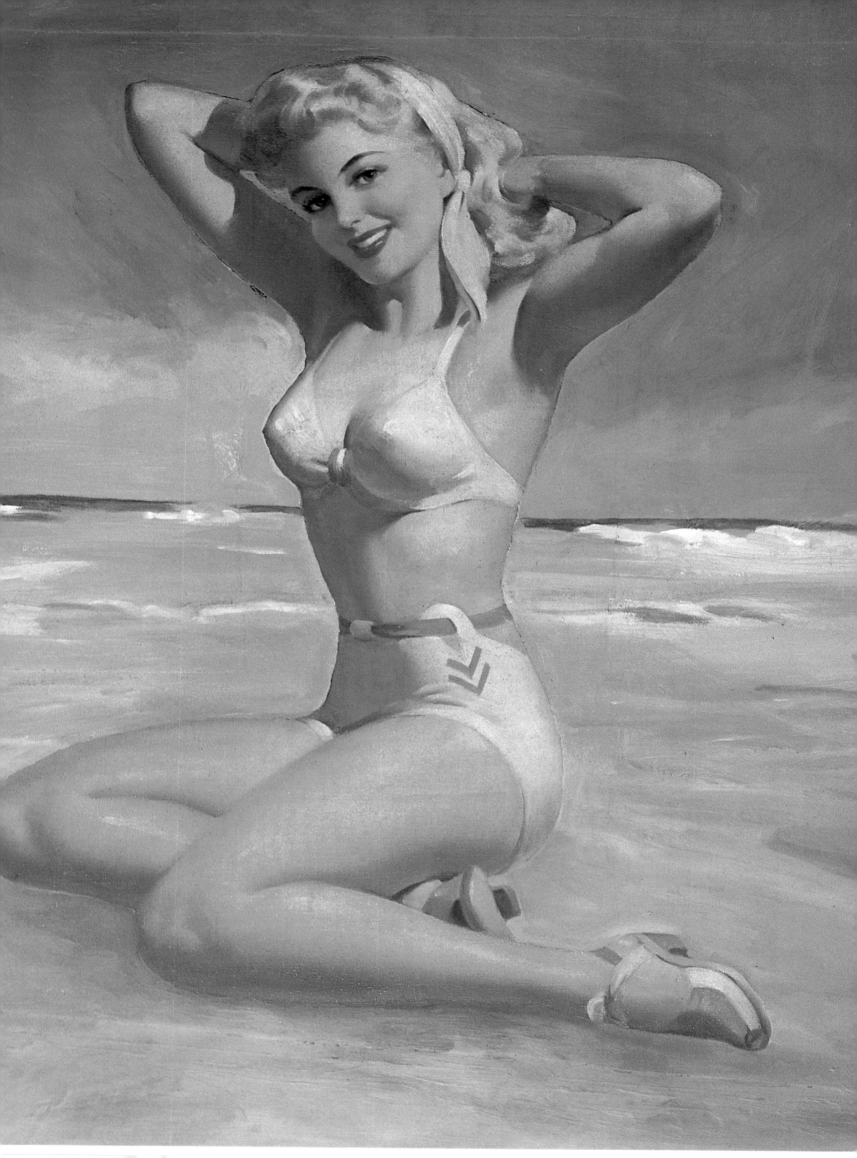

Pearl Frush

As one of the top three women pin-up and glamour artists in the calendar art market at mid-century, Pearl Frush readily commanded the respect of the art directors, publishers, sales managers, and printers with whom she worked. Yet because she worked primarily in watercolor and gouache, her originals could rarely be reproduced in large enough quantities for her to achieve widespread popular acclaim. A close examination of her work, however, reveals a talent for meticulously realistic images comparable to those of the far better known Alberto Vargas.

Frush was born in Iowa and moved to the Gulf Coast of Mississippi as a child. She began drawing as soon as she could hold a crayon in her hand; when she was ready for formal studies, she enrolled in art instruction courses in New Orleans. After additional training in Philadelphia and New York, Frush joined her family in Chicago, where she studied at the Chicago Art Institute under Charles Schroeder.

Frush opened her first studio in Chicago in the early 1940s. While she accepted freelance jobs, she also worked at the studio of Sundblom, Johnson, and White. By 1943, she had become one of the Gerlach-Barklow Calendar Company's most important artists, creating a string of popular series: Liberty Belles, Sweethearts of Sports, Girls of Glamour, and Glamour round the Clock. In 1947, her Aquatour series, a dozen pin-ups all located in aquatic settings, broke all sales records. By 1955, Frush had become a "hot property" in the calendar-publishing business, so it was only natural that Brown and Bigelow should seek her out. A year later, the firm published its first Frush pin-up, a horizontal picture especially done for "hangers" (large wall calendars with one print attached).

A vigorous and attractive woman, Frush enjoyed sailing, canoeing, swimming, and playing tennis, and she would often incorporate sport themes into her work. Portrayed in a crisp, straightforward style, her pin-ups and glamour paintings effectively captured the spirit of young womanhood. Her girls were wholesome and fresh, shapely but never overtly sexual. Somehow they were able to look both like movie stars and like the girls-next-door.

Frush's original paintings were executed on illustration board that usually measured about 20 x 15 inches (50.8 x 38.1 cm). She sometimes signed her paintings with her married name "Mann". Her renderings were always done with great precision, capturing every nuance of a subject in an almost Photo-Realist technique.

420

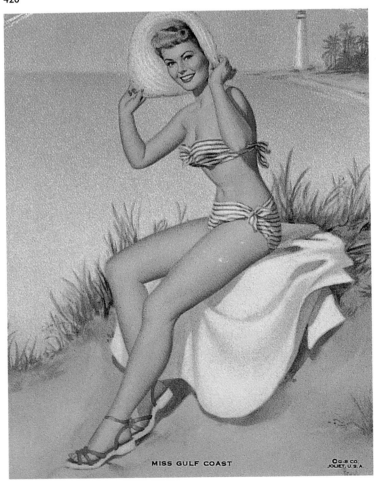

MISS GULF COAST

421

Opposite page:
422

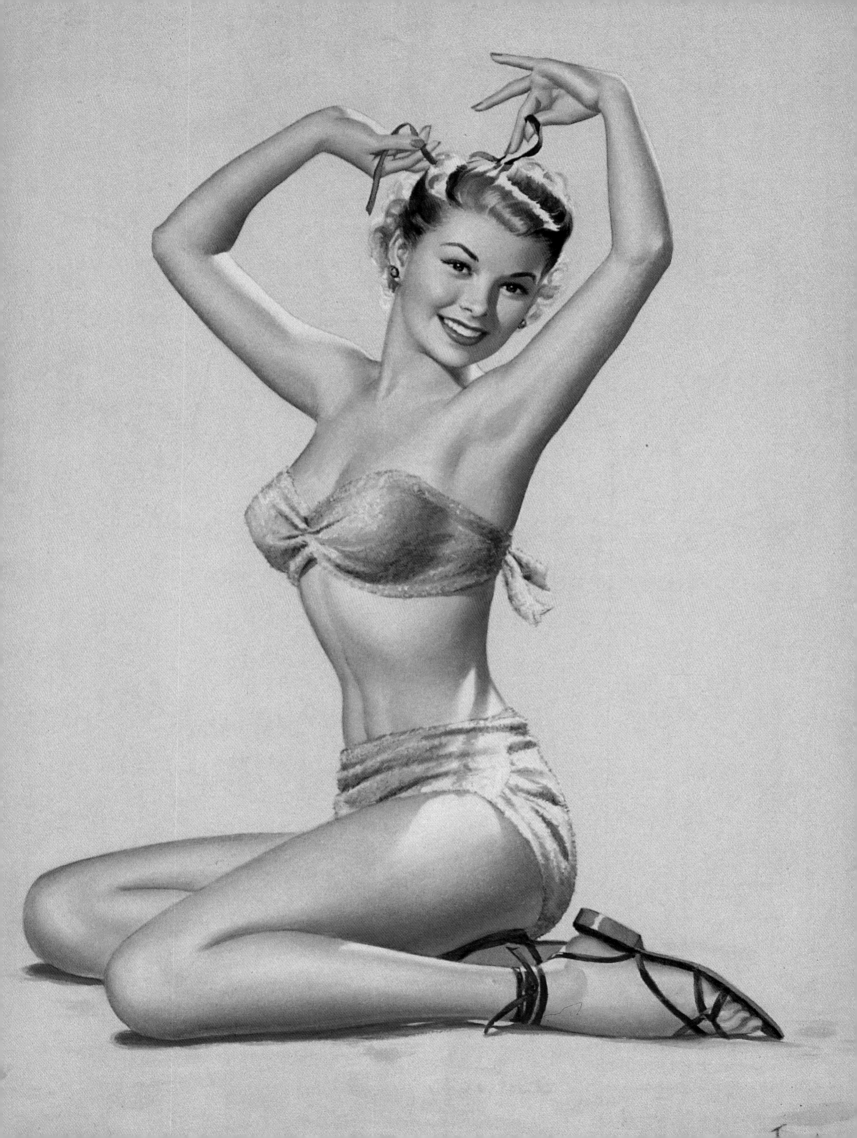

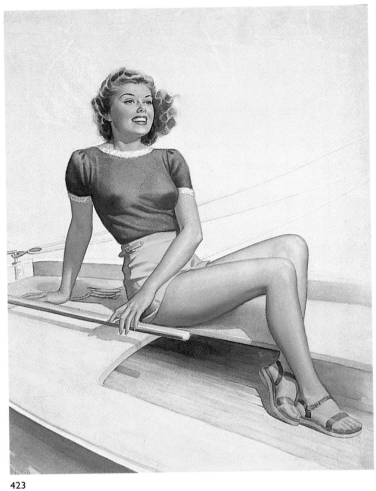

423

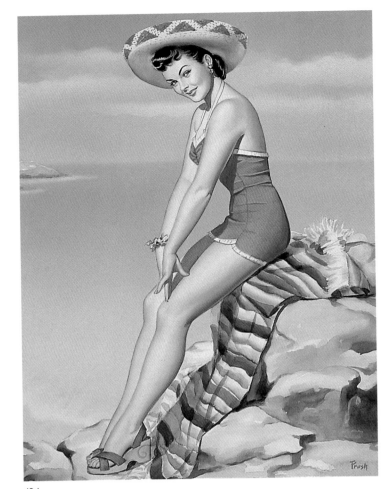

424

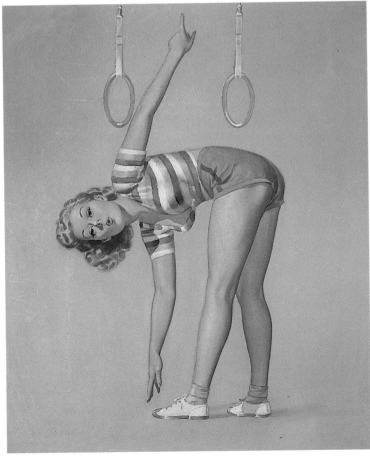

425

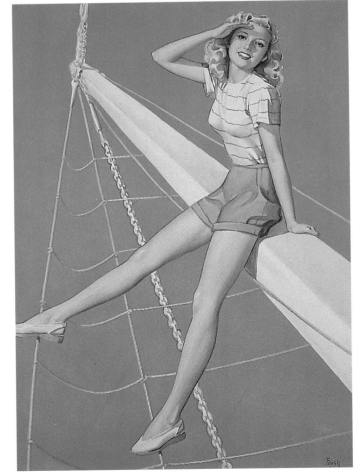

426

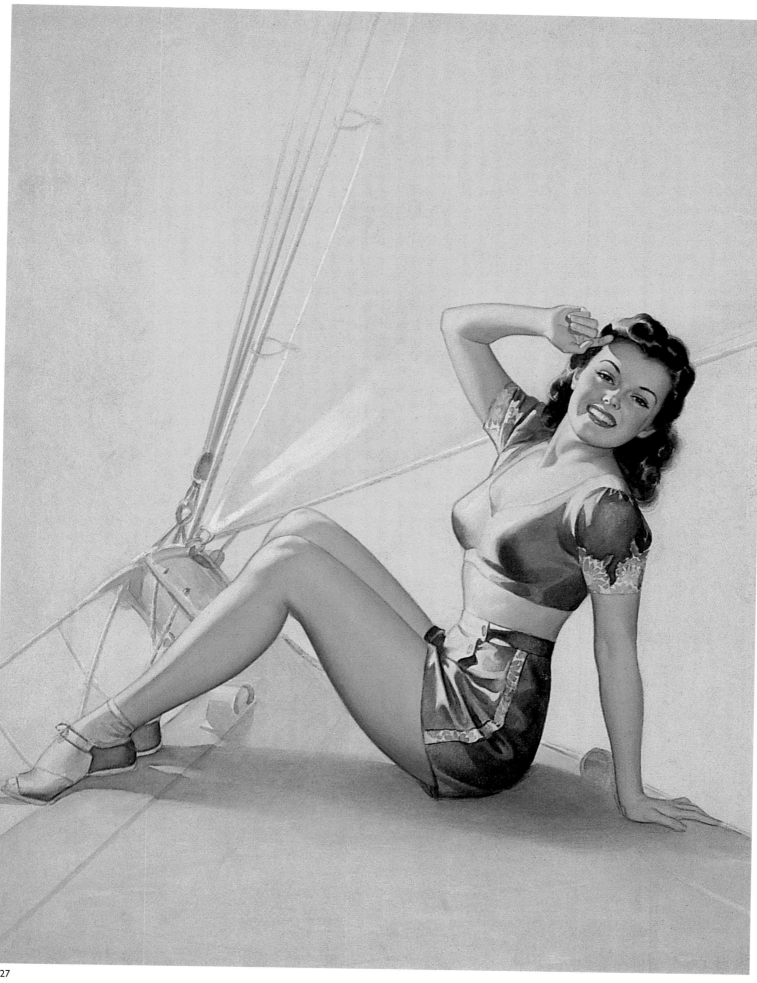

427

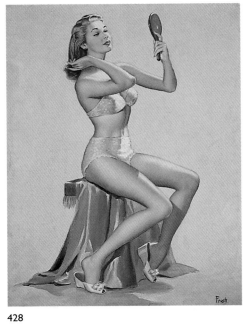

428

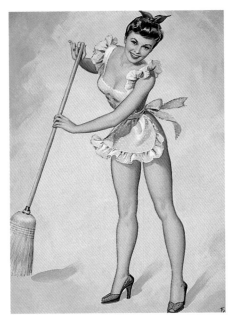

429

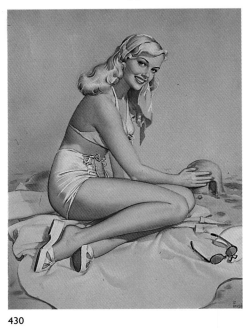

430

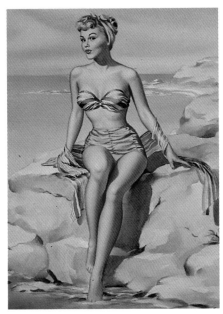

431

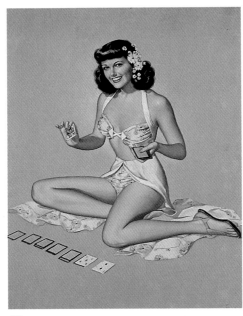

432

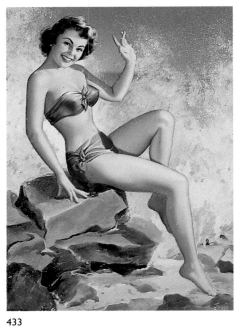

433

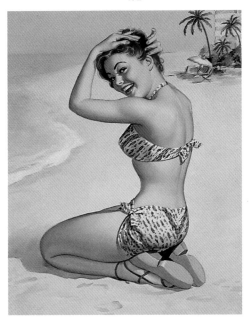

434

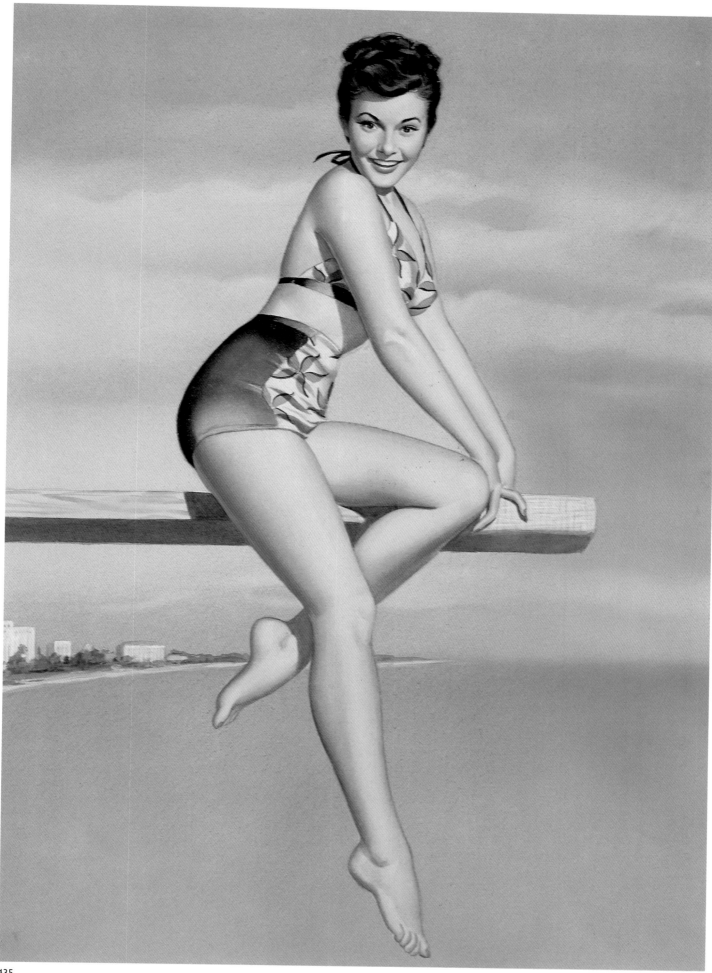

435

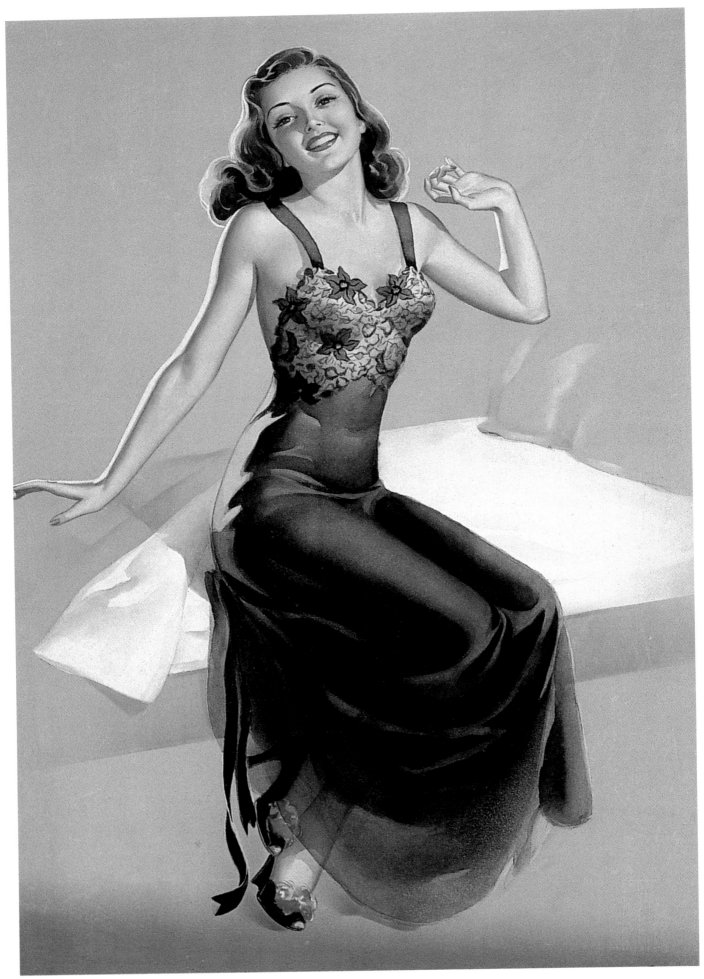

436

194 · Pearl Frush

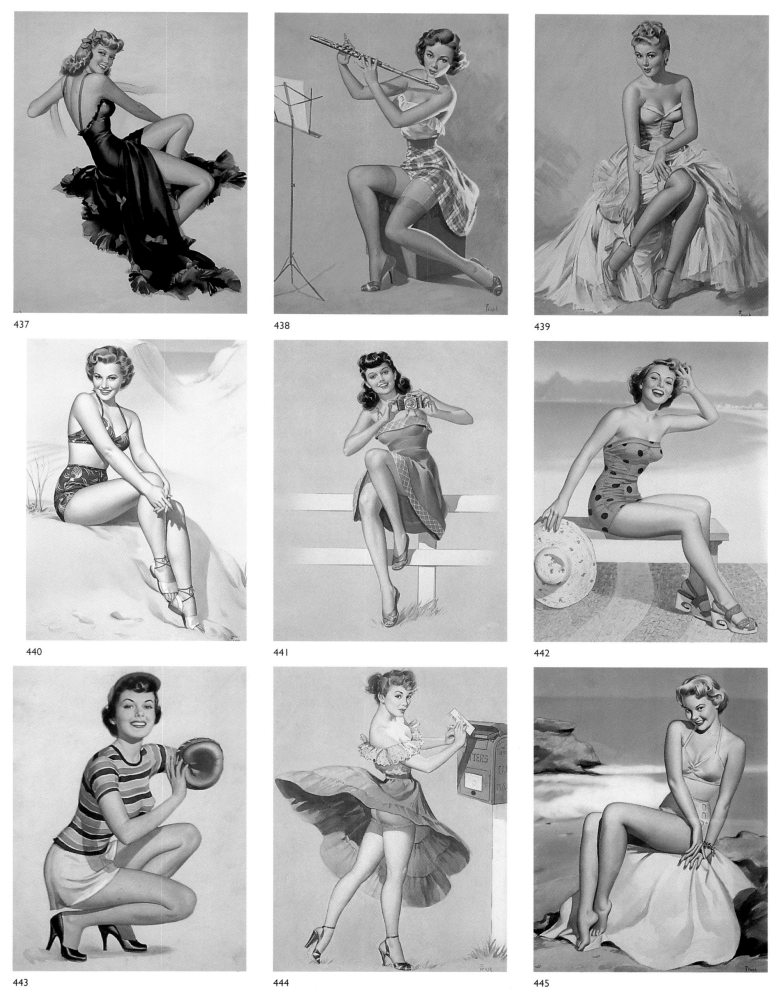

437

438

439

440

441

442

443

444

445

451

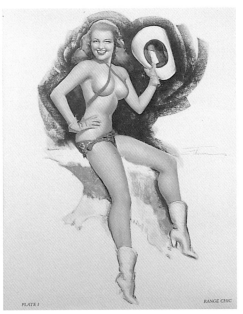

452

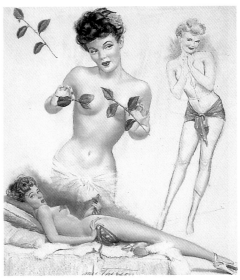

453

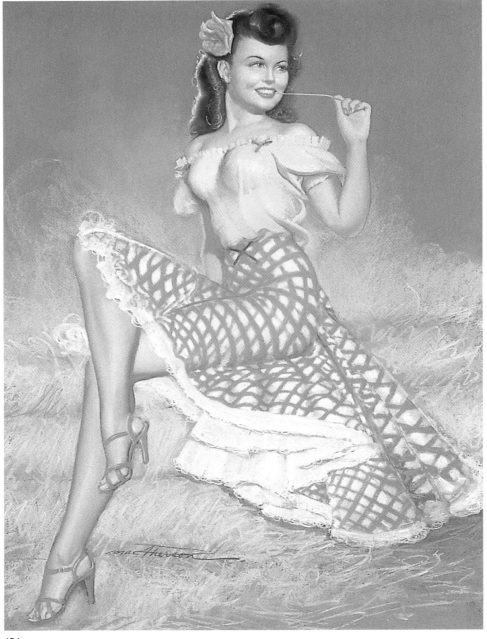

454

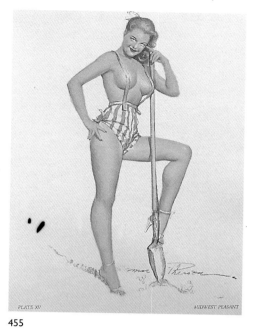

455

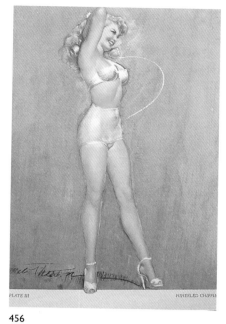

456

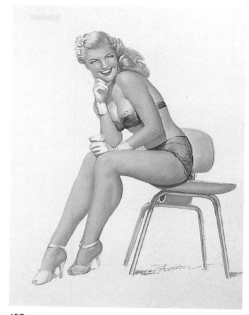

457

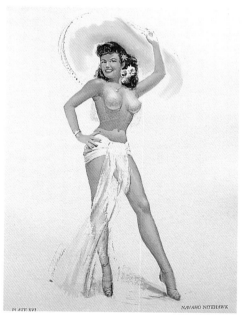

458

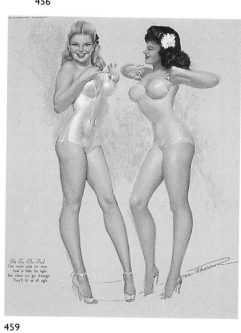

459

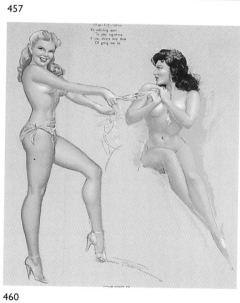

460

461

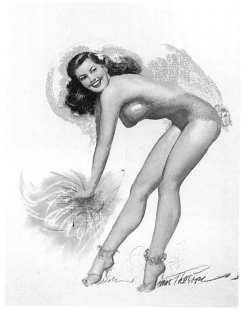

462

463

Bill Medcalf

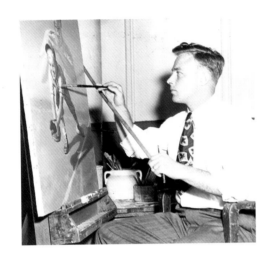

Medcalf's pin-up work, like Elvgren's, set standards for artistry and imagery for his contemporaries. When Medcalf joined the staff of resident artists at Brown and Bigelow on March 18, 1946, he hoped to get some pointers from his two idols, Elvgren and Norman Rockwell, who were both contributors to the firm. When he met both men at a Christmas party that year, he was therefore stunned and flattered when they asked him how he imparted such a finished glow to his work.

Medcalf painted more than twenty years of beautiful pin-ups for Brown and Bigelow, handling all the special-project calendar commissions for their most important customers. For his first assignment in 1947, for Kelly-Springfield's Celebrity Tires, Medcalf painted a beautiful girl walking her dog on an estate, with a sports car in the background (figure 478). Then, for Dorman Products (auto parts manufacturers), he created a breathtaking picture of a girl and her dog having a picnic in front of an automobile (figure 473). While still handling these special pin-up projects, Medcalf also went on to deliver one winner after another to a new, more traditional Brown and Bigelow series, The Baseball Hall of Fame.

In 1949, Medcalf did his first pin-up "novelty fold" specialty item for the firm: a booklet that unfolded four times, each time revealing a larger pin-up image, the last being an oversized picture with an advertising message. Named one of the company's top five pin-up artists in their 1951 Business Builder, Medcalf released his first pin-up hanger the next year. Entitled Beautiful Morning (figure 469), this depiction of a young girl just waking up proved to be a best-seller. The versatile Medcalf took on the responsibility for the company's American Boy calendar series in 1953, and he also created many best-selling evening-gown subjects for their glamour line (figures 474–76).

William Medcalf was a Midwestern boy, born in Minneapolis. All of his art education came from schools near his hometown, under teachers like Cameron Booth and Stan Fenelle. In 1940 and 1941, he worked in the art department of the United States Treasury's Bureau of Engraving; in 1942, he joined the Navy as a gunner's mate.

During his tenure at Brown and Bigelow, Medcalf worked first at the company's headquarters, then out of his home studio in a suburb of St. Paul, often using his family and neighbors as models. In a September 1950 article for a local art school magazine, he said this about his work: "I look for the things that make a girl appear feminine, outside of her face and figure, that is, her pose, expression, the way she fixes her hair, the way she handles her eyes, her buttons and bows" and "I play up the face and expression, making her look pleasant and sweet, with sex appeal but without sophistication, like someone's sweet sister."

Opposite page:
464

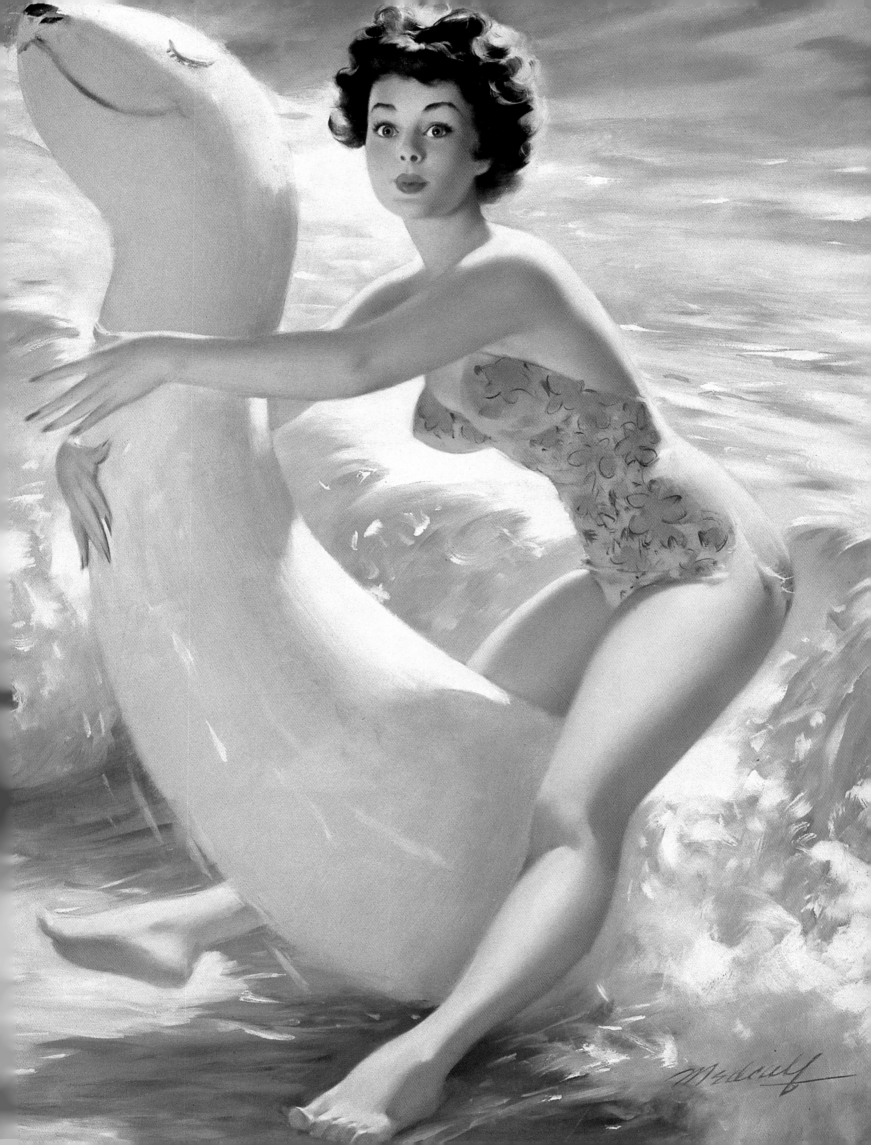

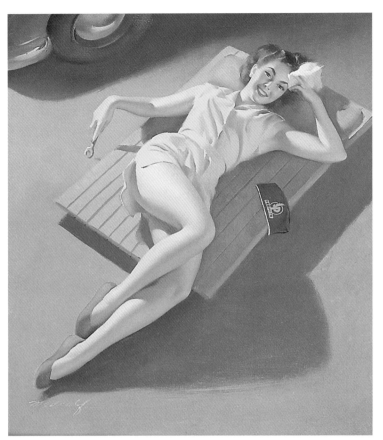

465

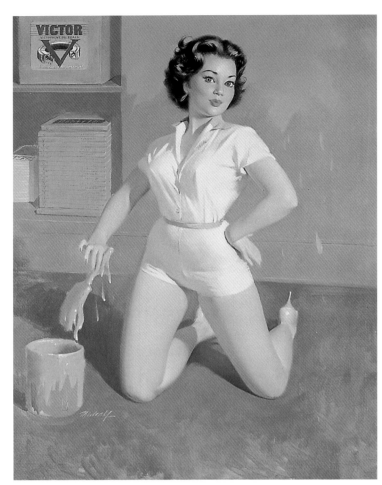

466

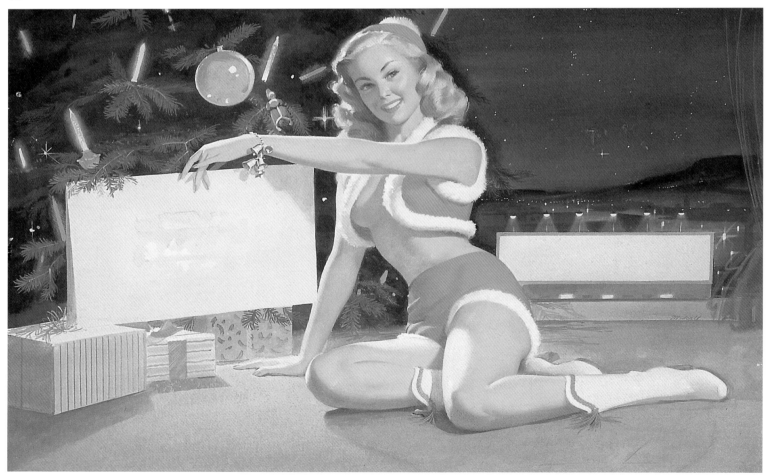

467

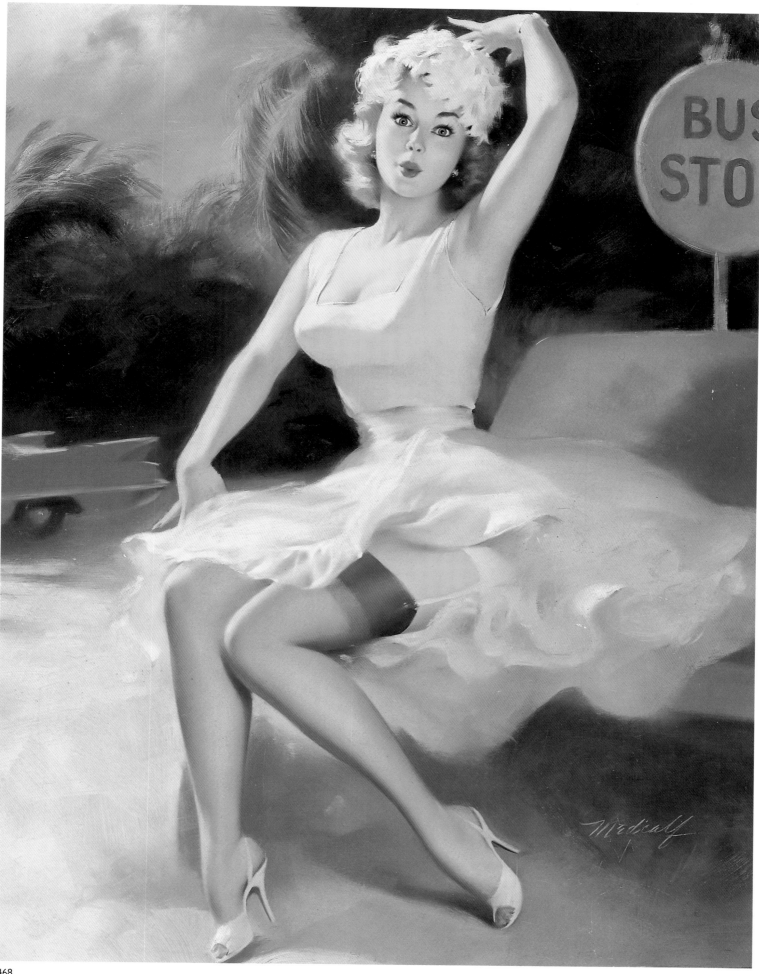

468

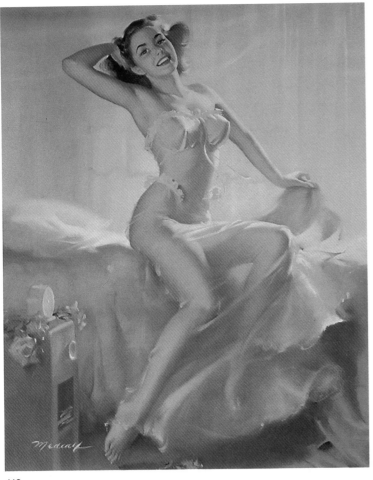

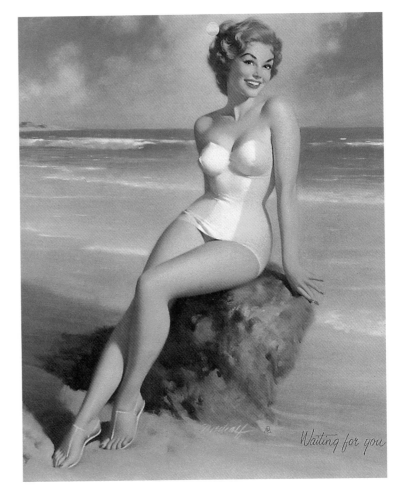

469

470

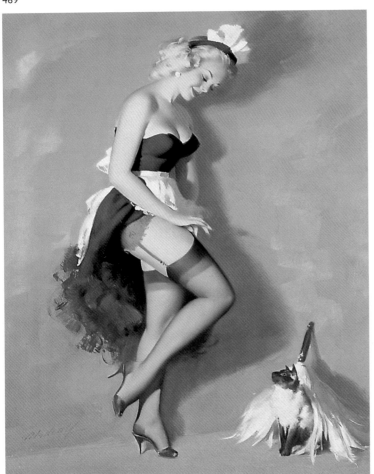

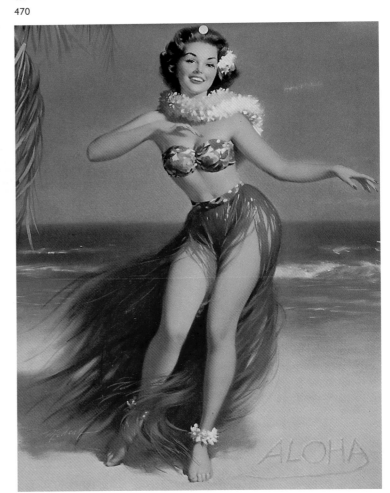

471

472

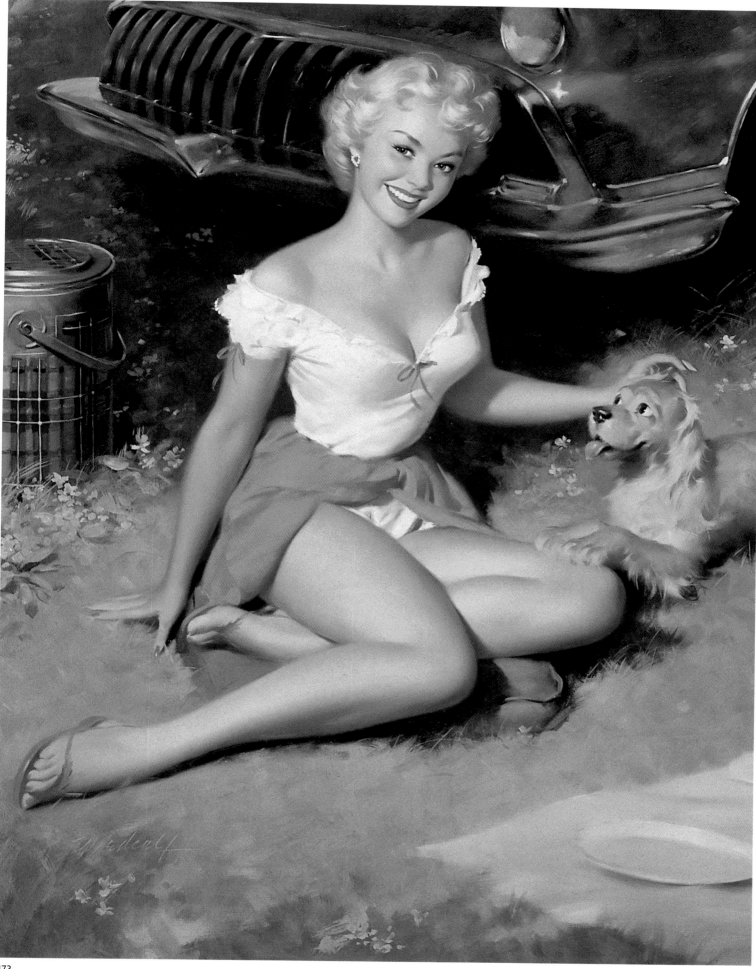

473

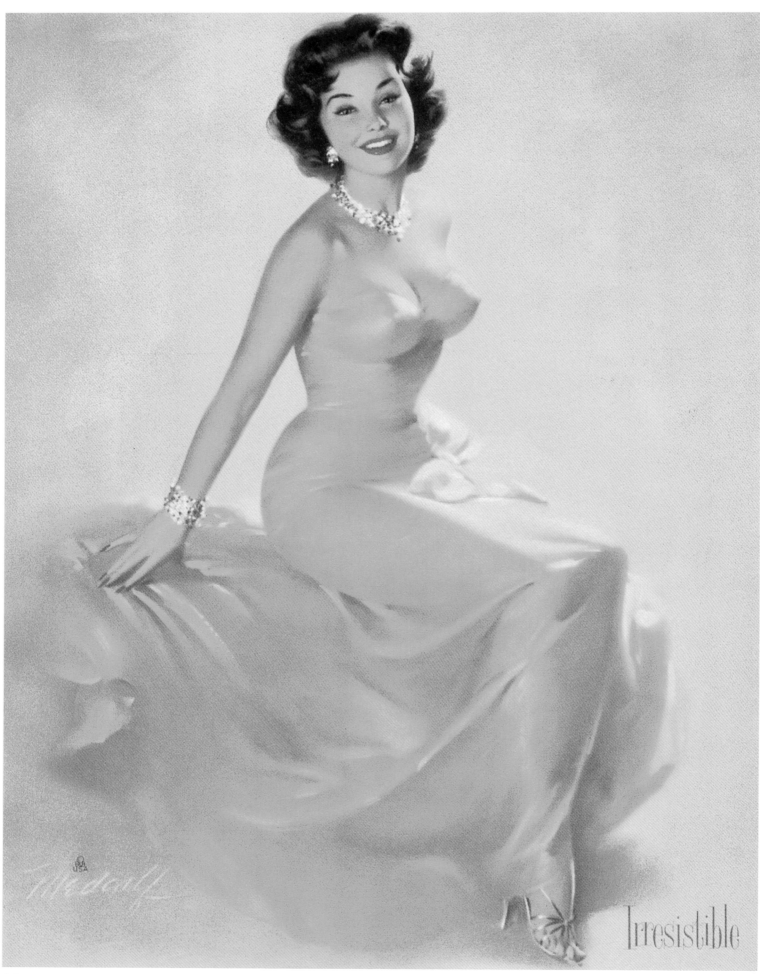

Irresistible

474

208 · Bill Medcalf

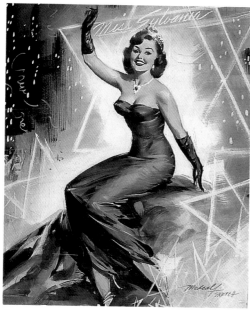

475

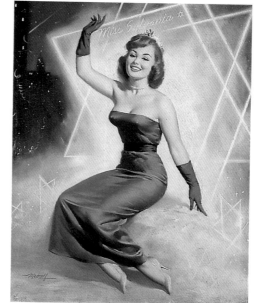

476

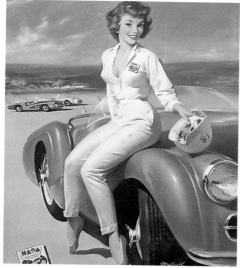

477

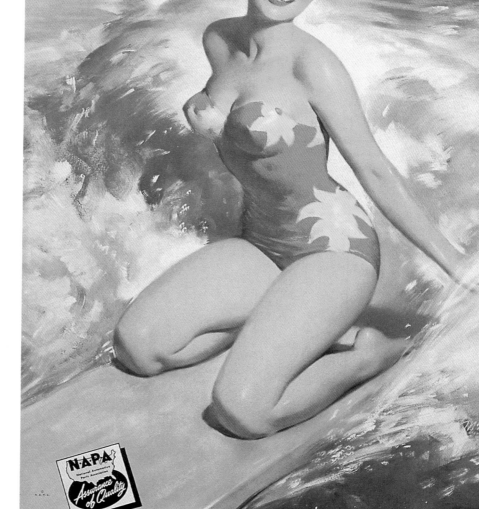

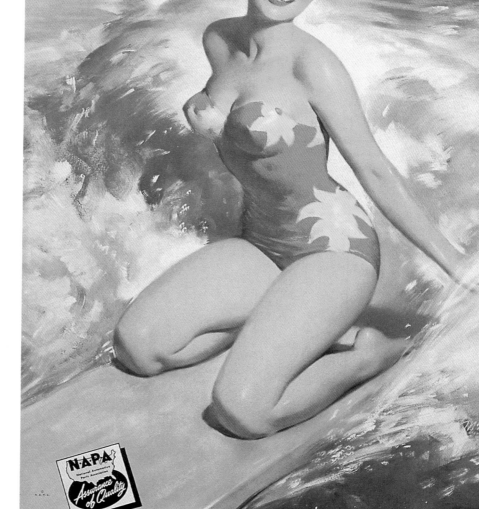

478

479

Al Moore

Born in Illinois, Al Moore played college football at Northwestern University and professional football with the Chicago Bears. After attending classes at Chicago's Art Institute and Academy of Art, he opened a commercial art studio in New York in the late-1930s. By the mid-1940s, his clients included major companies like Galey and Lord, Beauty Counselors, the Viscole Corporation, and Champion Spark Flags.

During the war years, Moore painted posters for the government and also took on assignments from Old Gold cigarettes, *Cosmopolitan*, *The Saturday Evening Post*, and *Collier's*.

Advertising work for U.S. Rubber, Nash automobiles, and Coca-Cola led, in 1946, to Moore's breakthrough assignment – he was chosen by *Esquire* to replace Alberto Vargas, the most popular pin-up artist of the day. Among Moore's triumphs at the magazine were his creation of the *Esquire* Girl, his answer to the Varga Girl (figures 482–86); the 1948 *Esquire* calendar (with Ben-Hur Baz and others); front covers in 1948 and 1949; and the rare honor of painting the entire 1949 calendar himself. By 1950, his two-page gatefolds in *Esquire* were collected by millions of Americans.

Moore contributed four pin-ups (figures 481 and 487) and a centerfold print (figure 480) to Brown and Bigelow's Ballyhoo Calendar for 1953, which was as huge a success as Elvgren's work for the previous year's calendar. In the 1950s, his corporate clients included Modern Munsingwear, Hertz Rent-a-Car, and the McGregor Corporation. During the same years, his illustrations appeared in *American Magazine*, *Woman's Home Companion*, *McCall's*, and *Woman's Day*, and he painted several front covers for *The Saturday Evening Post*. As an active member of the Society of Illustrators, Moore was asked to paint the poster for the society's 1959 exhibition; it was such a success that both Pan American Airlines and Germaine Monteil Perfume also commissioned posters for their national marketing campaigns.

When photographs began to replace artwork in magazines and advertising, Moore decided to retire and pursue fine-art painting, including portrait commissions. Shortly after he moved to Crawford, Colorado, he accepted a commission from the United States Olympic Committee for three paintings for their world headquarters that would call attention to the problem of illegal steroid use by athletes. Moore died in April 1991.

Moore's pin-ups for *Esquire* and Brown and Bigelow were executed primarily in gouache on illustration board averaging 26 x 20 inches (66 x 50.8 cm). His pin-up girls could sometimes have a dreamy, young look, yet at others be sophisticated and sensual; they had an earthy quality very different from Petty's and Vargas'. His granulated skin tones produced the almost iridescent quality that immediately identifies a Moore original.

Opposite page:
481

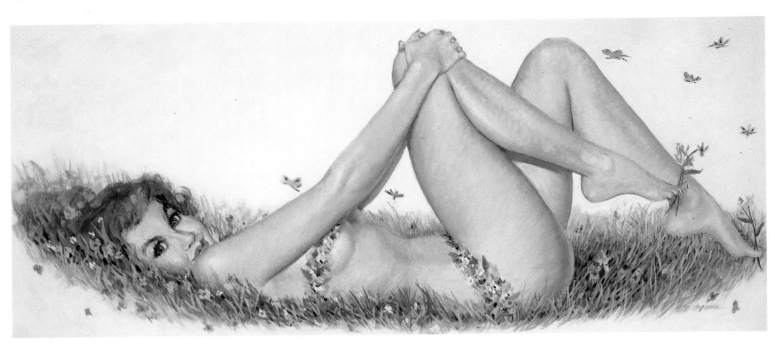

480

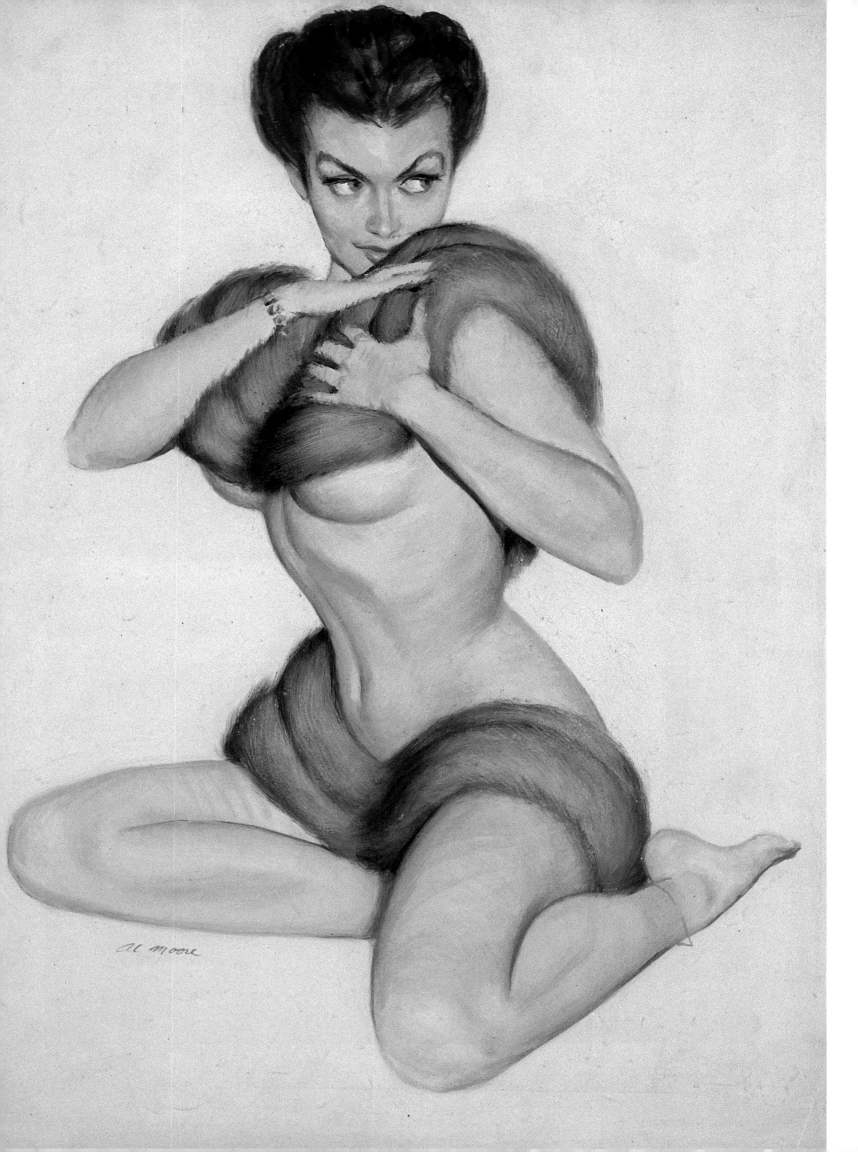

Earl Moran

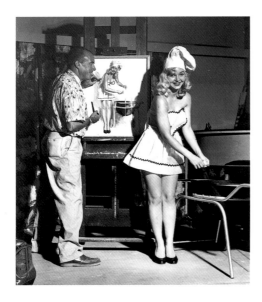

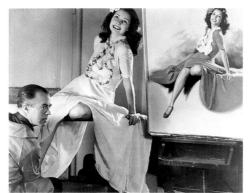

One of the century's most important pin-up and glamour artists, Earl Steffa Moran was born December 8, 1893, in Belle Plaine, Iowa. As a farm boy from the Midwest, he grew up to crave the lights and excitement of big cities. His first instruction in art came under the direction of John Stich, an elderly German artist who had taught the great illustrator W. H. D. Koerner. Moran also studied with Walter Biggs at the Chicago Art Institute, while working for a large engraving house that specialized in men's fashion illustrations.

After two years at the Institute, Moran headed for Manhattan and enrolled at the famed Art Students League, where he took instruction from the muralist Vincent Dumond, Robert Henri, Thomas Fogarty (Norman Rockwell's teacher), and the legendary anatomist George Bridgman. In 1931, he moved back to Chicago and opened a small studio, where he specialized in photography as well as illustration. Moran later sent some paintings of girls in bathing suits to two calendar companies as a way of introducing himself; when both Brown and Bigelow and Thomas D. Murphy Company bought the work, his career was officially launched.

In 1932, Moran signed an exclusive contract with Brown and Bigelow. His first pin-up for the company, *Golden Hours*, depicted a sensuous Art Deco girl in a baby blue bathing suit set against a brilliant orange background (figure 508). So successful was this image that it was licensed out for many uses, even as decoration for a huge five-pound box of chocolates.

Between 1933, when *Golden Hours* was first published, and 1937, when he burst upon the New York scene, Moran's pin-ups sold millions of calendars for Brown and Bigelow. In 1940, *Life* ran a feature article entitled "Speaking of Pictures", which focused largely on Moran's work and made him something of a national celebrity (figures 488, 514 and 515). In October 1941, he helped the brilliant magazine publisher Bob Harrison launch a new men's magazine called *Beauty Parade*, and he later contributed pin-ups to other Harrison magazines such as *Flirt*, *Wink*, and *Giggles*. By 1942, Moran had moved into a new studio on Fifth Avenue that became a meeting place for artists and café society celebrities. Two years later, his estranged wife, Mura, filed for divorce, bitterly accusing Moran of adultery with Chili Williams, a model and starlet known as the Polka Dot Girl. The press had a field day.

In 1946, having survived his scandalous divorce proceedings and having become Brown and Bigelow's best-selling pin-up artist, Moran packed his bags and headed for a sunnier life in Hollywood. He had already painted many movie stars, including Betty Grable, for publicity posters. Soon after his arrival, he interviewed a young starlet named Norma Jean Dougherty who wanted to model for him. For the next four years, Marilyn Monroe posed for Moran (figures 492, 504, 506 and 507), and the two became friends. She always credited him with making her legs (which she felt were too thin) look better than they were, and he once remarked that "her body was as expressive as her face, which made all the poses good".

Moran lived in the San Fernando Valley from 1951 to 1955, hosting fabulous parties, directing and starring in a short television film, painting portraits of Earl Carroll's Vanities Girls, and maintaining his position as a star of the pin-up world. After a move to Las Vegas about 1955 and several years of living in the fast lane, he returned to Los Angeles and worked two more years for Brown and Bigelow. Moran then decided to call it quits and to devote his time to painting fine-art subjects, with nudes as his favorite theme. Signing with Aaron Brothers Galleries, he painted for collectors until 1982, when his eyesight failed. He died in Santa Monica on January 17, 1984.

An expert on lighting his models and sets, Moran used photography especially skillfully to capture the candid, natural expressions he sought in his work. He worked in various mediums and sizes throughout his career, and his originals for the pin-up and glamour market varied widely in size. Generally, though, he was most comfortable with pastels and liked to work large – usually 40 × 30 inches (101.6 × 76.2 cm), on toothed paper mounted on heavy illustration board. He did paint in oil on canvas in the 1940s (figure 505) and in oil on canvasboard in the 1950s; occasionally he used gouache on illustration board. Some of his magazine work for Harrison is signed "Steffa" or "Black Smith".

Opposite page:
488

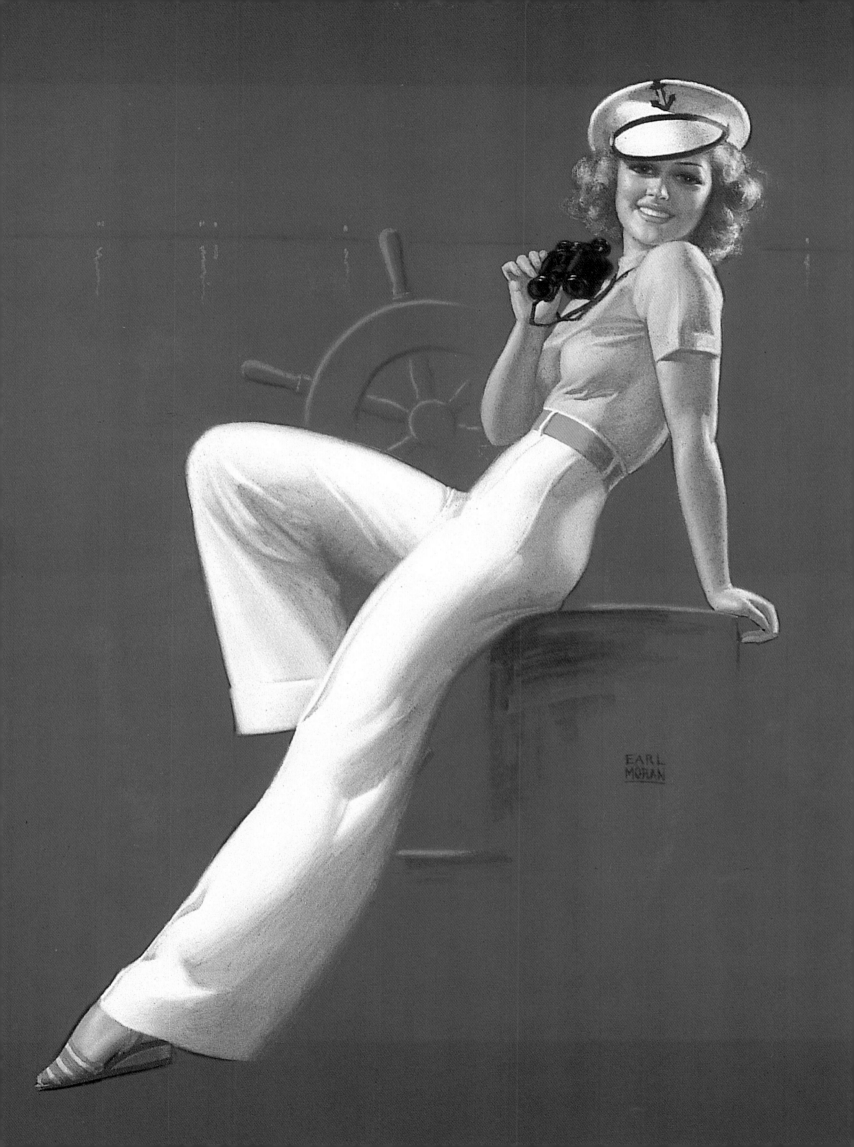

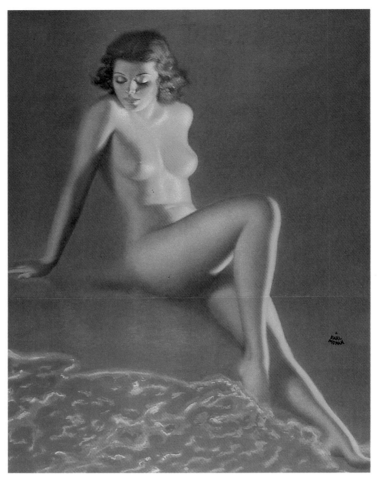

489

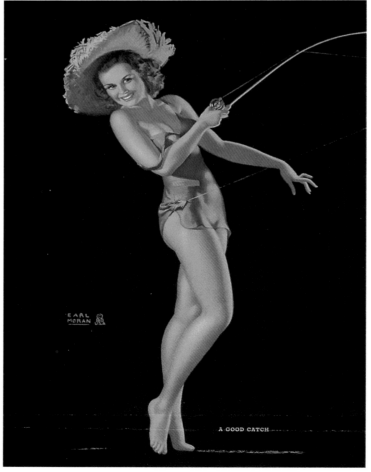

490

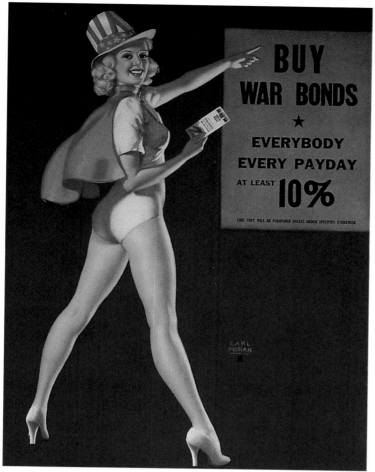

491

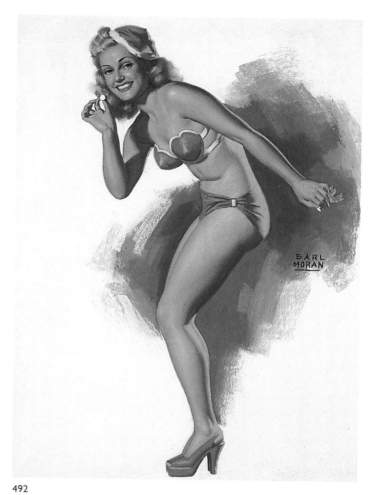

492

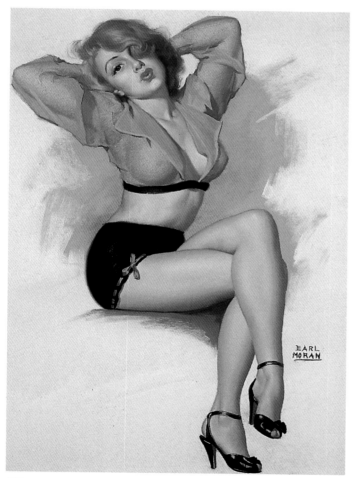

493

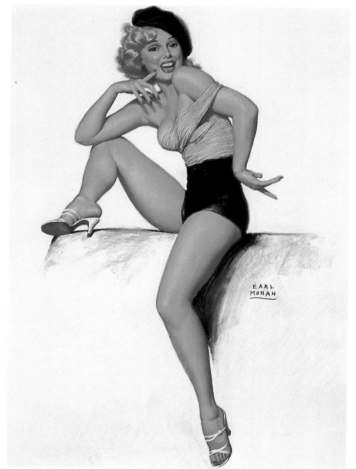

494

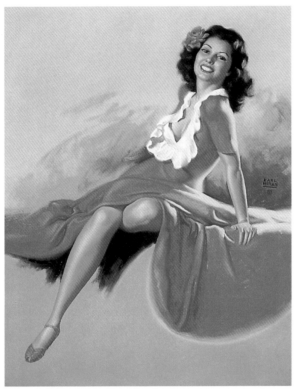

499

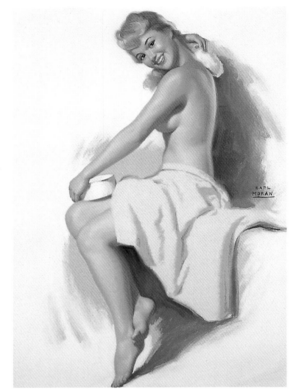

500

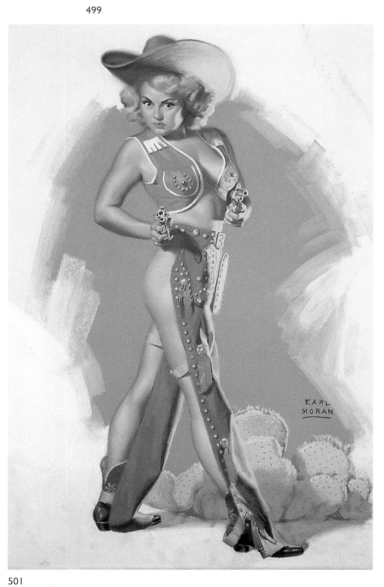

501

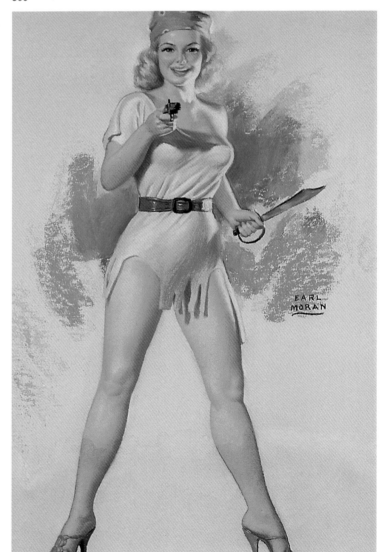

502

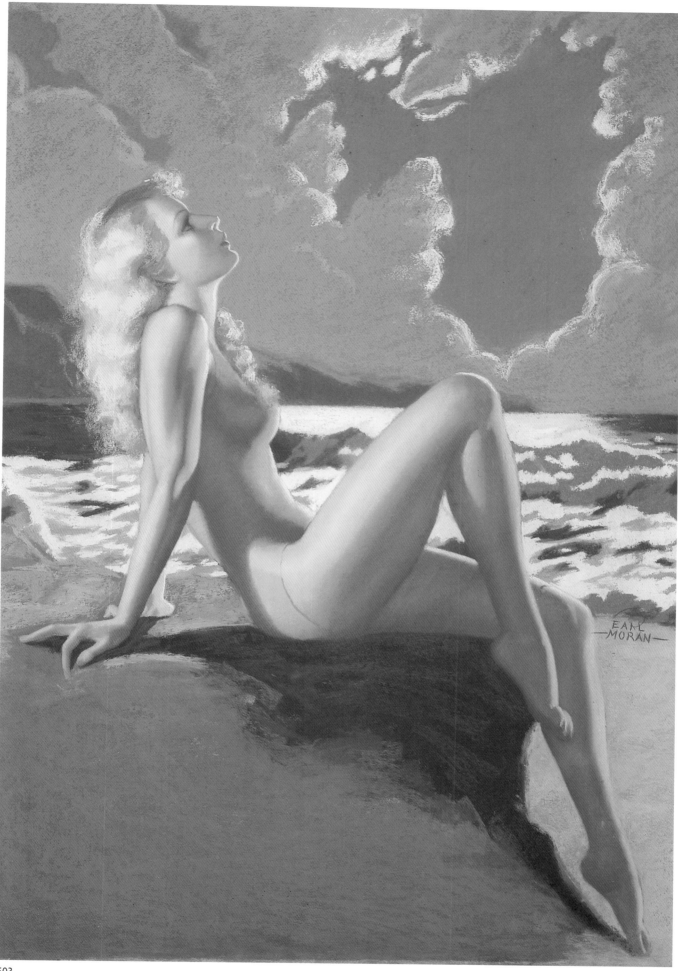

503

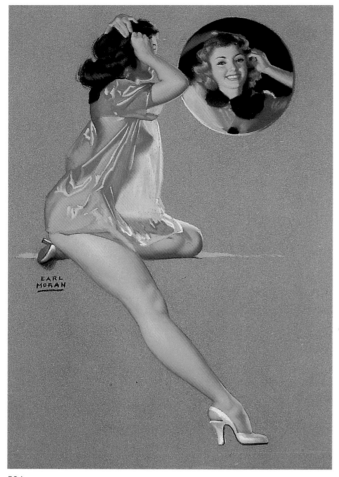

504

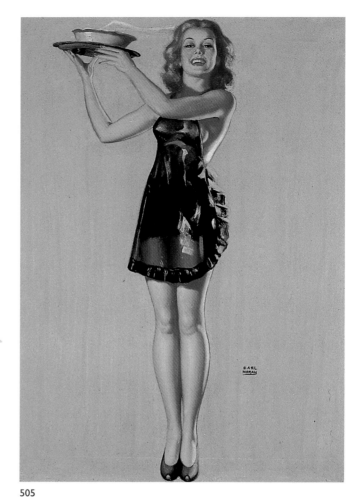

505

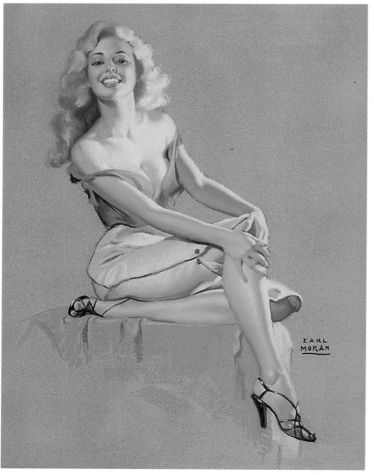

506

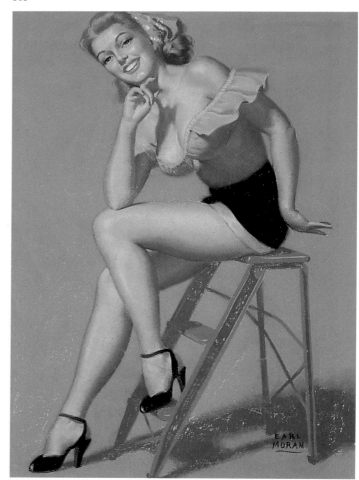

507

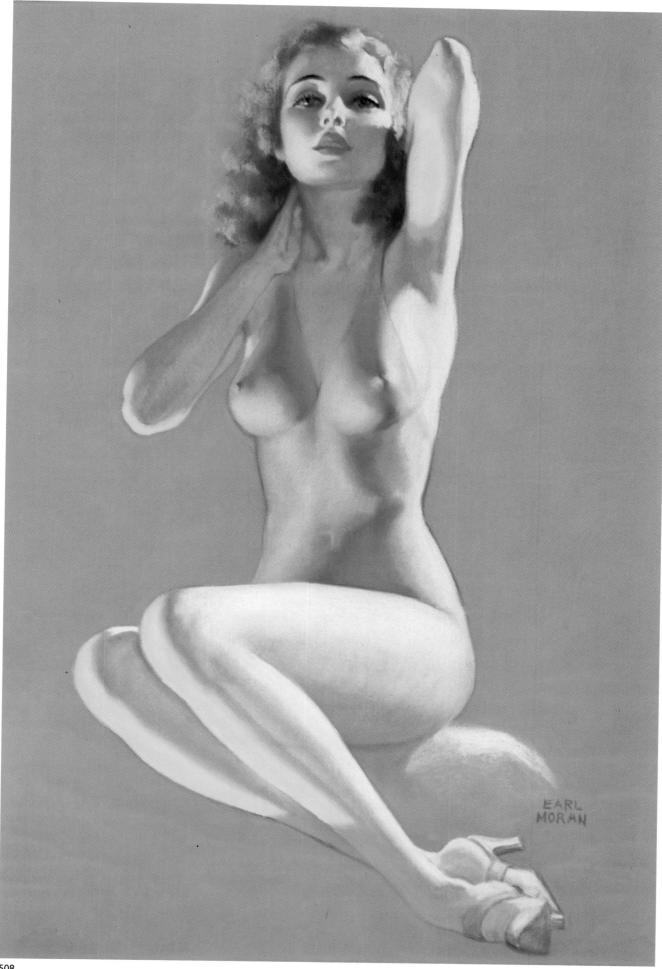

508

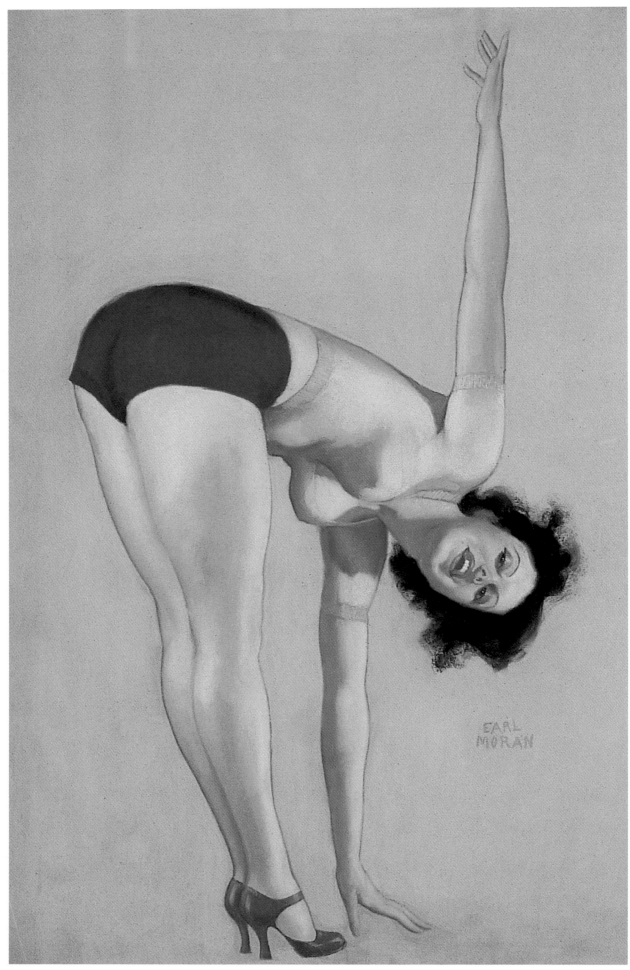

509

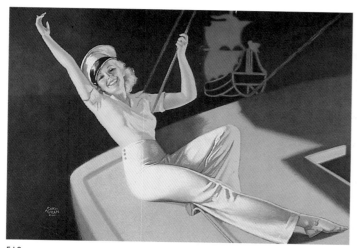

510

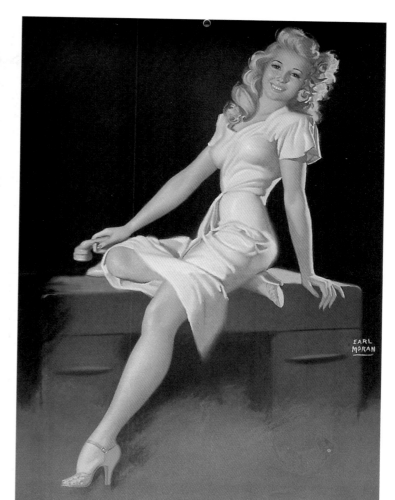

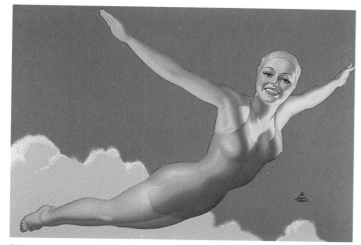

511

512

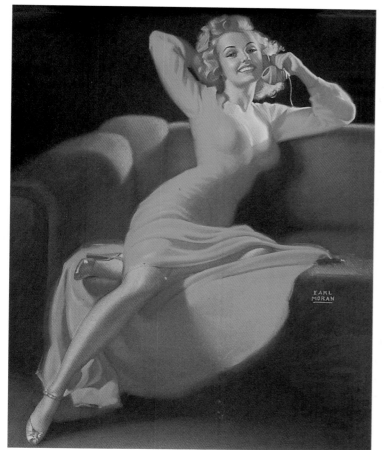

513

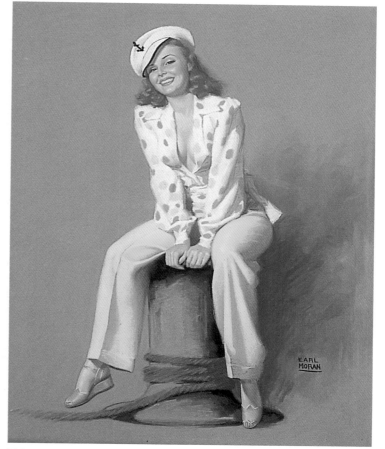

514

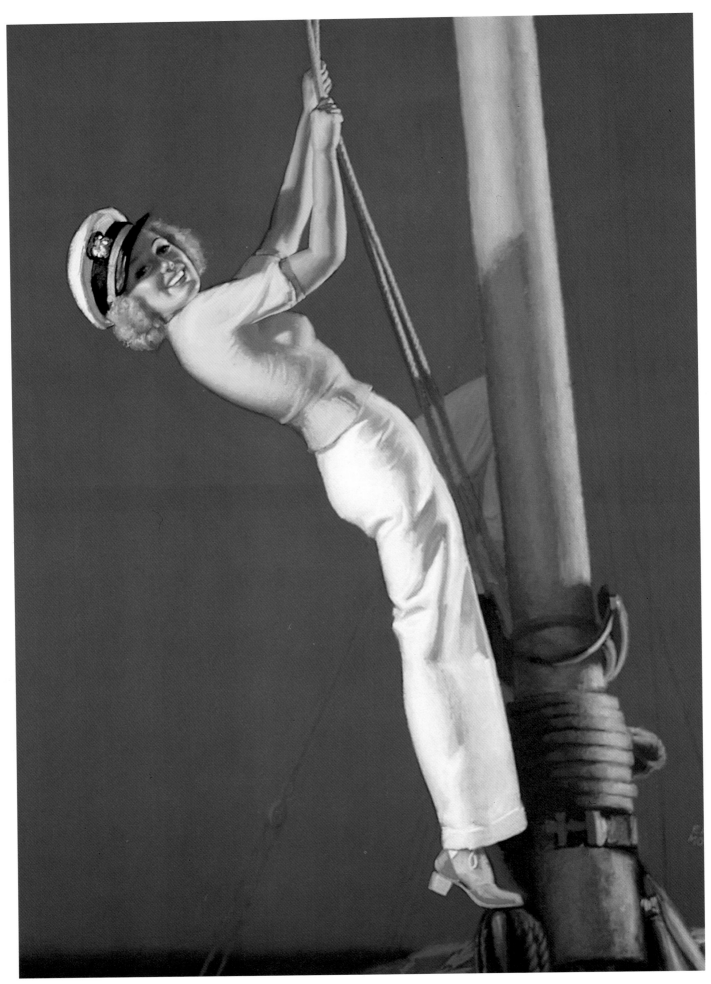

515

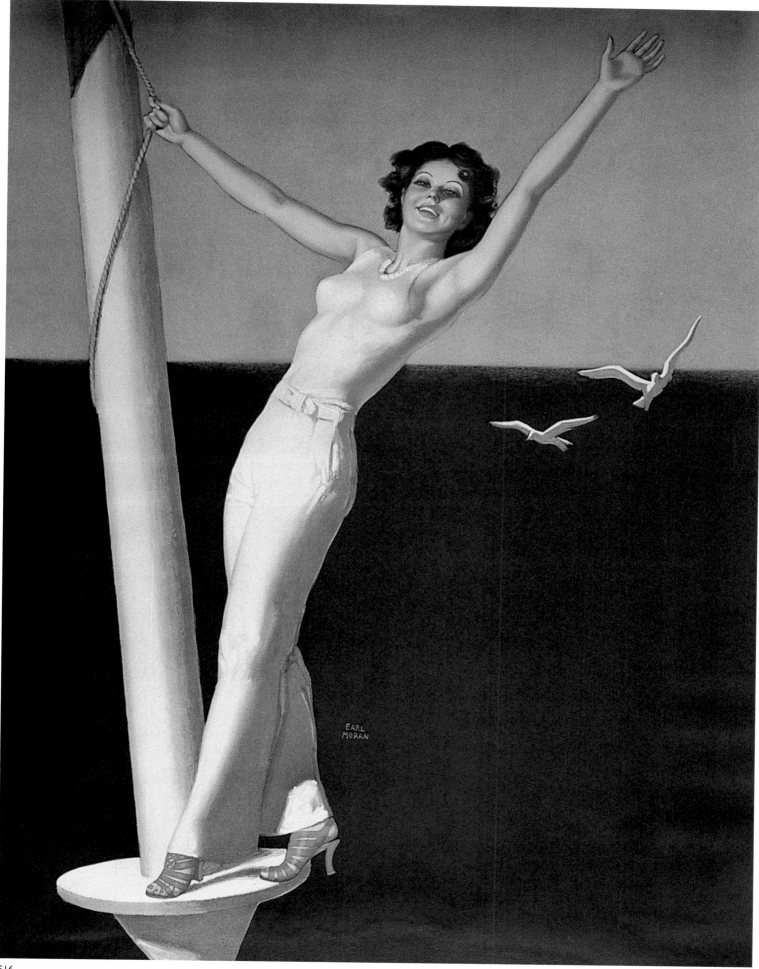

Zoë Mozert

Zoë Mozert, the most successful and publicly well known of the three female calendar artists, was born in 1907 in Colorado Springs, Colorado. As soon as she was old enough, she changed her real name, Alice Adelaide Moser, because she said she could never become famous with a name like that. In 1925, she entered the Philadelphia School of Industrial Art where she studied under Thornton Oakley, a former student of Howard Pyle. To pay her tuition, she modeled in art classes at the nearby Women's School of Design.

Mozert moved to New York in 1932. In the next four years, she painted more than four hundred front covers for movie magazines like *Screen Book* and *True Romance* and for pulp magazines like *Paris Nights*. In 1937, Paramount Pictures asked her to create advertising art for their film *True Confessions*, starring Carole Lombard.

Covers for Hearst's *American Weekly* followed, as did advertisements for Wing cigarettes featuring Greta Garbo and Clark Gable. Mozert was a judge at the 1938 Miss America Beauty Pageant, along with James Montgomery Flagg and George Petty. Interviewed in Atlantic City by Pathé newsreel, she was increasingly recognized as a top glamour artist, receiving assignments from Dell, Fawcett, Street and Smith, and King Features.

In 1941, Brown and Bigelow bought Mozert's first nude and signed her to an exclusive calendar contract. A poster for Howard Hughes' film *The Outlaw* added to her fame, and she was asked to appear in a 1945 Paramount Pictures film entitled *Unusual Occupations*. During the war, her pin-up series for Brown and Bigelow called Victory Girls was published both in calendar and mutoscope-card form. *Pic* magazine published an October 1946 cover story on Mozert entitled "Pin-Up Girl Who Paints 'Em Too!" – a reference to the fact that she was her own best model; she often posed herself before a mirror after she had skillfully manipulated the lights in her studio. She also worked as a consultant to the film *Never Say Good-bye*, about a calendar artist trying to paint the perfect pin-up.

After moving to Hollywood in 1946, Mozert created the publicity poster for Republic Pictures' *Calendar Girl*, a movie about the Gibson Girl. By 1950, she had become one of the "big four" at Brown and Bigelow, along with Armstrong, Moran, and Elvgren. Her nudes had become so popular that many of the firm's biggest accounts had standing orders for a specified number of calendars every time a new one was released. Her most popular image, *Song of the Desert* (1950), depicted an exquisite blonde nude and her Arabian horse. She and Armstrong had introduced horizontal pin-ups to Brown and Bigelow's hanger line, and their cowgirl pin-ups were highly successful in that format.

Mozert left Hollywood for Arizona in 1956. Her 1958 marriage to the artist Herb Rhodes ended two years later in divorce. She died in Arizona on February 1, 1993.

522

Opposite page:
523

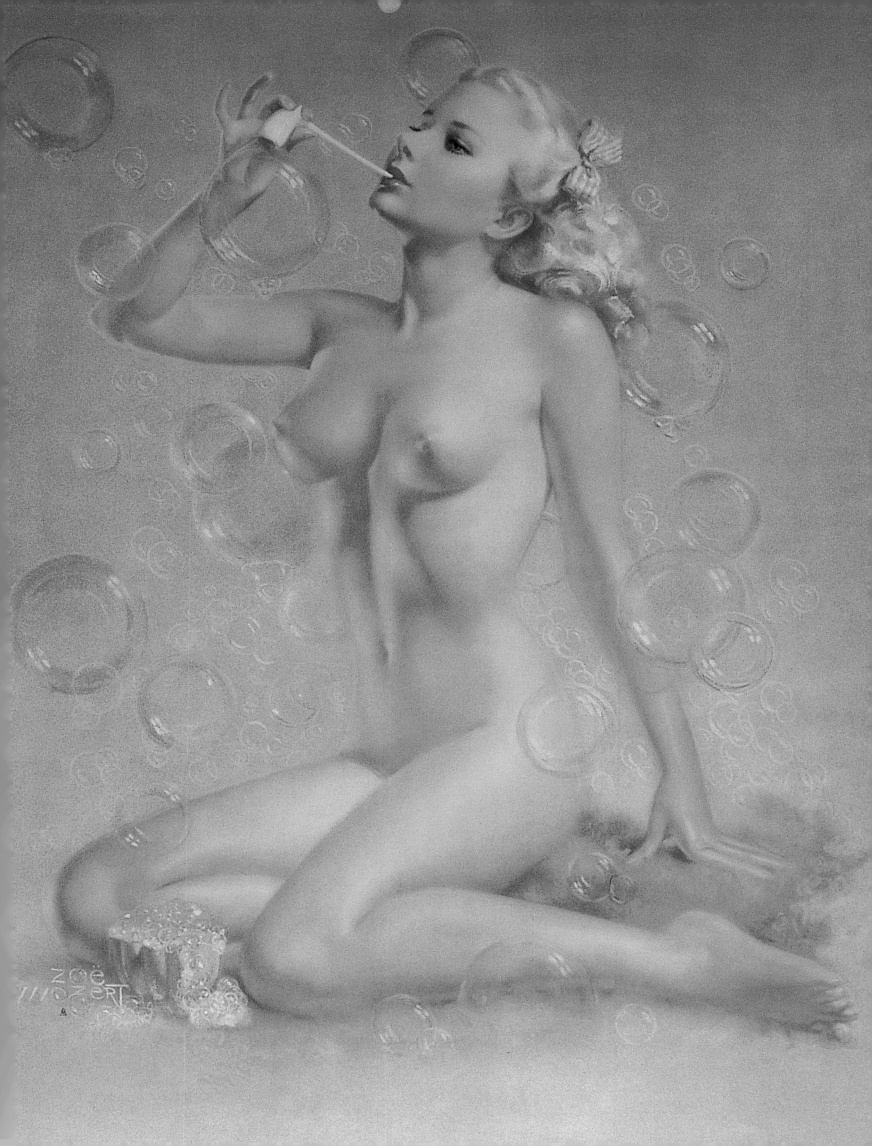

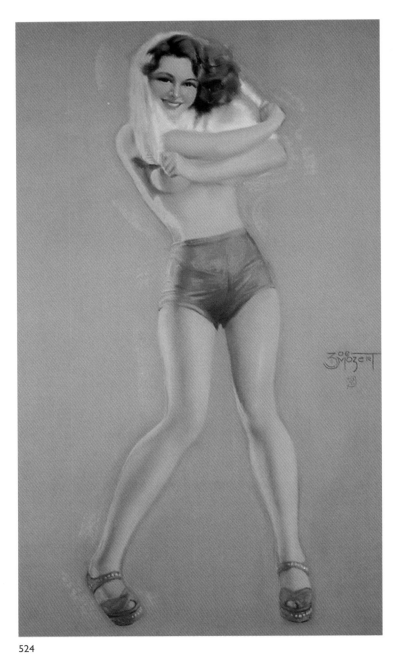

524

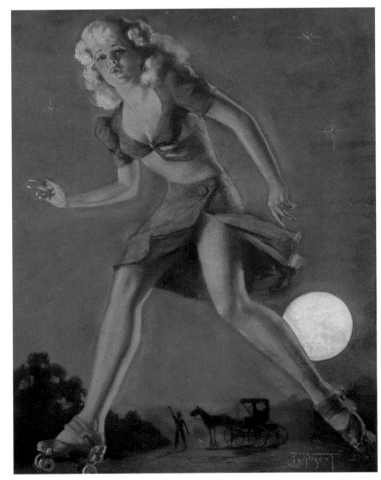

525

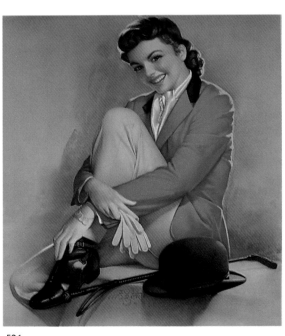

526

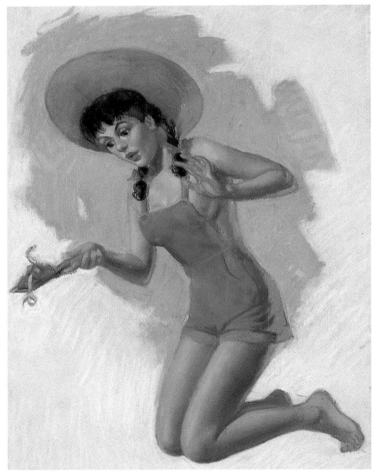

527

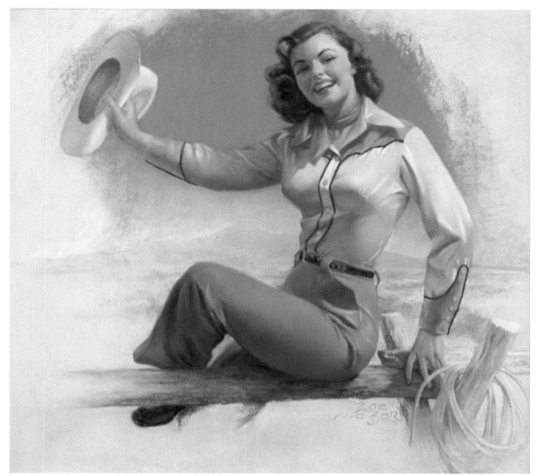

528

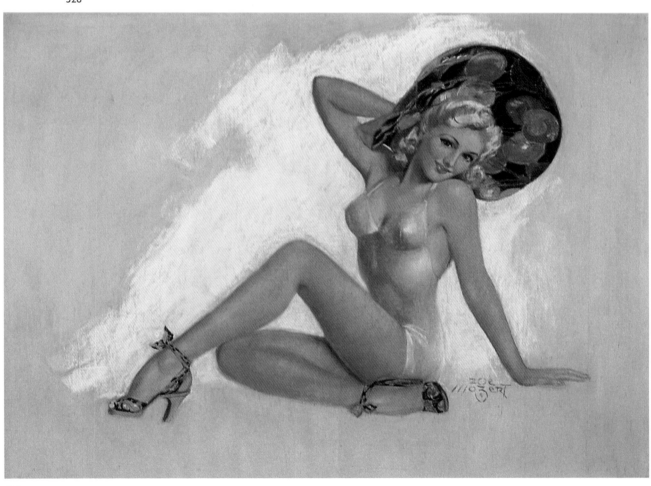

529

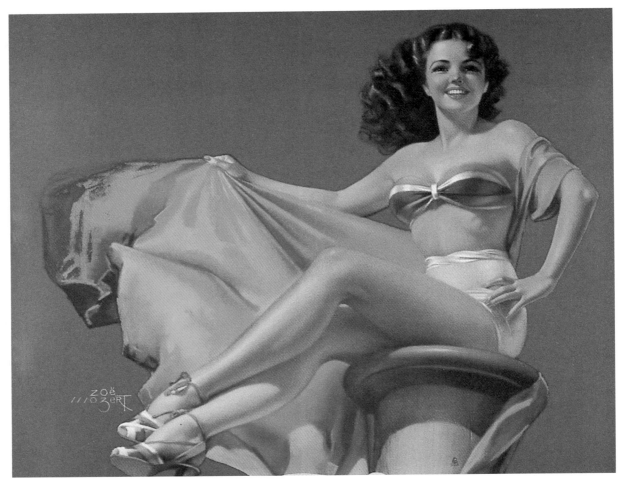

546

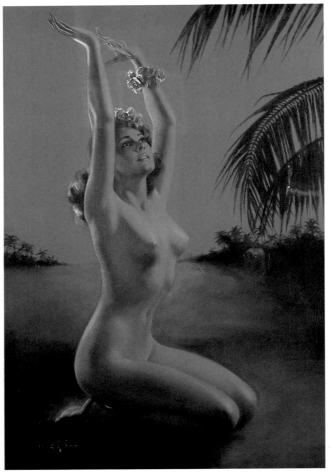

547

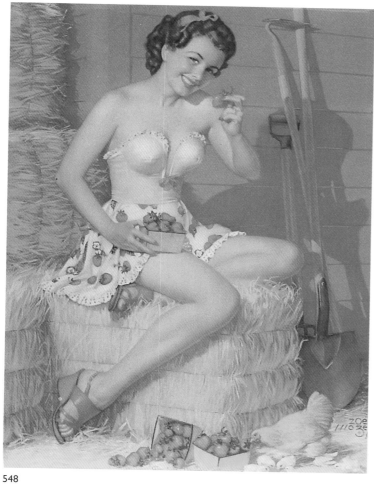

548

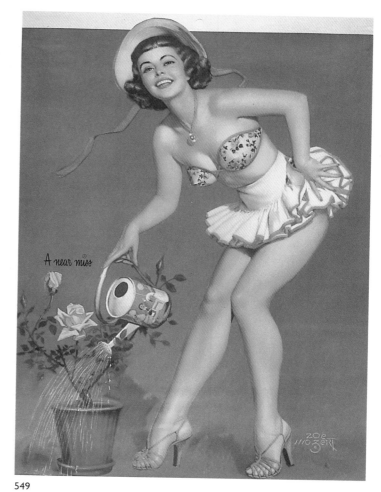

549

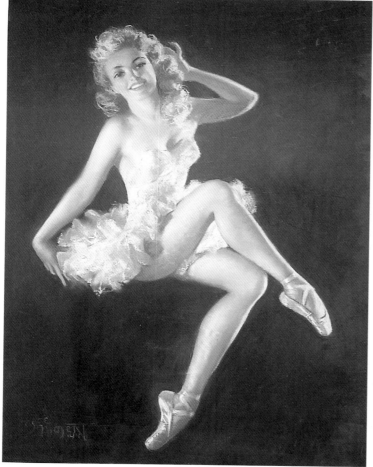

550

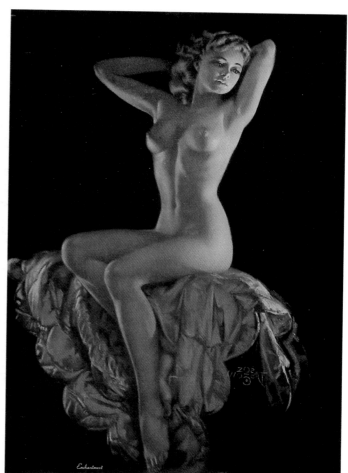

551

K. O. Munson

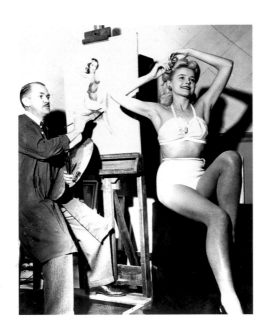

Knute (K. O.) Munson was born in Oslo, Norway, and grew up in Sweden. His family moved to the United States when he was a teenager and settled in Michigan. Munson received his first commission before he ever studied art, when a local doctor hired him to draw medical illustrations for his lectures on surgery. Munson went to Chicago when he was twenty-three to study at the Academy of Fine Art and the American Academy of Art, where his teachers included Andrew Loomis. He later studied with Harvey Dunn at the Grand Central School of Art in New York City.

Returning to Chicago, Munson got a job illustrating catalogues for men's clothing and accessories and became on the job friends with Earl Moran. Loomis later advised Munson to consider advertising art as a career and referred him to Outdoor Advertising Incorporated, where he painted advertisements for Milky Way candy bars. In 1936, Munson received a call from Moran, who was then a staff artist at Brown and Bigelow. Moran told him the firm had liked the samples he sent and that he should "grab [his] paint brushes and get here right away".

Seven years later, Munson inherited the firm's popular Artist's Sketch Pad calendar when Earl Mac Pherson entered the service. He revised the calendar a bit, applying a vignette technique inspired by Dean Cornwell's work that produced the overall effect of an intimate studio work. Munson's pastels for the calendar featured healthy, vital women, full of warmth and softness.

In 1945, Brown and Bigelow used Munson's pin-ups for their Direct Mail Calendar line. He continued to produce dozens of pin-up paintings and drawings for the firm until 1949, when he decided to return to Chicago. There he kept busy as a freelancer. Earl Carroll's Theatre Restaurant in Los Angeles, billed as "the Glamour Spot of Hollywood", commissioned him to do a painting for an over-size souvenir postcard. Among his many advertising jobs were assignments from Lucky Strike cigarettes, Kelly-Springfield Tires, U.S. Rubber Corporation, and Goodrich Tires.

During his years at Brown and Bigelow, Munson had become an accomplished color photographer, and in his new studio on Chicago's North Side, he added photographic work to his commercial art jobs. In 1958, *Artist and Photographer* magazine ran a cover story entitled "K. O. Munson and His Glamour Queens". Munson, described as "unpretentious, congenial, frank", reflected as follows on the interplay between painting and photography: "The camera becomes one of the painter's most useful and important tools. Painting, on the other hand, with its centuries of tradition and its massive accumulation of knowledge has been invaluable to the photographer. . . Each has much to offer the other".

Opposite page:
552

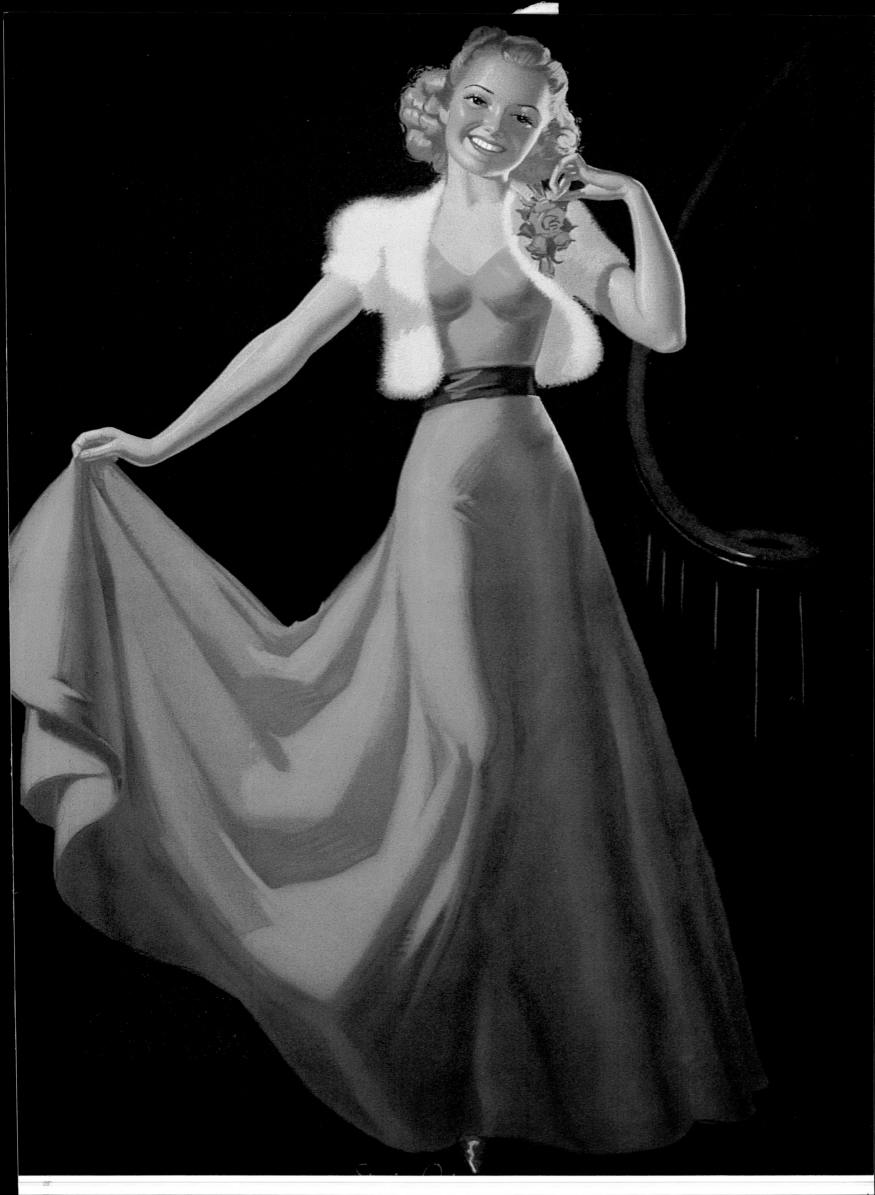

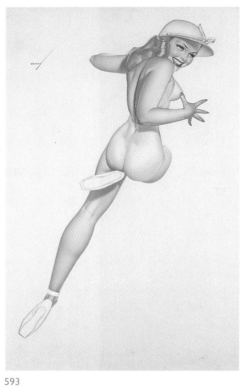

593

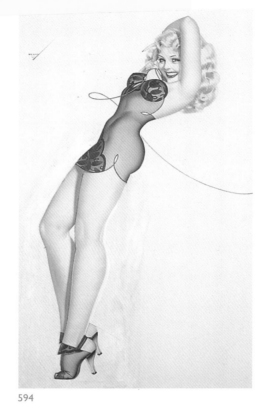

594

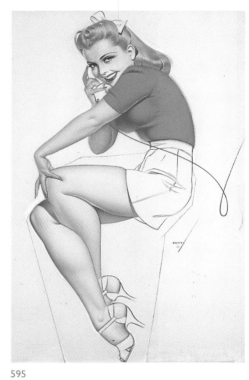

595

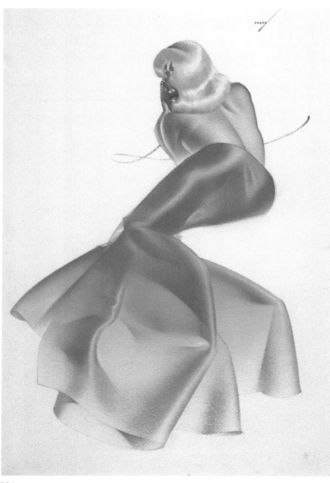

596

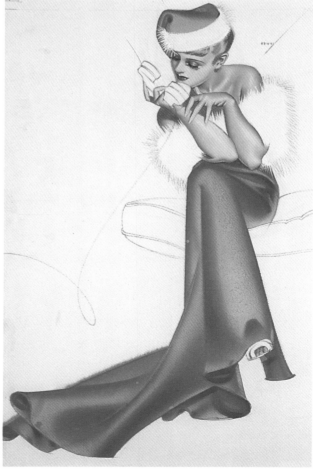

597

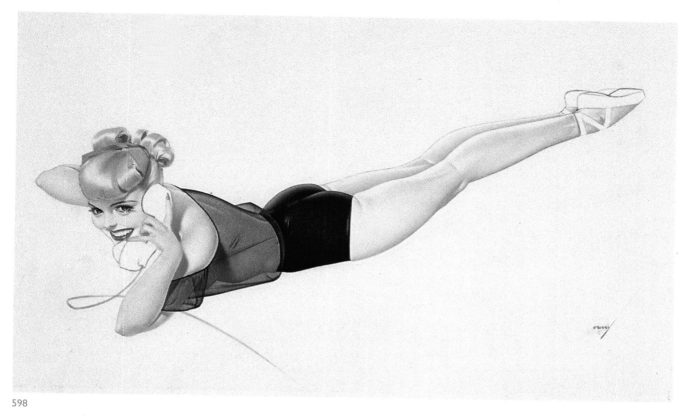

598

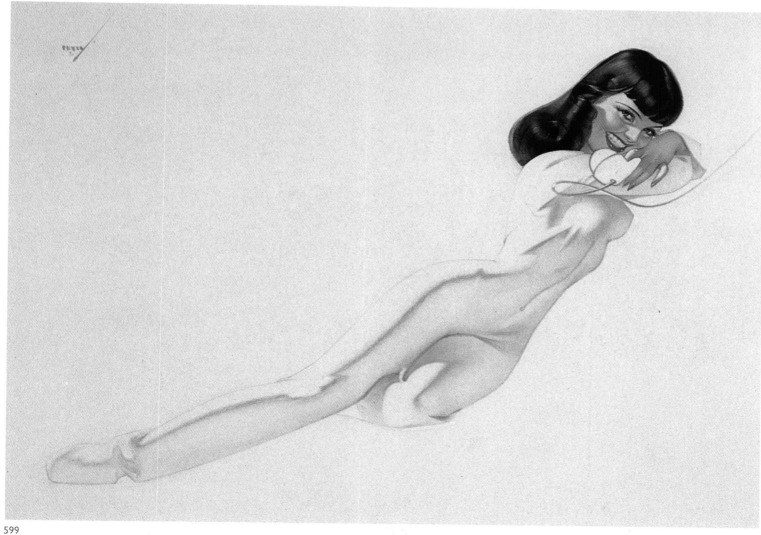

599

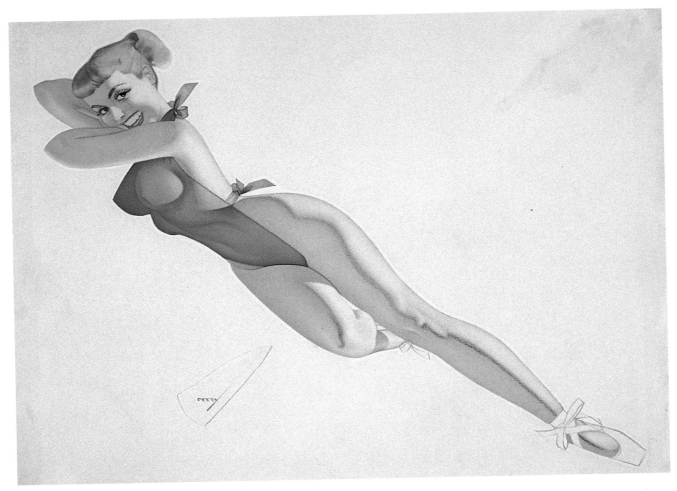

600

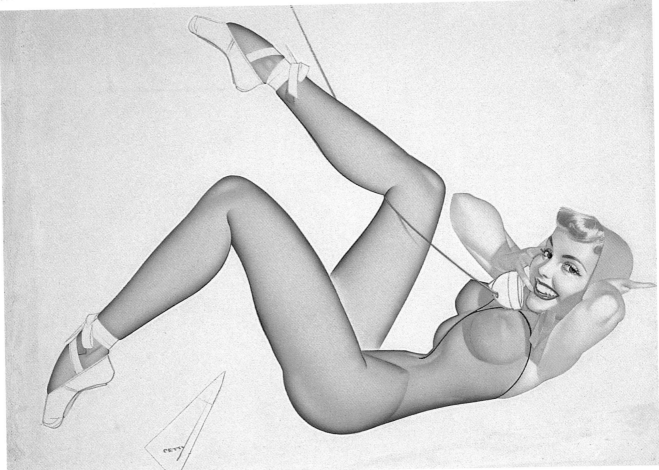

601

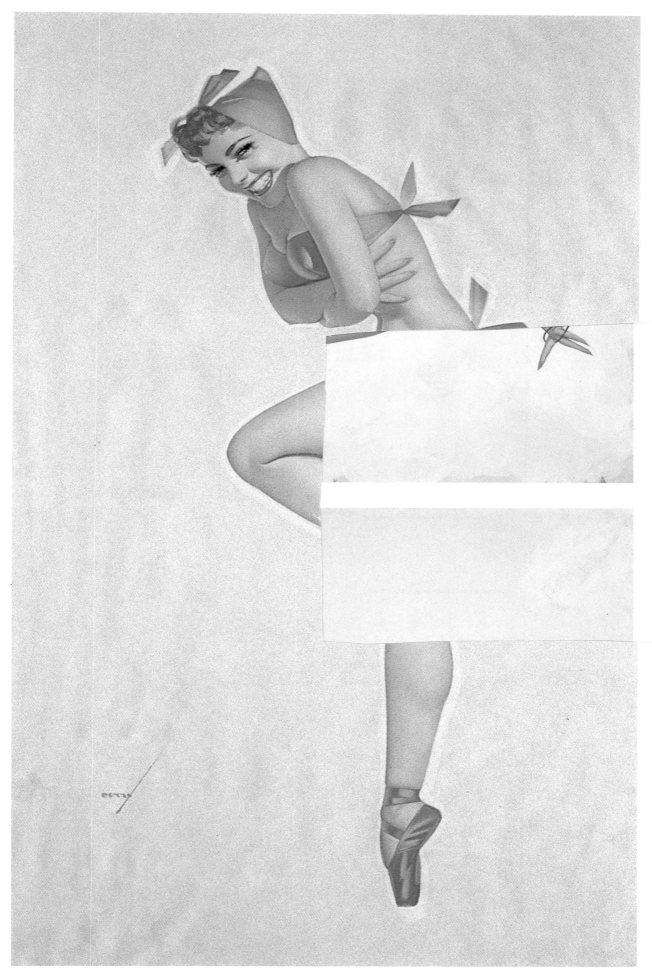

602

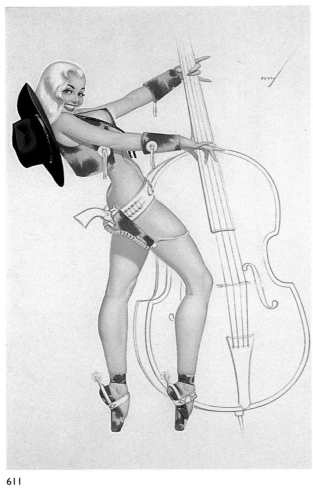

611

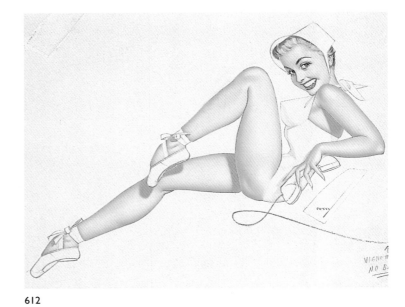

612

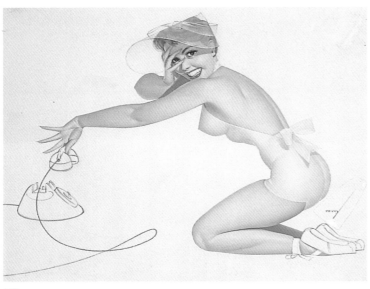

613

614

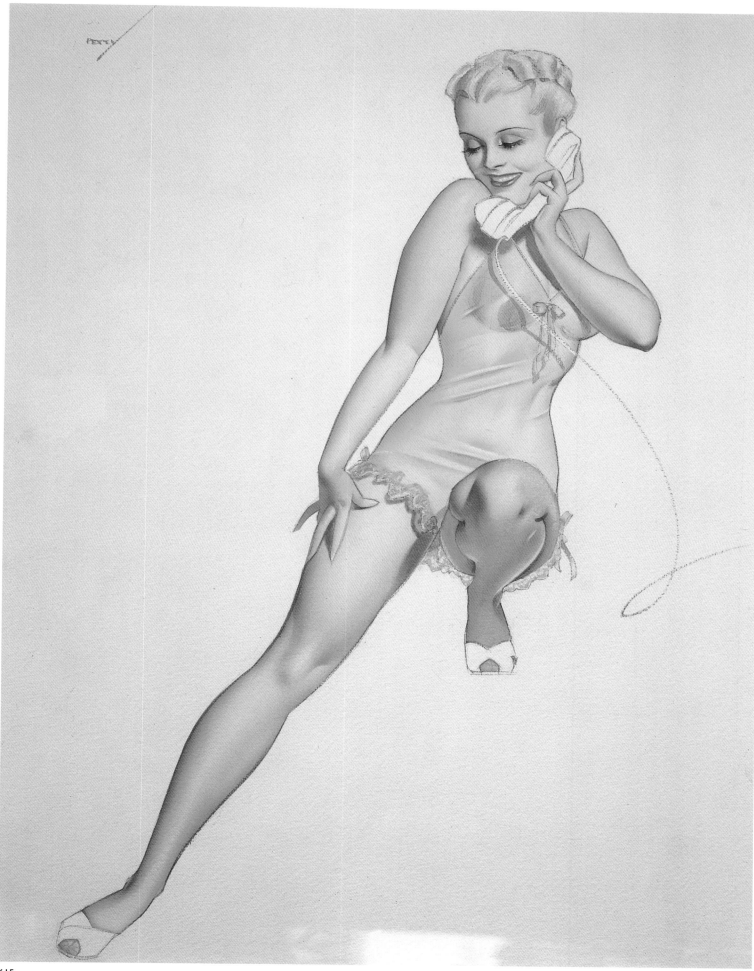

615

Edward Runci

Ed Runci was an outstanding painter of pin-ups during the 1940s and 1950s whose smooth style was much admired by his contemporaries. Unlike the other artists who came out of the Sundblom school, Runci applied his paint in thin, flat brushstrokes that created a soft-focus, Photo-Realist effect.

The child of Italian immigrants, Runci was born in Genua, Italy, of Sicilian descent, and lived in Italy until the age of 10. He died of pneunomia in 1985 in San Bernadino, California, at the age of 65. During World War II, he fought with the Marines at Guadalcanal. Later, his difficult convalescence from the horrors of that experience was helped by a nurse who encouraged him to draw. Back home in Detroit, he continued practicing his art and began experimenting with oil paints.

Seeking models for his work, but too shy to approach strangers, Runci enlisted his mother's help: it was she who persuaded a beautiful young woman who worked at a defense plant to pose for her son. Jeanette would become Runci's most famous model as well as a close friend. About 1947, he married an accomplished artist named Maxine and the two established a home and studio near Big Bear, an isolated spot perched high in the mountains near Santa Barbara.

After selling his first glamour painting to the Shaw-Barton calendar company in 1947, Runci teamed with Maxine to paint nine glamour images for Brown and Bigelow. Yet it was his subsequent work for Shaw-Barton that immortalized Runci's name as a pin-up and glamour artist. That firm's outstanding national marketing campaign promoted his work effectively for many years. All the spectacular pin-ups the artist delivered to Shaw-Barton shared one trait: the Runci girls were always happy, even when caught in awkward situations.

At the peak of his career, Runci finally came to terms with the trauma that had haunted him since Guadalcanal and, in gratitude, painted a portrait of Christ that went on to become a much-beloved religious calendar subject. When Maxine died, he lived for a while in Arizona, where he fulfilled a lifelong dream to paint Western scenes. He was living on the California ranch of Jeanette and her husband Frank when he died.

Runci used two different signatures on his pin-up and glamour paintings: one in a beautiful script, the other in a more printed, block style. He is known to have signed a few pin-ups with the name "Stevens" (figure 625). Maxine signed her paintings with an exaggerated block signature, using an over-size R in her last name.

Opposite page:
616

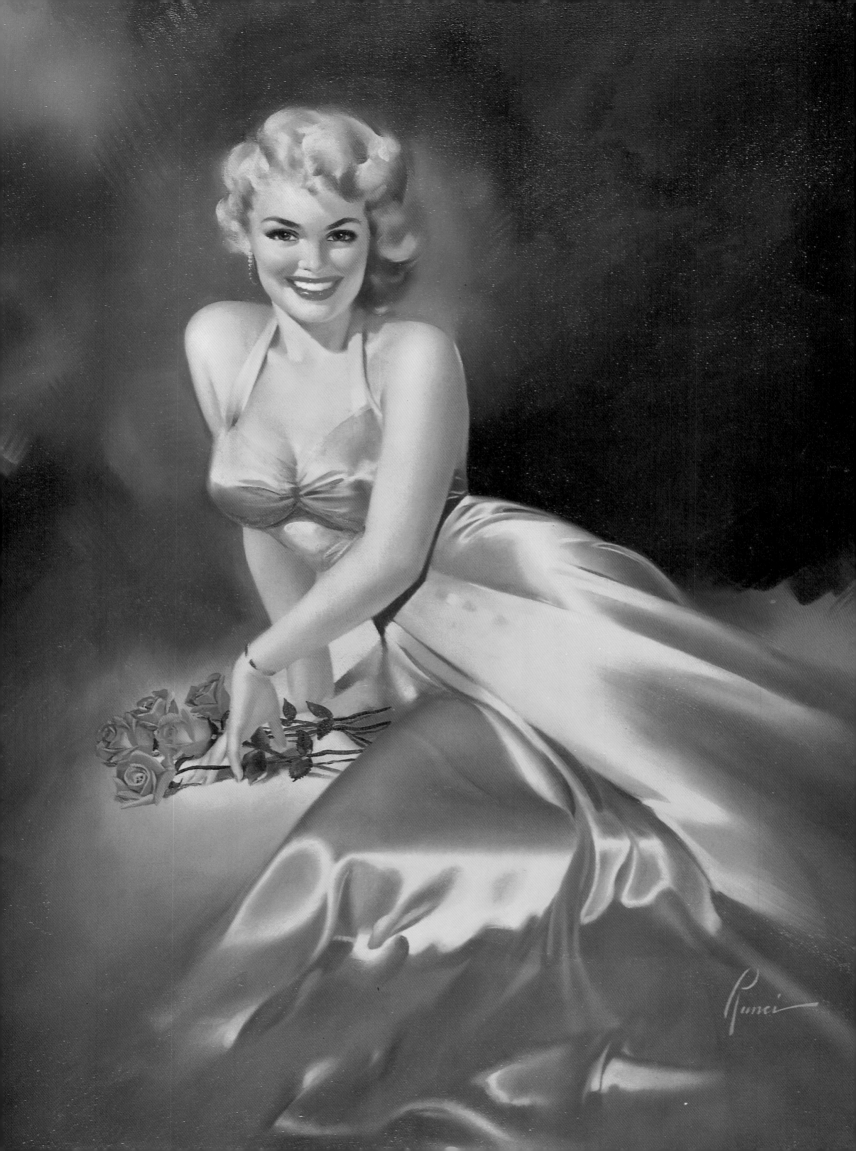

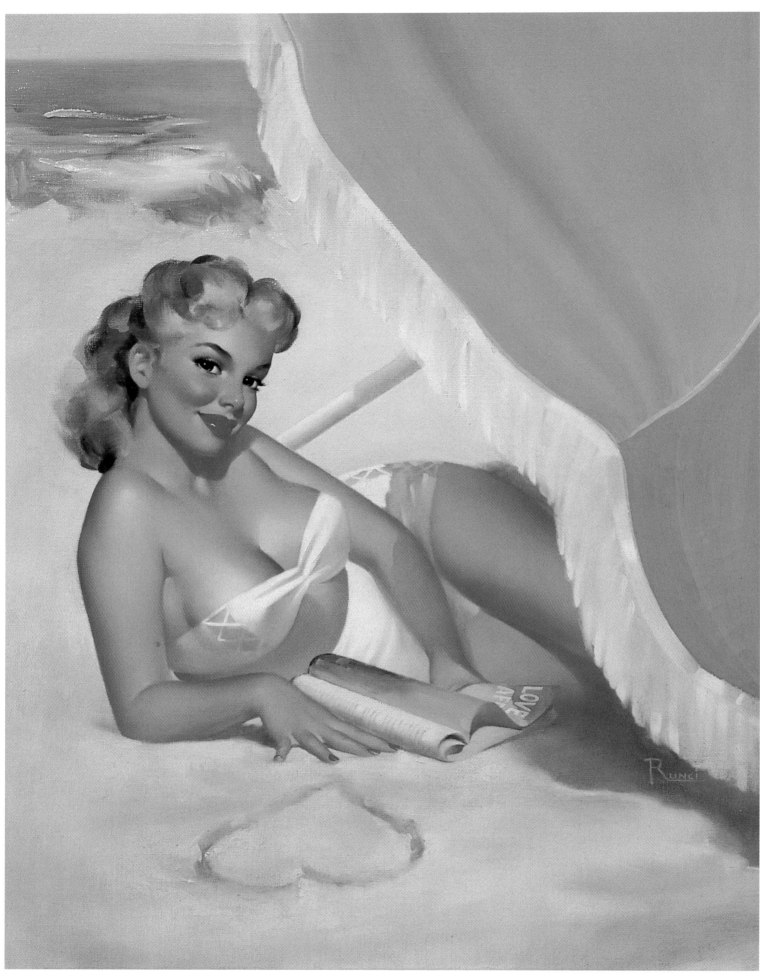

617

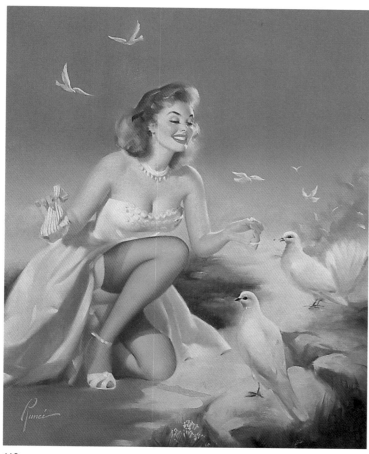

618

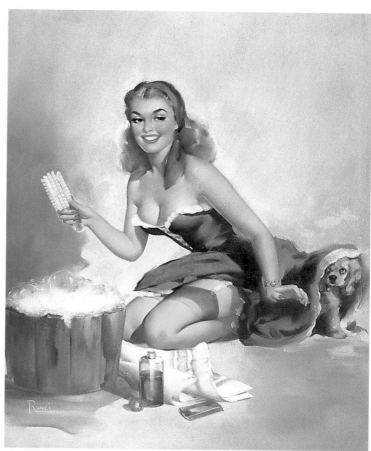

619

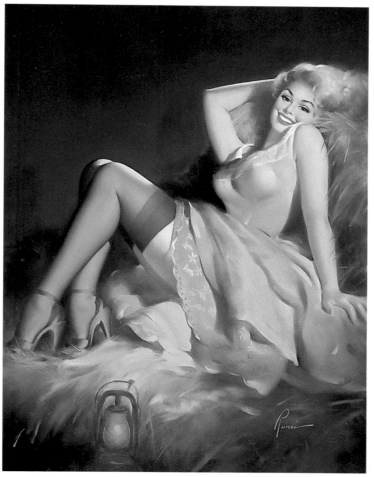

620

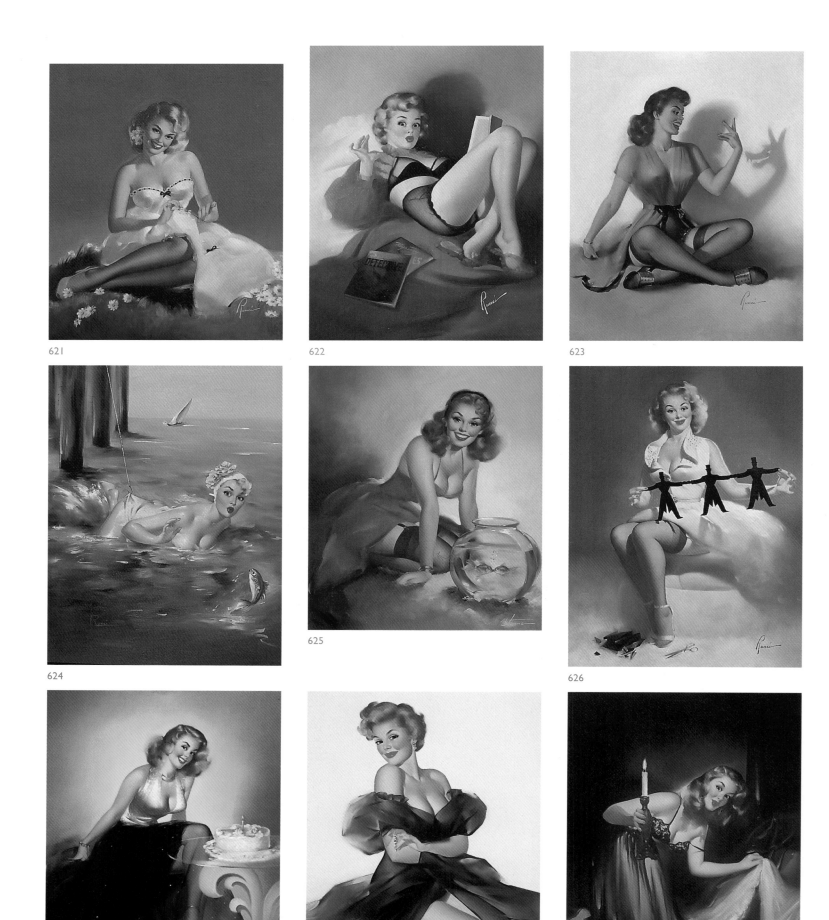

621

622

623

624

625

626

627

628

629

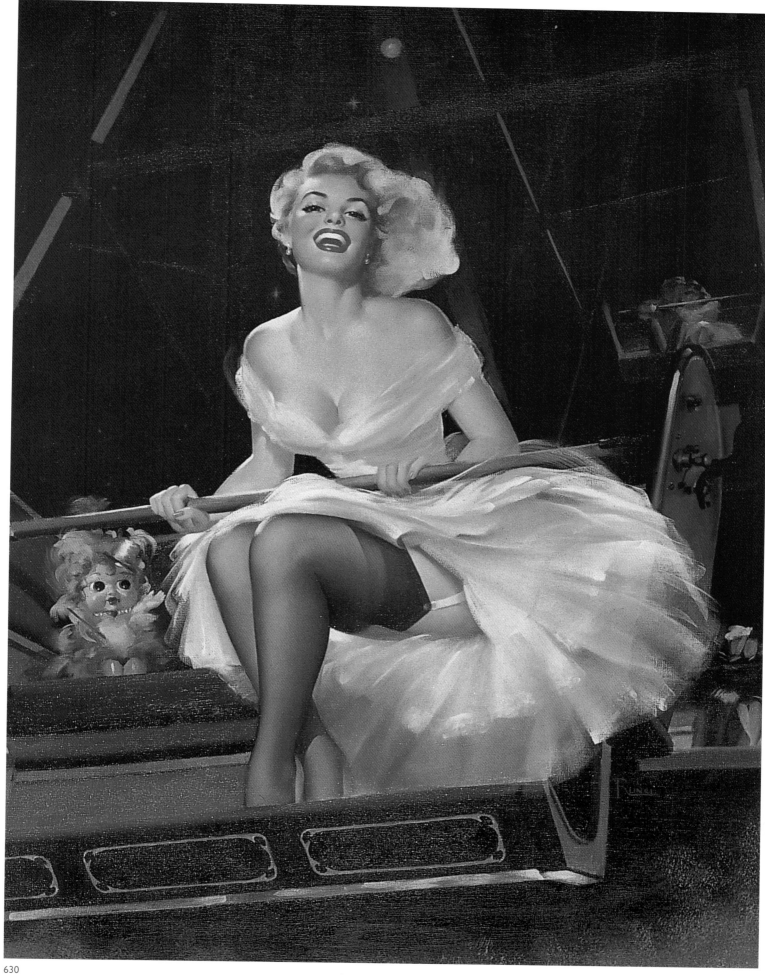

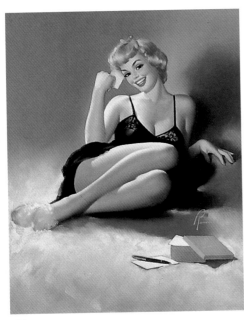

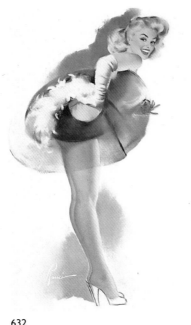

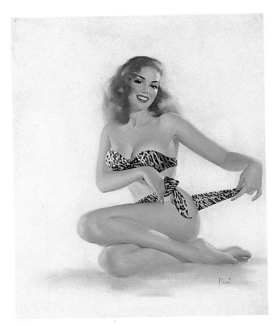

631

632

633

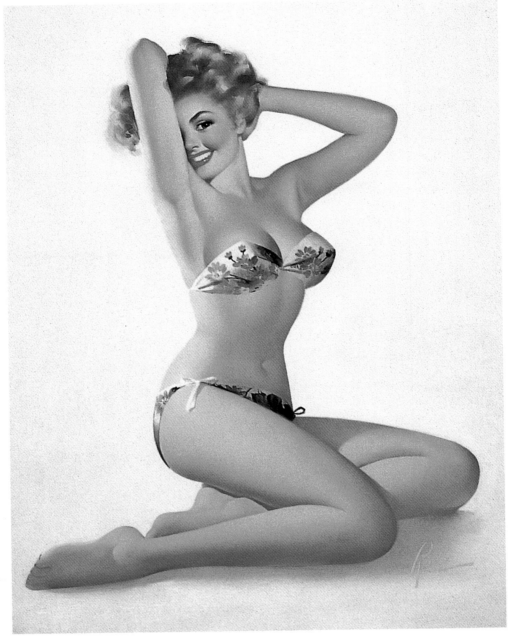

634

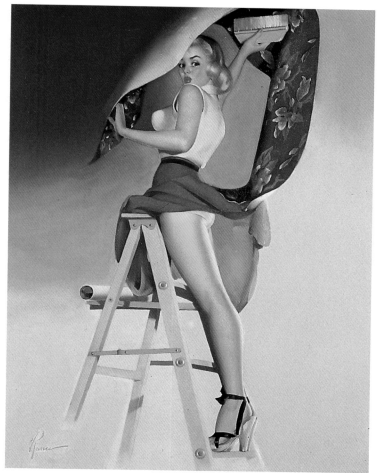

635

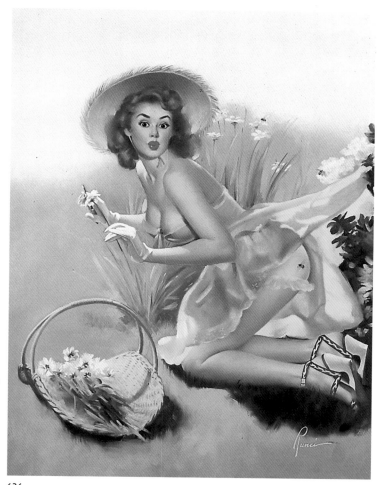

636

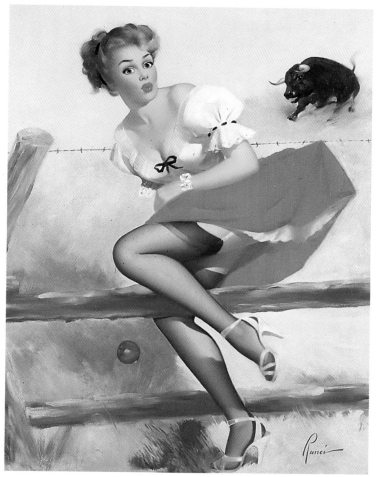

637

T. N. Thompson

From its initial publication in 1943, the Artist's Sketch Pad was a yearly institution in the calendar-publishing business. Originally created by Earl Mac Pherson for Brown and Bigelow, the calendar's format was adopted by most major pin-up publishers for almost twenty years. There were twelve one-sheet pages of pin-ups, spiral bound along the top of the calendar, that featured a central image surrounded by a group of smaller ones.

About 1948, Mac Pherson hired an assistant named Jerry Thompson, an accomplished artist who wanted an opportunity to improve his pin-ups. When Mac Pherson was stricken with polio late in 1951, Thompson found himself with the responsibility of painting the yearly Mac Pherson Sketch Book for the Shaw-Barton calendar company. He handled this project until 1958, while also creating a similar calendar for the John Baumgarth Company of Melrose Park, Illinois.

One image from the Baumgarth calendar, published in September 1952, was also sold as a single, one-sheet "hanger" calendar. Entitled *Want to See Me Swing My Baton?* (figure 649), this image of a majorette was Thompson's most popular and one of the company's best money-makers. More than a million matchbooks with this picture were sold to advertisers who wanted their products or businesses associated with its all-American baton girl.

Thompson also had pin-ups published by the Kemper-Thomas calendar company. In 1950, he did a well-received series of advertising paintings for Dodge Trucks that featured scenes on a farm with horses and shiny new pickup trucks (figure 656).

Thompson painted both on canvas and illustration board. Unlike Mac Pherson, he often combined mediums in the same painting, adding pastel, gouache, charcoal, and graphite to his oils. His paintings ranged in size from 20 x 16 inches (50.8 x 40.6 cm) to 36 x 28 inches (91.4 x 71.1 cm). Only about half of his commercial pin-ups are signed.

Opposite page:
638

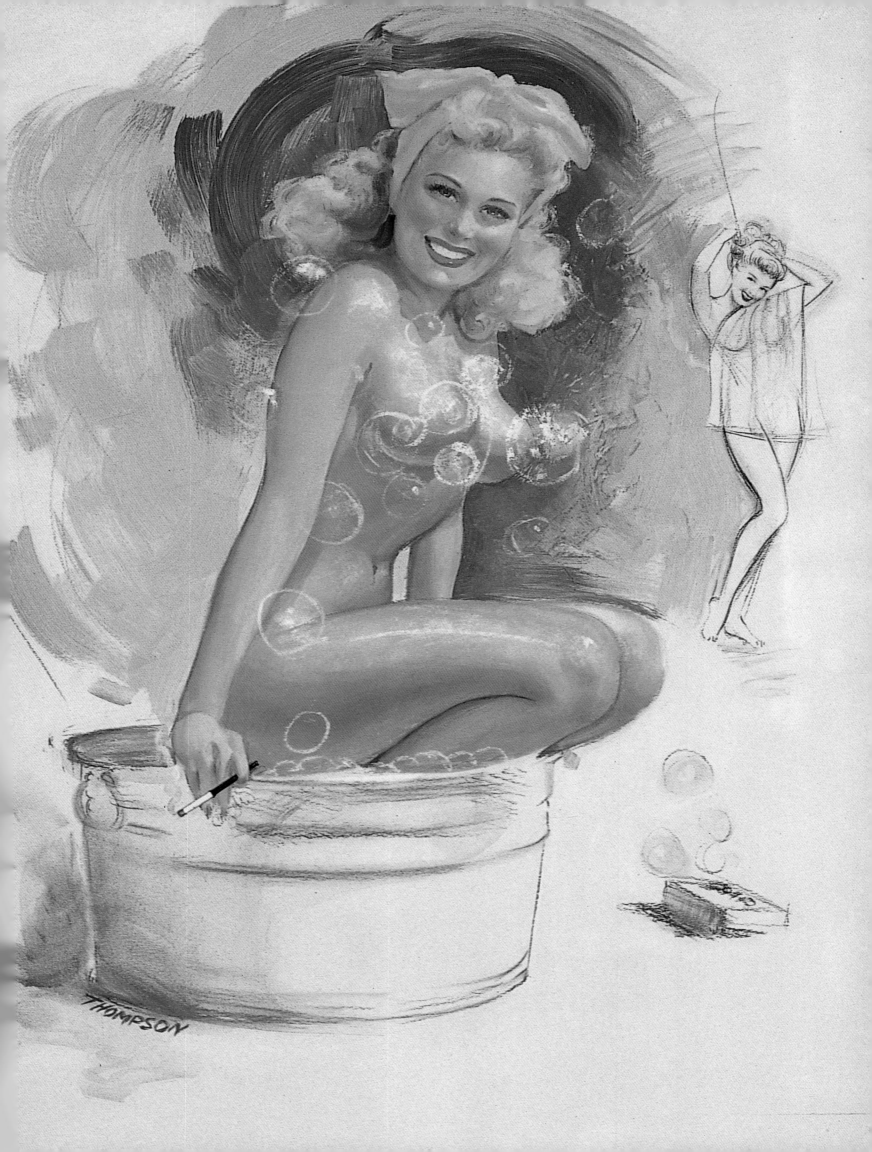

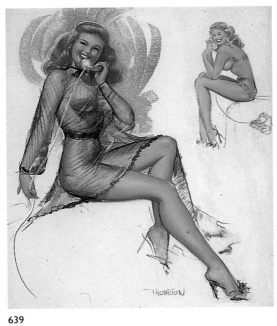

639

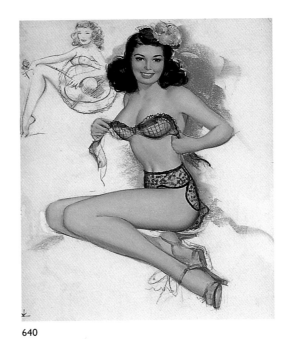

640

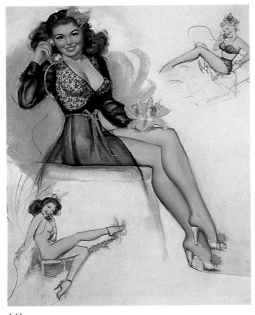

641

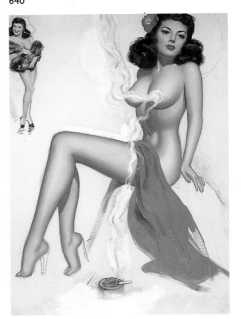

642

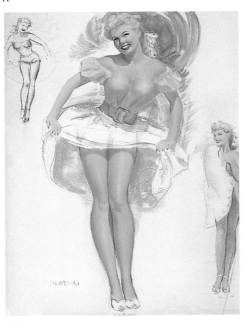

643

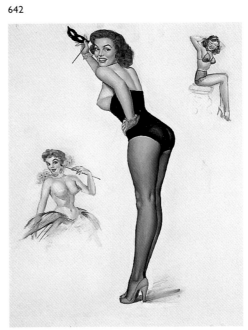

644

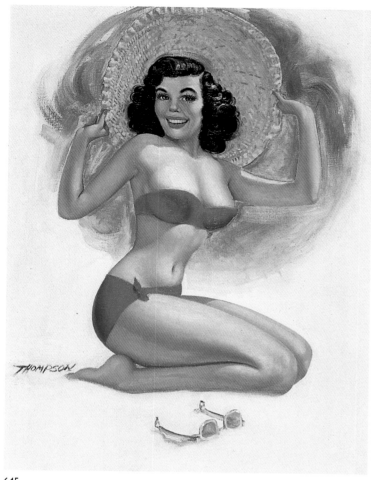

645

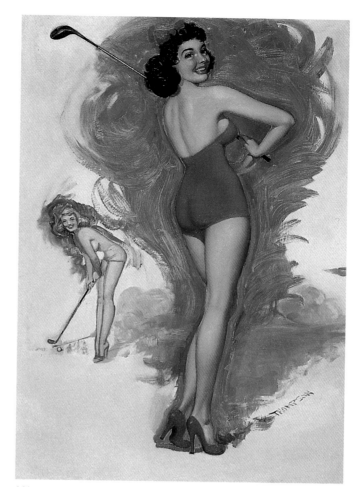

646

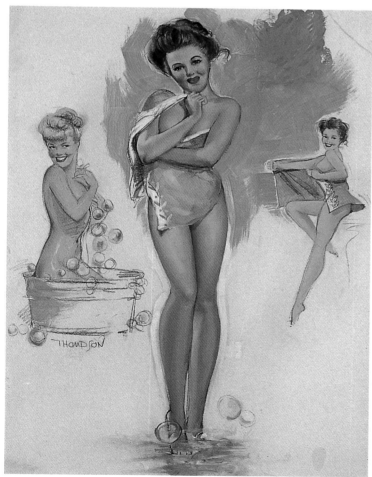

647

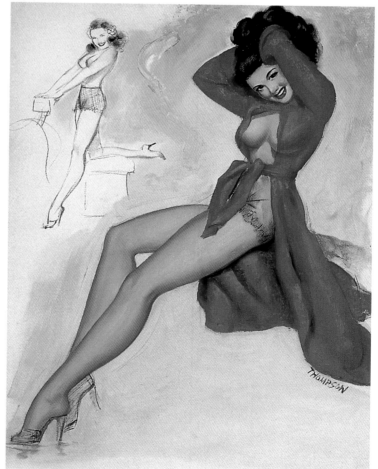

648

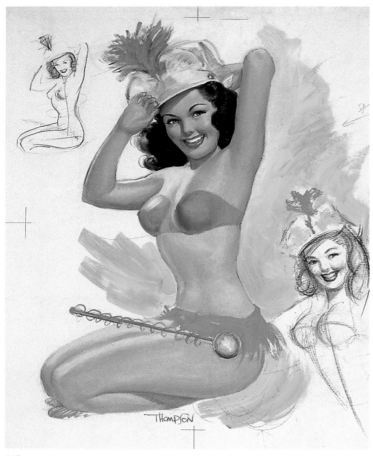

649

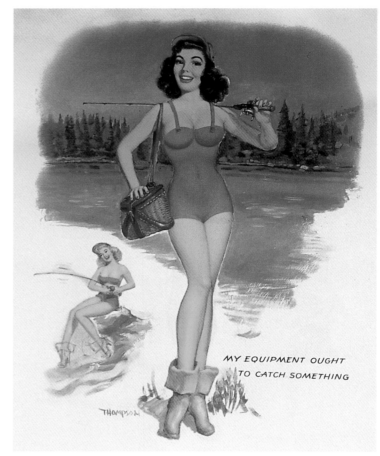

MY EQUIPMENT OUGHT
TO CATCH SOMETHING

650

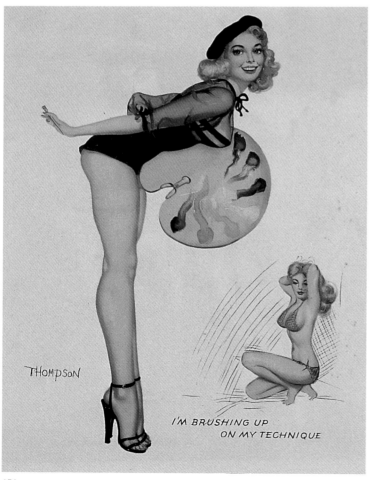

I'M BRUSHING UP
ON MY TECHNIQUE

651

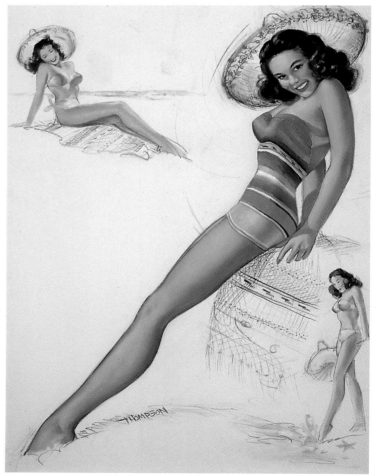

652

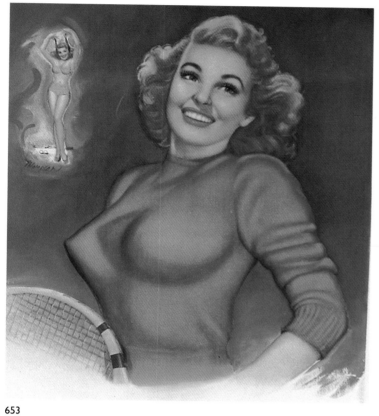

653

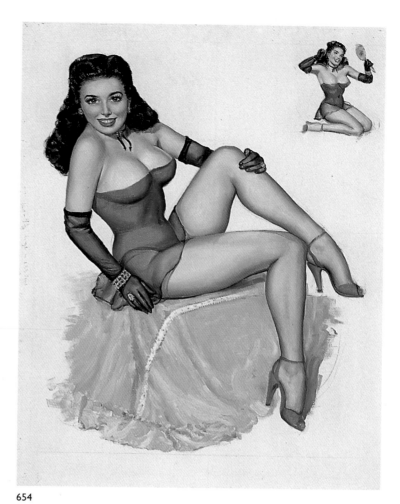

654

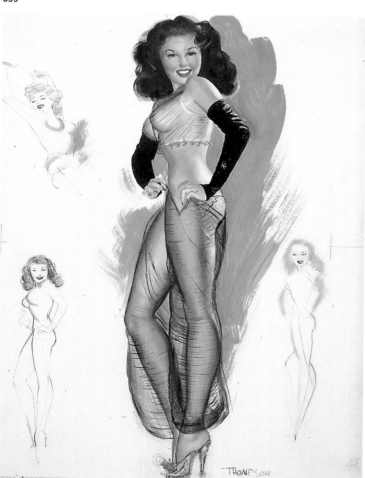

655

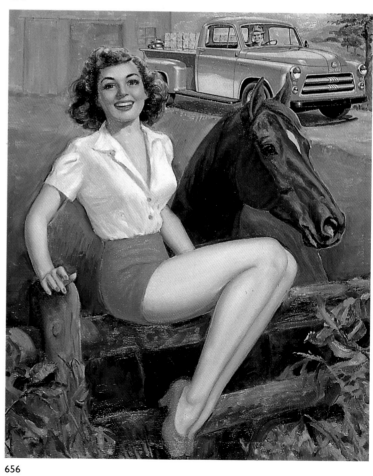

656

Alberto Vargas

From the time *Esquire* first introduced America to the Varga Girl, in 1940, the name Vargas has been synonymous with pin-up and glamour art. In fact, the word *vargas* has actually been applied to almost every kind of pin-up subject – a fitting tribute to the most famous and prolific glamour artist of all time.

Born February 9, 1896, in Peru, Alberto Vargas was the son of a renowned photographer, Max Vargas, who had taught him how to use an airbrush by the time he was thirteen. In 1911, while accompanying Max on a trip to Paris, Alberto came upon the famous magazine *La Vie Parisienne*, and its sensuous front covers by Raphael Kirchner made a lasting impression on him. He studied in Zurich and Geneva before leaving Europe because of the war and arriving on Ellis Island in October 1916.

Vargas' first encounter with America happened about noon at Broadway and Fourteenth Street, when he was suddenly surrounded by a lunchtime crowd of smartly dressed office workers. Mesmerized by their grace, sophistication, and beauty, the young artist decided he would spend his life glorifying the American Girl.

Vargas' first job was drawing fashion illustrations (mostly in watercolor and pen and ink) for the Adelson Hat Company and Butterick Patterns. Eventually turning to freelance commercial illustration, he was painting in a store window in May 1919 when he was asked by a representative of the Ziegfeld Follies to show his work the next day to Mr. Ziegfeld.

Within twenty-four hours, Vargas found himself commissioned to paint twelve watercolor portraits of the leading stars of the 1919 Ziegfeld Follies for the lobby of the New Amsterdam Theatre. Yet, although he was in the company of the most beautiful girls in the world, he knew there was only one woman for him: Anna Mae Clift, a showgirl with the rival Greenwich Village Follies. For the next twelve years, Vargas painted all the Ziegfeld stars, including names such as Billy Burke, Nita Naldi, Marilyn Miller, Paulette Goddard, Ruth Etting, Eddie Cantor, and W. C. Fields. He soon developed a friendship with Ziegfeld, who let the young artist call him "Ziggy", a name used only by the impresario's closest friends.

In 1927, Vargas went to work for the Paramount Pictures' art department in New York and was chosen to create the original artwork for the film *Glorifying the American Girl*, which was being produced by Ziegfeld. Working in an atmosphere of extraordinary harmony between artist, producer, and film, Vargas created advertising artwork that, aside from general distribution, also appeared in Paramount's *20th Anniversary Book*, published in 1927 for the company's stars and executives (see figure 20).

Vargas maintained a full schedule throughout the 1920s, working for a diverse group of clients in addition to the Follies and Paramount. He painted front covers for *Tatler* and *Dance* magazines, did hairstyle illustrations for *Harper's Bazaar*, and even designed some countertop displays for Old Gold cigarettes. Yet he still found time to paint his favorite Ziegfeld Follies stars for his own pleasure, including the daring Shirley Vernon, whose 1927 portrait was preserved in his private collection.

Vargas and Anna Mae Clift were married in 1930 and moved to Hollywood four years later. Twentieth Century Fox soon hired the artist to paint pastel portraits of their stars, as did Hellman's Mayonnaise, which commissioned a series of full-length movie star portraits for their advertisements. By 1935, Vargas was working for Warner Brothers and, before the decade was over, for MGM.

Vargas' first calendar jobs were two pastel glamour pin-ups executed for Joseph C. Hoover and Sons between 1937 and 1939. He became an American citizen in 1939, the same year that he received an invitation from *Esquire* magazine to visit with publisher David Smart in Chicago to discuss the possibility of working together. Vargas was immediately hired as a replacement for George Petty, whose contract was to expire in December 1941. Agreeing to drop the s from his last name in all his work for the magazine, he had his first painting published in the October 1940 issue. Two months later, *Esquire* introduced the first Varga Girl calendar, which sold better than any other published up to that time.

Over the next five years, Vargas became known worldwide, and his work – both in the monthly magazine and the yearly calendar – was eagerly awaited. Although he had a full schedule of work for *Esquire* during the war years, he often accommodated special requests from soldiers to paint mascot pin-ups. *Esquire* also allowed Vargas to do a series of patriotic pin-ups for William Randolph Hearst's *American Weekly* magazine, the only other magazine work permitted him during the *Esquire* years.

Vargas continued to paint Hollywood stars while he worked for the magazine. His 1941 movie poster of Betty Grable in *Moon Over Miami* was a great success; among the other leading ladies he painted were such stars as Jane Russell, Ann Sheridan, Ava Gardner, Linda Darnell, Marlene Dietrich, Loretta Young, and Marilyn Monroe.

Opposite page:
657

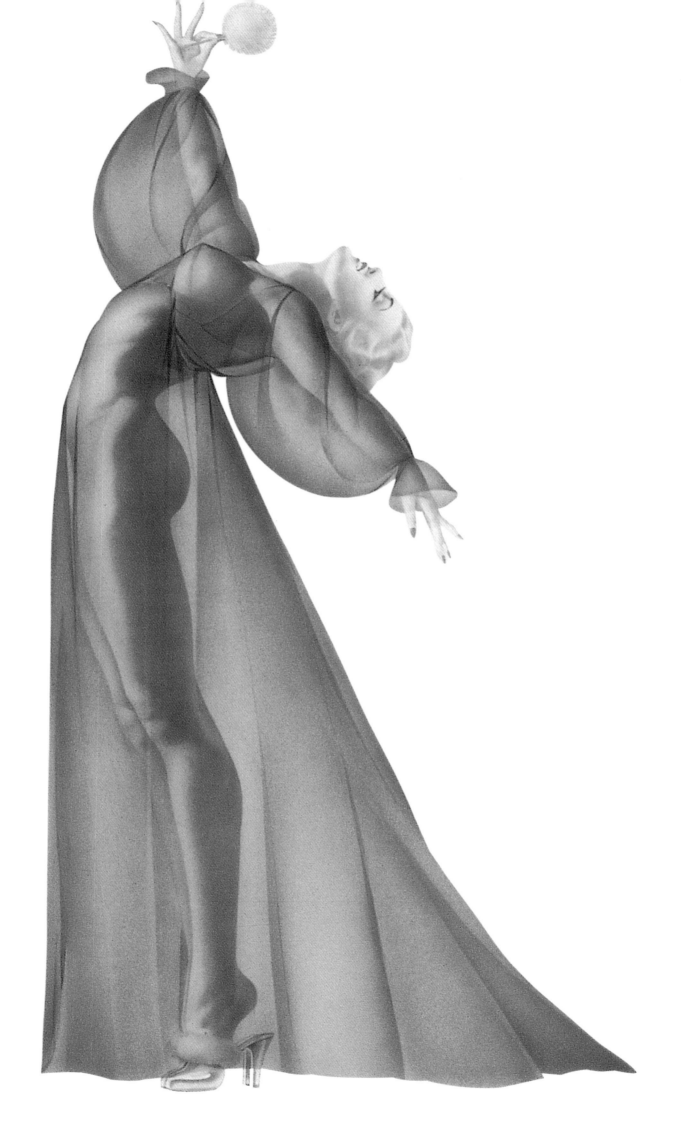

The most important commercial assignment of Vargas' career was the special three-page *Esquire* Girl gatefold he created for the January 1946 issue. Planned as a special holiday gift for the magazine's readers, the original painting had to be exactly 36 inches (91.4 cm) high so that it could be reproduced in its original dimensions on three pages of the magazine. Vargas responded to this challenge with one of his most breathtaking images.

When Vargas and *Esquire* went their separate ways in 1946, the artist immediately embarked upon a project to publish his own yearly calendar. In the meantime, the magazine published an *Esquire* Calendar for 1947 that consisted completely of unsigned Vargas paintings. By the time Vargas' 1948 calendar was published, *Esquire* had a court order barring the artist from selling or distributing any product bearing the name "Varga", which the magazine had copyrighted. In 1950, a court ruled that Vargas would have to sign all his subsequent paintings with his full name.

During the early and mid-1950s, Vargas took on many commercial assignments, including a pin-up of Shelley Winters for the RKO film *Behave Yourself*, a deck of Vargas Girl playing cards called "Vargas Vanities", and a series of pin-ups for the pocket-sized British magazine *Men Only*. In 1957, *Playboy* magazine published a pictorial feature on Vargas' nudes, which drew the attention of publisher Hugh Hefner. In August 1958, Vargas and Anna Mae traveled to Lima, Peru, for a highly successful exhibition of his paintings. They were greeted upon their return with a personal invitation from Hefner to have Vargas' work appear monthly in *Playboy*.

Embarking on this momentous association in 1960, Vargas was to paint 152 works for *Playboy* during this period, adapting to new moral standards and more explicit sexuality. Vargas painted only two front-cover images for *Playboy* during his long reign as the magazine's primary artist: a cut-out figure of a girl in a bathing suit that was part of a montage created by art director Reid Austin in 1961 and the cover for the March 1965 issue.

During the *Esquire* years, from 1940 to 1946, Vargas usually prepared a total of four preliminary studies for each published painting. Three of these were drawn on a fine tissue paper, the fourth on a heavy vellum parchment paper. The three tissues showed increasing detail from one state to the next until the parchment state which, because of the paper's color and texture, was almost identical to the final painting. These studies would often be drawn with the model as a nude, Vargas simply adding the clothing to the final painting for publication. At *Playboy*, Vargas did one tissue and occasionally a few parchment studies for each published painting.

When Vargas' wife passed away in November 1974, the artist lost much of his interest in painting and in life. Toward the end of the 1970s, he worked on an autobiography with Reid Austin, *Vargas* (Harmony Books). His career was revived somewhat when he painted an album cover, *Candy-O*, for the rock-n-roll band The Cars; he also designed two other record album jackets for singer Bernadette Peters. He died on December 30, 1982, in Los Angeles.

Note: *Charles Martignette possesses the finest and, without doubt, the largest collection of works by Vargas, outside of the residual holdings of the artist's estate. His collection contains sparkling examples of virtually every period and facet of the artist's long, illustrious career as a pin-up artist and painter of beautiful girls and women.*

It is, therefore, very unfortunate for us, for the reader, and, in fact, for the memory of this great artist that we have been forbidden to show all this wonderful art herein. In a letter denying us reproduction rights, representatives of the estate had this to say: "With reference to your proposed 'PIN UPS' book, we have reviewed the list of illustrators and artists you intend to include. While a few are very well known, most are not. It is apparent that Vargas is the best known and would be judged by the company he keeps. The fundamental difference between you and our clients is that they do not believe it is in the best interests of the Estate to treat Vargas merely as a 'Pin Up' artist. We all know he was so much more than that."

Our reply included the following: "100% of literate people who are capable of absorbing information know that Vargas was a pin-up cartoonist for Playboy. *Most people know that he was also a pin-up cartoonist for* Esquire, *some even that he was a pin-up calendar artist. No one knows of him as anything else."*

Fortunately, through the good graces of the Esquire *magazine archives, we are able to include works from a small segment of the artist's career in this volume, which we are sure will always be the single most important record of the genre. We feel certain that Playboy magazine would also have assisted us, had they been free to do so.*

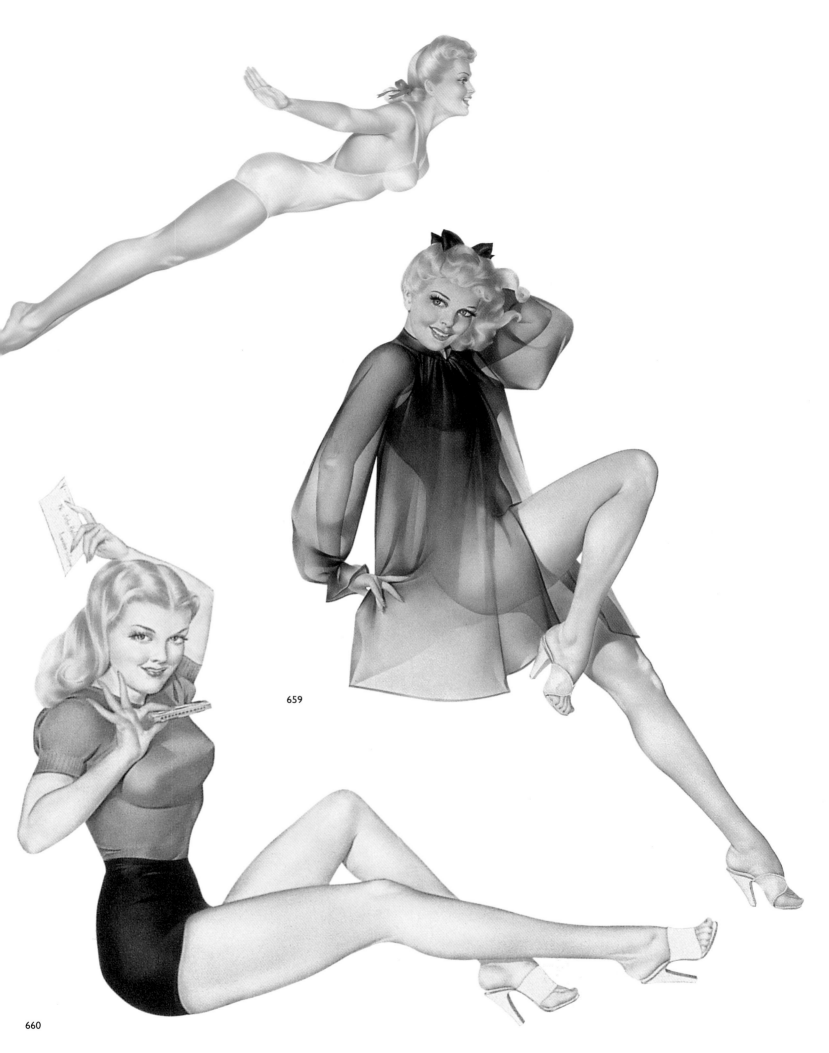

659

660

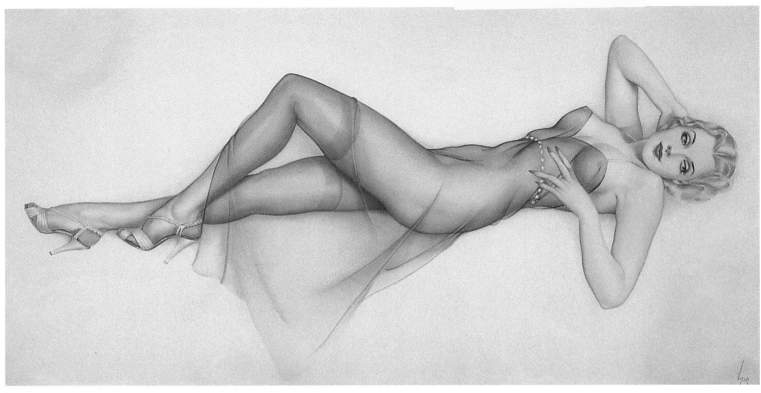

661

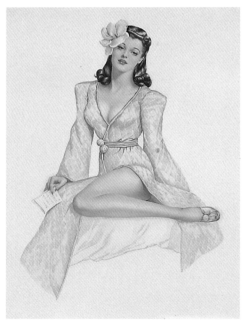

662

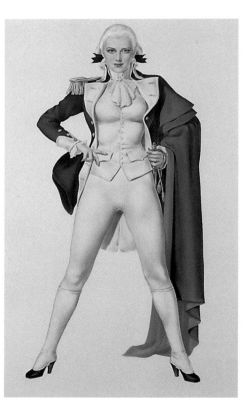

663

664

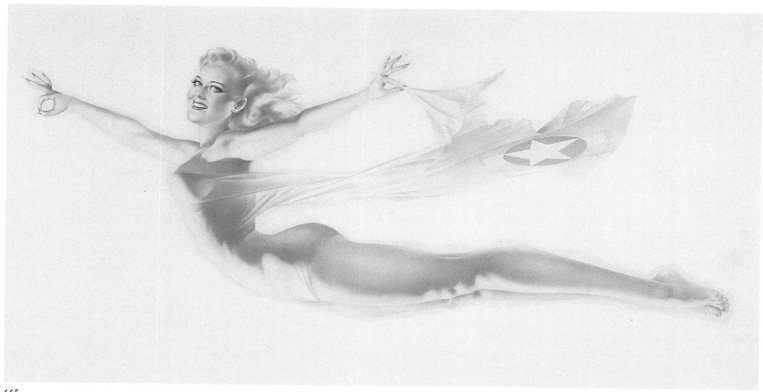

665

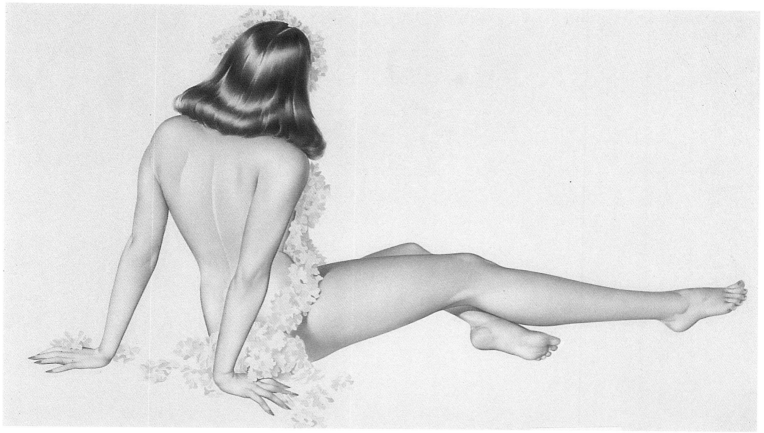

666

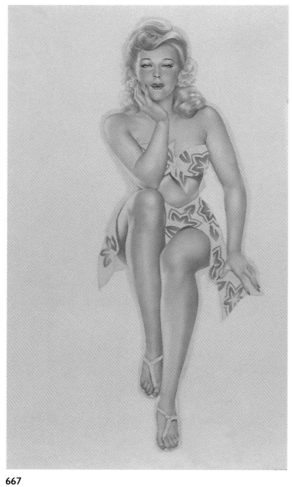

667

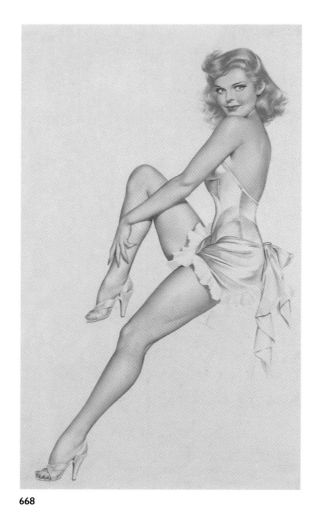

668

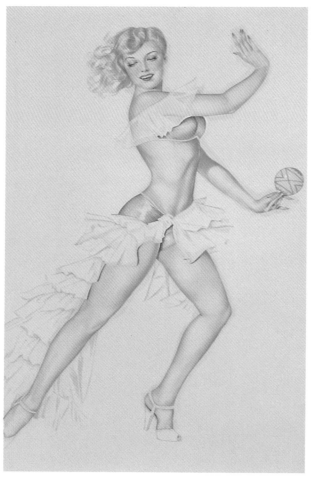

669

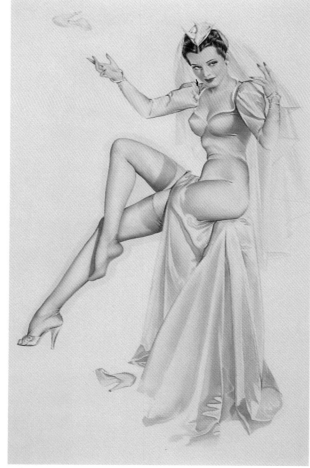

670

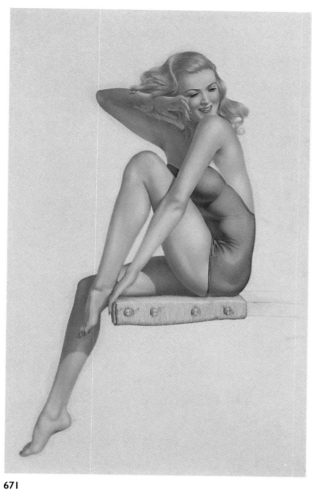

671

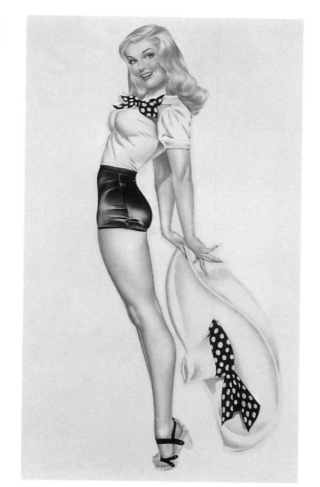

672

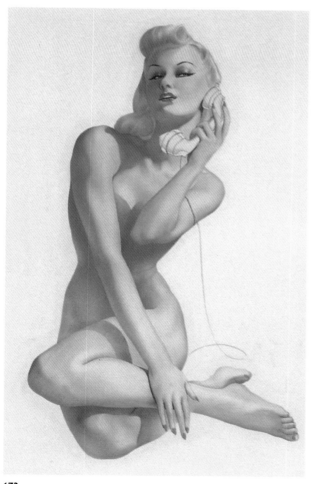

673

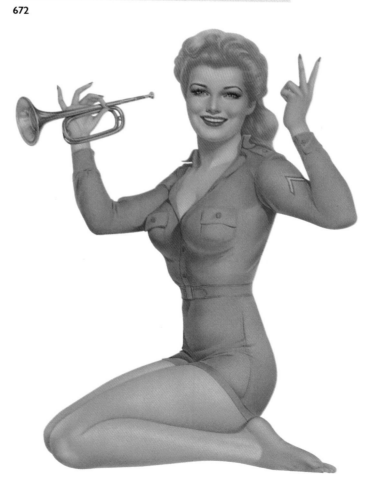

674

Alberto Vargas · **287**

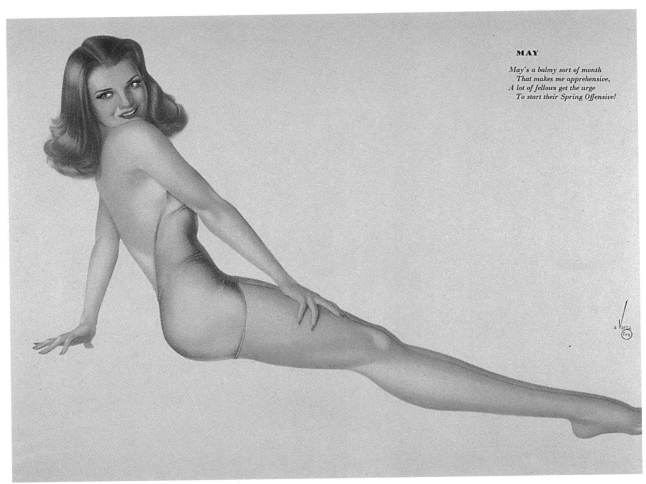

MAY

*May's a balmy sort of month
That makes me apprehensive,
A lot of fellows get the urge
To start their Spring Offensive!*

675

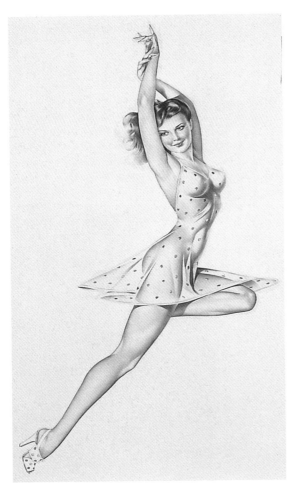

676

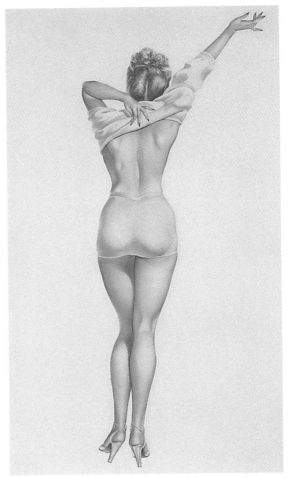

677

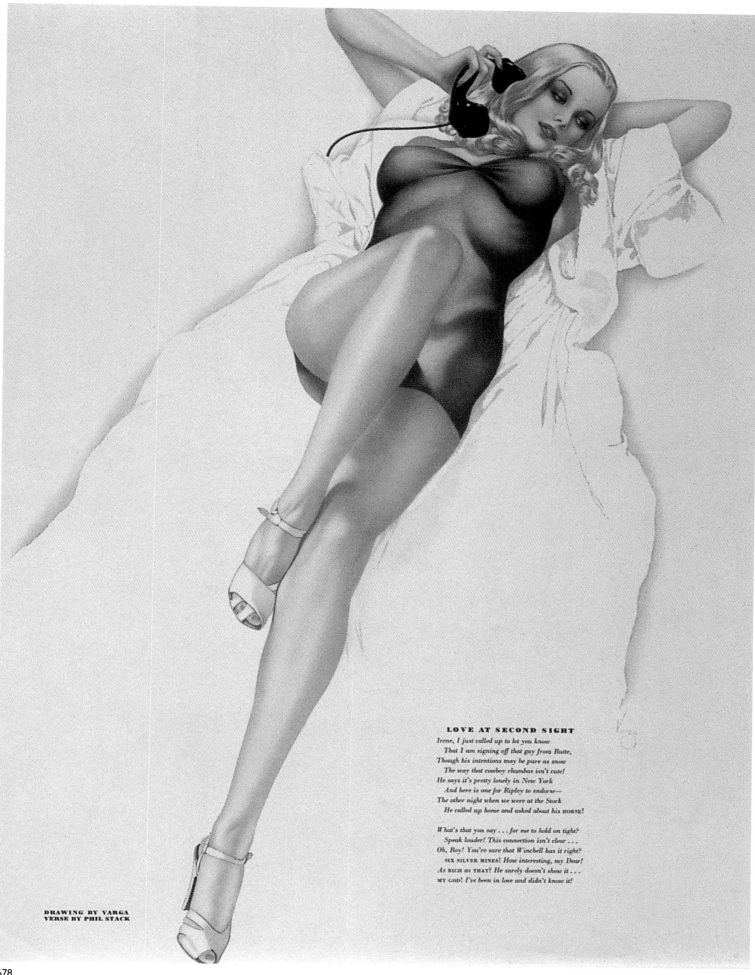

LOVE AT SECOND SIGHT

Irene, I just called up to let you know
That I am signing off that guy from Butte,
Though his intentions may be pure as snow
The way that cowboy rhumbas isn't cute!
He says it's pretty lonely in New York
And here is one for Ripley to endorse—
The other night when we were at the Stork
He called up home and asked about his HORSE!

What's that you say . . . for me to hold on tight?
Speak louder! This connection isn't clear . . .
Oh, Boy! You're sure that Winchell has it right?
SIX SILVER MINES! *How interesting, my Dear!*
AS RICH AS THAT? *He surely doesn't show it . . .*
MY GOD! *I've been in love and didn't know it!*

DRAWING BY VARGA
VERSE BY PHIL STACK

678

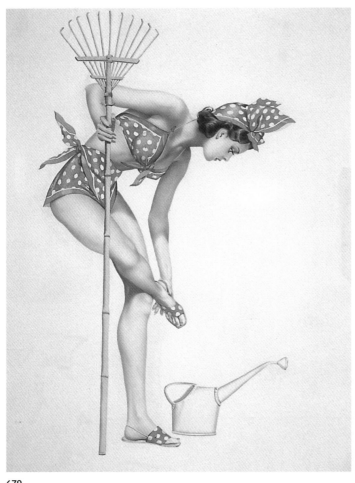

679

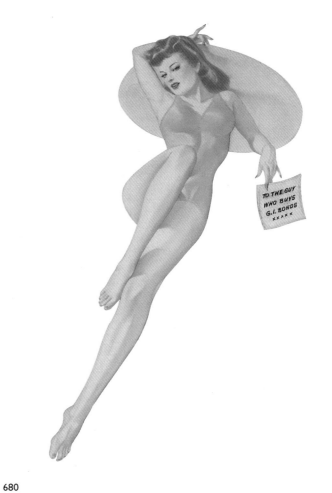

680

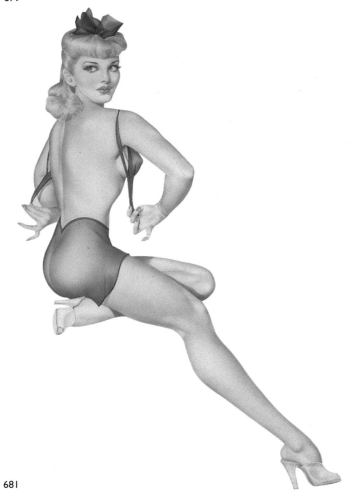

681

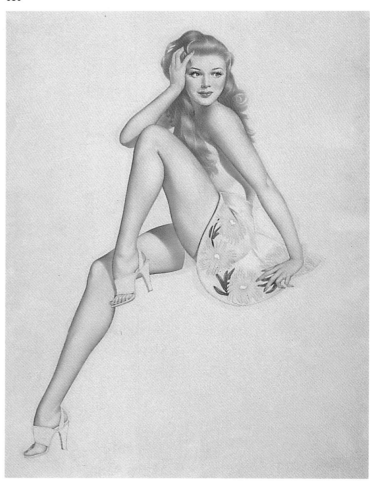

682

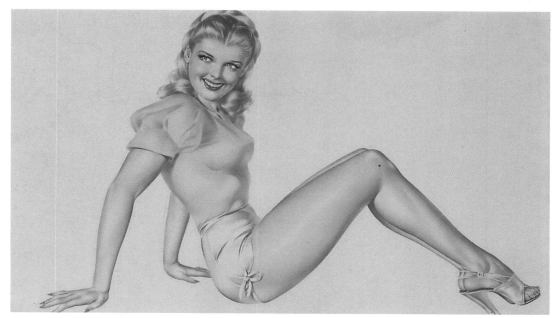

683

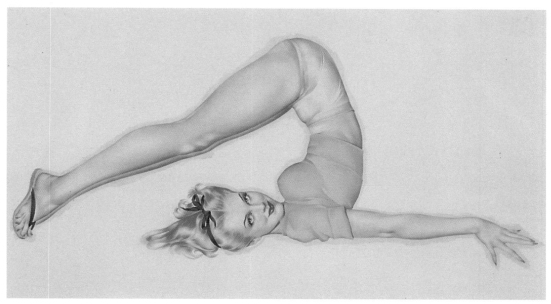

684

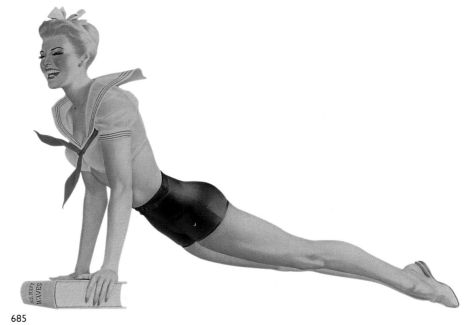

685

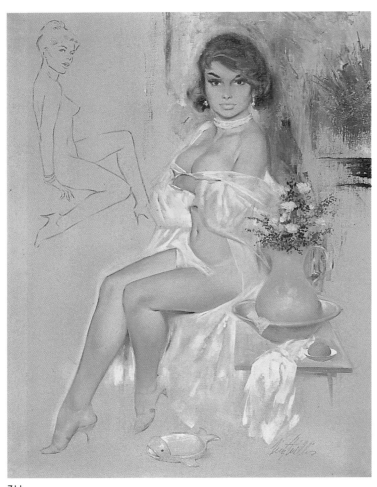

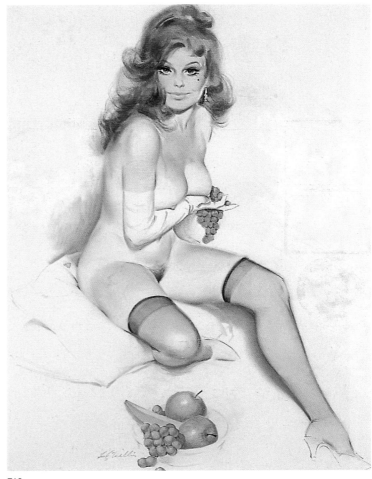

711

712

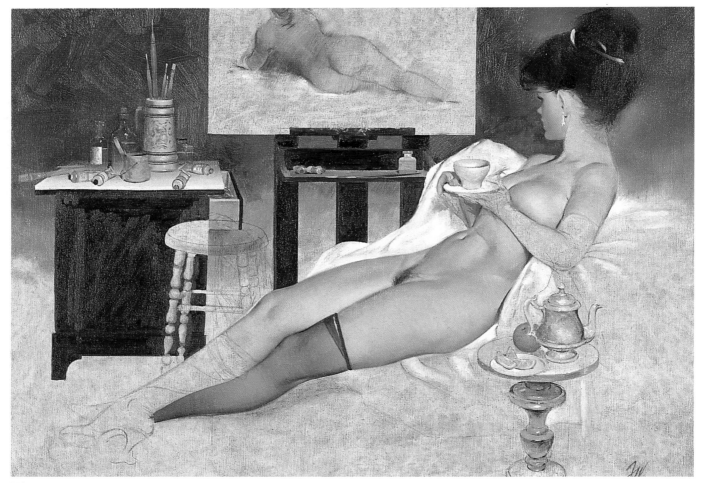

713

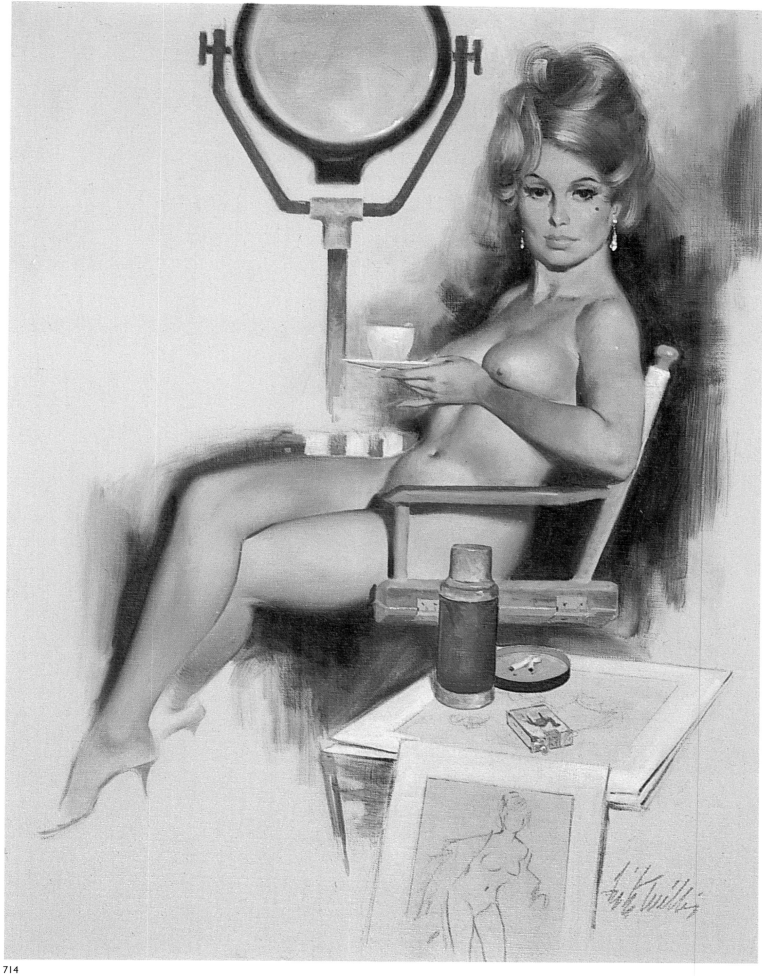

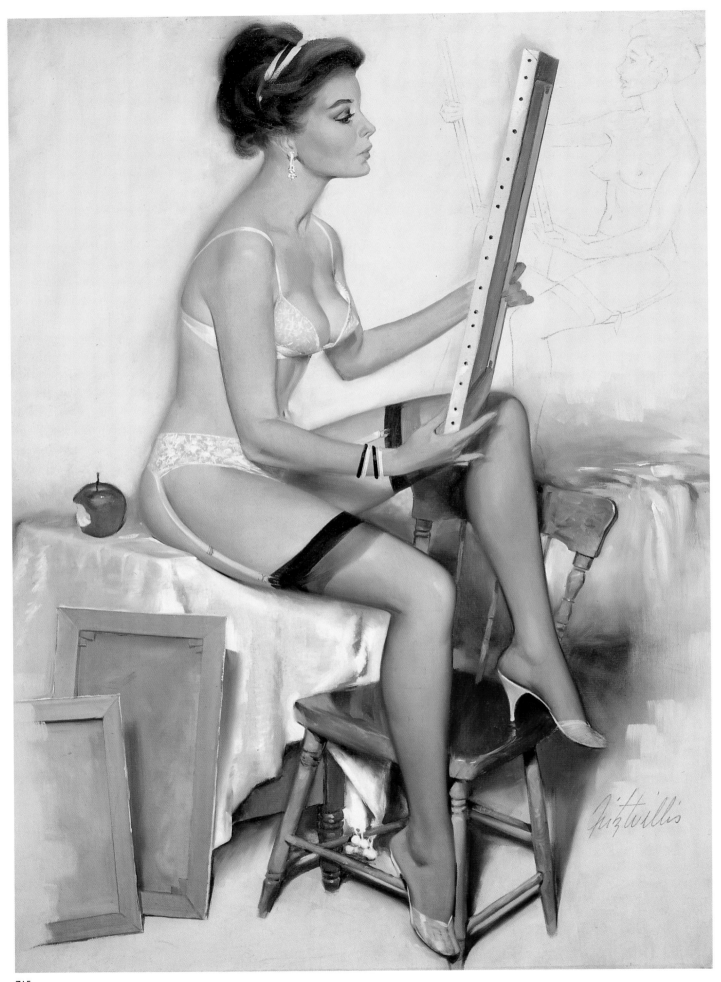

715

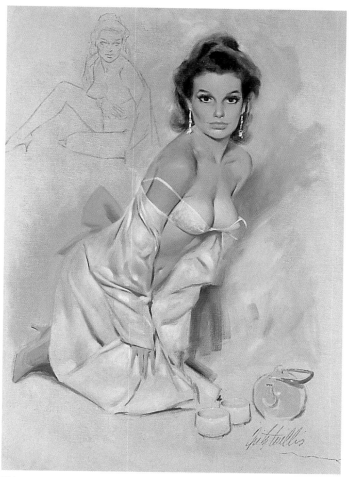

716

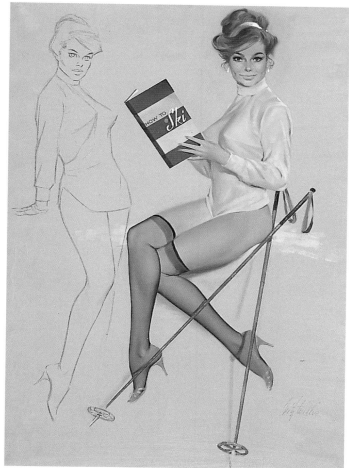

717

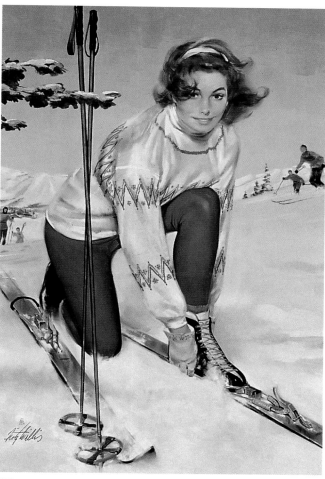

718

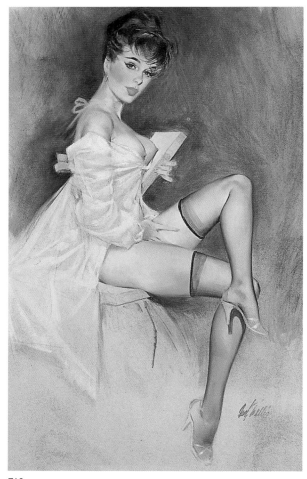

719

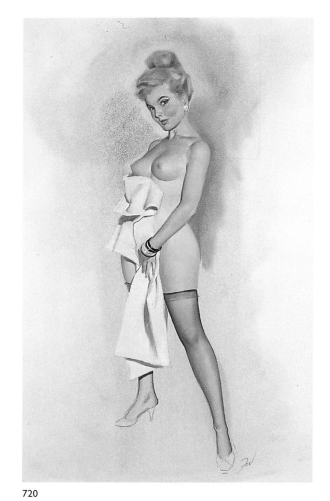

720

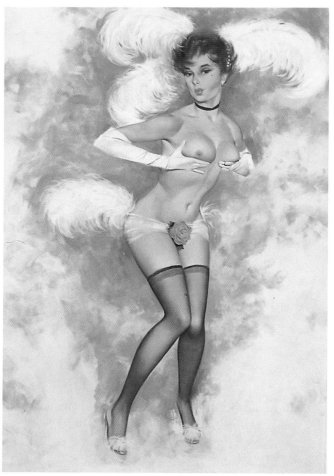

721

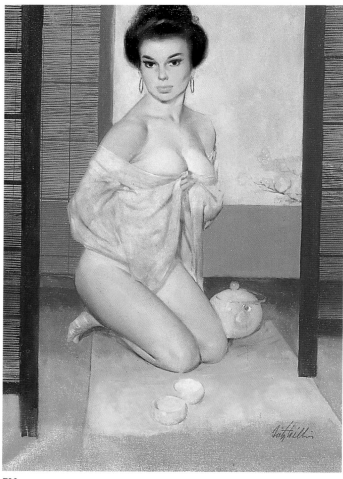

722

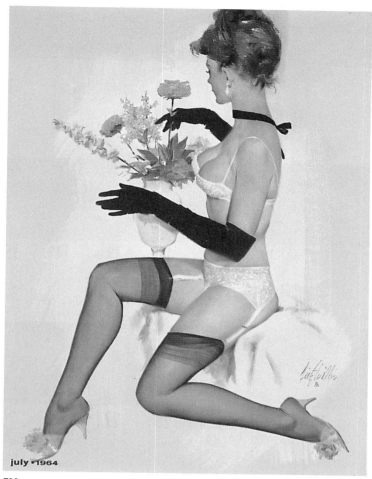

july · 1964

723

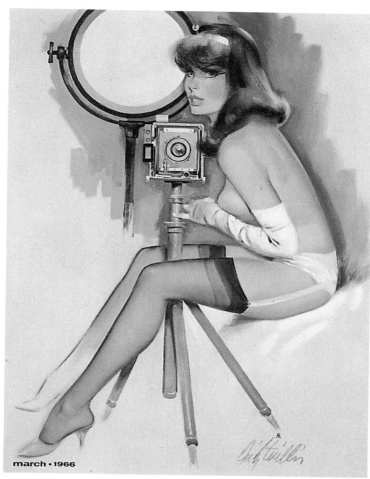

march · 1966

724

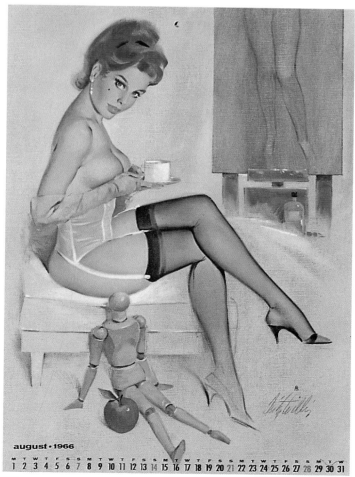

august · 1966

M	T	W	T	F	S	S	M	T	W	T	F	S	S	M	T	W	T	F	S	S	M	T	W	T	F	S	S	M	T	W
1	2	3	4	5	6	7	8	9	10	11	12	13	14	15	16	17	18	19	20	21	22	23	24	25	26	27	28	29	30	31

725

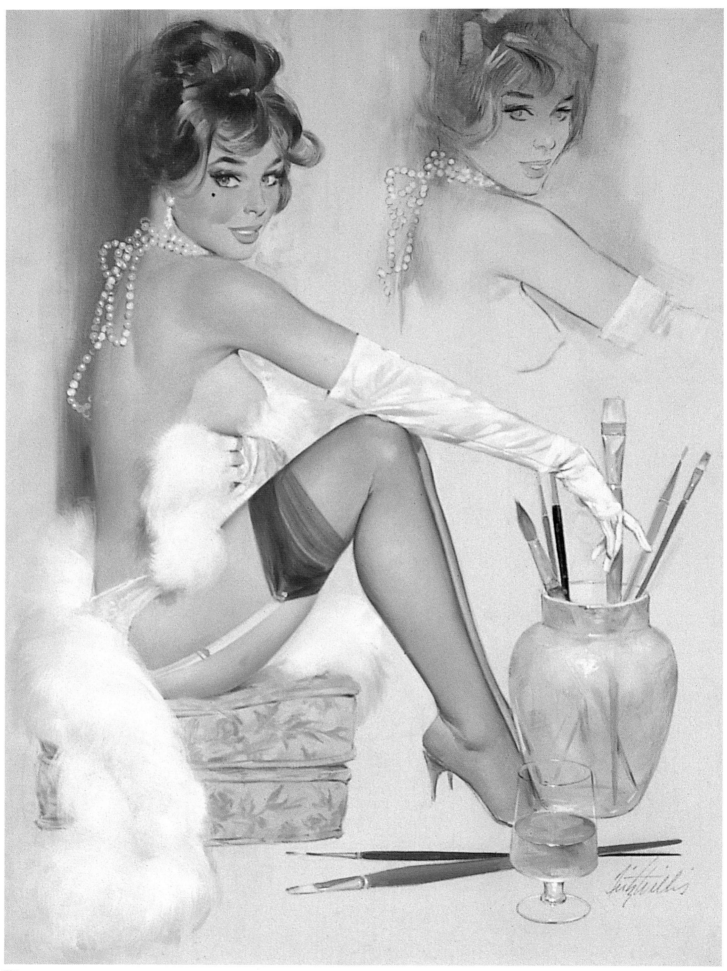

726

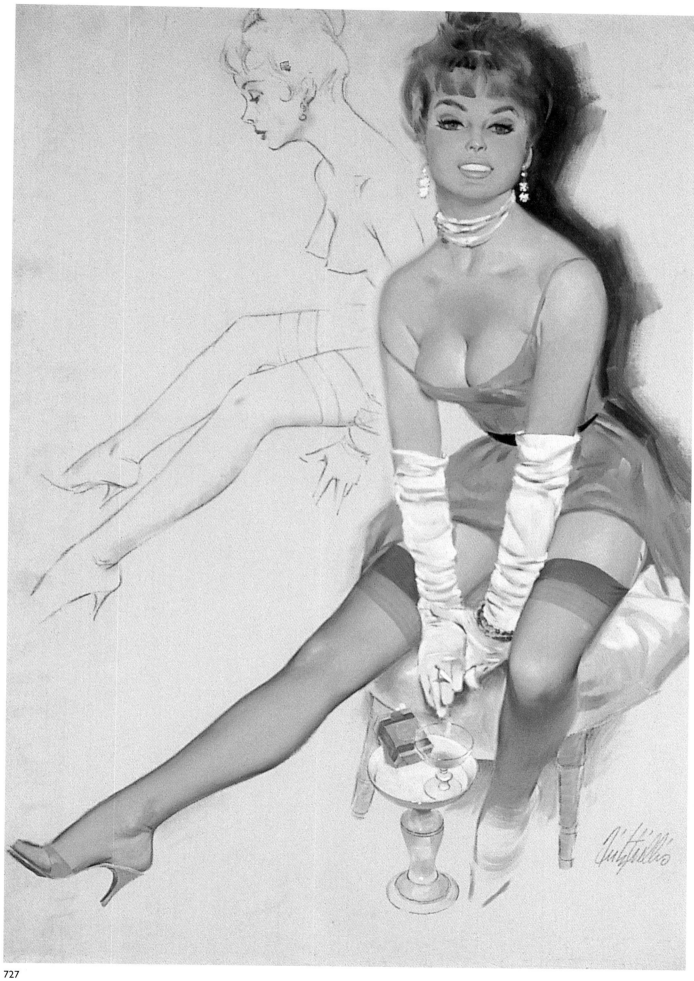

727

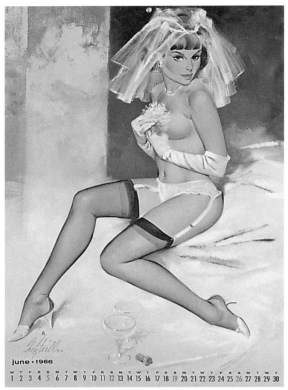

728

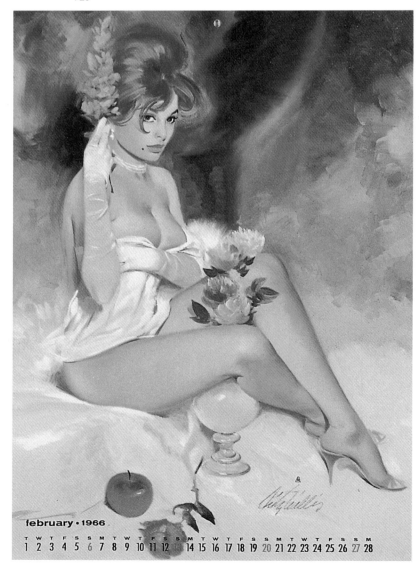

729

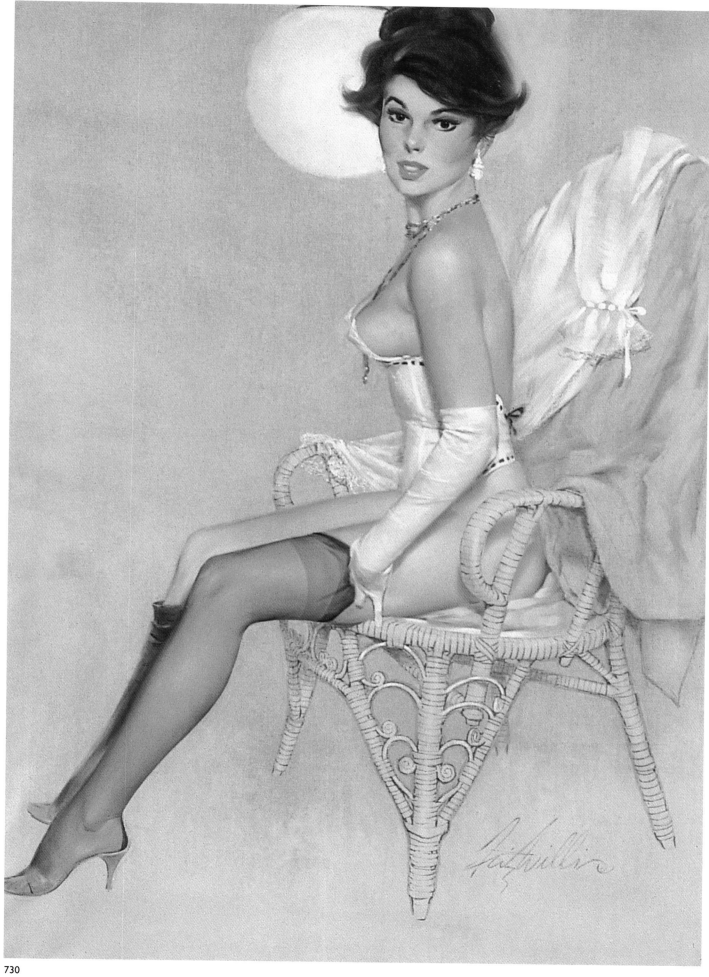

730

Ted Withers

When Withers began painting pin-ups for Brown and Bigelow in 1950, he had already spent twenty-five years working in the Hollywood film industry. He was ready for a change, and so was the calendar company, which assigned him the honor of painting the Artist's Sketch Pad calendar for the 1954 market. Withers' first twelve dreamy pin-ups would be followed by many more in years to come, until the calendar passed on to Fritz Willis in 1961.

Edward Withers was born in Wellington, New Zealand. After studying at Wellington College, he enrolled at the Royal Academy in London and later at the South Kensington School of Art and the Slade School of Art. Eager for more training, Withers moved to Paris and the prestigious Académie Julian. During World War I, he saw service in Samoa, Egypt, France, and Germany and received three decorations.

In 1924, Withers came to America with his wife and two children. In his Hollywood years, he did a number of celebrity portraits while employed in a series of jobs, including art director at MGM Studios, supervisor in the trick and miniature department at Universal Studios, art director for Earnshaw-Young Advertising Agency, and art director for the Sterling Press Lithograph Company. He also painted fine-art works for his own enjoyment, and his award-winning landscapes were widely exhibited.

In November 1950, at his first Brown and Bigelow cocktail party, Withers was talking with Norman Rockwell when Rolf Armstrong and Gil Elvgren arrived. These two pin-up greats were introduced to Withers, who was bowled over when Armstrong praised him as "one of America's greatest, most versatile painters" and Elvgren, who had a keen interest in photography, added "one of the best photographers in the country".

Withers had an analytical mind, a great personality, and a superb sense of humor – not to mention the technical skills of a Da Vinci. In a letter to Brown and Bigelow, he once described the view from his Hollywood apartment in this way: "At night I look out on a carpet of jewels composed of neon and street lights, and here I work and am grateful that way over the eastern horizon, you nice people multiply my effort and enable me to live very well indeed". He passed away in Los Angeles in early 1964.

Opposite page:
733

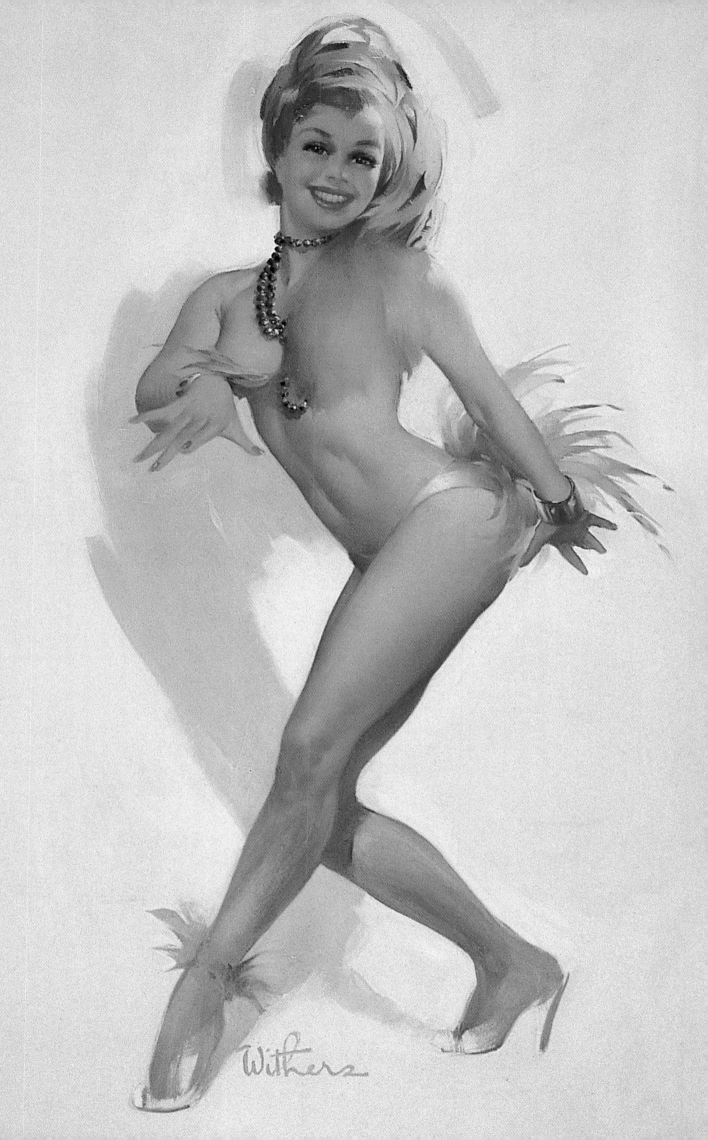

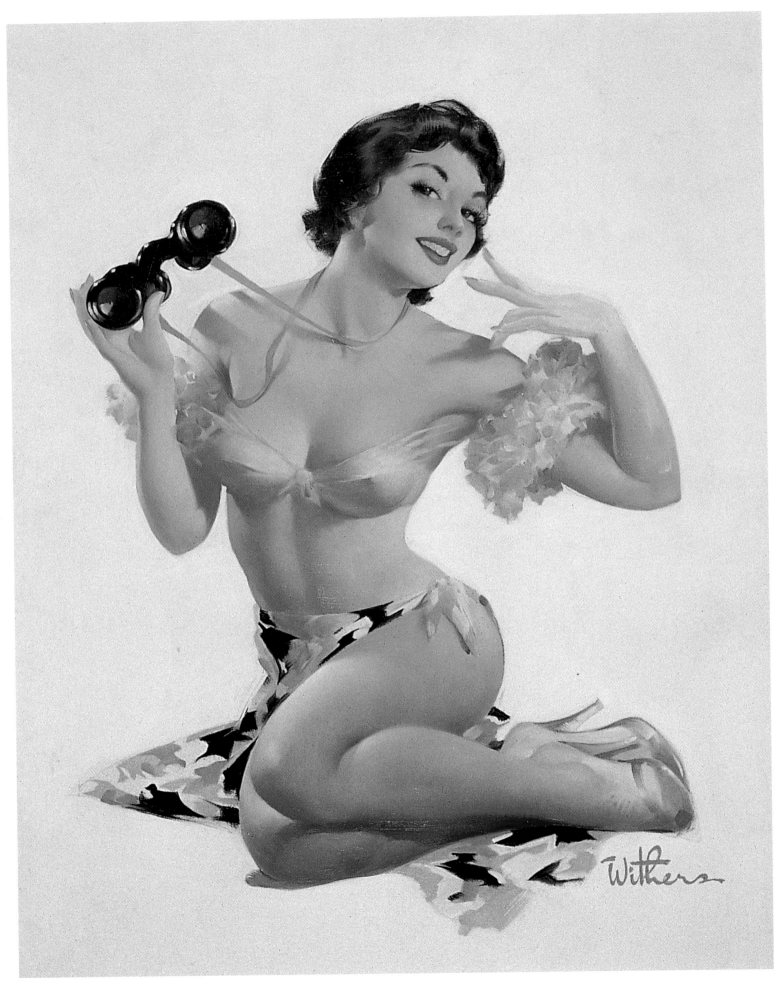

734

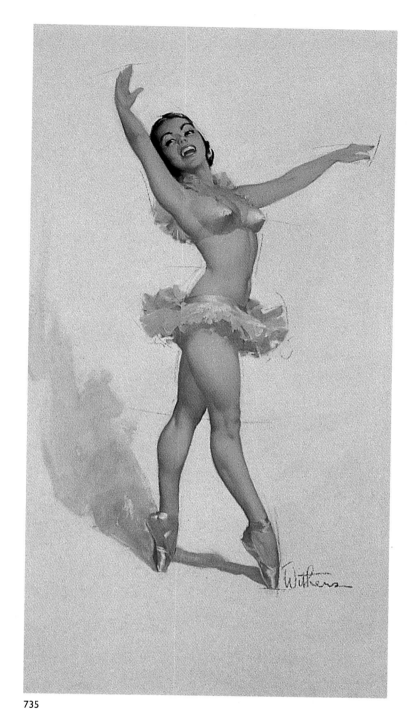

735

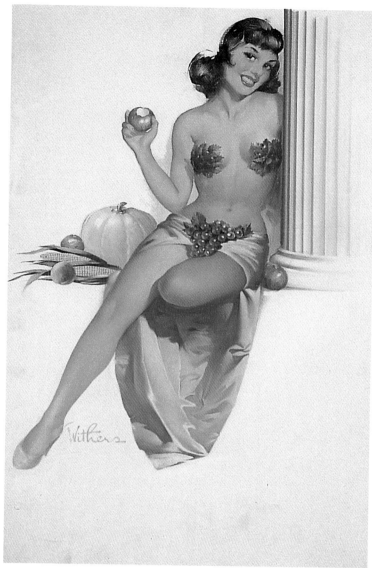

736

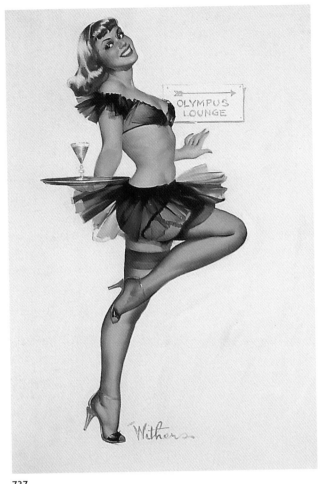

737

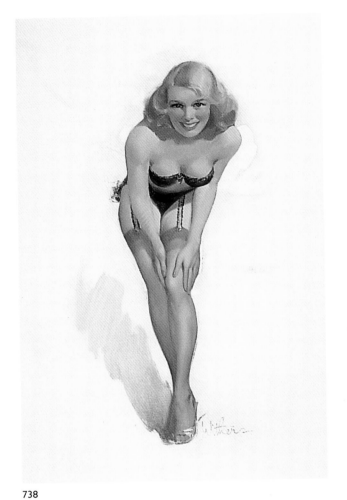

738

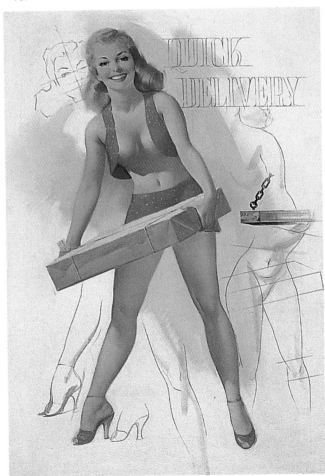

739

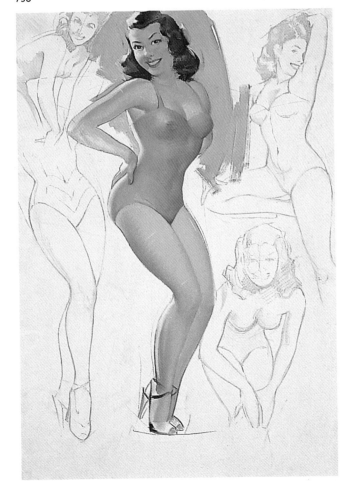

740

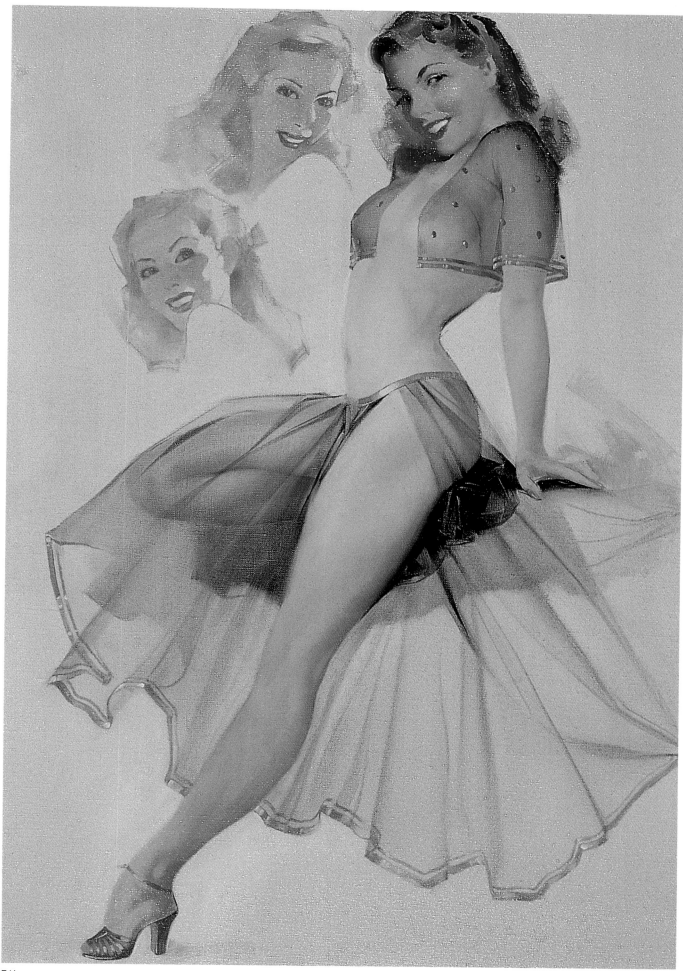

741

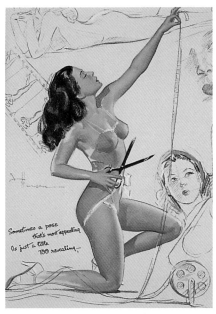

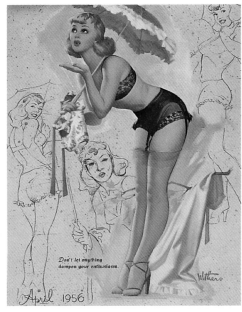

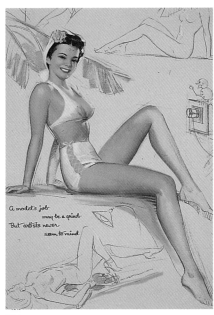

742

743

744

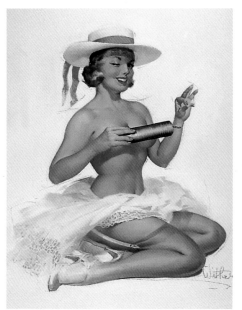

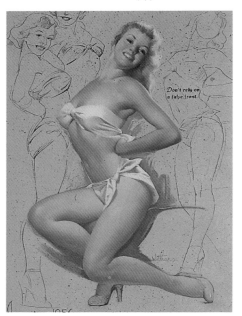

745

746

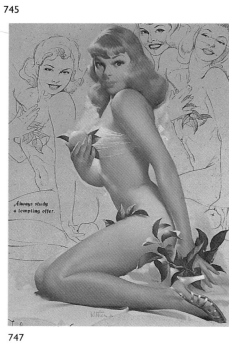

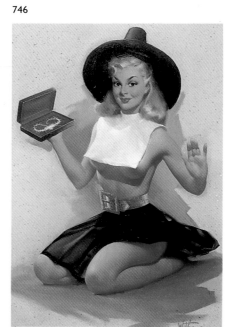

747

748

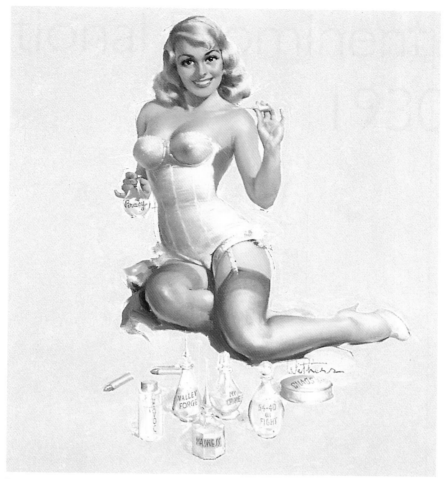

749

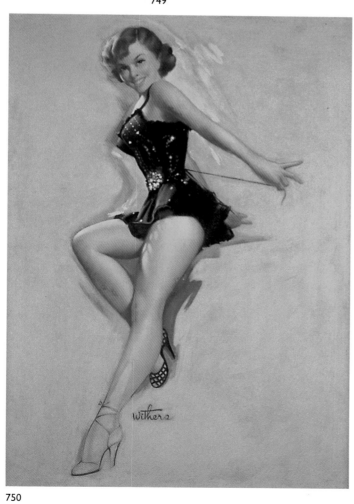

750

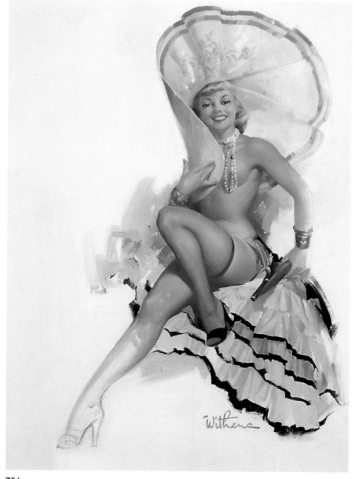

751

Eddie Chan

Chan painted sexy pin-ups for both *Esquire* magazine and Br[...]
Esquire as two-page gatefolds, beginning in 1952, and also as [...]dar.
Chan was one of a handful of artists selected for Brown and [...]r
(among the others on the project were Al Moore, J. Frederic[...]

In addition to pin-up and glamour art, Chan painted a serie[...]e
Hearst newspaper's Sunday magazine supplement. During his [...] great deal of
advertising work for national accounts. From the late 1940s through the 1960s, he also painted front
covers and story illustrations for most of the major mainstream magazines.

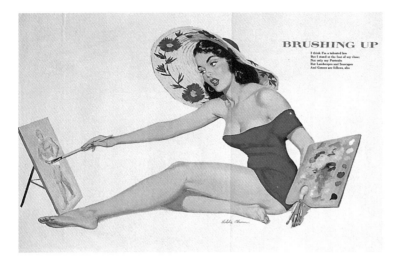

774

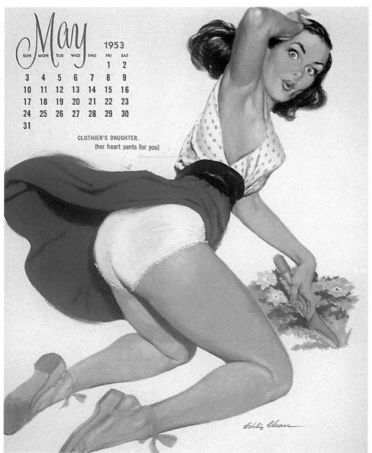

776

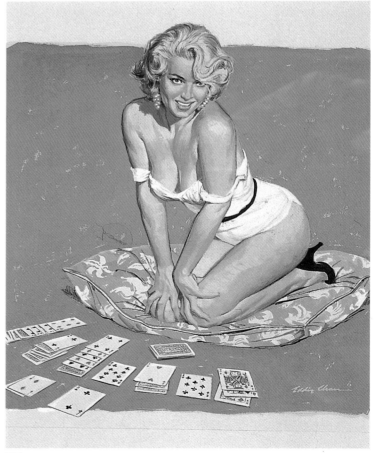

777

Although *Esquire* initially hired Al Moore to replace Vargas in the late 1940s, it was Ernest Chiriaka who took over the magazine's twelve-page calendar from 1953 to 1957 – a great responsibility since the calendar had continued to be the largest-selling and most popular in the world.

Born in 1910, Chiriaka got a job painting movie and theater posters for the Associated Display Company in New York City in the early 1930s, even though he had had no formal art training. Realizing he had much to learn, he enrolled in the Art Students League and then moved on to study at the Grand Central School of Art under Harvey Dunn, his greatest influence. In the late 1930s, he worked for the pulps, doing front-cover paintings mainly of Western subjects. Among the "slicks" that employed him were *The Saturday Evening Post* and *Cosmopolitan*. During the 1940s and early 1950s, he created front-cover paintings for *American Weekly*, the Sunday-magazine supplement of the Hearst newspapers.

Chiriaka's first pin-ups were for *Esquire* in 1952. Working in gouache, he produced works that had very distinctive skin tones, especially in their printed form. Chiriaka contributed pin-ups to the 1953 Brown and Bigelow Ballyhoo calendar and later did three additional pin-ups (figures 778 and 783) that the firm published as separate calendars. He also traveled often to Hollywood to paint film stars.

In the late 1930s, Chiriaka had devised wonderful front covers for Western pulp magazines. He later went on to create front-cover Western subjects for the paperback book market, working mostly for Pocket Books and Cardinal Editions. When his career in commercial illustration ended, Chiriaka brought his love of the Old West to the field of fine art. His distinctive style, influenced by Impressionism, established him as one of the greats in the field of contemporary Western painting.

Ernest Chiriaka

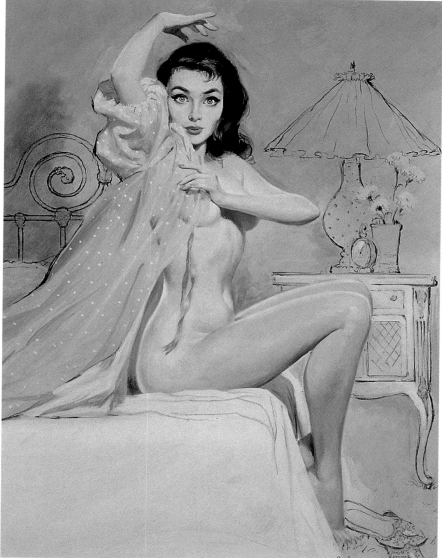

778

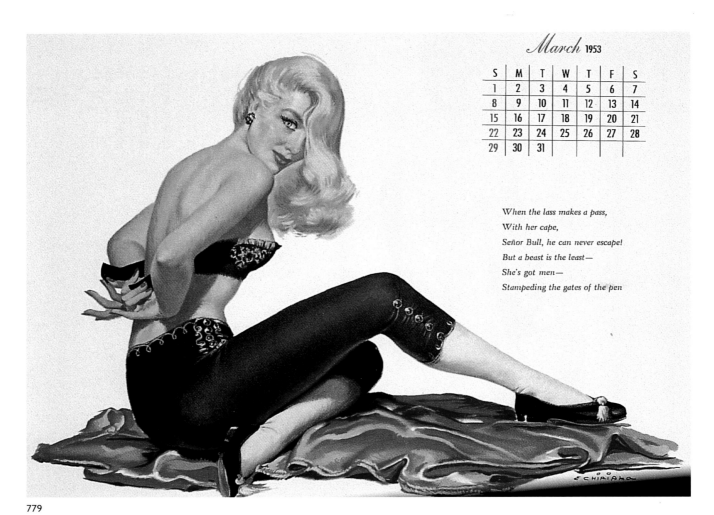

S	M	T	W	T	F	S
1	2	3	4	5	6	7
8	9	10	11	12	13	14
15	16	17	18	19	20	21
22	23	24	25	26	27	28
29	30	31				

When the lass makes a pass,
With her cape,
Señor Bull, he can never escape!
But a beast is the least—
She's got men—
Stampeding the gates of the pen

779

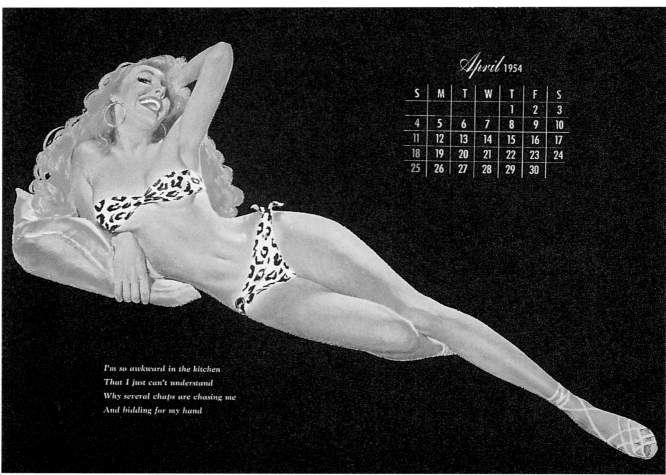

April 1954

S	M	T	W	T	F	S
				1	2	3
4	5	6	7	8	9	10
11	12	13	14	15	16	17
18	19	20	21	22	23	24
25	26	27	28	29	30	

I'm so awkward in the kitchen
That I just can't understand
Why several chaps are chasing me
And bidding for my hand

780

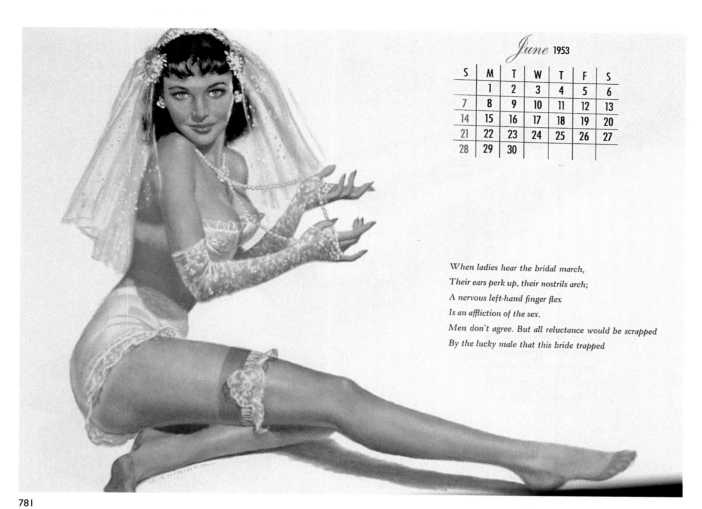

S	M	T	W	T	F	S
	1	2	3	4	5	6
7	8	9	10	11	12	13
14	15	16	17	18	19	20
21	22	23	24	25	26	27
28	29	30				

When ladies hear the bridal march,
Their ears perk up, their nostrils arch;
A nervous left-hand finger flex
Is an affliction of the sex.
Men don't agree. But all reluctance would be scrapped
By the lucky male that this bride trapped

781

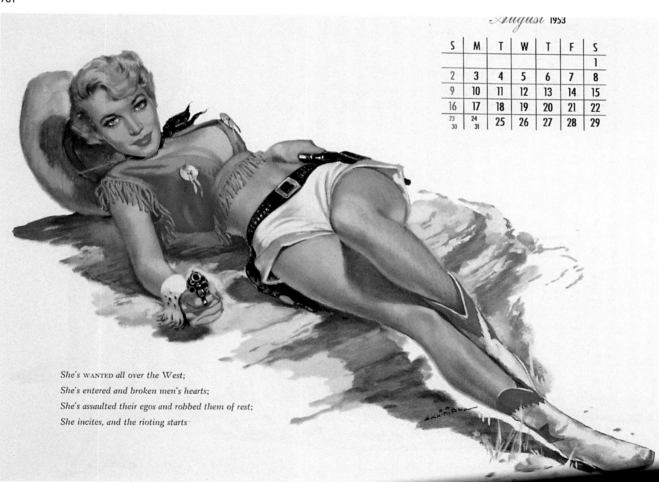

August 1953

S	M	T	W	T	F	S
						1
2	3	4	5	6	7	8
9	10	11	12	13	14	15
16	17	18	19	20	21	22
23 / 30	24 / 31	25	26	27	28	29

She's WANTED *all over the West;*
She's entered and broken men's hearts;
She's assaulted their egos and robbed them of rest;
She incites, and the rioting starts·

782

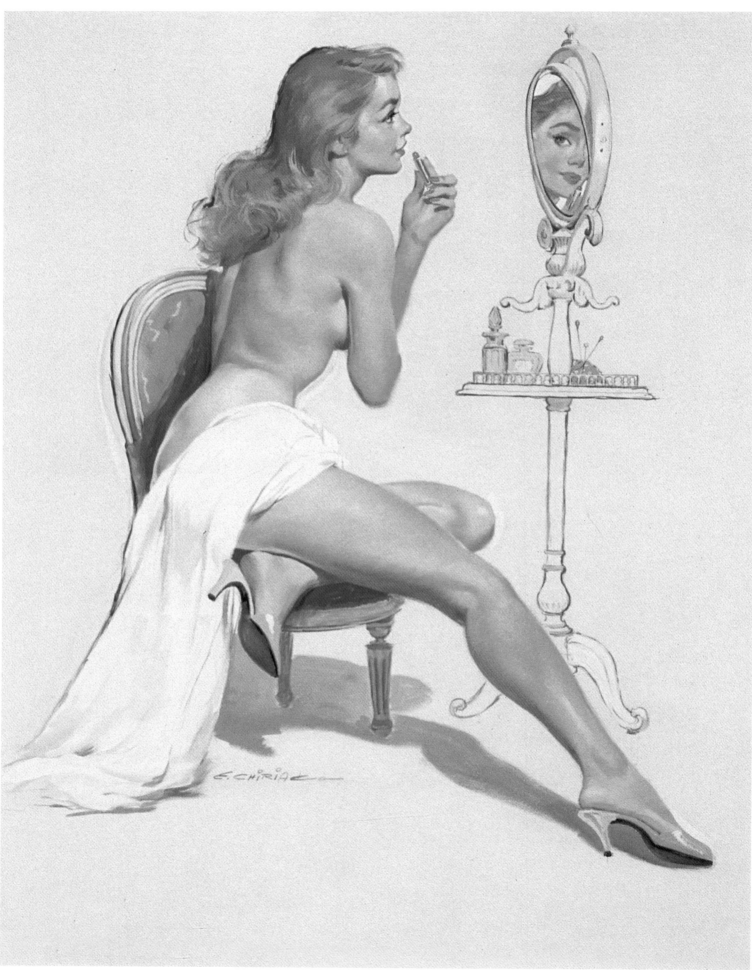

338 · Ernest Chiriaka

Clough was born in 1910 and grew up in Houston, Texas. He studied at the American Academy of Art in Chicago as well as at the New Orleans Art School. Although it was Gil Elvgren, with whom he corresponded at length, who had the greatest influence on him Clough also traveled to California to meet Earl Moran, whom he admired, and to Taos, New Mexico, to see Zoë Mozert after she retired.

Clough's commercial art was published by the McCleery-Cummings Company in Washington, Iowa, and the Skinner-Kennedy Company in St. Louis. His business clients included the KLM Corporation and the Keherlinus Lithography Company, both in Chicago.

In 1958, Clough moved to Hollywood, California. He later returned to Texas, where he died in 1985.

Forest Clough

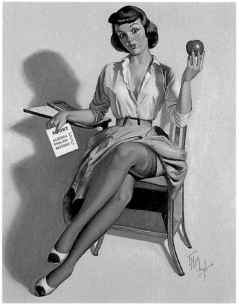

784

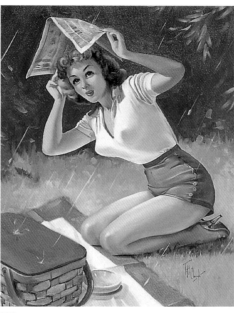

785

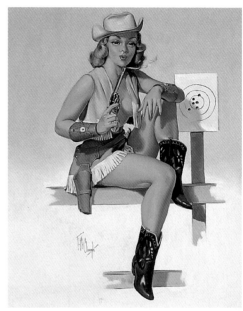

786

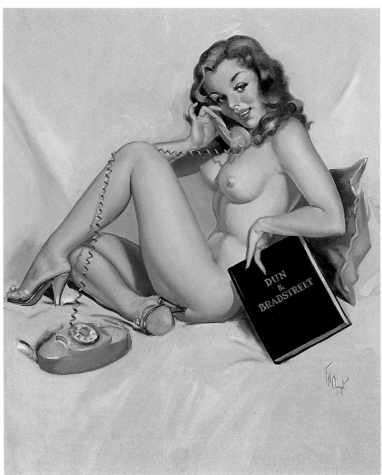

787

Howard Connolly

Connolly was born in 1903 in New Bedford, Massachusetts. During the 1920s, he attended the Swin School of Design there, the Massachusetts School of Art in Boston, and the Art Students League in New York. He also studied in Europe under the great English watercolorist Sir Russell Flint, and later at the John Pike School of Watercolor in New York.

From the beginning of his career, Connolly's first love was capturing the beauty of women in his art. His earliest commercial work was for Montgomery-Ward in 1930 (later corporate clients included Campbell's Soup, Beefeater Gin, Armstrong Tires, and Newport cigarettes). He also worked as a painter of movie signs and billboards, most notably for the Tremont Theater in Boston. In 1938, *Collier's* published his first glamour art magazine cover, and his pin-ups soon began to appear on magazine covers as well. During the 1940s and 1950s, he created full-length pin-ups for various calendar companies.

In 1946, Connolly was commissioned to paint a portrait of Miss America, for both the United States and Canadian markets, and the magazines *Romance* and *Love* also carried his work. Among his 1950s paintings were covers for *Car Life* (1954) and reprints of his Miss America pin-up in *Toronto's Star Weekly* (1952, 1954). Highlights of his 1960s work include covers for *Ford Times* (1966, 1969) as well as illustrations for *Collier's*.

Connolly taught at the Academy of Art in Newark, New Jersey, as well as at schools in Westerly, Rhode Island. He is a member of the American Watercolor Society and the Society of Illustrators. He has consistently credited Rolf Armstrong as his greatest artistic inspiration.

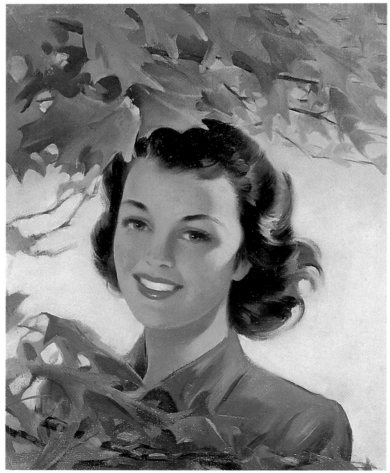

788

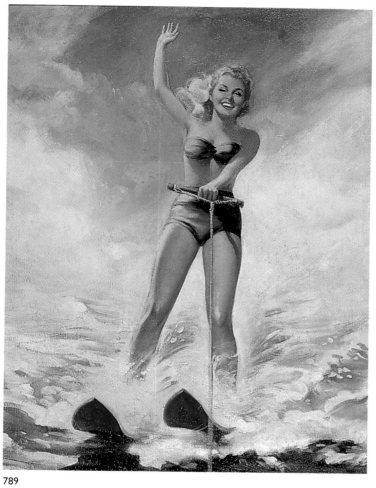

789

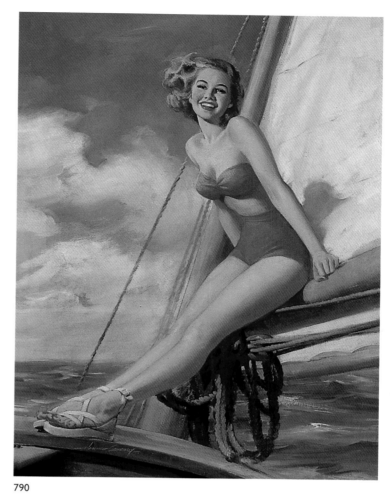

790

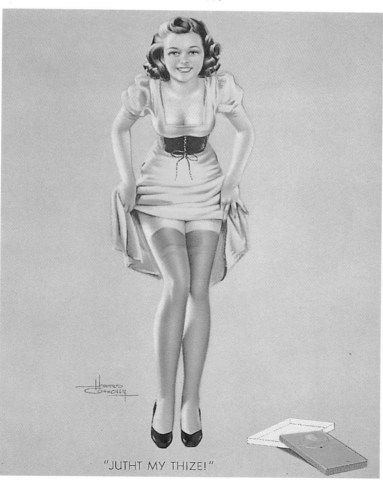

"JUTHT MY THIZE!"

791

Bradshaw Crandell

In 1935, Bradshaw Crandell signed a ten-year contract with the Gerlach-Barklow Company of Joliet, Illinois, for the delivery every year on or about Thanksgiving of one pin-up girl pastel for the sum of $10,000 per painting. This arrangement not only made Crandell the highest paid pin-up artist of the time, but also underscored his tremendous importance in the field of commercial art, and specifically in the glamour industry.

Born in Glens Falls, New York, in 1896, Crandell attended Wesleyan University and then studied commercial illustration and fine art at the Chicago Art Institute. At the age of twenty-five, he sold a design to *Judge*, the first of his many prestigious front-cover assignments featuring glamorous women. In the mid-1930s, Crandell replaced Harrison Fisher as the illustrator of *Cosmopolitan*'s monthly front covers. Working exclusively in pastel on illustration board, he designed more than twelve years of covers for the magazine, often using movie actresses as his models to capture the latest trends.

The versatile Crandell enjoyed working in many fields of illustration, including calendars, advertising-specialty products, and film posters. He painted the two most famous pin-up girls as the subjects for movie posters: Rita Hayworth, in *The Loves of Carmen*, and Betty Grable, in *Footlight Serenade*. In 1939, both he and McClelland Barclay designed posters for the film *Hotel for Women*.

Crandell was an active member of the Dutch Treat Club, the Artists and Writers Association, and the Society of Illustrators. He particularly enjoyed portraiture, and his work in that genre included likenesses of several state governors and many prominent society figures. Although he worked mostly in pastels, Crandell sometimes employed charcoal on canvas when the assignment required it.

During a career that spanned twenty-five years, Crandell created many images that combined sex appeal, sophistication, and glamour in his own distictive way.

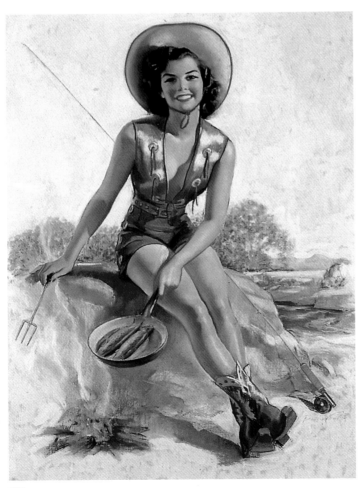

792

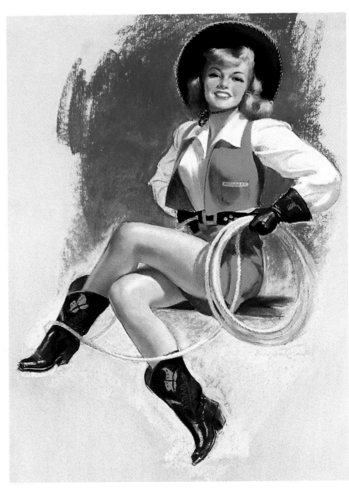

793

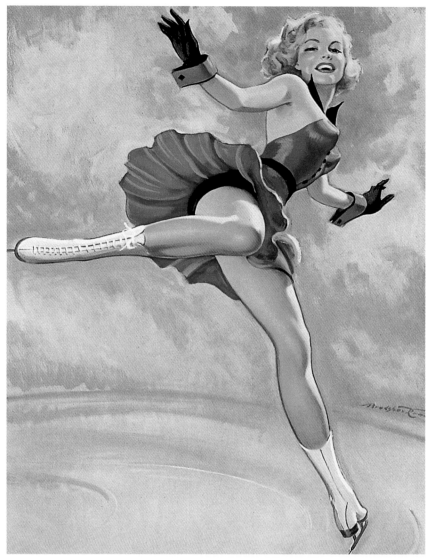

794

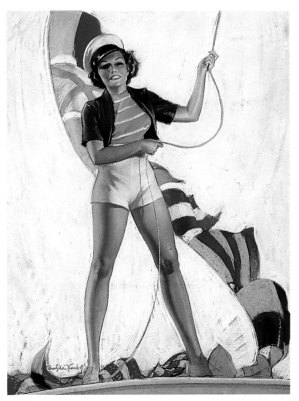

795

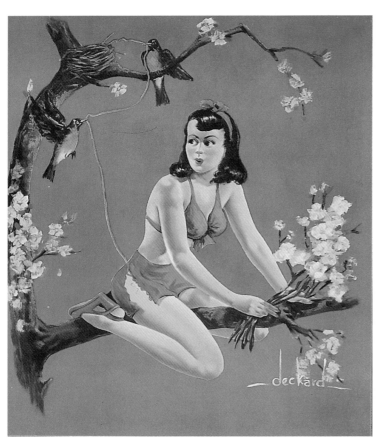

796

Ruth Deckard

According to pin-up authority and renowned collector Max Allen Collins, Deckard was a Chicago-based artist who had many of her pin-up paintings published by the Louis F. Dow Company in St. Paul. She began working in the mid-1930s and created pin-ups until about 1950. One of her most famous images was *What Lines!* (figure 797), which showed a classically posed girl wearing a black bra and panties talking on the telephone while her dog sits next to her listening.

Deckard worked in oil on both canvas and illustration board; her originals measured, on average, from 30 x 24 inches (76.2 x 61 cm) to 36 x 24 inches (91.4 x 61 cm).

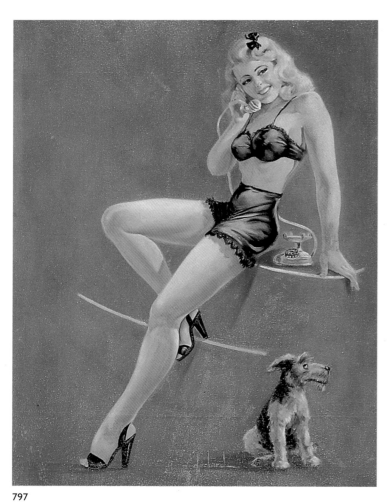

797

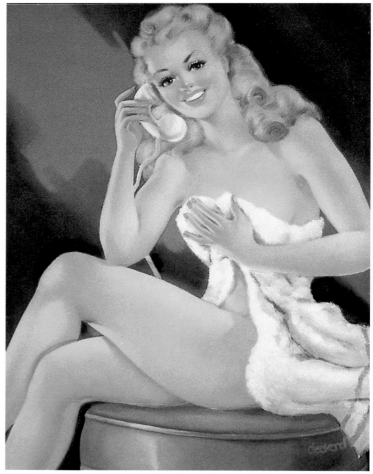

798

Joe De Mers

One of America's top glamour artists, De Mers was first known in the mid-1940s for his sexy pin-ups, but he later attained fame as an illustrator of romance fiction for magazines like *The Saturday Evening Post*, *McCall's*, *Ladies' Home Journal*, and *Reader's Digest*.

Born in 1910 in San Diego, De Mers attended Los Angeles' Chouinard Art School and studied there with Pruett Carter. He later enrolled at the Brooklyn Museum Art School, where one of his teachers was Reuben Tam. Between 1927 and 1937, De Mers worked in the art department at Warner Brothers in Hollywood. He met Fritz Willis there, and the two became close friends. During his last three years at the studio, De Mers taught at Chouinard. He began his freelance career in 1937 with an assignment from *Fortune* magazine.

De Mers began painting pin-ups in the late 1930s. After working for several calendar companies, he was approached in the mid-1940s by the giant Shaw-Barton Calendar Company. The firm's top-flight national sales force soon had the entire nation familiar with the artist's work. In 1946, De Mers received the biggest break of his career. His pal Fritz Willis had been asked to paint the first image in the *Esquire* Gallery of Glamour; the magazine next turned to De Mers and commissioned him to do the second, as well as to become a regular contributor to the series. The joint pin-up that De Mers and Willis contributed to the magazine's October 1946 issue was a significant development in the history of American illustration. The two artists went on to create other works together for the magazine, while continuing to paint individual pin-ups as well.

During the 1950s, De Mers taught at the Parsons School of Design in New York City. In 1953, his pin-ups gained a new family audience when they appeared on the cover of the Ice Capades program. De Mers's fine-art paintings were exhibited at the Museum of Modern Art in New York and at the Los Angeles County Museum. He died in 1984 on Hilton Head Island, South Carolina.

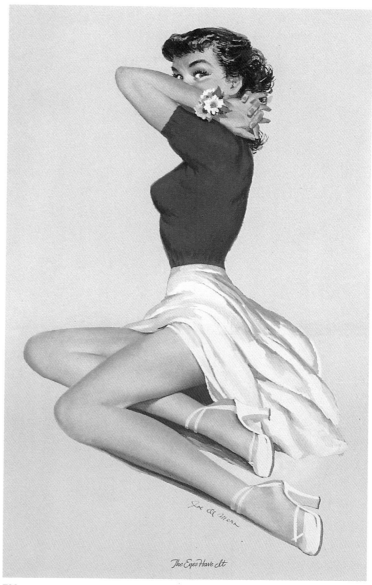

799

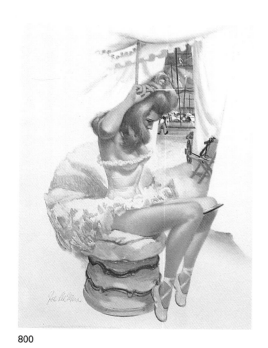

800

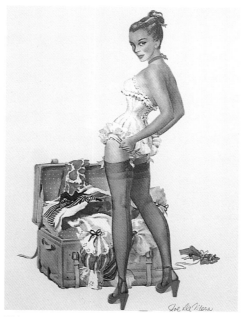

801

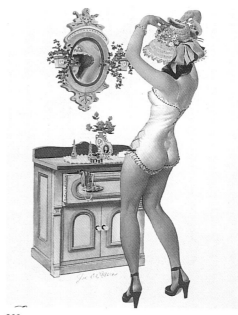

802

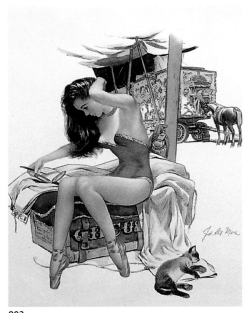

803

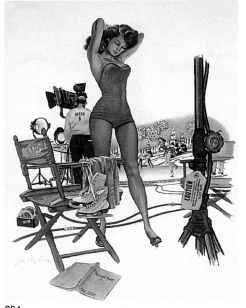

804

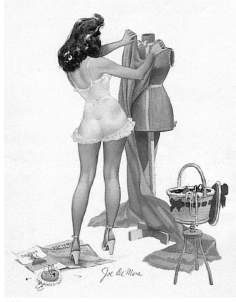

805

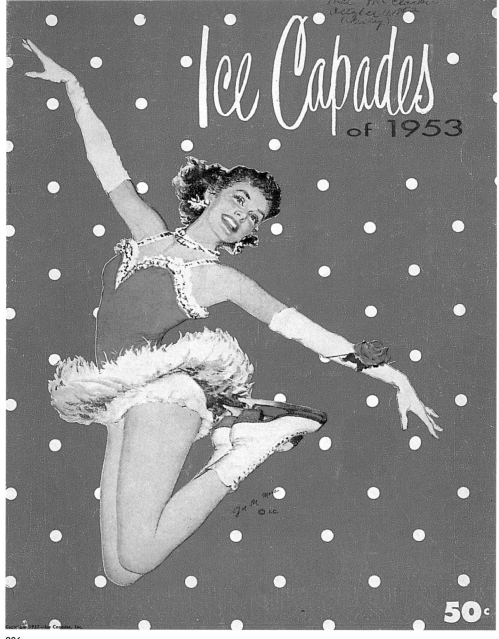

806

Merlin Enabnit

Enabnit was born in 1903 in a small town outside Des Moines, Iowa. He began his career as a window dresser at a Chicago department store, while taking courses at the Cummings School of Art. He first painted pin-ups in 1936 for the calendars of Louis F. Dow Company. About this time, he also worked for two years in England, with considerable success.

The Shaw-Barton Calendar Company became Enabnit's major publisher, using his pin-ups on advertising-specialty products as well as on calendars. Signing his work with his first name only, Enabnit produced a series of successful ads for Formfit, Jantzen Bathing Suits, and the White Owl Cigar Company. In the mid-1940s, he worked in Hollywood painting portraits of movie stars like Harold Lloyd and Virginia Mayo for publicity and promotional uses.

Known as the "Wizard of Color", Enabnit devised his own system of producing and using colors by drawing upon natural sources. He published *Nature's Basic Color Concept* in 1975 and spread the message expressed in that book through workshops, magazine and newspaper interviews, and television appearances.

Enabnit worked primarily in oils, in a large format (40 × 30 inches; 101.6 × 76.2 cm) and with a rich palette reminiscent of the Sundblom school's. He worked from photographs of his models, combining the best features of each to reach an ideal figure. A gregarious, warm personality and a devoted family man, Enabnit received an honorary doctorate from the Royal Society of the Arts in London in recognition of his talent. In 1969, he and his wife moved to Phoenix, Arizona, where he spent his time painting the colors of the Southwestern desert. Enabnit died in November 1979.

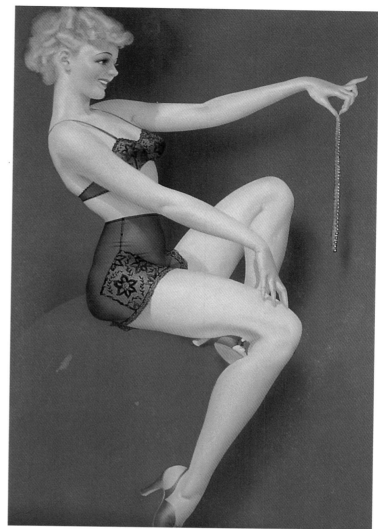

807

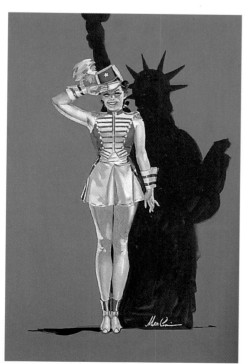

808

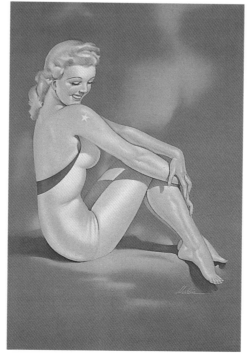

809

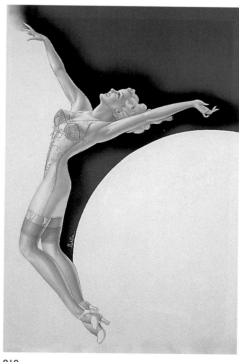

810

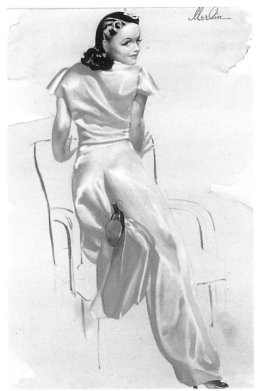

811

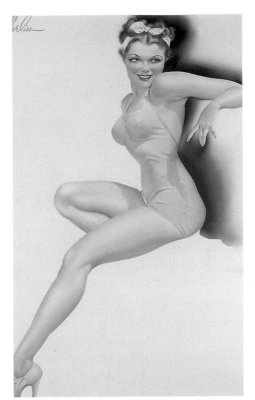

812

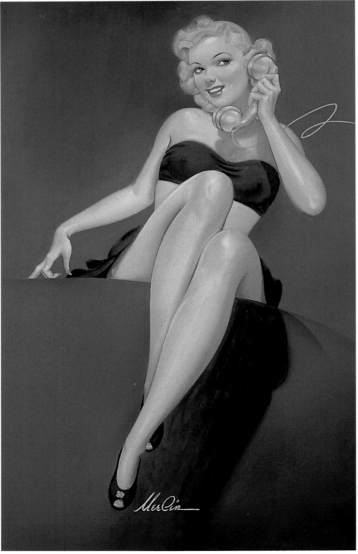

813

Jules Erbit

During the 1930s and 1940s, Erbit's pastel pin-up and glamour calendar subjects featured wholesome, all-American girls attired in conservative clothing. These sedate beauties lacked the strong sex appeal that marked the creations of so many of his contemporaries. Erbit was born in Budapest and as a teenager illustrated for a magazine there before winning a scholarship for study in Munich. He came to the United States in 1930, settling in New York and opening his first studio in Carnegie Hall. Erbit had five daughters, who often provided him with inspiration. In 1933, Erbit secured his first assignment from Brown and Bigelow, and he worked for them until 1945. Yet, wanting the widest possible exposure, he contracted with American Artists to represent him to other publishers as well. As a result, he worked for most of the top calendar houses, including Joseph C. Hoover and Sons, which hired him to paint more than a dozen glamour images for their Superior line. One of these, *Waiting For You* (figure 818) from 1939, became the best-selling of Erbit's "glamour girls". His most popular pin-up, *All-American Swinger* (figure 822), was published by another of Erbit's new clients, Oval and Koster. This girl in a one-piece bathing suit riding on a swing sold more than one million calendars. Erbit also received many advertising commissions, the most well known being his ads for Palmolive Soap in 1933. Erbit worked exclusively in pastel on heavy board measuring 40 x 30 inches (101.6 x 76.2 cm). He retired from the glamour art business about 1950 to focus instead on portraiture and his now-grown family.

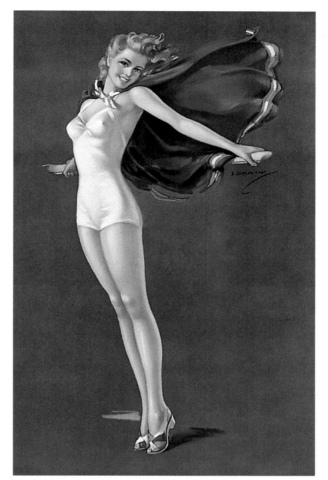

814

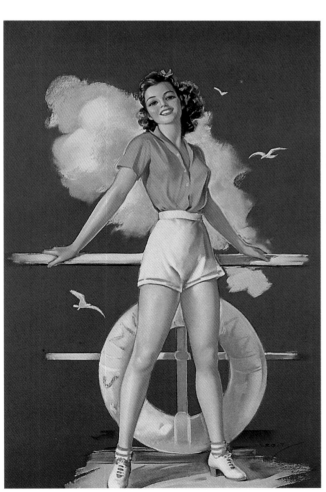

815

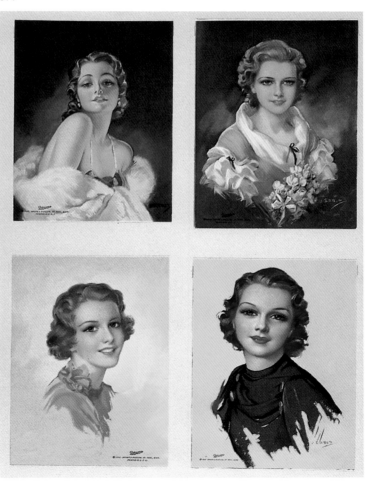

816

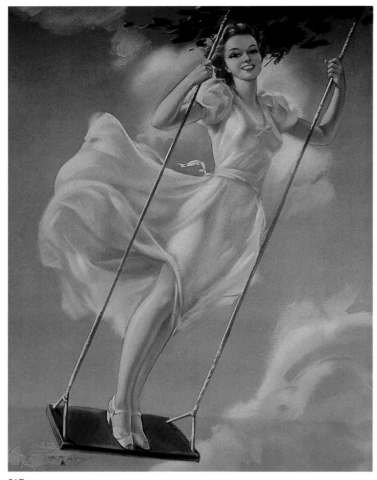

817

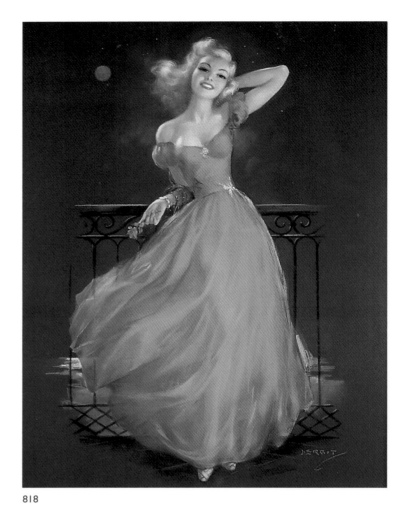

818

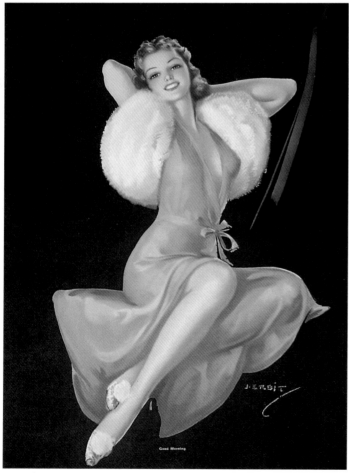

819

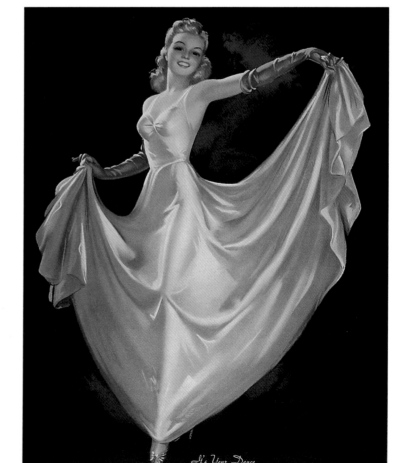

820

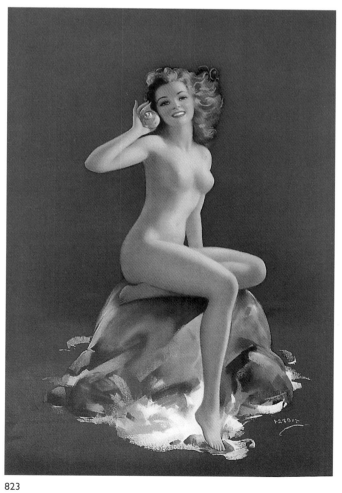

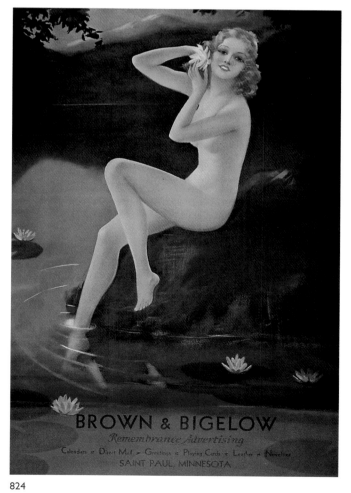

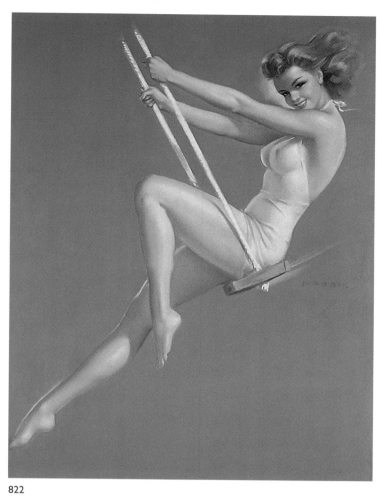

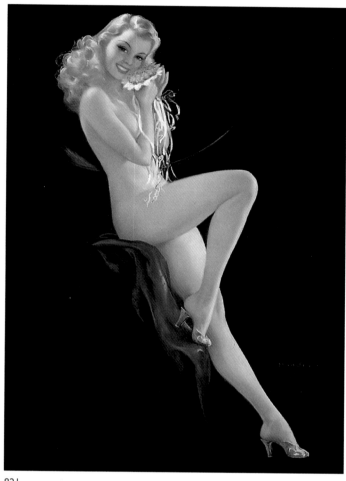

821

822

823

824

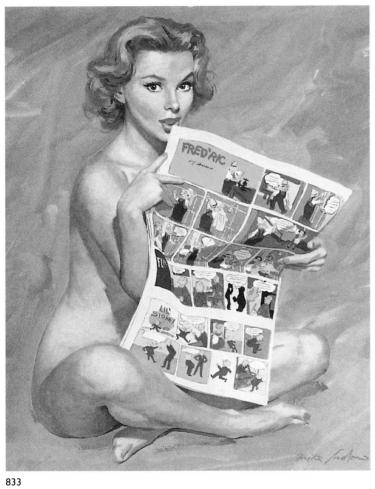

833

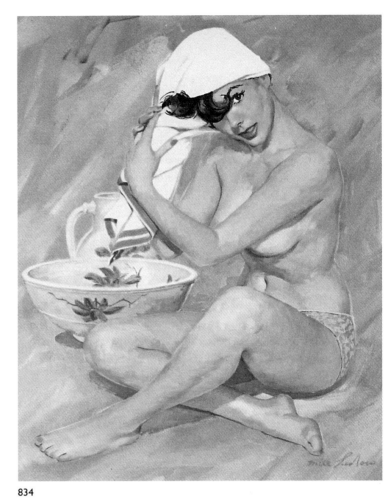

834

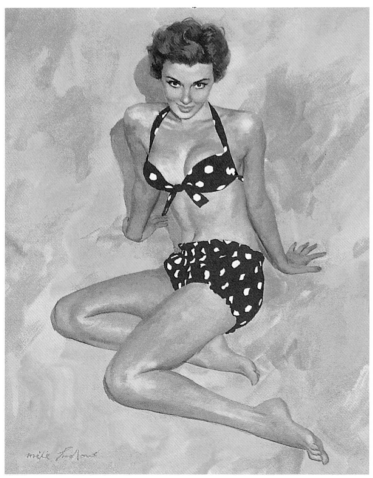

835

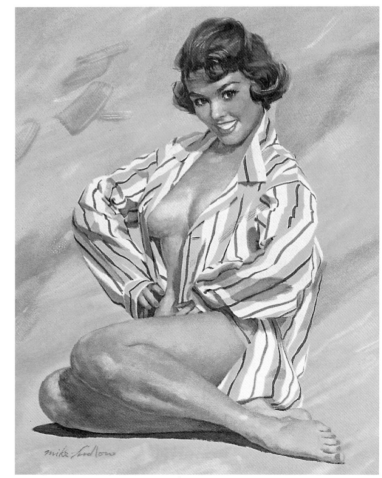

836

M. Miller

During the 1940s and 1950s, M⬚⬚⬚⬚⬚⬚⬚⬚⬚⬚⬚⬚⬚⬚⬚⬚⬚rtists agency in New York City. His pin-ups appeared on calendars published by the Shaw-Barton and Kemper-Thomas companies. Miller provided pin-ups to the latter firm for a 1949 twelve-page calendar that featured his work along with that of Erbit, Sarnoff, and F. Sands Brunner. He worked in oil on canvas in a format measuring 28 × 22 inches (71.1 × 55.9 cm).

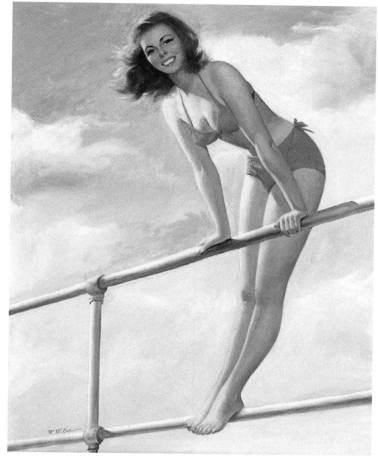

837

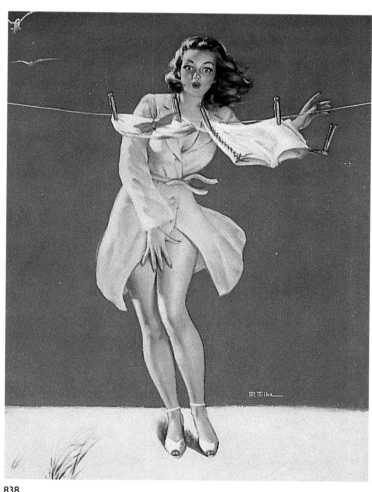

838

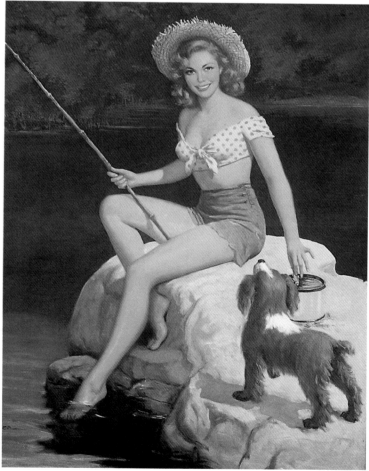

839

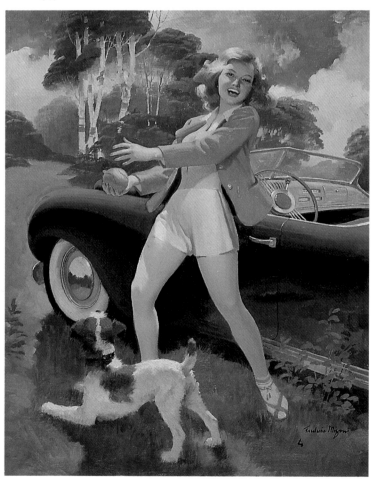

840

Frederic Mizen

Before Haddon Sundblom ever painted an advertisement for the Coca-Cola Company, Frederic Mizen had contributed many exquisite oils to the company's national ad campaigns. Most of Mizen's pin-ups depicted wholesome, all-American girls involved in sports or other enjoyable pastimes.

Born in 1888 in Chicago, Mizen studied at Smith's Art Academy from 1904 to 1906 under John Vanderpoel, DeForrest Shook, and Walter Marshall Clute. He also attended night classes at the Chicago Art Institute. His first job was with Gunning Systems, the predecessor to General Outdoor Advertising Company, the giant national ad agency that specialized in billboard campaigns. Mizen became one of the country's leading billboard illustrators, executing pin-up-like advertisements that sold everything from beer to sunglasses. Johnson and Johnson and General Motors were among the dozens of major corporations that sought his services.

Mizen's earliest calendar pin-ups were created for the Louis F. Dow Company about 1938. During the 1930s and 1940s, he was also active in the mainstream illustration field, creating front covers for *The Saturday Evening Post*, *Cosmopolitan*, and many other important publications. Mizen died in 1965.

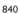

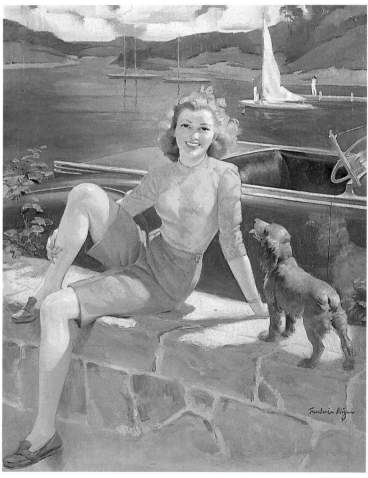

841

842

When Mayo Olmstead enlisted in the United States Navy in 1943, he never suspected that the course of his life would be changed forever. After basic training, he found himself in the Philippines, where he enrolled in commercial art courses. By the time he was discharged in 1946, he had decided to pursue a career in illustration.

Olmstead was born in Glendale, California, in 1925. At Hoover High School there, he was admired for his ability to copy extremely detailed illustrations from his physiology textbooks. He married Doris Larson on June 19, 1947, after returning from the war. Between 1947 and 1950, Olmstead attended Glendale's School of Allied Arts. Referred to Gil Elvgren by one of his teachers, he was hired by the Stevens/Gross studio in Chicago on the same day he was interviewed.

Olmstead worked for Stevens/Gross for three years, sharing assignments for *Sports Afield* magazine with Joyce Ballantyne. In 1953, he became a staff artist at Brown and Bigelow, again with the help of Elvgren. The firm immediately assigned him to paint pin-ups for the special calendar line they had created for major accounts. He shared this job with another staff artist, Bill Medcalf.

One of Olmstead's most significant achievements during his four years at Brown and Bigelow was a best-selling double set of playing card decks illustrated with two exquisite nudes entitled *Sincerely Yours* (1955), which Brown and Bigelow saw as their follow-up to Elvgren's card deck set *Hats Off*. Olmstead also created a series of large "hangers" that featured pin-up girls and automobiles. He painted all of his pin-ups in oil on canvas, generally measuring about 24 × 30 inches (61 × 76.2 cm), and he always signed his Brown and Bigelow pin-ups "Mayo". (Later, in the 1960s, he painted many works in gouache on illustration board.)

Olmstead left Brown and Bigelow in 1957 to freelance, but he continued to work for the company on that basis well into the late-1970s. He also accepted many assignments for glamour head-and-shoulder subjects as well as commissions for non-pin-up works from such clients as the 4-H Club and the Ford Motor Company. Between 1968 and 1978, Olmstead created the art for the Wheaties cereal boxes, including the famous image of Bruce Jenner, the 1976 Olympic Decathlon gold medalist.

Olmstead once told an interviewer, "To experience my subject tak[ing] on realism and form before my eyes has been a constant source of joy and amazement." He credits his wife and Gil Elvgren as the two most influential people in his life and career. Olmstead's pin-ups were the last original art Brown and Bigelow used before they turned to photography for their calendar-girl subjects.

Mayo Olmstead

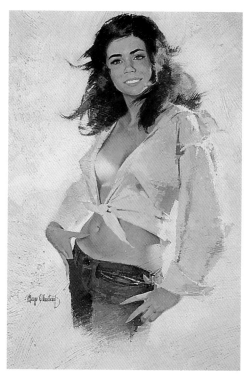

843

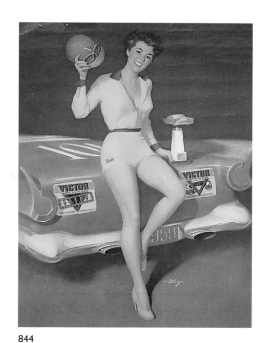

844

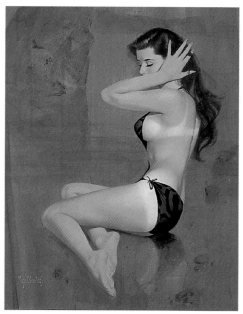

845

846

Walt Otto

Walt Otto was born in Horicon, Wisconsin, in 1895. His family moved to Oshkosh when Otto was seventeen. Showing an early talent for drawing and a sensitivity to color, he opened his own photo studio in 1915. After service in World War I, Otto moved to Chicago to study art, and his first job, at the Edwards and Deutsch lithography company, gave him the chance to observe four of the leading artists of the day: Haddon Sundblom, Andrew Loomis, Frederic Mitzen, and James Montgomery Flagg.

In the 1920s, Otto's work appeared on the front covers of national magazines like *Woman's Weekly* and *The Saturday Evening Post*. He studied advanced painting at the Art Institute of Chicago during 1931–32, while also maintaining a busy career as a freelance illustrator. Between 1935 and 1945, Otto's artwork was seen on billboards, posters, and point-of-purchase display materials for a host of major United States corporations, including Alka Seltzer, Shell Oil, Schlitz Beer, Kellogg's, and H. J. Heinz. More often than not, Otto would incorporate pin-up themes into such mainstream advertising creations.

After teaching aerial photography and mapworks during World War II, Otto returned to a thriving pin-up and glamour career. His most classic images are the country girls who appeared on millions of calendars during the 1940s and 1950s. Attired in shorts and halters and accompanied by their trusty canine companions, Otto's girls had strong roots in America's countryside. His oil-on-canvas paintings of these images were usually quite large, measuring 40 x 30 inches (101.6 x 76.2 cm), and always carried Otto's distinctive logo signature. Not to be limited to one theme, Otto also became well known for a series of sophisticated, glamourous evening-gown pictures.

Otto returned to Oshkosh when his wife died in 1952. A few years later, he was asked, for the third time, to paint a cover for *The Saturday Evening Post*; Otto thus began and ended his career with an honor rarely bestowed on pin-up artists. In 1961, the New York Graphic Society published one of the fine-art works that Otto painted during the last ten years of his life. Appropriately titled *Summer Idyll* (figure 849), this Otto girl with her toe dangling in a stream clearly sums up many themes of the artist's career. Otto died in Oshkosh in 1963.

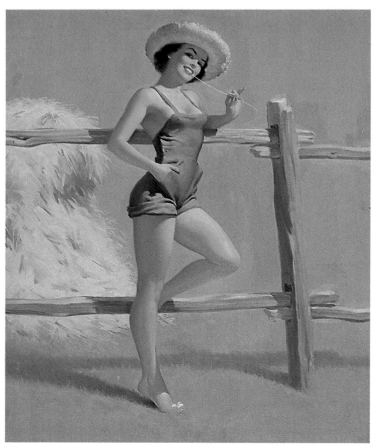

847

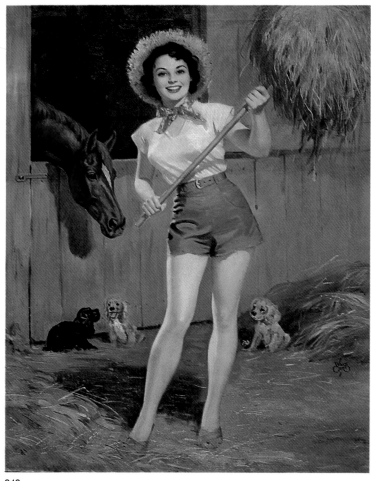

848

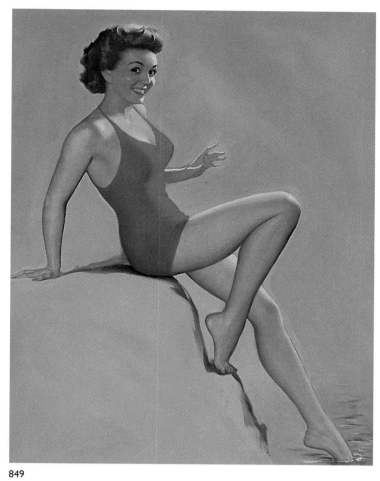

849

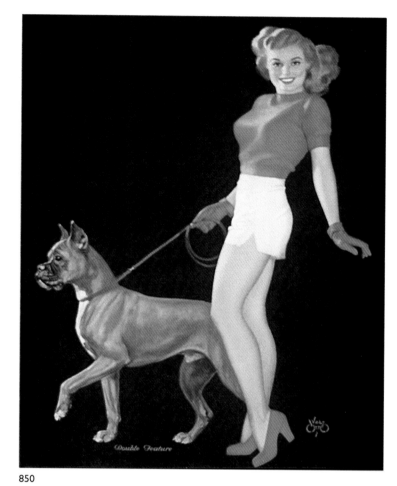

850

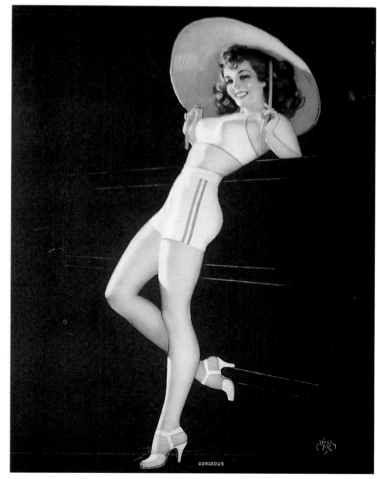

851

852

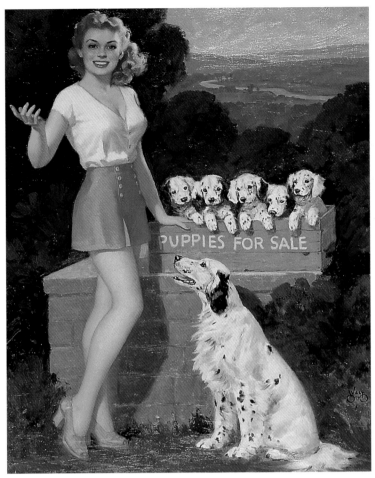

853

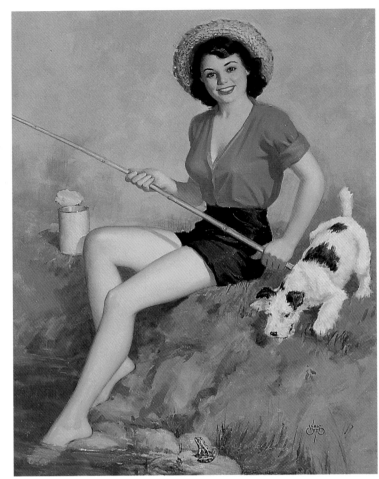

854

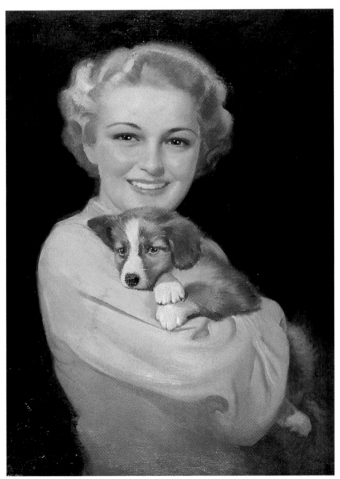

855

Jay Scott Pike

When the A. Fox calendar company needed an artist to complete the last two years of Art Frahm's "panties-falling-down" series, they turned to Jay Scott Pike. Among the memorable images he created for Fox are a gas station scene (figure 857) and, as the last in this important series, a picture set on a construction site entitled *Dog Tied* (figure 856).

Pike was born in Philadelphia in 1924. He enrolled at the Arts Students League in New York at the age of sixteen and, after service in the Marines, resumed his art studies at the Parsons School of Design, Syracuse University, and the Ringling School of Art in Sarasota, Florida. Besides sexy pin-ups, he has painted award-winning illustrations for magazines and comic books as well as advertisements for major corporate clients like Proctor and Gamble, Pepsi, General Mills, Ford, Borden's, and Trans World Airlines.

Near the close of his commercial career, Pike turned to painting canvases of sensuous fine-art nudes. His exquisite pencil drawings of nudes first appeared in the Playboy clubs before being published as limited-edition graphics. In recent years, he has also accepted many portrait commissions.

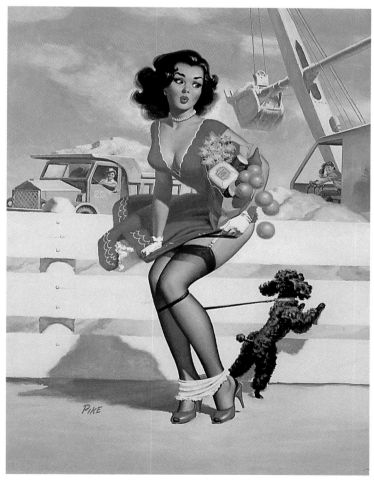

856

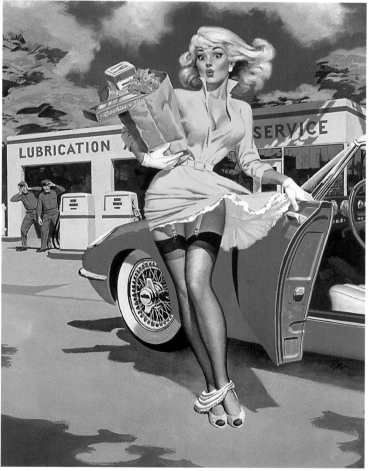

857

Bill Randall

Noted for his phenomenally successful Date Book calendars of the 1950s and 1960s, Randall was born in 1911 and attended the Chicago Art Institute. He worked as a commercial artist until the war, during which he joined with the French underground on a counterpropaganda campaign to create anti-Nazi artwork. Randall first gained notice in 1946, when *Esquire* selected him as a regular contributor to their Gallery of Glamour; he also painted centerfold pin-ups for *Esquire* and contributed ideas to their yearly calendar.

Randall also produced a great deal of advertising art for American corporations. Scotch Brand Celluose Tape, Minnesota Mining and Manufacturing, Palmolive Soap, White Rock, and General Motors were among the many mainstream companies that incorporated his pin-up images into their advertisements.

In 1950, Randall did a front-cover painting for *Parents* magazine. The same year, he also began a series of front covers for *American Weekly*, Hearst's Sunday-magazine supplement, which throughout the decade brought his pin-up themes to a larger audience of American readers than any other magazine. Randall also provided a similar set of images to Hearst's other Sunday supplement, *Pictorial Weekly*, and created a notable string of front covers for *Collier's* from December 1952 to April 1953.

The first of Randall's Date Book calendar series was published in 1953 by the Kemper-Thomas Calendar Company in Ohio. One of the most successful in the company's history, the series is sometimes compared to the Artist's Sketch Pads published by Brown and Bigelow. However, Randall's sketches were executed in gouache rather than in pencil and were drawn on an overlay rather than on the painting itself. The result was that his calendars had a more light-hearted feeling, accented by the cartoon-like side sketches. That a photograph of Randall often appeared on the front of the calendar only enhanced his celebrity.

Though he is best remembered for the Date Book series, it should not be forgotten that Randall was a highly prolific, versatile illustrator who painted pin-up and glamour art for a vast range of markets; he even illustrated seven books during his multifaceted career.

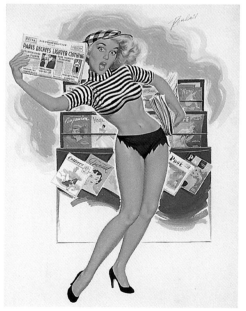

858

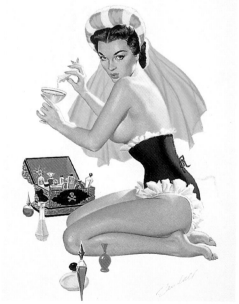

859

861

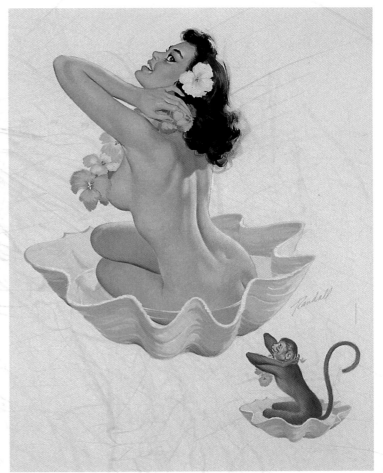

862

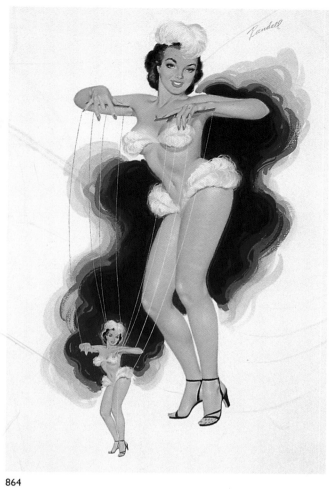

864

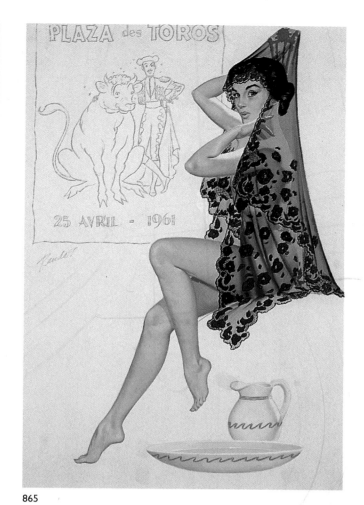

865

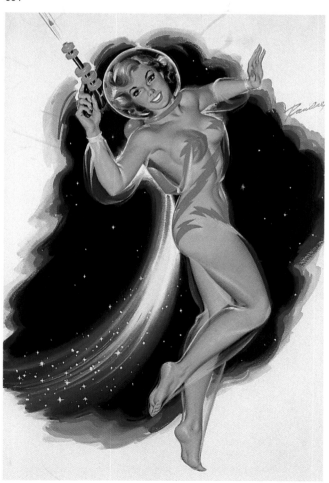

866

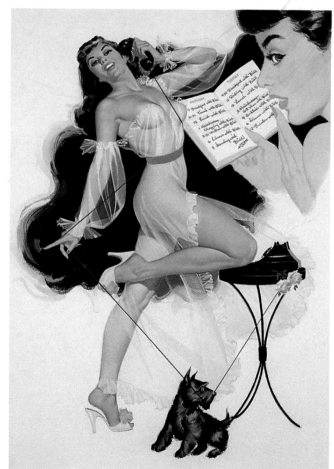

867

Arthur Sarnoff

Sarnoff was born on December 30, 1912, in New York City and grew up in Brooklyn. At the Grand Central School of Art, he was inspired by the teacher Harvey Dunn and later studied with John Clymer and Andrew Wyeth.

During a long and prolific career, Sarnoff has been successful in a wide variety of fields. From his first pulp-magazine job in the early 1930s, he went on to create front covers and story illustrations for all the leading mainstream magazines. His more than thirty years of calendar work included glamour images, with a particularly sophisticated use of lighting, for the Kemper-Thomas Company in Ohio in the 1940s, as well as pin-ups for the U. O. Colson Company of Illinois in the 1950s and 1960s. Among the many prominent national ad campaigns he worked on were those for Karo Syrup (1940s), Lucky Strike cigarettes (1951), and Camay Soap (1942–52); he has only recently completed a series of ads for Coors Beer.

Sarnoff, who has long admired the work of John Singer Sargent, has had a distinguished career in portraiture; his depictions of President and Mrs. John F. Kennedy are among his most accomplished portraits. Since the mid-1960s, he has provided illustrations for lithographs to the Arthur Kaplan Company, including his phenomenally successful series of dogs playing cards and shooting pool. His pool-playing scene entitled The Hustler was the best-selling commercial print of the 1950s and one of the most famous and widely reproduced images in contemporary art.

In 1995, Sarnoff was teaching art classes in Beverly Hills, California.

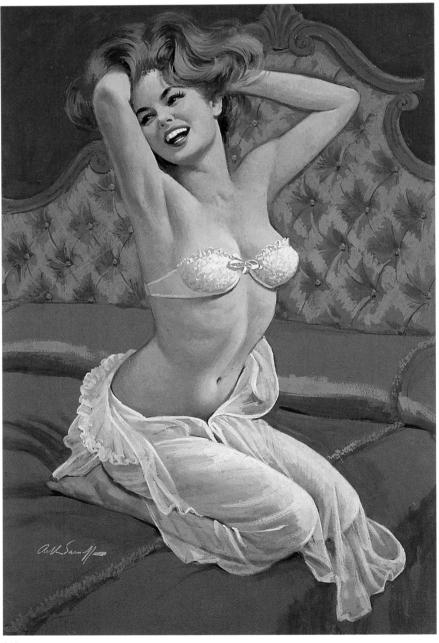

868

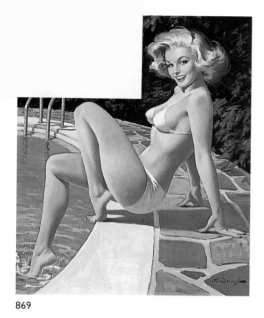

869

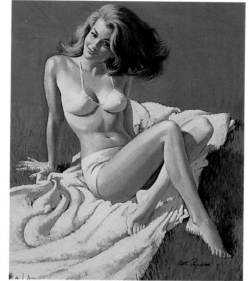

870

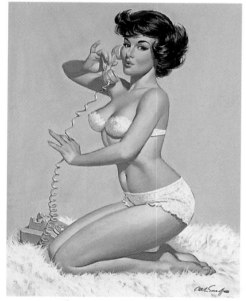

871

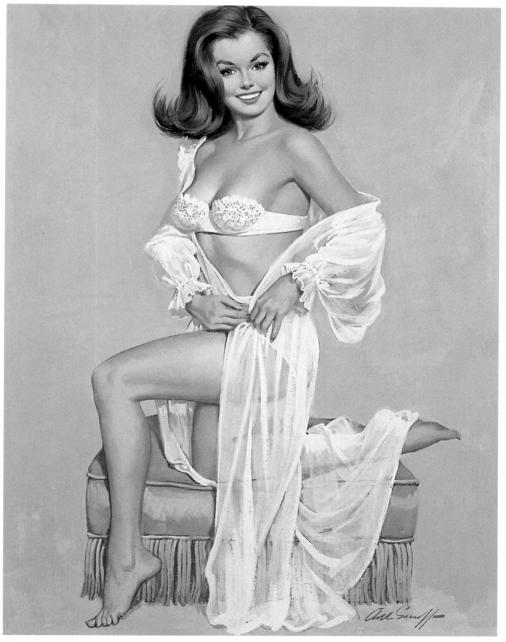

872

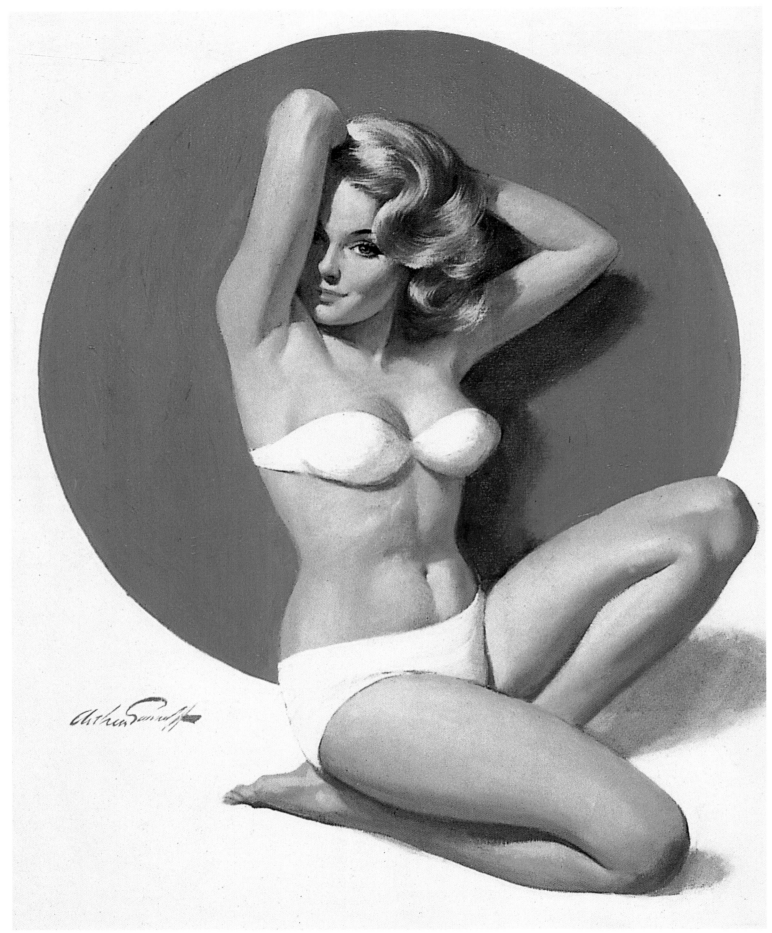

873

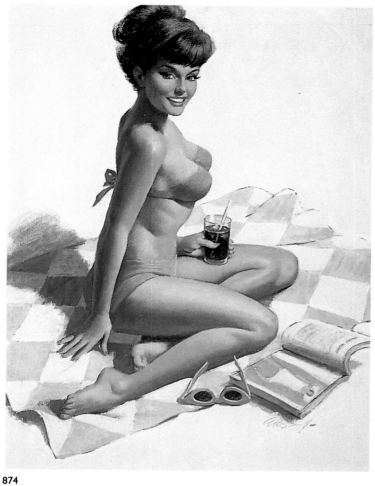

874

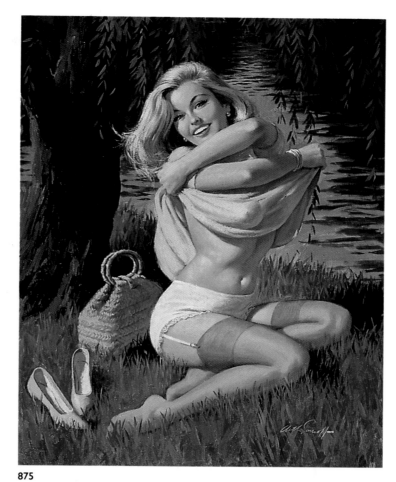

875

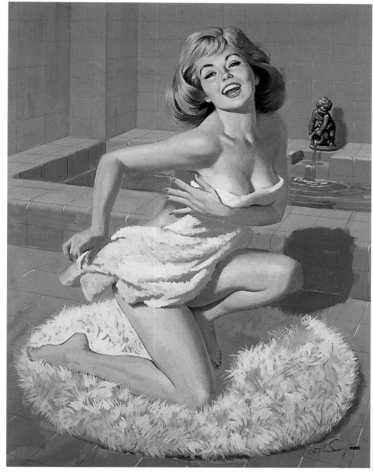

876

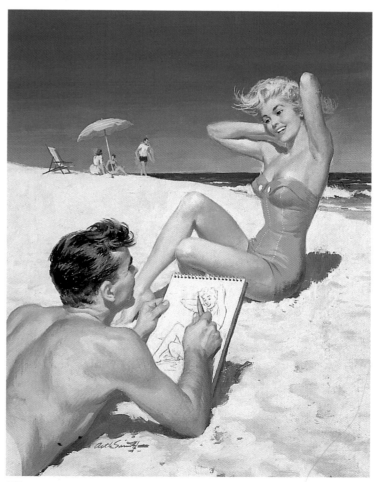

877

Mauro Scali

Scali was a pin-up and glamour artist who had the unusual ability to paint in two different styles: either "tight", with an almost photographic clarity, or "loose", with an Impressionistic freedom of form. *Esquire* was a major client for his glamour work, which first appeared as the magazine's centerfold in February 1952 and in subsequent issues was reproduced in both horizontal and vertical form. The artist also created full-page illustrations and calendar images for *Esquire*.

Scali worked in New York, where he was represented by the top-flight American Artists agency. Besides his work for *Esquire*, he illustrated many magazine stories and created numerous cover paintings for paperback novels.

Most of Scali's pin-up art was published from 1948 to 1963. He enjoyed using various mediums, and most of his pin-ups were executed either in oil on canvas averaging 30 x 24 inches (76.2 x 61 cm) or in gouache on illustration board averaging 14 x 11 inches (35.6 x 27.9 cm).

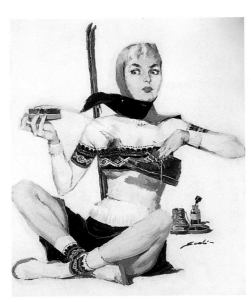

878

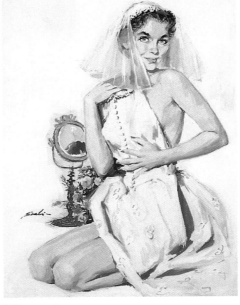

879

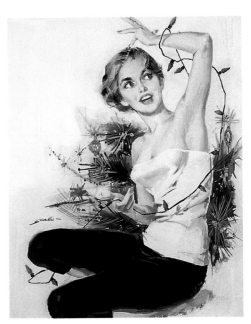

880

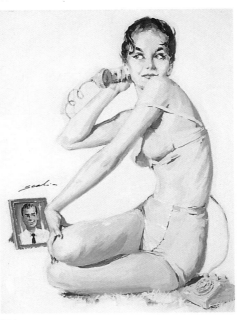

881

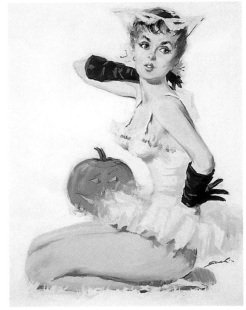

882

In 1968, Brown and Bigelow was among the last few companies to feature paintings in their pin-up and glamour calendars. Looking for new artists, the firm turned to Lou Shabner, a British painter who had been a successful glamour artist for more than twenty-five years. Responding to Shabner's reputation, the firm must also have admired the incredible Photo-Realistic effect of his exquisite paintings.

During the 1940s and 1950s, Shabner found millions of loyal English fans for his glamour portraits and classic pin-ups, which were published mainly as twelve-page calendars, first in London and then distributed throughout England and the rest of Europe. Although many of his models appeared to be British, others had a distinctly American look. There was a dream-like quality to his glamour art that sometimes left viewers almost light-headed. A printed Shabner calendar was so photographic that it was hardly ever recognized as having been reproduced from original paintings.

Shabner's pin-up girls ran the gamut of expressions — glamorous, sexy, provocative, proud, sweet, poised, joyous. Working primarily in gouache on illustration board, he occasionally painted in oil on canvas; the average size of a Shabner work was 20 × 16 inches (50.8 × 40.6 cm). Shabner often illustrated the front covers of his English calendars with a charcoal drawing of an inviting pin-up girl. No matter what medium he worked in, Shabner always attained the same strongly realistic effect.

Lou Shabner

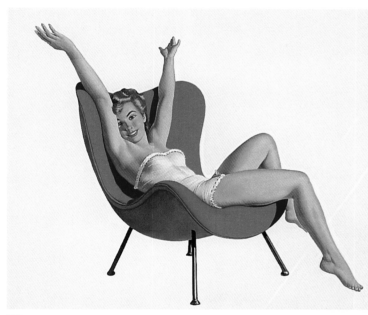

883

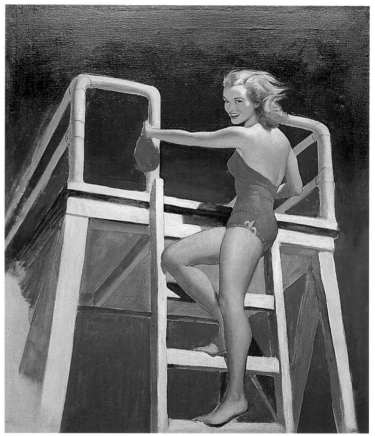

884

John Shilling/Jack Whittrup

Whittrup v ... influential Chicago-based Sundblom circle. Under Haddon Su ... uch fellow artists and friends as Gil Elvgren, Al Buell, Joyce Ballar ... /hitmore.

Whittru ... 912. After attending the University of Wisconsin, he studied at ... Academy of Art, where his teachers included Bill Mosby, a n ... of Art. He painted posters for the Army–Air Force Training Aids Division during the war, then briefly moved to Santa Fe and studied with Randall Davy and Theodore Van Soelen.

Whittrup opened a studio in New York in 1946 and formed the Illustrators Group, a sort of Sundblom circle of his own. Within a year, the group was very busy indeed, Whittrup having attracted attention through his twenty-four-sheet billboard painting for Atlas Lager Beer, commissioned by the McCann-Erickson Agency. Beginning with a shapely ballerina, his full-page ads for Lucky Strike cigarettes appeared in every national magazine in 1951.

Whittrup did a pin-up for Brown and Bigelow that was published as a single-sheet calendar for 1958. This was followed, in 1961, by another action-oriented pin-up for the firm's 1962 line: a snappy beach girl entitled *Let's Play!* that Whittrup signed with the name John Shilling. By this time the artist had a flourishing career as a painter of government and political figures, and so it is possible that he preferred his pin-up work to be credited to another name.

Whittrup's fame as a portraitist continued to grow, with many exhibitions of his work throughout the United States. He and his wife moved to Boca Raton, Florida, in the early 1970s, and he taught at that city's Center for the Arts. He died about 1990.

Showalter

Nothing is known about Showalter, but the piece illustrated here (figure 887) is worth noting.

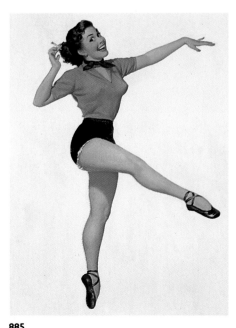

885

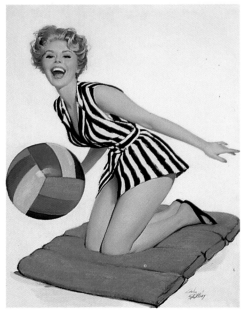

886

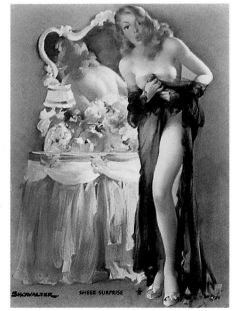

887

A member of the Sundblom school of illustration, Skemp first attended the Art Students League in New York in 1928–29, then went on to the Grand Central School of Art, studying in those years under George Luks, Thomas Hart Benton, and Harry Ballinger. But it was not until his association with Haddon Sundblom in Chicago that he came into his own as an artist.

Skemp and fellow Sundblom protégés like Elvgren, Buell, and Ballantyne, modeled their art in large part on that of the older artist. During his pin-up and glamour career, Skemp worked for several major publishing houses, but his original paintings are very rare today.

In the field of advertising, Skemp developed national campaigns for companies like Schlitz Beer, Studebaker Cars, the Ford Motor Company, and, most notably, for the Coca-Cola Company, where his images coordinated well with Elvgren's and Sundblom's work for the firm. He also created many story illustrations for mainstream magazines, including *The Saturday Evening Post*, *Collier's*, and *Sports Afield*.

Skemp often adopted Elvgren's "situation" poses in his work, depicting girls caught off-guard in various activities. The use of primary colors was another characteristic of his work. He painted in a large format, usually 40 × 30 inches (101.6 × 76.2 cm), in oil on canvas.

Skemp was a member of the Society of Illustrators and the National Arts Club. His paintings are in both public collections (the Pentagon, the United States Coast Guard, and the New York Public Library) and corporate ones (AT and T, Reynolds Tobacco, and the Franklin Mint). Between 1949 and 1953, Skemp won numerous medals from the Art Directors Club of Chicago. He was born in Scottsdale, Arizona, on August 22, 1910, and died in Westport, Connecticut, in 1993.

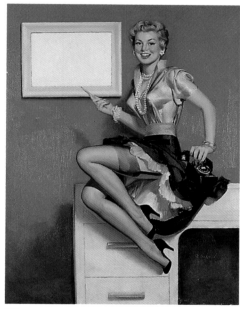

888

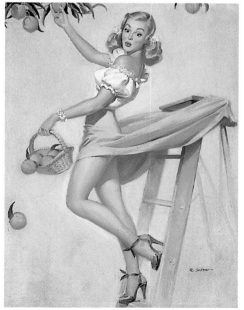

889

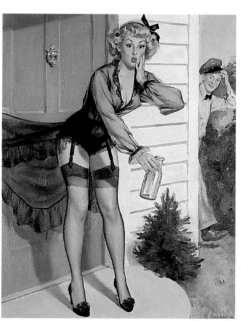

890

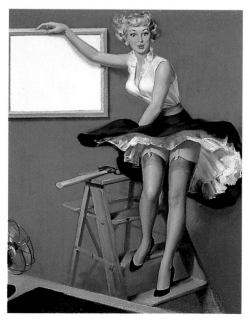

891

J. Frederick Smith

In 1946, when *Esquire* announced its new Gallery of Glamour series, the list of artists included the name of J. Frederick Smith, along with many of the top illustrators of the day. Working out of his New York studio, Smith was a brilliant artist who enjoyed incorporating pin-up and glamour themes into his mainstream work. His advertisements for Whitman's Chocolates, for instance, featured mothers who were as glamourous as movie stars.

Although Smith's pin-ups for the Gallery of Glamour were impressive, it was his special assignments for the magazine that distinguished him from his colleagues. His memorable three- or four-page illustrated articles, with titles like "Personal Interpretations", first appeared in 1946. He also painted pin-ups for *Esquire*'s famous two-page gatefolds as part of a relationship that was to last more than a dozen years.

From about 1945 on, Smith was represented by the well-known American Artists agency. In 1952, the firm made a deal with Brown and Bigelow whereby several prominent *Esquire* pin-up artists would combine forces to create a calendar. The result, the 1953 Ballyhoo Calendar, contained three pin-ups by Smith: a girl with a record player (figure 892), a girl holding a carnation up to her face, and a bikini-clad beach girl. All were painted in gouache on #80 Bainbridge drawing board, which imparted a special luminosity to Smith's colors.

Smith was born in Pasadena and grew up in Covina, California. He moved east in 1938 and settled in Greenwich, Connecticut, where he opened a studio for his freelance commercial art work. Many mainstream magazines immediately commissioned him to provide illustrations for their love and romance stories. After service in the Information and Education Section of the army during World War II, Smith plunged back into the glamour illustration business. He was elected an artist member of the Society of Illustrators in November 1947.

Smith attained much success as a pin-up, glamour, and mainstream illustrator in the first half of his career; he spent the last half as a highly skilled glamour and fashion photographer. He went on to receive many photographic commissions from magazines, ad agencies, and corporate clients, and his work found its largest audience in magazines like *Reader's Digest* and *The Saturday Evening Post*. In the 1960s and 1970s, several art books featuring photographs of his ideal feminine beauties were published. Whether he was working in illustration or photography, that ideal was Smith's abiding subject.

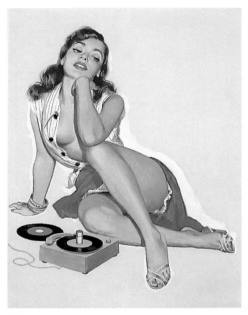

892

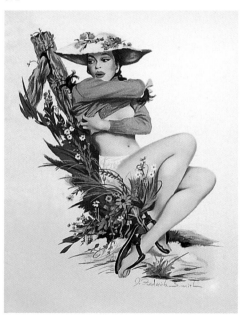

893

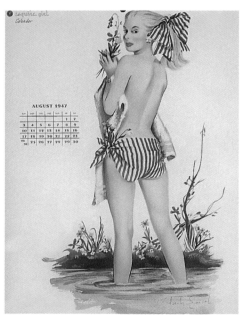

894

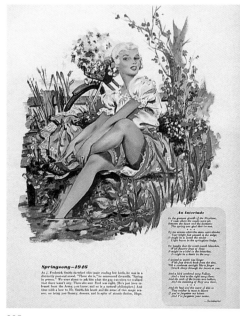

895

Sundblom is recognized today as the inspiration behind the best pin-up and glamour artists from the 1930s through the 1960s. Influenced by artists like Howard Pyle, John Singer Sargent, Anders Zorn, Robert Henri, J. C. Leyendecker, Walter Biggs, Pruett Carter, and Sorolla, he himself went on to affect dozens of artists who had distinguished careers in every area of mainstream illustration. Among the many Sundblom influenced in the pin-up and glamour art field were Elvgren, Ballantyne, Buell, Moore, Skemp, and Whittrup (Shilling), and among the second generation in the field, Bass, Brulé, D'Ancona, Frahm, Olmstead, Medcalf, Otto, Runci, Sarnoff, and Withers.

Born in 1899 in Muskegon, Michigan, Sundblom studied at the Chicago Art Institute and the American Academy of Art. Upon graduating in 1920, he served as an apprentice at the Charles Everett Johnson Studio in Chicago. In 1925, he formed a studio with Howard Stevens and Edwin Henry, and his career immediately took off. In his most important commission, from the Coca-Cola Company, Sundblom actually set the pattern and style of the firm's long-term national advertising with his classic illustration of Santa Claus (1925). Another series of national ads, for Cashmere Bouquet soap, allowed him to develop his characteristic sunlit glow, free-spirited brushstrokes, and wholesome yet romantic imagery.

Sundblom received advertising commissions from clients like Palmolive Soap, Colgate Toothpaste, Maxwell House Coffee, and Aunt Jemima (the latter, from the late-1930s until the mid-1950s). He also worked for all the major weekly and monthly mainstream magazines and, in the mid-1930s, began to paint occasional pin-up and glamour pieces for calendars.

The artist's last assignment, in the early 1970s, was a front-cover painting for *Playboy*'s Christmas issue, showing a smiling Sundblom Girl wearing a Santa Claus hat. "Sunny" died in Chicago in 1976, but not before his priceless instruction and artistic brilliance had influenced the entire realm of American illustration.

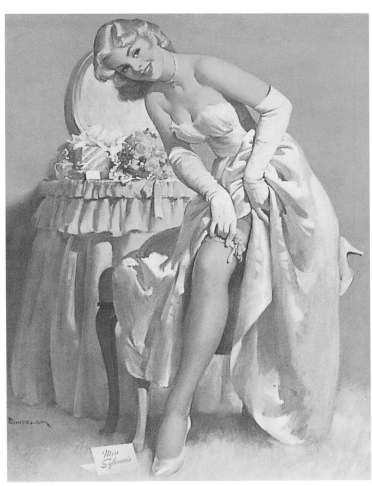

896

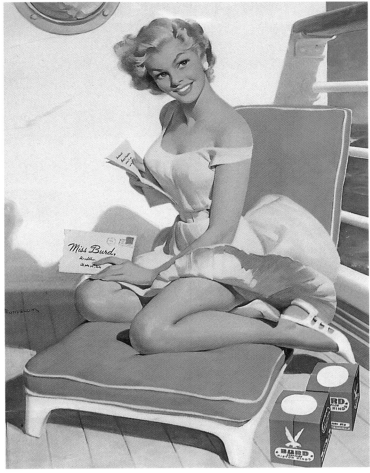

897

Si Vanderlaun

Vanderlaun painted works in a slick style that reproduced with photographic clarity and crispness. His entertaining pin-ups – either situation poses or narrative scenes – were published by several major calendar companies during the 1940s and 1950s.

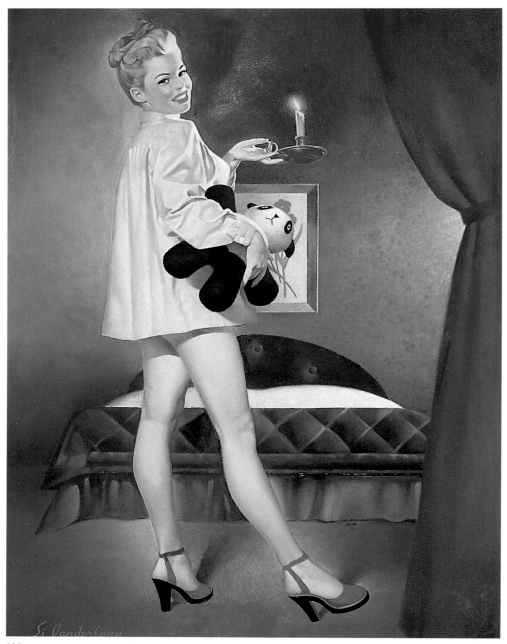

898

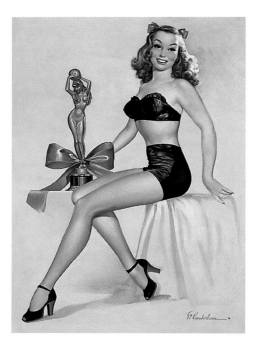

899

To date, there have been virtually no books that seriously document and illustrate the works of the American pin-up artists from the 1930s to the 1960s. With the exception of Alberto Vargas, none of the individual artists in the genre has even been the subject of a monograph.

There have been three books, however, that have touched on the subject. *The Pin-Up: A Modest History* by Mark Gabor was published in 1972 by Bell, a division of Crown Publishers, in New York. Unfortunately, the book contained fewer than a dozen illustrations of paintings by American pin-up artists. The second attempt to treat the subject came in 1976, when A & W Visual Library in New York brought out Michael Colmer's *Calendar Girl*. But again only three dozen or so true pin-up paintings were reproduced. Both of these books emphasized photographs of nude girls, which ranged from the artistic to the tasteless, but neither included pin-ups of the "girl-next-door" variety.

Then, Francis Smilby (Francis Wilford-Smith) entered the field. Smilby had been friends with Vargas through their shared publisher, *Playboy* magazine, and had had a successful career as an illustrator, providing a full-page color painting to *Playboy* for more than twenty-five years (as he continues to do today). Of all those who worked in the 1940s and 1950s in the pin-up field, he is, to the best of our knowledge, the only artist still active. Figure 902 shows an example of his current "pin-up legs", and figures 900 and 901 two Smilby cartoons.

In 1981, Smilby produced *Stolen Sweets: The Cover Girls of Yesteryear. Their Elegance, Charm, and Sex Appeal* for Playboy Press (distributed by Harper and Row, New York). Drawing on the thousands of books and magazines he had collected as sources for his own work, he wrote and illustrated a history of the cover girl from the first French illustrations in the 1890s through the "U.S. Girlies" of the 1930s.

Smilby's is the best book previously available. While it focuses on an earlier period than the present volume, *Stolen Sweets* is devoted exclusively to the fine art of illustrated magazine covers. It reproduces paintings of beautiful, sexy girls in a clean, fun-loving, and celebratory spirit rather than in an exploitative or pornographic way. Smilby and his book set wonderful precedents for us when we embarked on *The Great American Pin-Up*.

Bibliography

"I just hate the way men undress you with their eyes"

900

"Tell me, is this your first wet T-shirt competition?"

901

902

Index of Artists

Our acknowledgments to those who have helped make this volume possible must begin with the mention of our dear friend Art (the King) Amsie. A longtime friend of Gil Elvgren and Fritz Willis, Art was for many years the only person to champion pin-up artists. He collected, documented, and preserved their works and managed to communicate to the small group of people who held the original artwork that there was value in ferreting out and saving such art. He is the single most important link to the past in this field. We thank him for making his archives, collections, and documents available to us over the past twenty years.

It would have been impossible to have a book as extensive and all-encompassing without the whole-hearted support of the owners and staff of Brown and Bigelow, clearly the greatest calendar-publishing company ever. Without exception, all of the finest, most significant pin-up calendars and spin-offs were the domain of Brown and Bigelow from the turn of the century until about 1970, when the Golden Age of pin-ups ended. William Smith, Sr., and William Smith, Jr., gave us their enthusiastic support and the rare opportunity of spending days in their archives. At their headquarters in St. Paul, Minnesota, with temperatures of thirty below zero outside, we spent hour after hour with Linda Sue Johnson, Licensing Director, and Teresa Roussin, Licensing Coordinator, going through fifty years of images and other printed materials. Linda Sue and Teresa provided us with a great deal of invaluable information, some of which appears herein and some which will enhance future monographs. Then, Brown and Bigelow photographer Brad Knefelkamp shot more than three hundred printed works for possible use in this book.

An equal debt and thanks must be acknowledged to the staff at *Esquire* magazine, a division of Hearst Publications. David Graff, Vice President and Director of Brand Development, Lisa Kreger, Associate Licensing Manager, and Tom Robotham made it possible for us to include Alberto Vargas in the book along with all the other artists whose works appeared in *Esquire*, the singularly most important publication in the field of pin-up and glamour art.

LeRoy Darwin reminded us of the people in Ray Bradbury's *Fahrenheit 451* who assumed the role of "talking books" to keep the classics alive in an age of book-burning. Over many years, he focused on one or two artists and amassed verbal and visual histories, while waiting for the day when someone would be able to record it all in print. Like Art Amsie, LeRoy has preserved a great deal of pin-up history, with particular interest in Earl Moran and Rolf Armstrong. He, too, generously opened his trove to us.

Other guardians of these artists' legacy include Drake Elvgren, son of the greatest of the pin-up painters, who shared personal memories and documents. Tom Skemp, San Crandall, and the Driben family, including Adrienne, Leo, and Aaron, all did the same. Zoë Mozert's brother Bruce sent a videotape showing fifty of her original paintings, and Joyce Ballantyne spoke to us about herself, Al Buell, and others.

Marianne Phillips is the "talking book" on Zoë Mozert as well as a font of information on Joyce Ballantyne and many of the other artists.

Ronald Feldman was our entrée to the George Petty Estate.

The collectors who supplied photographs of their paintings include Clarke and Janice Smith, who are among the earliest pioneering collectors of this art and whose collection is the source of much information and imagery herein. We also thank Stuart David Schiff and Barry M. Shaw for the photographs they provided.

The collection of Ray and Harriet Warkel is one of the finest, and their contribution to our efforts has been massive. In Paris, our friend Pierre Boogaertz, the only European dealer in illustration art, has been another great help. We must also thank collector and pin-up authority Max Allan Collins for his knowledge and contributions to the book.

And a special thanks to Walt Reed. Author, illustrator, historian, and founder of Illustration House, Walt is also a dealer and auctioneer with a wide-ranging collection of illustration art. We are grateful for his help and for his lively, thoughtful overview of pin-up history.

Our gratitude also goes to staff members at the Louis K. Meisel Gallery who have aided in the preparation and publication of this book: Diane Sena, Louis's first line of research and text-editing assistant, without whom he would never get the first word on paper in any intelligible way, and Aaron Miller, researcher and traveling photographer, who along with Steven Lopez has photographed almost all of the artwork in this volume.

In addition, thanks go to Dirk Luykx and Gilda Hannah for their fine design work. We are also grateful

to Margaret Donovan, Louis's editor for fifteen years and five books, for her contributions to the book. At Taschen, we thank Burkhardt Riemschneider, the project editor who brought the book to the firm; Mark Thomson, who coordinated the project; and finally Benedikt Taschen himself, who is unaffected by public opinion and prejudice and who publishes what he likes, with no holds barred.